Self and History
A Tribute to Linda Nochlin

Self and History
A Tribute to Linda Nochlin

Edited by Aruna D'Souza

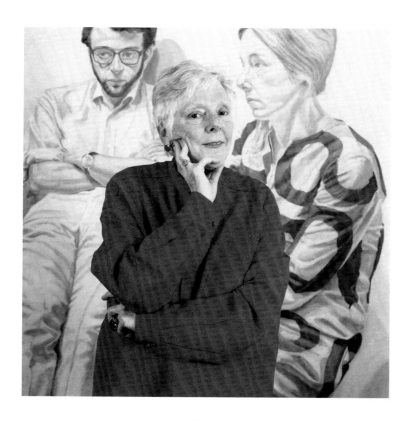

With 98 illustrations

Title page: Linda Nochlin in her Manhattan apartment, 1999
(see also 72)

Designed by Liz Rudderham

© 2001 Thames & Hudson Ltd, London

First published in paperback in the United States of America
in 2001 by Thames & Hudson Inc., 500 Fifth Avenue,
New York, New York 10110

thamesandhudsonusa.com

Library of Congress Catalog Card Number 00-101149
ISBN 0-500-28250-1

Printed and bound in Singapore by CS Graphics

Contents

Fragments and Paradoxes:
Linda Nochlin's Theories of Art

Aruna D'Souza

In the spring of 1999, a group of scholars gathered together at the Institute of Fine Arts, New York University, for a symposium in honor of their mentor, colleague, and friend, Linda Nochlin. Nochlin, who holds the Lila Acheson Wallace Chair in Modern Art at the Institute of Fine Arts, and who has in her distinguished career also taught at Vassar College, the Graduate Center at the City University of New York, and Yale University, is best known as a pioneer in the feminist critique of art history. Indeed, her essay, "Why Have There Been No Great Women Artists?" published in 1971, was a remarkable and controversial challenge to art historians to radically change their working methods and their conceptual frameworks in order to transform their field intellectually, politically, and ethically. Her subsequent explorations, over a period of thirty years, of the themes of identity, marginality, opposition, and alienation have been the means by which Nochlin has placed gender at the center of an intensely political academic practice.

To characterize Linda Nochlin as a feminist art historian tells a profound truth about her intellectual stance, as long as one is willing to understand her feminism not as a single methodology, "a kind of...Vaseline which lubricates an entry into the problem and ensures a smooth, perfect outcome every time," as she herself once colorfully put it.[1] As early as the 1970s, Nochlin rejected essentializing feminisms, in favor of treating feminism as a lens through which she explores art-historical problems and that structures her very way of seeing. If Nochlin has been a pioneer – and an on-going force – in the feminist critique of art history, her work has been no less important in the development of a social history of art; while a number of art historians have expended energy questioning the possibility of the coexistence of these two approaches, Nochlin cannot conceive one without the other in her work.[2] And if her writings have focused primarily on the issue of femininity and its social construction in the nineteenth and twentieth centuries in Europe and America, they have not been devoid of considerations of ethnicity and race as well. In fact, it is clear that it is precisely Nochlin's feminism that allows these other terms – these terms of difference, of Otherness – to come to the fore.

The contributors to this volume were not given a theme or a topic to explore; rather, they were asked only to present a paper which, in some way, spoke to the impact that Nochlin's scholarship has had on their work. The title of both the symposium and this book, *Self and History*, derives from her own words: "Nothing, I think, is more interesting, more poignant and more difficult to seize, than the intersection of self and history." Poignant and difficult to seize, perhaps, because she resists any notion of the transparency of experience to the historical context, while still insisting that the individual is a privileged link to that history. All the papers gathered here address this question in some way, whether the self is conceived as a political, biographical, or sexual subject, or whether the history in question is one distinct from, or continuous with, our own. If some of the contributors to this volume address the intersection of Linda Nochlin's own life – personal and intellectual – with its historical context, in all of its transience and complexity, others investigate what it means to be a historical actor, what it means for one's life to take place in a moment and to be marked by that moment. This collective sensitivity derives, ultimately, from Nochlin's example. It is a testament to the richness of her art-historical approach that the resulting essays are so different from one another, while sharing this common concern.

In the introduction to her most recent book, *Representing Women*, Nochlin characterized her approach to art history as "ad hoc," a phrase which is typical of her writings in that it hides a complex set of ideas in an innocuous – even frivolous – locution. Nochlin's notion of the ad hoc is a refusal on her part of any single methodological approach or a grand historical scheme: no overarching theories of Modernity or the Avant-Garde here, thank you very much, no single project that guides the trajectory of her work. No "master narratives," in other words – in this sense her practice is a decidedly postmodern one. But to call this method ad hoc is too deprecating a description (indeed, Nochlin is the only one who could get away with it). One might instead refer to Lévi-Strauss's theory of bricolage, as she herself does, in characterizing this deceptively anti-methodological stance: not a refusal of theory by any means, Nochlin's conceptual eclecticism is a highly considered one, which takes as its first principle the responsiveness and the flexibility of the intellectual in relation both to the object of study and to the needs of the argument, so that each one reflects and transforms the other.[3]

The *bricoleur*, however, does not simply respond to, and explain, an environment or set of circumstances as a given, but actively *transforms* meanings by a manipulation of signs:

Together, object and meaning constitute a sign, and, within any one culture, such signs are assembled, repeatedly, into different forms of discourse. However, when the *bricoleur* re-locates the significant object in a different position within that discourse, using the same overall repertoire of signs, or when that object is placed within a different total ensemble, a new discourse is constituted, a different message conveyed.[4]

Nochlin's practice of *bricolage*, then, is not simply an adaptive method of constructing an argument, but an intervention into the realm of signification itself: her re-placing of the most familiar of nineteenth-century paintings in a new, alien context is a way of re-positioning it within feminist discourse. The notion of *bricolage* posits the possibility of women's active resistance historically within patriarchal culture, by transforming the very terms of that culture– parallel to what Dick Hebdige describes in his book on subcultures – as well as the possibility for the (feminist) art historian herself to transform and bring to light meanings working within the (manipulated) terms of the discipline. Nochlin's struggle to change the terms of art history is a struggle in language, even if this language is a visual one – and as always, a struggle in language is at root a political gesture. No less than her feminist activism is this intellectual project committed to a liberation of women, in a political sense.

The provisional, collagistic nature of *bricolage* seems well suited to this art historian, for Nochlin has stated her discomfort with universal theories, single truths which explain the complexity of experience: "Indeed," she has written, "when I am tempted to make some broad generalization – about my work or anything else – I take a deep breath and wait until the temptation passes."[5] There may be a particular irony involved in claiming, then, that if there is anything that unifies Nochlin's work – other than her commitment to feminism and women's liberation – it is the dual notion of the fragment and the paradox. For the fragment and the paradox both work against unity: the fragment, obviously, as an image of disunity both literal and conceptual, and the paradox as the upsetting of seemingly stable ideas and situations, of renting unity from within.[6] The fragment is an ever-present entity in Nochlin's writing, both determining her subject matter – as in the body in pieces, or the truncated legs of Manet's *Masked Ball at the Opera* (1873, National Gallery of Art, Washington, DC), or the cropped bottom of a dog scurrying out of the frame of Degas's *Bellelli Family* (1858–67, Musée D'Orsay, Paris), about all of which she has written[7] – and the form her writing often takes, in what she writes about, and how she writes about it. The notion of paradox allows Nochlin to admit a complexity in her

understanding of how and why representational codes are manipulated within an ideological moment: her work is filled with stories of misogynist artists who create progressive images of women, marginalized artists who create works that partake of current stereotypes, and every possibility in between. Nochlin's embrace of the subtleties of the paradoxical allows her to construct a picture of artistic intentionality that rejects simplistic cause-and-effect models.

Where better to begin an exploration of Nochlin's use of the fragment than her succinct study, *The Body in Pieces: The Fragment as a Metaphor of Modernity*, given as the twenty-sixth Walter Neurath Memorial Lecture in 1994. In a sweeping view of nineteenth-century art history, she traces the visual representation of the fragmented body in all of its aspects: as a political and psychosexual response to the French Revolution, and political turmoil generally; as a sign of the fleeting glances and hurriedness of modern experience; and as a signal of the realism – the truth claim – of a certain brand of mid-century art making, among other things. What is striking in this piece, as in much of her writing, is the refusal to draw broad conclusions. Just as the series of body parts illustrated in the book refuse the possibility of the human body's unity, so Nochlin's text is composed as a series of fragments – "discrete, ungeneralizable situations," as she put it. This is not an unusual form in her oeuvre: "Women, Art, and Power," one of her most significant essays, was conceived as an on-going project, its form mutating each time she published it or gave it as a lecture, bits added on and transformed in response to her changing scholarly activity; while essays like "The Myth of the Woman Warrier" are less analytic than synthetic, demonstrating Nochlin's preference for putting together various instances or case studies as a way of demonstrating the conflicted terrain of signification.

Ultimately, this embrace of the fragment in Nochlin's work – both as subject matter and as formal device – is linked to her commitment to realism. For Nochlin's fragment is a synecdochic one, which, along with the metonymic excess of detail, is one of the characteristic features of a realist approach as described by Roman Jakobson. Jakobson identified the two poles of linguistic construction (metonymy and metaphor) as corresponding to two literary styles (realism and romanticism, respectively): "The Realist author metonymically digresses from the plot to the atmosphere and from the characters to the setting in place and time. He is fond of synecdochic details. In the scene of Anna Karenina's suicide Tolstoy's attention is focused on the heroine's handbag...."[8] While Nochlin's 1971 book on *Realism* treated a historically specific use of the term in nineteenth-century Europe,[9] Jakobson's formulation, because dependent upon the lessons of the poten-

tially transhistorical linguistic phenomenon of aphasia, suggests that realism is the instantiation of the metonymic pole of language, and thus is a kind of structural condition of language which has the potential to exist in a variety of historical contexts.

Nochlin seems to accept the possibility of Jakobson's structural formalism, both in her account of "The Realist Criminal and the Abstract Law," a two-part article in which she explores the structural dependence of modern idealist abstraction on base realism,[10] and in her continuing interest in contemporary realist artistic practices. It is no coincidence that Nochlin's work on nineteenth-century Realism coincided with an exhibition she organized at Vassar College in 1968, "Realism Now," which included such artists as Philip Pearlstein, Sylvia Mangold, Sylvia Sleigh, and Alfred Leslie. As Abigail Solomon-Godeau makes clear in her essay in this volume, Nochlin's affinity for realism is not a simple matter of aesthetic preference, but rather is a function of her political commitments: not simply because certain forms of realist art – Courbet's for example – were avowedly political at moments, but because realism affords the possibility of including experience itself (a contested term in early 1970s feminism) in the discourse of art.

While for many, unfortunately, the idea of "feminist art history" brings to mind endless catalogues of forgotten women artists, Nochlin's work obviously exceeds this narrow characterization. This is not to say that she has not been party to that very important task of historical recovery – "Women Artists 1550-1950," an exhibition which she curated with Ann Sutherland Harris in 1976 was a groundbreaking step in that project – or that she has not focused her attention on women artists in her writings – she has produced important work on Florine Stettheimer, Berthe Morisot, Mary Cassatt, Joan Mitchell, and countless other modern women. But neither has she felt limited to devote herself to the extra-canonical or marginal as it were: indeed, Nochlin's feminist gaze has been effectively trained on the very artists that make up the traditional pantheon of late nineteenth-century French art – Degas, Manet, Renoir, Courbet, and so forth. She sees no contradiction in being a feminist art historian and focusing her scholarly attention on male artists (although she is not unaware of the difficulties posed by her simultaneous activities of "looking as an art historian" and "looking as a woman"[11]).

It is in her writings on male artists, especially, that the notion of paradox comes to the fore, in her insistence that opinions personally held by individual artists necessarily interact with representational codes to produce meaning in the work of art, but that those opinions are never transparent to the ultimate meaning of a painting. Take, for example, "Degas and the Dreyfus Affair: A Portrait of the Artist as an Anti-Semite": in an argument

that is, at first glance, counter-intuitive, and upon closer inspection, profoundly truthful, Nochlin argues that Degas's virulent hatred towards Jews deposited itself in his work only insofar as he was using a familiar, widespread set of representational codes current in late nineteenth-century France, the same one from which Camille Pissarro, a Jew, also drew. To paraphrase Nochlin, there was no visual language available to artists like Degas and Pissarro with which to construct an image at once identifiably Jewish and at the same time "positive," because "the signifiers that indicated 'Jewishness' in the late nineteenth century were too firmly locked into a system of negative connotations."[12] Ultimately, Nochlin insists on a subtle relationship between personal politics and representational ones:

> One can separate biography from the work, and Degas has made it easy for us by keeping, with rare exceptions, his politics – and his anti-Semitism – out of his art. Unless, of course, one decides it is impossible to look at his images in the same way once one knows about his politics, feeling that his anti-Semitism somehow pollutes his pictures, seeping into them in some ineffable way and changing their meaning, their very existence as signifying systems. But this would be to make the same ludicrous error Degas himself did when he maintained that he had thought Pissarro's *Peasants Planting Cabbage* an excellent painting only *before* the Dreyfus Affair; Degas at least had the good grace to laugh at his own lack of logic in that instance.[13]

Nochlin is not interested in condemning, or celebrating, an artist's political position; she is interested, on the contrary, in seeing how or if that position seeps into the artist's art-making practice. Here she raises the possibility that image-making is not transparent to the artist's personally held beliefs by setting up the paradox of Degas the anti-Semite's sympathetic portrayal of his Jewish friend, Hélavy, in contrast to Pissarro's stereotypical caricature of Jewish bankers, targets of his anarchist politics. Likewise, in other works she suggests that a "positive" or "progressive" representation of women need not be tied to any enlightened thinking on the artist's part. Her piece on Géricault throws this idea into relief. Indeed, the whole essay constitutes a compelling paradox: how can Nochlin claim that Géricault, in his progressive *erasure* of women from his public artworks, was in fact making a positive contribution to the possibilities for representing women in nineteenth-century French art? She explains:

> No one can escape from ideology, history, or the psychosexual wounds requisite to coming of age in our culture, past or present, yet some few

have managed to make an intervention, no matter how slight, or with what lack of intentionality, in the seemingly monolithic structure of illusory signs and significations which construct femininity in the world of representation. Géricault, by absenting women from his representation the way he did, and by establishing feminine presence where he did, was one of those – highly exceptional – interveners in the dominant discourse of his time.[14]

Because of Nochlin's willingness to look at the manipulation of visual codes within a certain historical moment, and without a conceptual dependence on artistic *intentionality* as such, she manages to avoid the methodological trap of only being able to see so-called positive representations of women (or Jews, or blacks, or other marginalized figures) as a product of "proto-feminism" (or some other such enlightened stance), and negative representations as a result of misogyny.[15] The positions that cultural producers create for themselves or find themselves in at any moment, and the way in which representation produces meaning, are too complex to be stated so glibly, her work reminds us.

The range of essays in this volume attests to the impact that Linda Nochlin's work has had on areas of the discipline that far exceed her primary sphere of operation, late nineteenth-century French art, with topics that range, chronologically, from Rococo painting to Rachel Whiteread. (Had we not been restricted to the practical limitations of a two-day symposium, this volume could have been twice as long, and included work from many other fields, given the wide influence of Nochlin's writings.) Robert Rosenblum's essay is an apt introduction to what follows: he has known Nochlin the longest of any of the contributors, and provides insight into the youthful motivations that prompted her long career as an art historian. Later in the volume, a memoir – not an essay, for it is too poetic for that – by Eunice Lipton embraces the contiguity of her family's history and Nochlin's: a recollection of the latter's penchant for Spanish Civil War songs is the impetus for an exploration of Lipton's uncle's involvement in that moment of political resistance. Moira Roth spent a number of days interviewing Nochlin and digging through boxes of old family photos; the illustrated interview, a collaboration between Roth and her subject, most literally explores the intersection of self and history announced by the title of this book.

Abigail Solomon-Godeau produces another kind of portrait in her essay, "Realism Revisited": here, the author situates Nochlin's work on

nineteenth-century Realism historically, finding in it a political optimism or imperative that is very much linked to its origin in the early 1970s. Importantly, Solomon-Godeau makes clear the *continuity* between Nochlin's writings on Realism and her feminist stance as a structural principle, despite the fact that Nochlin rarely discusses gender explicitly in this realm of her writing. In a very different way, Rosalind Krauss revisits Nochlin's groundbreaking writings on Picasso's color in order to interrogate the artist's work from the 1930s; Picasso's troubled responses to Matisse and Miró, and his desire to reintroduce color into his work are seen as motivations for the development of his stylistic *pastiche*.

Along with Lipton and Roth, Molly Nesbit is interested in exceeding the limitations of academic writing: her piece on Rachel Whiteread's *Water Tower* is a sensitive musing on the relations between a work and its site, and imbricates – poignantly, even lyrically – the immigrant's experience and the artist's. To focus on the figure of the immigrant is particularly appropriate here, for Nochlin has explored the themes of alterity and exile throughout her oeuvre. These contributors' interest in writing *as such* is mirrored in Nochlin's own interest in creative writing, both in poetry – which she embraced at a very young age and has turned to once again, now – and other types of writing – as, for example, her small book on *Mathis at Colmar*, or her many forays into art criticism.

Kenneth Silver, Tamar Garb, Robert Simon and Carol Ockman draw inspiration from Nochlin's interest in so-called popular imagery – announced in her dissertation on Courbet, in which she discovered the artist's dependence on Epinal prints of the Wandering Jew to give form to his own self-portrait, and a familiar subject afterwards in her work. Silver's essay, a study of Roger de La Fresnaye's *Conquest of the Air*, starts out very much like one of Nochlin's essays: a direct, personal address, an enunciation of the subjective quality of the scholarly endeavor, prefaces a closely argued reading of the painting at hand, informed by the latter's writings on "tricolorism" in the art of Picasso. Garb's essay, "Framing Femininity in Manet's *Portrait of Mlle. E.G.*" is another example of the possibilities of Nochlin's particular approach to feminist art history for "visual culture": she explores a portrait of Eva Gonzalès by Manet in light of both the teacher-student relationship, and the popular imagery of disease and its relation to femininity. Robert Simon turns to the subject of violence in Géricault; while no doubt informed by Nochlin's writings on the relative absence of women in that artist's oeuvre, and his fascination with fragmented bodies and corpses, Simon himself was instrumental in her initial turn to the subject in the first place. Carol Ockman's "Women, Icons, Power" concerns representations of Sarah Bernhardt, finding this performer's own manipulation of her image

in the public eye a sign of her unlikely power as a woman, and a Jewish woman at that, in the late nineteenth and early twentieth centuries.

Ewa Lajer-Burcharth and John Goodman treat eighteenth-century subjects – the architectural fantasies of Jean-Jacques Lequeu and Rococo imagery, respectively – but in a way that pays homage to Nochlin's interest in sexuality and the pleasure of the text. Lajer-Burcharth examines Lequeu's "Lascivious Corpus," finding here that the feminization of architectural space in eighteenth-century boudoirs, for example, perversely exaggerated in Lequeu's fantastic visions of pudendal grottos and labial entries, sexualized architecture all. Goodman explores the unlikely conjunction of the French Enlightenment search for knowledge and an eighteenth-century penchant for "philosophical pornography" and sexual exploration, finding the titillating images of the Rococo a fitting articulation of the potential, sensual or otherwise, of this intellectual tradition.

The work of Carol Duncan and Stephen Eisenman, in very different ways, speaks to the political and social themes explored in Nochlin's work. Duncan, herself a pioneer in the feminist critique of the art-historical discipline, turns her attention to the establishment of the Newark Museum, and the progressive, democratic, and almost utopian ideals that motivated it. Eisenman's text on Gauguin's *Te nave nave fenua (Land of Sensual Pleasures)* recalls Nochlin's exploration of the image of the working woman, for he finds this painting to contain references to the economic realities of the colonized Tahitians, and specifically to a type of work that belied the timeless and ahistorical qualities of the female nude.

"Nothing…is more interesting, more poignant and more difficult to seize than the intersection of self and history": there are many selves represented here, many histories. In all, it is hoped that these essays will provide a fitting, and necessarily complex, intellectual portrait of a person – friend, colleague, mentor – who has transformed our ways of looking at art, and the world.

It is impossible to throw oneself into a project such as this and not incur huge debts of kindness. First thanks go to all of the contributors to the volume, whose love for Linda Nochlin made them *even* easier to work with than they would have been otherwise, and who patiently tolerated my own inexperience in realizing first a symposium, and then a book, of this scale. The original symposium was organized by a group of students at the Institute of Fine Arts: Larissa Bailiff, Sarah Ganz, Ellen McBreen, Tom McDonough, Jason Rosenfeld and myself were assisted by a number of student volunteers, as well as by Joan Lebovitz, Assistant to the Director, and

other members of the IFA staff. I would like to thank my co-coordinators for their hard work and dedication to the conference. Funding for the symposium was graciously provided by Catherine Stimpson, Dean of the Graduate School of Arts and Sciences, New York University; Seagrams and Sons Ltd through the kind help of Phyllis Lambert; and the Institute of Fine Arts. I am particularly grateful to James McCredie, Director of the IFA, for his steadfast support, without which the event would never have happened. Richard Sennett, Saskia Sassen, and Leonard Barkan hosted an incredible dinner to celebrate the end of the conference; their generosity and culinary skills were greatly appreciated by all.

Turning the conference papers into a publication would have been impossible without the patient assistance and good will of Nikos Stangos, Linda Nochlin's long-time editor, first at Penguin Books for *Realism*, then at Thames and Hudson; his assistant, Anne Straghan, and his colleagues at T&H were most generous, too, with their time and efforts. Feri Daftari, Assistant Curator in the Department of Painting and Sculpture, was especially helpful in teaching me the ins and outs of photo research; Yve-Alain Bois and Anne Higonnet both provided valuable information in my search for reproductions. Katherine Smith, Linda Nochlin's graduate assistant, provided immeasurable assistance. Thanks, as well, to the following institutions and individuals for their generosity: the Ohara Museum of Art, the Art Institute of Chicago, Raymond D. Nasher, The Public Art Fund, the Carnegie Museum of Art, the Harvard Museum Theater Collection, The Brooklyn Museum of Art, Deborah Kass, and Amy Young of the Robert Miller Gallery. Most importantly, James McCredie made an important, personal donation to the project, which has allowed us to include a large number of illustrations.

Of course, none of this effort would have been worth anything if not for Linda Nochlin, who has taught us, guided us, and inspired us in her almost forty-year career as an art historian and critic. Each task I had to complete and favor I had to ask was made easier because people were happy to make every effort for Linda's sake. Her own good nature and warmth in her interactions with her colleagues and students over the years greased the wheels of this enterprise without her even knowing it; for that, and for many other things, I give her my deepest thanks.

About Linda Nochlin

Robert Rosenblum

My academic and personal memories of Linda Nochlin go back almost half a century to the 1950s, when we first met as graduate students at New York University's Institute of Fine Arts. And if we went to school together, we also went to the school of life together, studying at home and abroad in Paris. To borrow the title of one of the essays in this anthology, our transatlantic lives were a mixture of "enlightenment and lubricity." Then in our twenties, we were of course eager to be young rebels, both inside and outside the precincts of academe; and in terms of art-historical pieties, this usually meant defying accepted canons.

The topics of our doctoral dissertations were rebellious in complementary ways. I was passionate about the then much-maligned art of Neoclassicism, with John Flaxman's weightless, linear purity as my Platonic ideal. Linda preferred the totally material, gritty world of Courbet, an earthbound artist whose grass-roots vulgarity was often considered at the time beyond the pale of that world of refinement and connoisseurship traditionally associated with art-historical good taste. And our enthusiasms for the most flagrant challenges to the prejudices of the 1950s often converged, particularly in the out-of-bounds world of Victorian painting and architecture. One such talisman was Holman Hunt's *Awakening Conscience* (1), which then represented everything people who liked respectable modern art were supposed to hate: hyper-realist detail, heart-wrenching narrative, cryptic symbols. (It turned out that from such a kernel, Linda, in her subsequent role as distinguished alumna, would later return to the Institute to give a lecture on this painting [1969], which, in turn, was amplified in a scholarly article on "The Fallen Woman," a path-breaking fusion of Victorian social history and art history unfamiliar to the stodgy pages of *The Art Bulletin* [1978].) And we also were thrilled by such offenses to architectural propriety as William Butterfield's All Saints, Margaret Street, where the "glory of ugliness," to quote John Summerson's precociously appreciative essay of 1945, suddenly spoke to us again with a ferocious urgency. For us, these about-faces in taste and the reading of art history coincided happily with the occasional presence of Henry-Russell Hitchcock at the Institute of Fine Arts. It was in one of his seminars, in fact, that Linda struggled with the elusive subject of

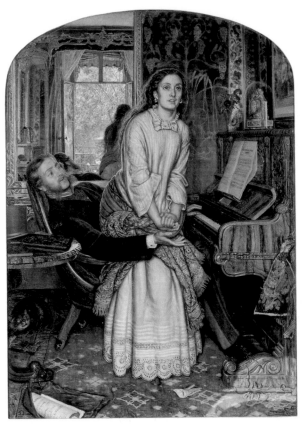

1 WILLIAM HOLMAN HUNT, The Awakening Conscience, 1853

"Realism" in nineteenth-century architecture, later to be incorporated in her classic over-view of Realist art (1971), still an indispensable staple in every student's cupboard.

Like all too few art historians, Linda passionately loved then as she loves now the experience of looking hard at art and trying to give words to what she sees and feels. It was a passion that could even transcend the usual confines of art-historical specialization, as revealed in a relatively unknown publication of hers, a slim, non-academic volume titled *Mathis at Colmar: A Visual Confrontation* (1963). Venturing outside her presumed academic "field," modern art, she had the audacity to put to print her quasi-poetic response to Grünewald's famous altarpiece (2). Here is a quote in which she scrutinizes, among may other close-up details, the visible drama of Christ's nailed, crossed feet:

They have lost their function as weight-bearing members, entities of flesh and bone that could walk, wear shoes, hold up a body…for now, they are twisted roots of suffering, stringy, pulpy and tobacco-colored like the old useless roots that appear above the ground, patient with toadstools, all sinews and puffs. The little toe of the right foot is softer, fleshier, pulpier than the rest; delicately lifted, it is painted in curving roundels of flesh, like a lamb-chop; the spike is cruel and ignorant as the butcher's hook, and over it the blood slowly pours down.

Although such an unbosomed analysis of a masterpiece might well seem out of place in most professional art-historical journals, its character of a vivid, first-person involvement with the many-layered visual and emotional densities of art was what could be counted on to nourish even the most theoretical or footnoted of Linda's prolific and hugely enjoyable writings.

But if this love for the visual flesh, blood, and drama of art is a constant in her work, she has used such pleasures to illuminate an amazing range of ideas. For better or for worse, Linda's most familiar public image is that of a now venerable feminist art historian – for better, because it is true; for worse, because this pioneering role has often pigeonholed her, blinding her audiences to the fact that the larger part of her work has nothing to do with feminist issues. If she wrote about many women artists – among others, Florine Stettheimer, Alice Neel, Miriam Schapiro, Nancy Graves, Joyce Kozloff, Judy Pfaff – men artists, from Watteau on, have had the lion's share of her attention in essays that as often as not have little or no relevance to questions of gender. But of course, she also was the founding

2 MATTHIAS GRÜNEWALD, Isenheim Altarpiece, detail of the Crucifixion, ca.1510–15

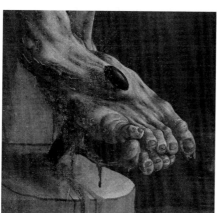

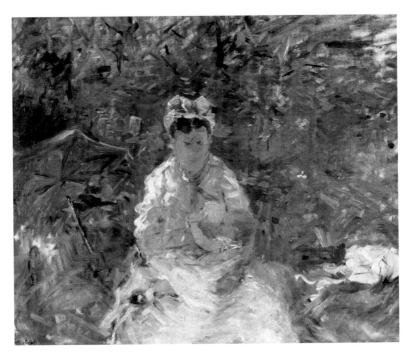

3 BERTHE MORISOT, The Wet-Nurse, 1879

mother of feminist art history. At Vassar College in 1969, she gave the first
course ever on "Women and Art"; in 1971, she published what became a
manifesto article, "Why Have There Been No Great Women Artists?"; in
1972, she shook up the College Art Association with a session that was
soon published under the title *Woman as Sex Object*, and that brought the
house down with her introductory slide comparison of a vintage erotic
photo of a coy nude woman holding, at breast level, a tray of apples next to
a photo she had taken of a naked young man holding a tray of bananas
aligned just below his fully visible penis (she titled it "Achetez mes
bananes"); and, in 1976, she organized, with Anne Sutherland Harris, a
landmark exhibition of women artists, 1550-1950. Such a sea change from
the 1970s alerted us all, male and female, consciously and subliminally, to
the ways in which both high art and popular imagery have enforced and
propagandized imbalances between the sexes that, once recognized, could
never again be hidden. In this respect, I always recall how years ago, while
teaching one of Gérôme's scenes of an Arab market where female slaves
were sold like horses, I treated the painting as a campy, erotic fantasy,
whereupon a young woman in my class got up and, with a quivering voice

that had to be heard, asked me how I could possibly joke about a picture representing such an offensive view of women's role in male society. I was mortified, because – thanks to Linda and her disciples – I finally realized the painful truth of the student's outrage. Similarly, I will always remember seeing the Berthe Morisot retrospective of 1987 and noticing, in particular, a dazzling little canvas of a nursing mother in which the brushwork's startling mixture of pastel delicacy and reckless agitation struck me primarily as an unexpected preview of Joan Mitchell's sensibility (3). But it was not until I read Linda's article on the painting (1989) that my eyes were opened to the equally startling subject, the representation of a woman artist's own infant daughter, Julie, at the surrogate breast of a wet-nurse, an ambiguous human situation that spoke poignantly about the ambiguities of class and gender and forever changed my own experience of what now has become the ordinary, but intense human drama beneath Morisot's Impressionist fireworks of pigment. And by now, the whole world should be grateful to Linda for almost literally bringing out of its closet Courbet's notorious *Origin of the World* (4), most recently sequestered by Jacques Lacan – first, in words and illustrations in an article in *October* (1986), and then, for all to see, in the Courbet retrospective at the Brooklyn Museum (1988), where its triumph over potential censorship prophesied its later acquisition by the Musée d'Orsay, whose gift shop now sells a color postcard of this once scandalous secret commissioned in 1866 by the Turkish diplomat Khalil-Bey. This must have been for Linda yet another victory in her lifelong battle to tell the truth about such things as sexuality and the battle of the sexes,

4 GUSTAVE COURBET, Origin of the World, 1866

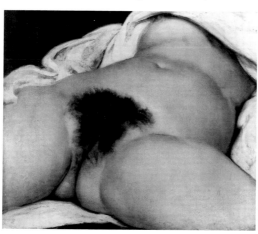

for the painting, long hidden from public view and from the purview of art historians, has now become almost as much of a classic in academic slide collections as *The School of Athens*.

There is hardly an area in the history of nineteenth- and twentieth-century art were Linda has not left an indelible mark. On the nuts-and-bolts level of compiling a source book of writings by artists and critics in the years between 1848 and 1900, her two-volume anthology, in which one can find everything from Monet and Hodler to Bouguereau and Seurat, has long had the authority of a reference-book classic. And if, because of her dissertation on Courbet and many publications about him and his progeny, she has been associated with the support of a realist aesthetic, try reading her essay on Ellsworth Kelly (1999) to realize how emotionally and verbally alert she can be when challenged by the opposite extremes of abstract art. Her portrait, after all, has been painted not only by such exemplars of twentieth-century realism as Alice Neel and Philip Pearlstein (5), but also, decades later, by Deborah Kass, in an update of Warholian silk-screen portrait photography and belt-line grid structure. It is a range that mirrors Linda's own passion for life, which means, among other things, embracing contradictions and existing, as she once defined realist art, "in the present tense." And her refusal to ask the same old questions or to stick to some preconceived method has yielded remarkable results even when she turned, on one happy occasion for the rest of us, to Picasso. Prompted by the huge MoMA retrospective of 1980, her article on the master's color – one of the hardest things to write about – opened endless vistas for Picasso studies, exploring such matters as his uses of a French nationalist tricolor palette, or his neo-Gauguinesque attraction to the complementary duo of yellow and violet as a code for his erotic venerations of Marie-Thérèse Walter. My own writings about Picasso often followed gratefully in these footsteps. And even in what at first might look like a throw-away introduction to a commercial gallery catalogue, *Andy Warhol Nudes* (1995), she brought to light and tackled issues students of Warhol had never confronted before, questions, for example, of the mix of aestheticism and pornography in these works, or the slippery categories of straight and gay in the depiction of male nudes.

Her ever-fertile efforts to explore unfamiliar territory has never stopped. Her classic essay on Orientalism (1983) is, among other things, a pioneering revelation of the way European art, in the age of colonialism, exoticizes and thereby subtly diminishes other cultures, an insight that has launched many studies of Western attitudes toward what is nowadays called the Other; and, in the same year, her study of the Puerto Rican painter, Francisco Oller, offers us fresh ways of thinking about the usually neglected issues of artistic regionalism, as she discusses the delicate balance between this

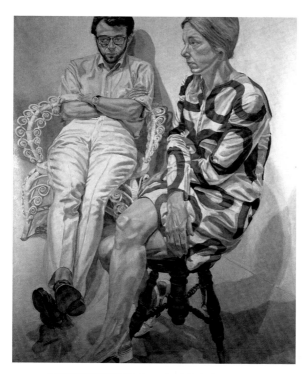

5 PHILIP PEARLSTEIN, Portrait of Linda Nochlin and
Richard Pommer, 1968

artist's experiences of French painting and his dedication to expressing
what was indigenous to his own distant land. And she can take on as
well the fullest spectrum of human realities as rooted to history. Degas is
forever altered when we read her accounts of his subtle undermining of
nineteenth-century family values or of his far less subtle attacks on Jews.
The imagery of nineteenth-century working classes is reconfigured when
she culls data from such diverse sources as the repertorial printmaker Paul
Renouard, the photographs of Jacob Riis, or the ambitious pictorial trip-
tychs of Léon Fréderic.

The warmth and energy of Linda's own persona and the wealth of
human experience she has enjoyed as well as suffered (twice widowed, she
has always emerged with renewed strength from personal depths) have
always radiated within her writing, where, even at its extremes of scholarly
or critical objectivity, her first-person realities can be savored. I am particu-
larly fond of a passage in her essay on MoMA's Bonnard retrospective
(1998), in which she perfectly pinpoints the pulsating actuality of looking

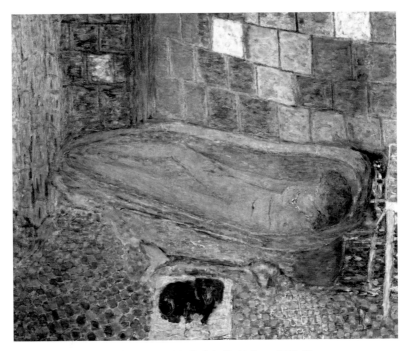

6 PIERRE BONNARD, Nude in Bathtub, ca. 1941–46

at art. The painting in question is *Nude in Bathtub* (6), and she describes it superlatively, awed by the artist's exquisite universe of constantly fluid colors and objects, and his attention to domestic detail: "the bath is painted in glittery greens and paler shades where water covers the body, tinged with purple," "the bather herself melts into anatomical dissolution, the head, and especially the face, completely rubbed out," "the commemorative implication of this multi-colored, evanescent, variously patterned image is sealed by the central position and faithful brown clarity of the little dachshund." But suddenly, she stops her description mid-way. "But wait! These are not my last words on Bonnard's bathers, apt as they might be for an elegiac grand finale. As a woman and a feminist, I must say I find something distasteful, painful even, about all that mushy, passive flesh. Yes, I am being naïve abandoning my art-historical objectivity, but certainly contradictory intuitions have a place in one's reaction to the work of art...." Nothing human, nothing real, it seems, is beyond Linda's reach. She has consistently refused to lock art up forever in a tower of ivory or a laboratory of theory. Her understanding that, like life, art must be in a perpetual state of change is what gives her and her work their contagious vitality.

Lascivious Corpus: Lequeu's Architecture

Ewa Lajer-Burcharth

"Sometime in the eighteenth century, sex as we know it was invented," asserted rather boldly cultural historian Thomas Laqueur.[1] What Laqueur referred to was, above all, the eighteenth-century "discovery" of the anatomical difference between the sexes: what he described as the replacement of the one-sex model, in which female genitals were seen merely as a negative or inverted reflection of male organs – exemplified by Vesalius's penile image of the vagina (7) – with the view that recognized the irreducible difference and anatomical incommensurability of man and woman. But Laqueur also had in mind another concomitant "discovery": of woman's orgasm as independent from her reproductive functions, a discovery that triggered a long-term process, both scientific and cultural, of reconceptualizing the relation between generation, sexual difference and desire.[2]

What I wish to consider is the *spatial* construction of sex at the moment of its modern cultural origins. The single most important location that contributed to this cultural construction was the boudoir, an eighteenth-

7 Vagina as Penis, diagram from ANDREAS VESALIUS, *De humani corporis fabrica libri septem*, 1543

century architectural invention. Originally, the boudoir was introduced as a space of refuge and reflection (from the French *bouder*, to brood). According to one of the period dictionaries the word designated a "small recess, near the chamber one occupies, for pouting unseen when in a bad mood."[3] The boudoir inherited its function as a retreat from its precedent, the seventeenth-century *cabinet*, that served the meditative purposes among others.[4] But unlike the chaste cabinet, the boudoir quickly acquired an expressly erotic dimension, becoming a privileged, if not exclusive site of erotic encounters, a space of seduction par excellence, and, moreover, a *feminine* space.

Thus, in his *Genius of Architecture*, an important design manual published in 1780, Le Camus de Mezières not only recognizes the boudoir as, specifically, a woman's space – "the abode of delight [...] where she seems to reflect on her designs and to yield to her inclinations" – but recommends that the room have a circular plan to echo the "gentle and well rounded" outlines of a woman's body in which muscles are not pronounced, thus making the connection between boudoir and femininity corporeally explicit.[5] Furthermore, he issues minute specifications regarding the decor of the boudoir: he warns, for example, against "harsh shadows cast by undue brightness," recommending instead "a dim, mysterious light [to] be obtained by the use of gauze artfully disposed over part of the windows." He is also particularly fond of tree motifs for the decor: "one might believe oneself to be in a grove."[6]

The boudoir was also a site of intense imaginary elaboration in eighteenth-century erotic painting and literature, particularly in the genre of *libertinage*. Here, though, we observe a curious transformation: while in architectural writing and practice boudoir is a space of femininity par excellence, in the libertine novels and painting it is, above all, a space of male seduction.

Jean-François Bastide's novella *The Little House*, a literary fantasy of architectural seduction, epitomizes this. In it, Marquis de Trémicour makes a bet with a flirtatious but virtuous young woman that he will seduce her and that he will do it, so to speak, *architecturally*: that it would be his house decorated according to Le Camus's prescriptions that would captivate the virtuous Mélite and force her to submit herself to him. He succeeds, of course, and it is *his* boudoir that serves as setting of his conquest. Traversing and interrupting the space of a woman's solitary reflection and pleasure was, as both Bastide's novella and the engraving from the period attest (8), the gaze of a man usurping the place of the shadow Le Camus envisioned as articulated through gauzes and veils, redefining the boudoir as a space of male desire and positioning the woman as its passive object.

These literary and visual representations testify to what may be called a "boudoir envy": a historically specific psychocultural symptom of male subject's yearning for what he did not have, a wish *to possess* feminine

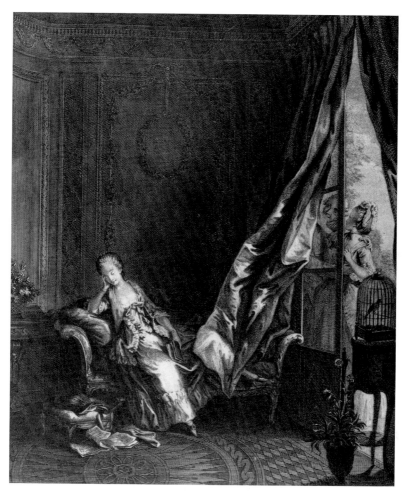

8 PIERRE MALEURVRE, after SIGISMUND FREUDEBERG, The Boudoir, 1774

interior in order to position himself in the field of desire, where, in effect, no stable position was actually tenable.

For Jean-Jacques Lequeu the boudoir seems to have been a favorite, certainly the most frequently designed space. With him we find ourselves, though, in a somewhat different location: it is not simply an abode of sensuous delight but a mirror-lined alcove of erotic fantasy that is at once far more explicit than the evidence considered so far, and strange. In one such design for an interior – *Un boudoir, coté du canapé* – a naked woman,

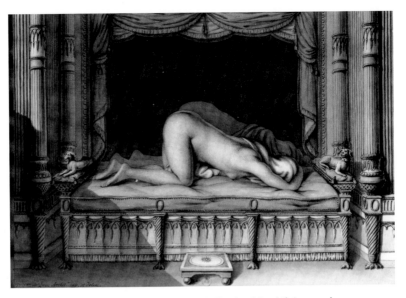

9 JEAN-JACQUES LEQUEU, Dessin d'un boudoir, côté du canapé

her head covered by a sheet, is propped on a sofa in an erotically suggestive yet somewhat unintelligible pose that does not belong to the standard eighteenth-century lexicons of the body, whether iconographic or pornographic (9). We get a sense of this scene being part of some story, some libertine plot – a particular mood is still hanging about – but the narrative connection has been occluded, setting the image and its meaning afloat.

The *Design for the Bed of the Beglierbeys of Roumelia in Sophia, Bulgaria,* an even more bizarre concoction, takes us into a realm of exotic phantasy, one of the eighteenth-century's privileged imaginary locations, which, however, gains here an unusually murky and mysterious articulation (10). Though it is a couple's bedroom, we only see the beglierbey's consort, a stout and fleshy female nude who rises from an ornate, canopied bed, gesticulating incongruously, like an orant. The bed itself is set in a thick forest, as if Le Camus's advice was being taken to the letter. The two designs are part of a whole series of beds, sofas and alcoves in Lequeu's oeuvre where ambiguity reigns, the veil of Obscurity replacing the gauze of sensuous illusion that had been recommended for such locations. Lequeu evidently operates within the already established discourse of architectural seduction but he reinscribes it, literalizing the boudoir fantasy as he fleshes it out, and pushing it in another direction.

The enigma of these images is matched by the enigma of their producer, Jean-Jacques Lequeu (1757-1826), an architect and draughtsman, of whom relatively little is known and who had actually built little, if at all.[7] What Lequeu has been best known for are the eight volumes of drawings which he tried but failed to sell during his lifetime. They were deposited by him at the Bibliothèque nationale in 1825, a gesture that not only rescued their author from inevitable oblivion but also inextricably linked his status as an architect to a *corpus* of images. These volumes consist mostly of the architectural fictions to the production of which Lequeu devoted himself, it has been said, for lack of other projects. There are, moreover, drawings of architectural elements culled from the repertory of classical forms as well as designs of mechanical instruments, drawn with utmost precision and a kind of intimacy. But these volumes contain also other bizarre images, notably of erotic or pornographic nature. Many of them are given cryptic titles (e.g., *And We Too Shall Be Mothers, Because...*) or an authorial commentary that does not, though, clarify the meaning of the images but rather renders them even more puzzling. Then, interspersed with the drawing sheets, there are the artist's personal documents, certificates, newspaper clippings and other papers.[8]

10 JEAN-JACQUES LEQUEU, Design for the Bed of the Beglierbeys of Roumelia in Sophia, Bulgaria, 1789

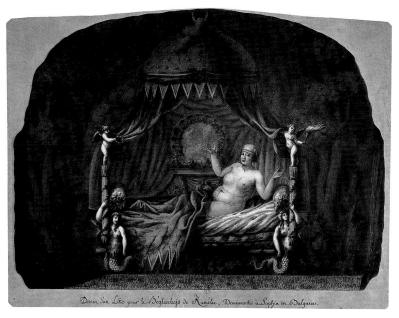

The unusualness of Lequeu's heterogenous corpus did not escape scholarly attention. But the exact nature of his project has been difficult to define and situate in relevant contemporary context. Thus Lequeu has been seen as a "forerunner of significant trends in the twentieth-century" architecture (this is Emil Kaufmann, his "discoverer");[9] as a psychotic marginal (notably by Jacques Guillerme who constructed Lequeu's work as a site of psychic projection of the architect's own sexual fantasies)[10]; and as a representative of the underworld of the Enlightenment or, alternately, as its critic (Anthony Vidler and Philippe Duboy, respectively).[11]

Duboy's interpretation, the most extensive, is perhaps also the most provocative, insofar as he suggested the large part of Lequeu's output to be a forgery produced by Marcel Duchamp. Duboy's theory is that, out of a deeply felt conceptual and aesthetic affinity, Duchamp, most probably aided by other accomplices (who may have included Georges Bataille, Jacques Lacan, and the then director of the Cabinet des estampes, Jean Adhémar) purloined Lequeu's drawing corpus from the Bibliothèque nationale and altered it.[12] Duboy never states where exactly would these alterations occur – where does Lequeu's folly end and Duchamp's own begins – but his hypothesis yields a provocative cross-cultural meditation on the hidden parallels between the two artists. Yet, it is also, in my view, an interpretive capitulation in the face of what seems to me evidently the work of a late eighteenth-century imagination. While Duboy offers many informed suggestions about possible links between Lequeu and the eighteenth-century context, it is precisely on the issue of desire that he "blocks out" all historicity, and instead calls forth the twentieth-century avant-garde oracle of libido, the Sibylline Marcel. But do we really need a Duchamp to understand the unorthodox sexual underpinnings of the imaginary world fleshed out in Lequeu's corpus of drawings? Wouldn't it be more instructive to explore the connection, complicated and circuitous as it may be, between Lequeu's spaces and the realm of spatial seduction imagined or conceptualized by such eighteenth-century architects and authors as Le Camus and Bastide?

In an attempt to reconnect Lequeu to his own time, I would like to suggest, then, a different approach by considering Lequeu's corpus as a cultural symptom. Rather than being critical of its time, Lequeu's work seems to me to speak of it in a far less controlled and more conflicted way, along the lines of the Freudian definition of the symptom as a "compromise formation," a sign of inner conflict or conflicting desires.[13] I wish, then, to consider the psychocultural dimension of Lequeu's work while relocating it from the artist as a person to the formal economy of his work. I will not be offering here an all-encompassing analysis of Lequeu's vast and complexly inscribed corpus, which engaged with many specifically eighteenth-century references, from

masonic culture to physiognomic tropes, but I will instead focus on two key aspects of his work that have not yet received proper attention, namely the phantasmatic quality of his spaces and its peculiar erotic function.

Lequeu's preference for elevation views over plans has been noted before.[14] It is, though, not only his inclination for the interior per se but the way in which he interpreted this mode of architectural representation, that is most interesting. His design for the *Boudoir on the Ground Floor of the House Known as the Temple of Earthly Venus* offers a telling example (11). Much of the effect of this image has to do with a new illusionistic technique of architectural drawing developed precisely in the eighteenth century to provide elaborate views of interiors. Through the deployment of shading a far more convincing illusion of the three-dimensional space was produced, allowing also for far more specific and varied articulation of wall surfaces.[15] It made it possible to turn architectural space inside out, as it were.

11 JEAN-JACQUES LEQUEU, Boudoir on the Ground Floor of the House Known as the Temple of Earthly Venus

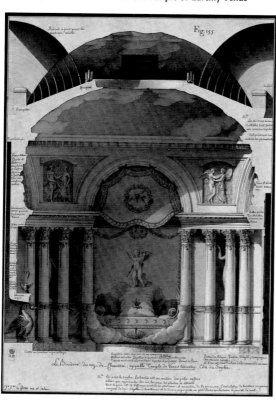

In Lequeu, though, this turning inside out helps above all to convey the phantasmatic dimension of the interior, its status as a hidden pocket of eros within architectural space. That the *Boudoir of the Earthly Venus* is, above all, a space of erotic fantasy is evident not only in the iconography of its extravagantly sumptuous decor, with the figure of Cupid, "his quiver filled with ardent arrows," presiding over the canopied bed and the sculpted episodes of love among the gods in the panels above, but also in the relentlessly erotic inscription of its decorative elements through careful annotations scribbled in the artist's own hand. Thus, Lequeu informs us, the shafts of the columns are decorated with the motif of virginity belts, while the figures standing behind them are described as "Pertunda, Volupie, Perfica, and Volupté," personifications of lascivious pleasures mostly invented by the author.

The odd combination of erotic excess and restraint – monuments to lubricity *and* virginity belts put together – is intriguing, as is the status of this phantasmatic interior as a scenography of absence. Structured around the hollow core of the niche that cradles an unoccupied bed of an absent goddess, this space, with its nocturnal staging that enhances the dramatic effect, seems to be haunted by what is missing from it. The partly hidden figures of the lascivious pleasures beckoning from behind the columns – strange creatures whose material status is impossible to gauge: are they stone statues or actual women of flesh and bones? – epitomize this aspect.

Striking is also the anatomical dimension of Lequeu's space in this and other designs. Some of his interiors look literally like giant internal organs, with the pinkish coloring of the dividing walls that resemble flesh. Often, Lequeu superimposes different aspects of elevation, such as details or plan, onto the drawing so that they have to be flipped back and forth, the view being gradually revealed by peeling away at the different strata of representation, a device borrowed from anatomical atlases.

Most telling comparison to Lequeu's interiors is offered by the anatomical illustrations of his contemporary, Jacques-Fabien Gautier d'Agoty, who used the technique of color engraving to obtain at once realistic and bizarre imaginary effects with his peeled-away skins that suggest flaying alive. Lequeu's views share with d'Agoty's the phantasmatic dimension of the body turned inside out. Explicit connection between Lequeu's project and the realm of the anatomical illustration is provided in his illustrated work *La nouvelle méthode*, published in 1792, where he attempted a systematic geometrization of the human figure – including details of anatomy, and simplifications with at times rather grotesque results.[16]

Yet, it is not just anatomy in general but the female genitals in particular that underwrite Lequeu's fictional interiors. At times Lequeu spells it out

explicitly, as in a note accompanying his design for a pleasure pavilion which he defines by quoting from the *Encyclopédie*: "*Pavillon* [pavilion].... In anatomy, the extremity of the Fallopian tube, which lies near the ovary: it widens like the bell of a trumpet and is edged with a kind of fringe."[17] What in Le Camus was a bodily metaphor for the interior, in Lequeu becomes more specifically a genital one. Notable in this regard is also Lequeu's proclivity for central plan, views of overgrown grottoes, bushy water sources, fountains, huts, openings and windows rendered in deeply dark wash, all of which rehearse more or less explicitly the analogy between architectural form and female sex (12).

Nowhere is this connection between architectural interior and female genitals at once more literal and striking than in Lequeu's series of strange

12 JEAN-JACQUES LEQUEU, Section of the Subterranean Grotto

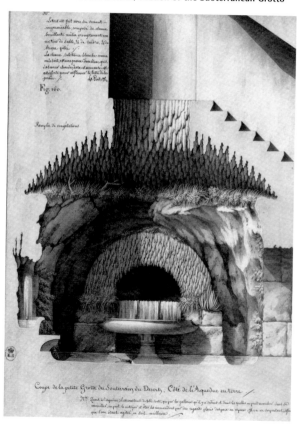

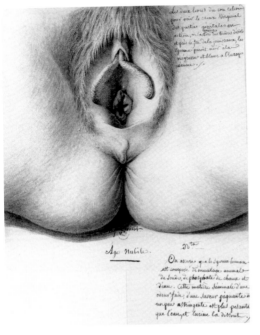

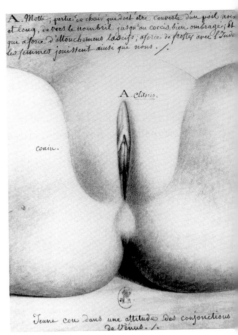

13 JEAN-JACQUES LEQUEU, Nubile Age

14 JEAN-JACQUES LEQUEU, Young Cunt

quasi-anatomical drawings (13-14). If his interiors were, in a sense, anatomical, these anatomies are in turn architectural: they are like elevation views of feminine genitalia opening up, repeatedly, to the structural core of interiority, an inner recess, that is framed but remains invisible. Mimic as they do a detached, scientific mode of presentation, there is a dimension of obscenity to these views that cannot be accommodated either within the anatomical or architectural discourse but that relates them instead to the pornographic tradition.

As such they remind one of the high-art forays into the pornographic, such as *Origin of the World* painted, much later, by Courbet for the exotic collector of erotica, Khalil-Bey, and representing, in Linda Nochlin's words, "the classical site of castration anxiety, as well as the ultimate object of male desire."[18] What nevertheless distinguishes Lequeu's views from Courbet's is not only the compulsiveness evident in Lequeu's repetition of these views many times over but also the fact that, through his inscriptions of these

bodies, they are defined as, primarily, the instruments of a lusting female subject rather than the object of male desire. It is, specifically, the *excesses* of feminine desire that Lequeu is concerned with in his presentation of the *Infamous Venus* with her, as he describes it, "elevated cunt, parts open by ardent desire...her face is on fire." As he is when he subtitles another genital view as *The Crater of An Adolescent Girl Animated by Unseemly Desire*, or when, in *Young Cunt*, he focuses on clitoris as an organ women use to produce their own pleasure – "les femmes jouissent ainsi que nous" (women come just as we do).

To understand the logic that governs these images, and the nature of anxiety behind them – for in this case it is not castration – we may resort to the Lacanian notion of *extimacy*: a kind of intimacy with an object that remains outside a given regime of representation. Lacan introduced this term as a version of the Freudian uncanny, which he thus also reformulated.[19] For Freud, the uncanny experience is produced by an encounter between the self and its double, an encounter that proves menacing insofar as the double evokes lack. For Lacan, the uncanny anxiety generated by the double has to do not with lack but with *excess* – it is the effect produced by an object that comes too close to the subject, that is too present.[20] This object constitutes a part that was necessarily lost with the emergence of the subject into autonomous existence and that returns to haunt it. Thus, for Lacan, the cause of uncanny or extimate anxiety is not lack per se but, as he provocatively puts it, "*the lack of lack*" – the loss caused by the eruption of the originary lost object into the psychic realm of the subject that, as it happens, had been constituted by its exclusion. Thus, in Lacan, the uncanny is a *spatially* articulated problem of the disturbed boundary between interior and exterior, both conceived as psychic realms. Extimacy amounts to a breakdown of this spatial distinction and with it, of the psychic stability of the subject.

In Lequeu, extimacy manifests itself as a *formal* problem: a repeated attempt to erect a frontier of representation between the inside and the outside that articulates, as it tries to stall, the excessive object. Thus his vaginal elevations are forms of spatial organization of excess – surfaces on which the distinction between the inside and the outside is negotiated – anxiously. It is precisely as a kind of excess, rather than lack, that female sexual organ appears in Lequeu's anatomical fantasy, an object that returns relentlessly not just in these views but in Lequeu's entire corpus, as a structure of his architectural designs, as a privileged figure of the interior, and as a kind of internal pressure – a pressure from within – exerted on representation. It manifests itself in such diverse and sexually "innocent" aspects as the dilated contours of his ornamental motifs that look like pregnant forms,

heavy with an invisible internal burden (15), or in the shadows of something amiss that so often traverses his interior scenes.

Given the time span in which Lequeu's was active, the late eighteenth and early nineteenth century, it is perhaps not surprising to find the extimate logic of the uncanny in his corpus, as it were. It was precisely at that time that the notion of the uncanny emerged as an aesthetic category. Its advent was intimately linked to the formation of the modern subject. It was in the Enlightenment discourse in general and in Kant in particular, that, as it has been suggested, we witness a surge of what may be called the Enlightenment uncanny: an appearance of the *new double* as an internal limit of the subject.[21] In place of the discredited metaphysical notion of the immortal soul there appears a kind of detached double that, unlike the soul, does not link the subject to the outside world, or the world beyond the perceptible reality, but instead emerges within the psychic realm of the subject, as the guarantee of its autonomy. Yet, detached and thus beyond the control of the subject, this new double could be encountered anywhere and at any time, and thus poses a constant threat to the psychic well-being of the subject. Floating within the symbolic realm of the self, it is something onto which the self can bump, so to speak, at any time – it is in this sense that it appears to the subject as its internal limit. This new double is then menacing in a specific sense, as that which threatens the subject *from within its own realm*, as an extimate object, and it is as such that it emerges as a source of anxiety at the end of the eighteenth and the beginning of the nineteenth century, when the new philosophical definition of the autonomous subject was further reinforced by the revolutionary discourse of the self as free.[22]

We may call Lequeu a draughtsman of the extimate understood as a condition of modern subjectivity, but in order to do so we first have to redefine this notion in terms of sexual difference and desire. For, in Lequeu, extimacy is articulated as a sexed notion, as a certain vision of a woman's body that returns as an internal pressure within his work. As such, it is not, though, just a function of Lequeu's private obsessions but a discursively conditioned phenomenon occurring in his work. It is an image of a woman's body as it could appear specifically to an eighteenth-century imagination (*pace* Duchamp), a body shaped by important discursive changes that occurred precisely on the level of the anatomical discourse. Thus, Lequeu's repeated returns to the woman's genitals had to do with the status of this organ as the very site of elaboration of the new conception of sexual difference. What we witness in the eighteenth-century anatomical discourse is the abolition of the feminine double of male subject – the invention of difference that Laqueur dubbed the anatomical discovery of

15 JEAN-JACQUES LEQUEU, Sculptural ornaments inspired by the frieze of the Temple of the Virile Fortune in Rome, 1794–95

the sexes.[23] One important effect of this scientific development that still needs to be fully recognized is the appearance of detached femininity. What had been until then a safely binary situation ceased to be one: because of the new discourse of sexual difference the woman's body turned in the eighteenth century into a menacing double of male subject, floating unfettered in the field of shared meanings and putting him at a risk of loosing his boundaries.

Another factor that has to be considered in regard to this shift is the emergence of gender as a fixed and normative, hierarchical construction of sexual difference in France in the wake of the French Revolution. As we well know, the advent of the Napoleonic regime created the legal bases for the domestication of women (I am referring to the *Code civil* introduced in 1804).[24] If woman was aligned with the new category, the home, it was as a function of her relation to man, as a kind of domestic subsidiary to the exterior and public realm defined as masculine. Hence that dimension of femininity that could not fit within the binary relation to man, the

autonomous femininity, and especially feminine sexuality that could not be subsumed by the maternal, reproductive role of the woman, became *unheimlich* – unhomely, extimate to the realm of femininity-as-domesticity, *un*related to masculinity, and homeless in representation. The modern medical discourse only exacerbated this new situation by releasing another free-floating specter of femininity – the notion of woman's desire unfettered by the reproductive function.

It is as such, as an object *en plus*, and as an excess of desire, that the woman's body haunts Lequeu's corpus. And it is as such that it appears as a belated symptom, the after-effect of the Enlightenment, in his work. Thus, as a cultural phantasy of femininity, his boudoir is not a space of envious male possession but rather a site invaded by the resurgent unaccommodated woman who disturbs the boundaries of the male subjective realm, destabilizing the notion of sexual difference, and disabling Lequeu's own architectural self-articulation as a professional. (No wonder he never builds but endlessly designs.)

What else than as an unhomely body – an architectural excess – that the lascivious woman emerges from the dark niche of the lunette in Lequeu's striking image curiously titled *He is Free* (16). Her erect breast defying the laws of gravity, her one raised thigh – as if she was rehearsing one of the lubricious poses of the Infamous Venus – the woman reaches out as if trying to catch a bird flying away – an object of her desire, which the title of this image defines as the new subject – a subject who is free. This image may be related to another striking work by Lequeu titled *What She Sees in Dream* (*Ce qu'elle voit en songe*) (17) for in both the detached object – literally the free agent – is defined as male, not just in gender (*he* is free) but in sex: via the bird with the tail ending in two testicles, in the first image, and, in the other, quite literally (and comically) as a detached phallus. The phantasy, indeed the dream, that we see articulated here attempts to reverse the new anatomical status quo that we have described earlier – the constitution of the woman as a detached double – by reimagining and realigning its freedom with maleness. Yet, these two works and the entire corpus of Lequeu constitute the testimony to the opposite – to its male author unstinting attachment to the woman as a subject and structure of representation, as a factor that exceeds and exerts pressure on his visual realm of meaning, and as that which keeps coming back to haunt the male subject: the differentiated, autonomous, and desiring woman.

To recognize the extimate logic of Lequeu's vision as a belated symptom of an eighteenth-century imagination is then to uncover a far more complex and unpredictable configuration of sexual difference and desire in this period than might be expected. But it is also to expose that logic's work

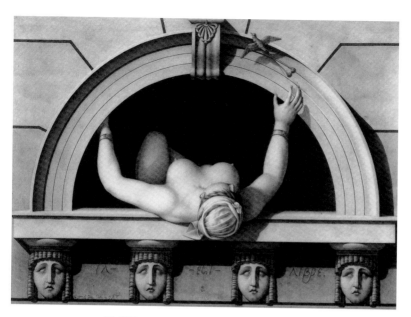

16 JEAN-JACQUES LEQUEU, He is Free, 1798–99

17 JEAN-JACQUES LEQUEU, What She Sees in Dream

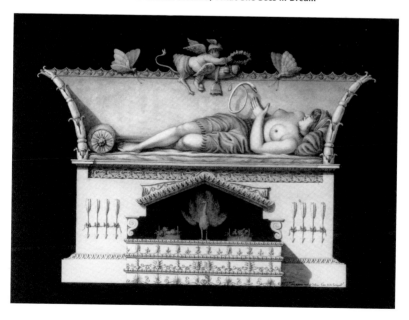

in Lequeu's definition of himself as a subject of his own representation. How else are we to understand Lequeu's discreetely lewd *Self-Portrait* of 1792, where it is in turn the architect himself who emerges from a niche of an imaginary library, surrounded by books and portfolios referring to his occupations, but also under the symbolic auspices of the beaver's tail featured in the keystone of the niche (18)[25]. The tail plays on the French words *la queu* and *castor* (beaver) that are also metaphors for male and female genitals, respectively. But, in the context of our discussion, how can we not recognize the tail as the detached signifier of femininity making its rounds and confusing the gender boundaries of the portrayed subject. The portrait thus indicates how intimately connected were the public, professional and sexual personae that Lequeu kept constructing for himself. It suggests beyond any doubt that, rather than mere accidents within his corpus, Lequeu's *Lascivious Figures* held a keystone place in it, as it were. No wonder also that this collection of images begins with the image of a hermaphrodite.[26]

If we were to describe Lequeu's portrait as uncanny, we must specify, though, that what is at stake in it is not an uncanny desire as Freud understood it, that is as a desire to return to the womb. It is, rather, the womb that returns here – for historically specific reasons – to haunt male subject, threatening to blur his sense of sexed identity, exceeding the architectural parameters of *his* space. It is a corporeal ghost of feminine desire that haunts this architect and his corpus.

Now, as a matter of fact, we do have other evidence pointing to Lequeu's confused identity as a person – hidden and locked under key in his chest of drawers, several expensive feminine silk outfits were reportedly found after Lequeu's death, prompting his scholars to suspect that he was a cross-dresser, at least.[27] But I want to insist rather on the cultural dimension of sexual ambivalence as a structure of his heterogenous corpus. For if this corpus speaks of Lequeu's inability to imagine sexual difference, if it represents a resolute refusal to enter the logic of gender, it has to do not only with his own but his times' difficulty to envision femininity as different *and* autonomous. And of envisioning feminine desire, other than extimate.

It is this passionate woman whom Lequeu could not imagine but extimately that beckons us to revisit eighteenth-century culture and its spaces in order to explore – intimately – the complex connections between femininity, subjectivity and difference, to reconstruct in its proper intricacy the cultural history of the self as a function of desire in the century that, as it has been argued, invented sex – but perhaps not quite as we know it.

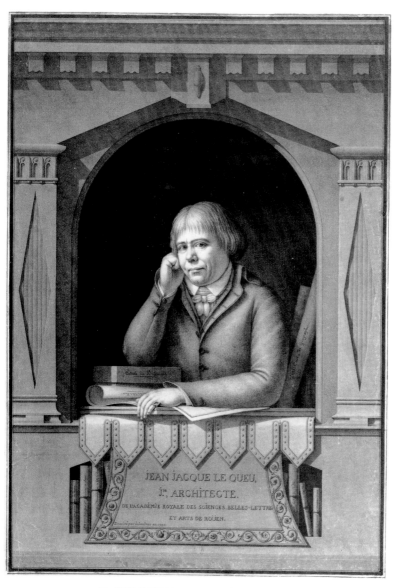

18 JEAN-JACQUES LEQUEU, Self-Portrait, 1792

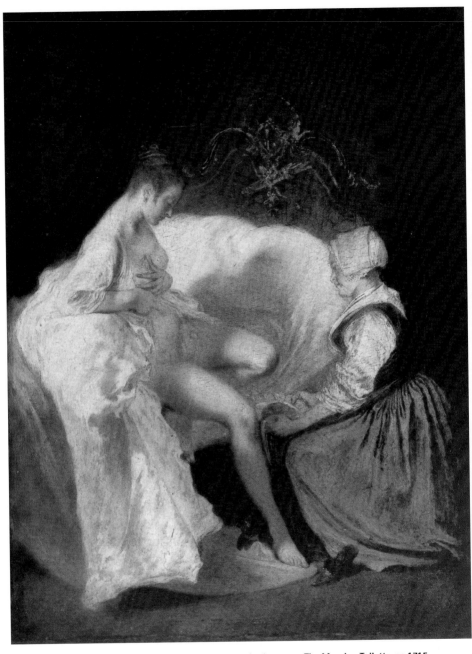

19 ANTOINE WATTEAU, The Intimate Toilette, also known as The Morning Toilette, ca.1715

Enlightenment and Lubricity

John Goodman

Let us begin with *The Intimate Toilette* by Antoine Watteau, probably painted about 1715 (19). We are in a lady's bedchamber in a moment of quiet intimacy. The mistress of the place perches on the edge of a mattress. She wears a loose white robe that has been drawn back to reveal much of her attenuated pink body, which is set against a shell-like surround of nacreous bedding. A female servant whose heavy clothing accentuates her mistress's physical vulnerability kneels before her, bowl and sponge in hand, about to perform the honors of the douche. The lady looks downward as if contemplating her own vulva, which is blurred by a judiciously placed waft of fabric. The servant's gaze is directed not at her lady's sex, as is sometimes said, but a bit higher, toward the sensuous bulge of her belly.[1]

This is anything but a generic picture of a lady at her toilette: the effect is rapt and ritualistic, the tone almost sacramental. Judging from the action of the figures as well as from the quiver decorating the headboard, an allusion to Cupid and the game of love, we are meant to infer that the "ritual" in question is post-coital. But the painting's hushed gravitas results from the carefully judged attention to the lady's lower abdomen: the site of human generation. As Linda Nochlin has suggested, Watteau may have intended an oblique allusion to Catholic mysteries here;[2] but if so, the result is not so much parodistic as bracingly heterodox, a compelling fusion of the sensual and the sacred. On a less historically controlled, frankly interpretive register, there is also an allusion to generation other than human, a hint that the two women are witnessing the emergence of the contiguous mass of fabric and sheets, radiant yet amorphous, from the woman's vulva, much as a spider secretes its web. Watteau could not have consciously intended any such meaning: however much the shelly articulations of the sheets in front of the figure resemble forms prevalent in Parisian artistic production of all kinds between 1725 and 1745, the peak Rococo moment when cartilaginous morphologies became ubiquitous, the artist could not have foreseen such developments. Nonetheless, this exquisite panel heralds the strain of organicist, gynocentric imagery that would flourish in French art over the ensuing decades, just as it uncannily anticipates the misogynist construction of this formal and thematic vocabulary by the emergent Neo-Classical faction in the years around 1750.

Now in a private collection, *The Intimate Toilette* is one of three surviving oils by Watteau that depict nude or seminude female figures in contemporary surroundings without allegorical or mythological trappings, the others being *Reclining Nude* (c. 1714-15, Norton Simon Museum, Los Angeles) and *Lady at Her Toilette* (c. 1715, Wallace Collection, London).[3] These three works have often been linked to an anecdote in the biography of the artist written by the comte de Caylus, who knew him. There it is reported that Watteau, on his deathbed, requested that several of his works skirting obscenity be burned. According to Caylus, the request was granted.[4]

A piquant story, especially when savored as we consider the three paintings. Even if we credit the anecdote, as I am inclined to do, we cannot be sure what the works in this bonfire of pictorial vanities looked like. Perhaps, however, we can hazard a few guesses: for instance that they pictured female nudes analogous to the surviving ones by Watteau. Perhaps even that, if the ill-fated compositions included male figures at all, they were not nude. For, despite bearing a grudge against his former friend (perhaps for having been effectively cut out of his will so many years earlier[5]), Caylus is unequivocal on the point in question: "no vice mastered him and he never made any obscene works."[6] Which I take to mean that, so far as Caylus knew, Watteau never produced anything that unequivocally belonged to "this genre" – in other words, pornography. And in matters pornographic, Caylus knew whereof he spoke. Between Watteau's death in 1721 and the composition of his biography more than two decades later, Caylus had become an influential antiquarian as well as an author of fiction, some of it incorporating episodes of soft-core porn. He knew his way around the world of obscene representation, ancient as well as modern.[7]

I open with these works, with this anecdote, for two reasons. Since the deconstruction of the myth of the melancholy Watteau by Donald Posner and the subsequent reconstruction of the artist by Norman Bryson as a quixotic anti-Lebrun, as the quiet contravener of the aesthetic of discursive overdetermination promulgated by the Academy before the triumph of Roger de Piles, the party of color, and the aestheticist ideal of the *tout ensemble*, Watteau has come to be seen, more than ever, as a springboard to the future of French painting, as a pivotal figure who cleared a representational space for the sensual allusiveness of the Rococo.[8] Thanks to the work of François Moreau, we are coming to understand that, while peripatetic by inclination, caustic by temperament, and *un peu berger* ("a bit shepherd-like"),[9] Watteau frequented freethinkers of the kind often called *libertins*:[10] the dealer Gersaint, who collected and trafficked in anti-religious works; the abbé Haranger, whose library contained many heterodox and libertine works, and Caylus himself. During Watteau's trip to London, his principal

patron was Dr Mead, whose library was also well stocked with provocative titles. This means that Watteau was situated, problematically but inescapably, at the social and historical conjuncture that issued in both the culture of Enlightenment critique and in the art of the Rococo.

Which brings me to my second reason. These images, this anecdote, serve to remind us of the perpetual elusiveness, in the modern era, of the boundary between decency and obscenity. An elusiveness famously addressed by Pierre Bayle (1647-1706), author of the *Dictionnaire historique et critique*, a work of formidable erudition whose project of demystification made it an important precursor of the *Encyclopédie*. In the celebrated "fourth clarification" added to the revised 1720 French edition of the *Dictionnaire*, Bayle defended himself against critics who had objected to the frankness of some of its entries, "since many women now read books." He writes: "It is impossible to close the door to all objects that may pollute the imagination," for this would entail fleeing, "as from the plague," "all conversations in which people speak of pregnancies, childbirths, and baptisms." And he continues: "The imagination is a gadabout that moves with extreme rapidity from effects to causes. It finds this path so well beaten that it gets from one end to the other before reason has had a chance to restrain it."[11]

Bayle's observations, appended to a book often called "the arsenal of the Enlightenment,"[12] bring me to my principal theme: the peculiarly vexed relationship, in the thought and visual culture of the French Enlightenment, between *logos* and *eros*, reason and pleasure. Such tension is, of course, the tragic core of the civilized condition generally, a theme memorably explored by Freud in *Civilization and Its Discontents*. But the boundary between nature and culture was notably fraught in the Age of Reason, when the French libertine tradition, with its roots in the materialist and sensationalist theory of John Locke, can be difficult to distinguish from the Enlightenment project. *Sapere aude*, dare to know: such was Immanuel Kant's definition of Enlightenment.[13] It was formulated in an owl-of-Minerva moment, when Voltaire and Montesquieu, Rousseau, Diderot, and Condillac were all dead. But Kant's injunction is wholly consistent with their intellectual practice, and a moment's reflection will suffice to grasp how it could be abused, twisted into the view that sensation is truth, or, in another misprision, how it could be used to justify extreme experience of the kind represented in the works of the marquis de Sade.

Over three decades ago, Robert Darnton first alerted us to the existence in eighteenth-century France of a vast subcontinent of illicit "philosophical" literature, as it was then known, that escapes modern categories of classification.[14] Everything from materialist theory, anti-clerical propaganda, criticism of government policies, and hard-core sexual narratives

can be found among these "philosophical" titles, and not infrequently within the covers of a single book, for example *Thérèse philosophe* (1748), in which the heroine, after many travails, finds happiness and intellectual liberation by embracing the materialist ethos. Or the much earlier *Académie des dames* (1680) in which "the opening of the vulva is equated with the opening of the mind" (20). I quote here from a more recent essay by Darnton in which he notes that these texts were written by and for men with the intent to arouse; they are rife with phallocratic prejudice, misogynistic blather, salacious descriptions of rape, and worse. As he says, while it would be "silly" to read into them "a modern argument for women's liberation," they are haunted by the notion of the independent woman, and not always in disapproving ways.[15]

Many historians now accept Darnton's view that the polyglot body of "philosophical" literature, which was widely disseminated, was at least as important as the canonical Enlightenment texts in creating a collective state of mind that ultimately made the French Revolution possible. In any event, this corpus constitutes the most substantial piece of evidence that the sex-Enlightenment boundary was exceptionally porous in the period.[16]

What of the visual evidence? This question resists summary response. In part because, in the wake of the anti-Rococo reaction that gathered force in the third quarter of the century, it is difficult for us to construe the relationship between the Enlightenment project and the figural exaltation of sensual pleasure characteristic of the Rococo as anything but adversarial. But we should be wary of this glib formulation, for it cannot withstand scrutiny.

It is now a commonplace to describe the Rococo in terms of a taste constructed as feminine, one privileging decorative effusion over discursive rigor. Recently, Donald Posner has explored the contemporary thematization of this development in a series of depictions of Hercules's abandonment of his masculine identity, trading club for distaff under the influence of the beautiful Queen Omphale.[17] In the classical sources, this episode follows upon Hercules' having committed murder in an uncontrolled fit of anger. As Posner notes, many early viewers of these works doubtless understood the subject in nondescript terms, in accordance with the old adage that love can tame our bestial natures. But these paintings also engage, however unbeknownst to their authors, with an untractable knot of aesthetic, ethical, and political issues that was a focus of contemporary debate. They betray a growing concern about the new antitheoretical, unashamedly playful and sensual vocabulary of the ascendent Rococo language. Roger de Piles, in the lectures to the Academy that he published in 1708, just before his death, had given renewed currency to the notion that painting is

20 ANONYMOUS, frontispiece to L'académie des dames,
1680

essentially seductive, effectively gendering at least his conception of it and
the attendant visual pleasures as feminine. The language in which he did
this is not without ambiguity. He describes the secret of a fine subject paint-
ing's appeal as "this truth which calls us" (ce vrai qui nous appelle), but he
also writes that this quality makes us "want to enter into conversation
with" its figures – for what purpose he does not say. At the end of the day,
however, there can be little doubt about his rejection of Lebrun's idealized,
rationalized, systematic approach to visual representation and response in
favor of one that is more intuitive, more focused on fleeting sensations,
which was associated in his mind with a kind of surrender at odds with
intellection.[18]

In the years around 1730, the increasing visibility of luxury artifacts and the ascendancy of a decorative aesthetic occasioned intense debate in Paris, prompting statements from both Voltaire and Montesquieu that "le superflu est nécessaire" (the superfluous is necessary).[19] This was a moment, likewise, when the preeminence of history painting was being challenged by a host of "lesser" genres flourishing under the aegis of the Rococo aesthetic. In other words, the masculine aesthetic principle was increasingly falling under the sway of subsidiary, marked, "feminine" cultural constructs. But this same moment also saw the appearance of the first canonical texts of the Enlightenment, Voltaire's *Lettres philosophiques* (1734) and Montesquieu's *Lettres persans* (1721), which, as Joan Landes has noted, is filled with evidence about the perceived ascendancy of women in Parisian society of the day.[20] According to Montesquieu, speaking through the mouths of his fictional Persian visitors, women had complete control over the government (Letter 107). And in an especially telling passage, he compares a woman at her toilette to a general girding himself for battle (Letter 110).

Women in control, women reading more and more books, women being converted to sensationalist positions that bucked social and religious orthodoxy, "feminine" taste triumphing in contemporary artistic production: such was the amalgam of perceived developments that increasingly preoccupied many male members of the Parisian elite. And around 1750, in the formative moment of the Neo-Classical reaction, their concerns sometimes issued in discursive panic. To cite one prominent example, Laugier, in his celebrated *Essai sur l'architecture* of 1753, writes of the "abyss" of "bizarreness" into which architecture had fallen under the pernicious influence of "the lesser arts," of his being "disgusted, shocked, revolted" by the "disorder" of certain contemporary buildings, calling for the resubjugation of maverick "ornament" to the "essential," "virile" beauties that should rightly prevail.[21]

In light of this historical and discursive context, it is interesting to consider images from the pre-Revolutionary years of female figures engaged in reading, an activity that can prove instructive, diverting, or arousing – and sometimes all three simultaneously. There are many contemporary portraits of men in their studies, but relatively few of these actually represent male figures engaged in the act of reading – or show them registering affective response of some kind to what they have read. In Chardin's Rembrandt-inflected *The Philosopher* (*Portrait of Joseph Aved*, 1734, Musée du Louvre, Paris), for example, a man is shown intent on a large folio but with features that are calm, conveying attentiveness colored by a low-key pleasure that is entirely decorous.[22] There are, of course, depictions of women-as-literate, the best known of which, perhaps, are portraits by François Boucher of Madame de Pompadour. In the most famous of these, now in Munich (1756,

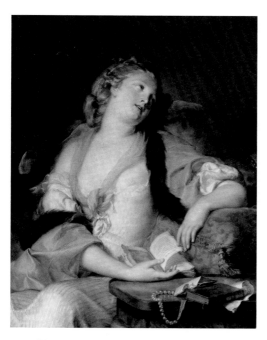

21 JEAN-BAPTISTE GREUZE, Lady Reading the Letters of
Heloise and Abelard, ca.1758-59

Alte Pinakothek), the sitter is surrounded by a flurry of feminine signifiers
that qualify our reading of her as Enlightened, most spectacularly the volu-
minous beribboned dress, whose vulgarity by standards of the time has
been stressed by Alastair Laing.[23] To my knowledge, there are no images of
eighteenth-century "bluestockings" comparable to Chardin's portrait of Joseph
Aved, save, perhaps, for other works by Chardin himself, for example his
Domestic Pleasures (1746, National Museum, Stockholm).[24] And there the
act of reading – shown in abeyance, the book closed momentarily in the
woman's lap – does not come across as much different from taking tea. It is
an agreeable diversion, nothing more. There is, however, an interesting
iconographic network of images of women and books that have no mascu-
line analogues.

In *Lady Reading the Letters of Heloise and Abelard*, the ur-image of the
artist's trademark eye-rolling females, Greuze gives us a woman in the throes
of sex and sentimental fantasy, cued by a love letter she has just read (21).
The artist based his figure quite closely on that of Marie de Médicis in *The
Birth of Louis XIII* (1622-23, Musée du Louvre, Paris) by Peter Paul Rubens,
from the famous cycle glorifying her.[25] As this composition was well known

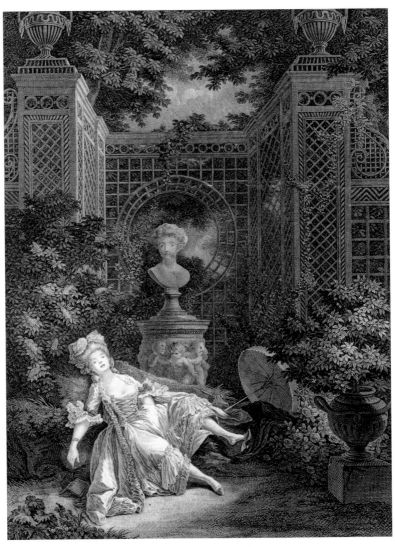

22 EMMANUEL DE GHENDT after PIERRE-ANTOINE BAUDOUIN, Noon, ca.1778

to the Parisian art-literate public, the impertinence of this derivation –
tantamount to *lèse-majesté* – would not have gone undetected (which may
explain why, despite its manifest quality and probable appeal to contempo-
rary sensibilities, the canvas was never shown at the Salon). Stunning in its
brazen lubricity, it was clearly designed primarily as a spur to male hetero-
sexual desire.[26]

But it cannot compete – as uninflected image – with *Noon*, a print by Emmanuel De Ghendt after a lost composition by Pierre-Antoine Baudouin, Boucher's son-in-law (22). Produced some twenty years after the Greuze, it is the uncensored version of the subject. The woman depicted here has been reading not a love letter but a book, in all likelihood a volume of "philosophical" pornography of the kind alluded to above, and it has prompted her to pleasure herself – under the ominous, commanding gaze of a male bust whose presence is inexplicable save as a reminder of the masculinist phantasmatic regime within which the image was meant to function.[27]

It is interesting to compare the Baudouin print with a painting by Jean-Frédéric Schall, *The Beloved Portrait*, a work from the 1780s that tells much the same story in slightly different terms (23). Here again, the erotic cue is a love letter, but the woman's response is intensified by a miniature portrait of – we are meant to assume – the letter's author.[28]

It bears repeating that there do not seem to be any analogous images from this period of men responding so excitably to reading matter. This despite the fact that men wrote almost all of the considerable body of

23 JEAN-FRÉDÉRIC SCHALL, The Beloved Portrait, ca.1783

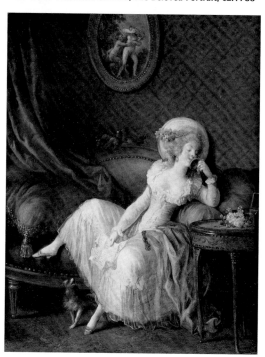

contemporary pornographic literature,[29] and that, as feminist scholars have recently documented, a few French women authors of the eighteenth century – notably Anne Thérèse de Marguerat de Courcelles, marquise de Lambert, and Marie-Jean Riccoboni – were challenging the sexual stereotypes parlayed by such representations.[30] Space limitations preclude examination here of more than a few relevant images. Nonetheless, I want to suggest that in eighteenth-century Paris, in the years coinciding with the rise of the Neo-Classical movement, male anxiety triggered by the perception of a large-scale incursion of women into the masculine realm of *logos* – whose attribute is the book – helped to shape an iconography that explicitly trivialized female aspirations to intellectual competence, much less achievement.[31] And that one aspect of the contemporary representational economy that effectively endorsed such misogynist views was the depiction of women, and women only, responding with sensual abandon to the word.

In addition to its toxicity on the register of sexual politics, this reactive phenomenon is an indication of a profound cultural ambivalence, in this High-Enlightenment moment, about the loss of control entailed by sensual surrender – figured primarily in this century, as in preceding ones, by the surrender of men to alluring women. An ambivalence that, while of long standing, had been exacerbated by the elusive yet pervasive tendency among many of the period's most audacious minds to conflate sexual exploration with intellectual boldness.

I would like to close with an examination of a passage from the *Encyclopédie*, for it is symptomatic of the extent of this ambivalence. It is the definition of "lubricity" from volume nine, published in 1765.

> Term designating an excessive inclination [*penchant*] in men for women, in women for men, when this shows itself outwardly by actions contrary to decency; *lubricity* is in the eyes, in the face, in gesture, in speech [*discours*]. It proclaims a violent temperament; it promises in *jouissance* much pleasure and little restraint. We say of certain animals, for example he-goats and cats, that they are *lubricious*; but we would not say that they are lewd [*impudique*]: it seems, then, that lewdness is an acquired vice, whereas *lubricity* is a natural defect. Lasciviousness has more to do with movement than with sensation.

We are told that lubricity is harnessed to the notion of intense pleasure and violent orgasm; also that the word designates corporeal and vocal expressions of excessive sexual desire, but only when this manifests itself in ways that are "contrary to decency": lubricity is represented as a function of cultural norms. But as the definition proceeds it loses clarity. We are told

that animals as well as humans can be lubricious, presumably when they violate decorum by rutting in public view. There follows the comparison of lewdness and lubricity, and here trouble starts. Lewdness is said to be an "acquired vice" and lubricity a "natural defect": which is odd, for in the preceding sentence lubricity is constructed as something that would be meaningless outside of culture. Yet now we are told that it is "natural," whereas lewdness is "acquired," or learned.

The harder our author tries to semantically pin down the nature of the relationship between lubricity and culture, the more muddled he becomes. And this in the critical engine of the Enlightenment enterprise. Surely such incoherence, in this discursive site, is indicative of the elusive and disquieting nature of the tie, historically and conceptually, between Enlightenment and libertinage. For how was the Enlightened man – I use the word advisedly – to reconcile intellectual critique with sensationalist adventurism? To shift to the register of visual arts production: How was he to articulate the enterprise of materialist demystification with surrender to the siren call of painting, as defined in nascent formalist and implicitly gendered terms by Roger de Piles, the presiding aesthetic voice of the Rococo?

The question is an important one, for, as I noted earlier, we tend to forget that the Rococo coincided with the generative years of the Enlightenment project. We are coming to accept that the historical relationship between the two is more complex than has long been allowed. A notion that finds support of a kind in the final line of the definition. "Lasciviousness has more to do with movement than with sensation." An odd assertion. What does it mean? Frankly, I am not sure. But the ultimate muddle of the *Encyclopédie* definition is an indication that in 1765, there was hedging in the inner sanctum of Enlightenment reflection when it came to casting aspersions on sensation, the holy grail of the movement's inaugural Lockeian and libertinist phase.

24 THÉODORE GÉRICAULT, The Raft of the Medusa, 1819

The Axe of the Medusa

Robert Simon

I. Text and Image

The history of art memorializes Théodore Géricault as a painter of epic scenes on a grand and monumental scale, *un peintre d'histoire*: he dreamed, wrote one of his nineteenth-century biographers, of working "on walls with buckets of paint, using brooms for brushes."[1] Yet only once in his career, over the course of 1818 and 1819, did Géricault produce and exhibit a large-sized canvas that could indisputably be called *un tableau d'histoire*. This was *The Raft of the Medusa* (24).

The classical doctrine of genres, elaborated in seventeenth-century French art theory and academic practice, aimed to codify, albeit with a fair degree of flexibility and open-endedness, what were taken to be the natural hierarchies and categories of painterly subjects – from history to portraiture to anecdote to still life – requiring for each a manner of treatment appropriate to its ostensibly self-evident importance. History painting – which might include literary or religious subjects, or "great" events – was morally, intellectually, and aesthetically the most elevated and demanding of the genres. By the early nineteenth century, the doctrine had been "naturalized as a central tenet of aesthetic lore," and though riven by political, aesthetic and institutional contention, continued to exert considerable force over contemporary painterly pedagogy, practice and critical understanding.[2]

The range of possible compositional and procedural approaches to narrative – whether based more or less directly on text (and visual sources and traditions), or contemporary event (which again might involve degrees of textual, visual, and "experiential" mediation) – varied enormously, as did notions of clarity, completeness, and coherence: the Napoleonic battle scene, in which a primary center of interest subsisted within a diverse, panoramic extension of action, required approaches and modes of understanding different from a narrowly circumscribed antique drama. And then there was the primordial problem of how and where a story told in bodies, gestures, environments and accessories might convey particular information and meanings, or how it might pass into the more general realms of metaphor, allegory, education, edification.

The initial task for the painter of history involved the selection and conceptualization of a single and singular moment rich in drama and significance; here the motion of narrative pushed against the structural constraints of the painter's art, limiting the painter to an instant frozen in time. According to Lessing's highly influential eighteenth-century discussion of narrative in the visual arts, the painter, unlike the poet, is bound by the limits of the medium to the representation of a single moment of a narrative chain or sequence. Transgression of this – say, by including in one work multiple incidents from different times – condemns a painting to incoherence, illegibility, and absurdity. So in order to convey successfully the richness of a complex instant, its causes and effects, the painter, in Lessing's words, "can use only one single moment of the action, and must therefore choose the most pregnant, from which what precedes and follows will be most easily apprehended."[3]

The story of *The Raft* turned on a specific event - a shipwreck off the coast of Africa in 1816 – which combined the complexities of Restoration politics with grotesque violence, and was taken up by journalists, playwrights and printmakers throughout France. In particular, a book written by two of the raft's survivors, Alexandre Corréard and Henri Savigny, published first in 1817, and reprinted in a series of ever-expanding editions beginning in early 1818, provided the artist with a textual source for the project. The basic narrative has been recounted many times, and does not need much elaboration here: a shipwreck; 150 men and women cast adrift on a raft; starvation, exposure, saltwater poisoning, hallucination, mutiny, sharks, hand-to-hand combat; death and more death; cannibalism. [4]

Géricault was quite familiar with the Corréard-Savigny book, and in fact knew its authors as well. He worked up a hundred drawings and painted studies detailing figures and episodes from the story, moments ranging from scenes of fighting and mayhem on the cramped quarters of this "fatal machine," as it was called, to the raft emptied of survivors, at the end of the tale.[5] What Géricault settled on for his final subject was this: one morning, thirteen days into the ordeal, a ship is sighted in the distance – visible in the painting on the upper right – and those survivors still in possession of strength of mind and body attempt to signal it. Corréard and Savigny describe the scene in detail:

A captain of the infantry looking towards the horizon, [caught sight of] a ship, and announced it to us by an exclamation of joy; we perceived that it was a brig; but it was at a very great distance; we could distinguish only the tops of the masts. The sight of this vessel excited in us a transport of joy which it would be difficult to describe; each of

us believed his deliverance certain, and we gave a thousand thanks to God; yet, fears mingled with our hopes; we straightened some hoops of casks, to the end of which we tied handkerchiefs of different colors. A man, assisted by us all together, mounted to the top of the mast and waved these little flags. [6]

The moment stretches, and reaches a tragic denouement:

For above half an hour, we were suspended between hope and fear; some thought they saw the ship become larger, and others affirmed that its course carried it from us: these latter were the only ones whose eyes were not fascinated by hope, for the brig disappeared. From the delirium of joy, we fell into profound despondency and grief... [7]

A few hours later, the brig returns, and the *naufragés* are saved.

The Raft of the Medusa seizes on the moment (from the text, or from some retelling of the story) when the English ship, the Argus, is being signaled – "A man... waved these little flags" – which in turn takes its place at the end of a more extended, though quite circumscribed, series of events and actions: the brig is sighted; handkerchiefs are readied; the signaler is helped to the top of the mast. Géricault substitutes a barrel and a crate for the mast, which keeps the signaler physically and compositionally connected to his fellow naufragés, while linking the action of waving to the simultaneous and prior efforts of his comrades. But at the same, frozen pictorial time, the scene connects, implicitly at least, to the despair to come, by virtue of the sheer and apparently unbridgeable immensity of the distance between the raft and the brig on the horizon, a magnitude of distance engaged by the great straining efforts of the naufragés to be sighted ("for above half an hour, we were suspended between hope and fear"). Efforts which will come to naught as the brig disappears: as one critic put it in 1819, Géricault was entirely to be complimented for "the idea of painting, at the picture's highest point, this man who exhausts himself in making useless signals."[8] The artist would seem to have succeeded quite admirably in selecting and articulating a "pregnant moment" from the raft story, gripped by tension, and which by virtue of its location within a moment of temporal extension and suspension, layers the narrative into the immobility of the medium itself.

Still, the painting takes on more ambitious narrative aims. Lessing is only one example of the many commentators offering practical advice to the *peintre d'histoire*, advice which reflected and shaped theoretical discourse and aesthetic "common sense." For instance, Charles Lebrun's remark

from a 1667 lecture on Poussin's *Gathering of the Manna* (1639), as reported by Felebien: "The painter, having only an instant in which he has to take the object he wants to show…sometimes has to join together many preceding incidents, in order to render intelligible the subject he wants to show…."[9] Or, a century later, Diderot's comment: "I said that the artist had only an instant; but that instant can coexist with traces of the one that preceded it and with signs of the one that will follow."[10] What follows is, once again, the Argus on the horizon, both catalyst of the painting's tension and an impossibly distant, fragile trace on the horizon, a distance and fragility heralding its disappearance.

There is, in the painting, a less obvious trace of "the instant which has preceded," prior to the sighting of the brig, connecting the moment of the painting less to a single preceding instant or incident, than to a complex cluster of episodes and causes. Corréard and Savigny's book of the Medusa story describes at length and in detail the combat on the raft, each and every weapon named. Mutinous sailors

> openly expressed their intention to rid themselves of the officers…and then to destroy the raft by cutting the ropes which united the different parts which composed it…. One of them advanced to the edge of the raft with a boarding-axe, and began to strike the cords: this was the signal for revolt: we advanced in order to stop these madmen: he who was armed with the axe, with which he even threatened an officer, was the first victim: a blow with a saber put an end to his existence.[11]

And not long after:

> The mutineers drew their sabers, and those who had none, armed themselves with knives…they retired to the back part [of the raft], to execute their plan. One of them pretended to rest himself on the little railing which formed the sides of the raft, and with a knife began to cut the cords. [12]

An officer is saved from "the seditious, who were going to cut out his eyes with a penknife."[13] But the fighting is relentless: "Every moment men presented themselves, armed with knives, sabers, and bayonets; many had carbines, which they used as clubs."[14] And increasingly desperate: "Those among our adversaries who had no arms, attempted to tear us with their teeth; several of us were cruelly bitten."[15]

For a while, Géricault lingered over the wild combat on the raft, and, at least by the evidence of the extant studies for the project, this seems to have

been second only to the sighting of the Argus as a possible subject choice for a large-scale painting. In a few elaborate studies men wield sabers and hatchets amidst a seething mass of bodies, living, dying and dead.[16] One particular episode, recounted by Corréard and Savigny, is grafted into Géricault's scene of combat, and given special attention in some separate, related sketches: a man plotted mutiny and murder, and when "the plot was discovered, he armed himself with the last boarding-axe that there was on the raft, wrapped himself in a piece of drapery, which he folded over his breast, and, of his own accord, threw himself into the sea."[17]

The last boarding axe disappears into the sea, and nearly all of the remaining weapons will soon follow. The fighting on the raft is over by the fifth day, when only 30 of the original 150 naufragés remain alive. Madness, combat, suicide, summary execution, fatal wounds precipitously thin their ranks. From the start they are starving and drunk: the little food brought on the raft – some biscuit paste – runs out the first day, and for liquid sustenance they rely on a few barrels of wine, supplemented by rain, seawater, and urine. Two complex sets of shame and scandal traverse Corréard and Savigny's narrative. First, the incompetence and cowardice of the Medusa's (Royalist) commanders, who run the ship into a reef, and set the raft adrift; and then the conduct of the (Bonapartist/Republican) survivors, who kill their (mutinous) comrades ("Spaniards," "Italians," "Negroes," "Asiatics"), and cannibalize the dead. (This begins by day three, though the officers hold out for a bit longer.)[18] If the first provides a context for the second, it is never an explanation, let alone a rationale, or self-pardon: Corréard and Savigny invoke delirium (brought on by exposure, saltwater poisoning, wounds, drunkenness) as one explanatory and ameliorating factor.[19]

On their seventh day, a final sin is committed, an act of deliberation, after which no further death takes place:

> We were now only twenty-seven remaining; of this number but fifteen seemed likely to live some days: all the rest, covered with large wounds, had almost entirely lost their reason; yet they had a share in the distribution of provisions, and might, before their death, consume thirty or forty bottles of wine, which were of inestimable value to us. We deliberated thus: to put the sick on half allowance would have been killing them by inches. So, after a debate, at which the most dreadful despair presided, it was resolved to throw them into the sea.... This dreadful expedient saved the fifteen who remained.[20]

And then:

> After this catastrophe, which inspired in us a degree of horror not to be
> overcome, we threw the arms into the sea; we reserved, however, one
> saber in case it should be wanted to cut a rope or a piece of wood.[21]

They wish to rid themselves of their weapons in case further disputes
arise among the remaining fifteen, but this is clearly as well a ceremony:
the dying thrown overboard, and the instruments of violence consigned to
an ocean grave. One single weapon remains, but its purpose has changed,
and is noted carefully. A few days later, sharks surround the boat, and "they
approached so near, that we were able to strike them with our saber."[22] And
on the twelfth day adrift, the day before they sight the *Argus*, the eight of
the surviving naufragés decide they are near land, set out to construct a
smaller raft, powered by a "little mast and sail," and "oars made of barrel
staves, cut out with the only saber we had remaining."[23]

On the lower right of the canvas, just beneath a man, reclining, his
back towards us, straining to see the *Argus*, and above another, dead, his
body stretched out of the raft and out of the picture frame, Géricault places
an axe with a broken shaft, some stains of blood visible on the blade:
retrieves it, as it were, from the sea. Narrative residue or "trace" of the vio-
lence and chaos and murder and bloodshed on the raft: a cannibal memento
perhaps, and even – going back to the start of things – a link in a narrative
chain that connects the moment of the painting to the blow that severs the
towline and sets the raft adrift[24]. Is not this broken axe sign and instrument
of the multiple cuts that give the story its motion?

II. Fragments of Time

*Many of the works of the ancients have become fragments. Many modern
works are fragments as soon as they are written.*
<div align="right">Friedrich Schlegel, Athenäum, fragment 24, 1798.</div>

Right at the beginnings of Géricault's public career, at the Salons of 1812
and 1814, the imaging of temporality and the categorical imperatives of the
genre hierarchy itself are summoned up as problems: self-contradictory,
insoluble, absurd. Announced in the 1812 Salon *livret* as *Portrait équestre
de M. D.****, the artist's enormous painting of a cavalry officer of the Imperial
Napoleonic Guard was hung again in 1814, but this time under the generic
title *Un hussard chargeant* (25). Could a portrait, specific by definition, be

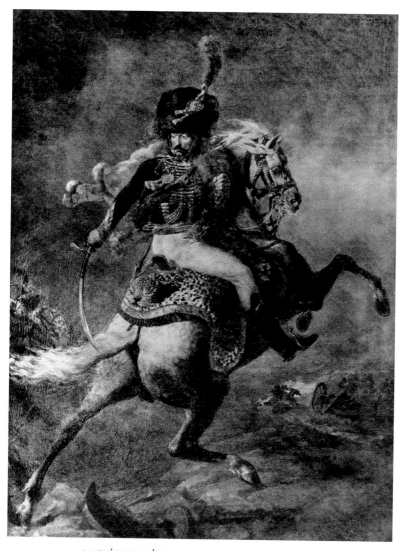

25 THÉODORE GÉRICAULT, Le chasseur de la Garde, 1812

anonymous? When does the monumentality of a generic image and its sub-
ject – an anonymous military portrait situated in an equally anonymous
battlefield – infringe upon the protocols of history painting?[25] Contempo-
rary critics saw the *Chasseur de la Guarde* (as the painting is now known),
as a "study", unfinished, incomplete, blown up to inappropriately colossal
proportions.[26]

The *Chasseur* has been recently described as a "synecdoche," a part standing for a whole, the whole in this case being the panoramic sweep and multiple scenes of the battlefield.[27] The description "fragment" has been used as well, which is complementary, but not exactly the same. In the late eighteenth- and early nineteenth-century Romantic sense of the term, the fragment seizes and turns on the multiple vibrating tensions, the provisional relations, between part (at once complete and incomplete) and whole: in the case of the *Chasseur*, between a study (unfinished, a moment in a process of work), and a large-scale military portrait (but divided from the genre system by its paradoxical anonymity); between a scene of war, sufficient in itself, and the larger ensemble to which it belongs and which it implies – the sweep and extension of the battlefield – which in its turn is a totality, or totalizing, of discrete episodes.[28]

Géricault's *Chasseur* is a tense equivocation between self-sufficiency and extension, traversed and structured by centripetal and centrifugal force. The man/horse ensemble simultaneously pressures and is concentrated by and within the tight framing, the horse's tail breaking and exceeding the image edge, while its front and rear hooves extend nearly to the picture borders. At the visual and dramatic core of the painting is a vexed image of concentration: the horseman, preternaturally calm and self-absorbed at the center of the vortex, point of focus and absence, withdrawn from the action. "He turns towards us," Michelet remarked, "and thinks…this time, probably about dying. Why not? Neither ostentation nor resignation. He is, quite simply, a man firm, of bronze, as if he had already died many times."[29]

We can see, quite clearly in the *Chasseur*, the underpainted trace of the horse's right foreleg and left hindleg, residue certainly of earlier conceptions and studies.[30] The cavalry officer's saber is as well accompanied by a very distinct trace, and these traces do work in the painting, indices and declarations of a work in progress, a progress to which this *Chasseur* belongs as an episode. The painting takes on a very special temporal, if not narrative dimension; Jean-Claude Lebenstzejn seems correct when he says: "In the *Chasseur*, the visible pentimenti of the saber and the horse's foreleg underline in a quasi-futurist manner the degree to which Géricault conceived his image as a fragment of time."[31] As such, projected into the work illicitly, literally violating the necessary instantaneity of the painted image from outside the picture's illusion – extra-diegetically as it were – is a double time element: the process of the image production, and the sequential unfolding of the cavalryman's movement.

Just a few years after the *Chasseur*, probably sometime in 1817, during and after his Italian trip, Géricault took up the subject of the race of the Barberi horses, based on a famous event he had seen in Rome. He appar-

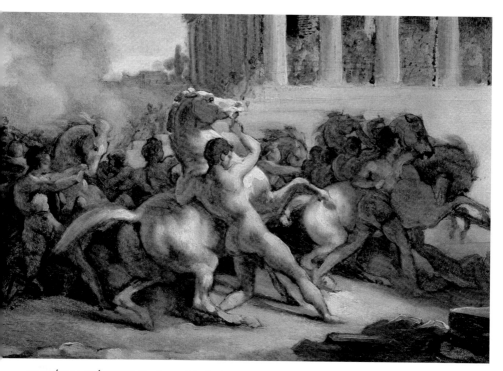

26 THÉODORE GÉRICAULT, The Race of the Barberi Horses, 1817

ently intended to produce a large-scale painting – which may or may not have been begun – but what remains of the project are a sizable number of sketched, watercolor and painted variations on the theme, some treating different stages in the race (26).[32] The subject provided the occasion for rendering a scene of great dramatic intensity, and while not a story per se, involved the selection of a moment: he seemed to have opted, early on, for the race's start. Antiquity is never far from Géricault's Rome, but across his many reflections on the Barberi race, he volatilizes the vision, mixing contemporary and antique costume, architecture, and decor, or at times ceding contemporaneity altogether to bas-relief, purged of incident and specific place. In a sense then, tradition itself – the dream, edifice and immobility of the Tradition – seizes the work in its grip, halting the movement of the race, removing the scene from a particular moment. Antiquity offers a solution to a problem: how to endow the contingency of anecdote with the complex grandeur of History? How to purge History of time?

27 THÉDORE GÉRICAULT, The Assassination of Fualdès, 1818

But for Géricault, a thoughtful and ambitious artist, a modern painter and a painter of modern life, the solution was at best provisional. He abandoned the Barberi race, and in early 1818 turned to other possible subjects for the next year's Salon, focusing for a while on the recent brutal murder in deep provincial France of a retired judge by the name of Fualdès.[33]

The Fualdès project upped the ante, the difficulty, the paradox and the absurdity of an enterprise that spanned a good part of his career: with this project the *peintre d'histoire* seeks his subject in pure ephemerality, the *fait divers*. A grotesque crime with Byzantine political resonances, *l'affaire Fualdès* commanded the attention of journalists, printmakers, songwriters and playwrights throughout France. Géricault produced at least five drawings based on distinctive scenes from the story, which placed side by side form a strip narrative of the crime, mixing and combining throughout figures clothed, in the nude, in antique and modern costume. Roughly, these

span the kidnapping of the victim, the killing, and the disposal of the corpse. The most striking drawing from the series sets itself inside a moment of tension, between an event just passed and a future possibility. Fualdès is stretched out on a table, dead, his throat cut, a pig drinking his blood from a bucket; a witness to the crime has been discovered, and she is dragged into the room, the killers arguing over whether she ought to be killed as well (27).

How to construct some sort of legible account of this story, packed with incident and anecdote, plot and sub-plot? Could the costumes and gestural rhetoric of antiquity transform a grotesque local melodrama into History? Géricault took as direct models and inspiration for his version of the Fualdès crime any number of lithographs and engravings that produced their own accounts of the story. From a ragged industry of representations, prototypes emerged, each with their own audience in mind. For the fans of gothic horror, some served up the details of the murder in all of its hellish glory, while others offered no more than a stiff and simple diagram; some were framed on hand-colored broadsheets by text and song – tales of crime and punishment, lucid morality plays.[34]

What did Géricault have to offer in response to all these? Could he match the specificity and legibility of reference and detail, the unwashed simplicity and intensity of drama? Charles Clement, Géricault's nineteenth-century biographer, wrote that the artist abandoned the subject when he realised that the popular versions of the story were better than anything he could do.[35] But then again, a certain failure was guaranteed at the start, if what the artist had in mind was a public history painting – guaranteed by the paradox and travesty of a grand and great subject fashioned from penny print, *fait divers*, and bloody melodrama.

III. The Cut

Géricault's *The Race of the Barberi Horses*, *The Assassination of Fualdès* drama, *The Raft of the Medusa*, the fragmentation and illicit temporality of the *Chasseur*, are all moments in a single and deeply pondered project, a serial reflection on the possibilities and impossibilities of the modern narrative subject, of the doctrines, demands and "common sense" of the genre system: in other words, a work in progress. Rather than look upon the very many drawings and paintings of singular moments from Géricault's narrative projects as studies that will reach their resolution in a finished painting, these might be viewed on and as the arc of a process of work, of which they are fragmentary episodes (as well as being synecdoches of the

panoramic extension of this work). This enterprise develops a particular tension in the project and process of *The Raft*, where the artist takes up, simultaneously, the episodic strip narrative, and the individual painting, the one declaring the insufficiency of the other. As someone has recently put it, in this "antithetical relationship" between serial narration and singular work, Géricault makes manifest what the *tableau* "lacks," and "one could nearly say, its constitutive impossibility."[36]

Géricault's axe is a critical device in *The Raft's* narrative machinery. It is positioned at the right-base angle of a pyramid that condenses and diagrams the temporal elements of the Medusa story. At the apex, the sighting of the Argus, a moment of suspense and suspension, looking ahead to tragic disappointment and finally salvation; at the left base, the man who has always been identified as a father cradling and mourning his dead son, in the classic gesture of melancholy, self-absorbed, withdrawn from the action; and the axe, trace of prior violent incident, scandal, and causes.

But the axe is a particularly strange device, a cutting instrument that joins together the pieces of the story. If the very coherence of history painting, its fantasy of plenitude and completeness, is dependent upon a system of exclusions and substitutions – very simply, how and which elements get left out of the story, and what stands in for that which is absent – then this axe can be the emblem of the aporias that continually cross Géricault's work in progress, his reflection on the possibilities and impossibilities of the narrative image.

The Raft of the Medusa is an anguished reflection on the painting of history. Was not this enormous canvas no more than a mere anecdote, a *fait divers*, a fragment? At the Salon of 1819, the painting was announced simply as *Une scène de naufrage*, and perhaps we ought to take seriously Géricault's reported deathbed assessment, "*La Méduse*, bah! Une vignette!"[37] One contemporary critic remarked that "instead of cutting the extremities of the raft by the borders…[Géricault] could have presented it in its entirety. By isolating it on all sides in a vast stretch of ocean and enlarging the horizon, he could have shown, by the remoteness of all human aid, the peril in its full grandeur."[38] The critic operates inside of melodramatic clichés. In this huge fragment and vignette, the *peintre d'histoire* merges as one two images and investments, the "Grand Machine" – the ambitious painting of history – and the "fatal machine" of the raft. Géricault's painting is marked everywhere by breaks and cuts: split timbers; strands of rope, a body stretching out of the picture, divided by the lower edge of the frame; the borders of the raft-machine itself. So too is Géricault's work in progress – an oeuvre of fragments, episodes, vignettes – marked everywhere by breaks and cuts, and *The Raft's* axe gives form within the narrative itself to the ruptures and dis-

continuities through which the story takes visible and articulate shape, through which its fantasies, occlusions, machineries become whole. And here a certain compelling work of interpretation may begin.

In her foundational article, "Géricault, or the Absence of Women,"[39] Linda Nochlin examines the systematic "displacement of the feminine in Géricault's production." Following very carefully the details of the Corréard-Savigny text and the artist's compostional strategies for *The Raft*, she describes how a family group that figured prominently in the text "has been replaced by the single sex, 'father-son dyad,'" in this case, *The Raft's* dead son and absent father.[40] And looking at the straining effort of *The Raft's* all-male cast of naufragés toward the distant ship on the horizon, she writes:

> This mounting toward nothingness, toward the perpetually doomed and frustrated chase after the missing phallus, is as far from the psychic (and formal) structure of Davidian balance as it is from that of Delacroixian allegory, in both of which women *must be present to figure the opposing term, the closure of the trope*, as it were. Géricault's figuration remains – painfully, dramatically, romantically – open.[41]

Recurring scenes of "masculine vulnerability," and "castration imagery, in the form of executions and decapitations, haunt the Gericauldian imaginary":

> I would say, that despite the nonpresence of women in Géricault's *oeuvre*, the *signs* of femininity and the feminine – in the form of the castrated or otherwise marginalized or disempowered male body – abound in his work. It is simply that these signs of the feminine have been detached from *the representation of the actual bodies of women*.[42]

Linda (I take the liberty of referring informally to someone who has been both teacher and dear friend) concludes:

> Within the complex but generally oppressive discursive construction of femininity during the early years of the nineteenth century, I understand Géricault's removal of women from his *oeuvre* as constituting a relatively positive gesture: an absence that is, in fact, a moving and positive presence.[43]

Which is to say, putting it very, very crudely, that Géricault makes something out of nothing. What I have been looking at is an antithetical and complementary gesture, through which Géricault makes nothing – bits

28 THÉODORE GÉRICAULT, Severed Heads, 1818

and pieces – out of something; or rather, through which the fullness of visual narration, its doctrines, common sense, possibilities and limitations, are placed beneath the signs of irresolution, doubt and failure.

It would not be fair to conclude without at least a glance at Géricault's most famous couple (28). Like nearly everything he did, a work that never, during his lifetime, left his studio, and that had no possible place in the domains of public art. But it is complete and perfect in a fashion, one of his very few resolved and finished paintings, I would say, in which the subject is fully disarticulated, and where the story comes to a halt.

Periodically, from the mid-eighties on, the writer Lynne Tillman has written essays on various museums and museum exhibitions for which she adopts the persona of Madame Realism. Madame Realism is, as one might suspect, a realist, although in a form that we might associate with its Brechtian, rather than its vernacular sense. As she drifts with the crowds through the National Gallery's 1986 exhibition "Treasure Houses of Britain: Five Hundred Years of Private Patronage and Art Collecting," Madame Realism finds herself irresistibly reminded of the television series *Dynasty*; informed by the audio guide that "British houses are as much a part of the British landscape as the oaks and the acorns"…that the people in these houses "vessels of civilization" developed a "civilized outlook which helped to produce parliamentary democracy as well as the ideals that shaped Western civilization,"[1] Madame Realism is skeptical. "The term 'civilized outlook' set Madame Realism's teeth on edge. Houses natural like scenery? Was this the divine right of houses? She doubted that something could be both natural and civilized at the same time."[2]

That same year, Madame Realism visits the Renoir exhibition at the Boston Museum of Fine Arts. Here too Madame Realism – the spectatorial equivalent of Judith Fetterly's "resisting reader" – has problems. "She didn't like these paintings. They were almost ridiculous when they weren't bordering on the grotesque, and then they became interesting to her. What had happened to this guy on his way to the top?…The women were all flesh… and the faces of men, women, and children were notably vacant. Madame Realism envisioned a VACANCY sign hanging in front of *Sketches of Heads* like a cheap hotel's advertisement that rooms were available."[3]

In the months that have passed since I first decided to "revisit Realism" because it seemed an appropriate homage to Linda Nochlin (who might herself be considered another Madame Realism), I have been thinking about Tillman's Madame Realism. For Madame Realism's realism, which consistently resists all invocations of the natural, whether in the form of the naturalization of stately British houses or the naturalization of Renoir's nudes could well be seen, with respect to representation, as, in fact, an *antirealist* position. Madame Realism's acknowledgement that the natural and

the civilized can hardly be congruent is analogous to the obvious fact that reality and its representation cannot coincide. Furthermore, seeing, for Madame Realism, is emphatically not about believing, and whatever she might wish to say about the nature of the real, it is certainly not delivered to her through museum installations or painted canvas. In this, Madame Realism shares much with contemporary philosophy for, as Christopher Norris informs us, "anti-realism is nowadays the default theory among many philosophers and strong sociologists of science."[4] And if we grant that, analogously, the default position in the study of the visual arts – painting, photography, film – is likewise the conventionalist position, that is to say, the belief that all theories and therefore all knowledge are socially produced, that there are as many "realities" as there are different theories and indeed languages of reality, on what conceptual basis does one approach, much less distinguish between, the different realisms that have consistently emerged in two thousand years of image making in Western art, much of it produced under the sign of mimesis?[5]

Certainly one moment of realism that remains a touchstone for considerations of the subject was that which has occupied such an important place in Linda's own work. It is now more than a quarter century since *Realism* was published, and it remains a standard text in the field.[6] *Realism* is of course about nineteenth-century realism, mostly in France, for this was historically the first period in which aesthetic realism was named as such, in which Realism was an identifiable "movement" and "style" and in which, at least in some instances, such as in certain works by Courbet, realism could be identified with a progressive politics. I will return to Nochlin's work on realism shortly, but it must be said at the outset that the nature and terms of realism, or more precisely, realisms, before and after the nineteenth century, are, however, far more difficult to map. Art-historically speaking, its purview includes Roman republican portraiture, the art of Caravaggio and his followers, a great deal of the art of seventeenth-century Spain and Holland, and in eighteenth-century France one often calls realist the art of Chardin. On the other side of the nineteenth century, there are the heterogeneous realisms of the twentieth: American Scene painting, *Neue Sachlichkeit*, Socialist Realism, Photorealism, and so on and so forth. To this already capacious category, one might add those genres in Western art, for example, the portrait and the still life, which almost by definition would seem to be moored to the empirical real. Finally, insofar as realism inscribes the real within its lexical purchase, even those styles that reject mimeticism or illusionism – Surrealism, *Nouveau Realisme*, Capitalist Realism, even certain forms of pure abstraction – retain its referent. Thus, symbolism invokes a real beyond appearances, photomontage evokes a

real behind appearances, and idealist abstractions invoke a real above appearances.

Insofar as the concept of the real is inscribed within the word realism, any consideration of its meanings, necessarily extends beyond the aesthetic. As Terry Lovell observes, "To investigate realism in art is immediately to enter into philosophical territory – into questions of ontology and epistemology: of what exists in the world and how the world can be known."[7] Although an anti-realist stance has been – and remains – an important aspect of twentieth-century philosophy, an anti-realist bias has had an even longer history within aesthetic theory. Indeed it seems fair to say that realism has been in bad odor almost as long as there have *been* realist practices in the visual arts. Its critiques extend as far back as Plato and are subject to constant reformulation as new critical articulations – such as feminism – emerge. Taking Pliny's tale of Zeuxis's grapes as the locus classicus of mimetic theories of the visual arts, and continuing up through the art of Duane Hanson, the mimetic impulse has continually provoked the most devastating and indeed convincing critiques. From Plato to Nelson Goodman to Roland Barthes to Jean-Louis Baudry, the illusionism deployed for the representation of reality has been revealed as pernicious deception, as formal convention, as ideological mystification, and, with respect to film, as Baudry's duplicitous "representations mistaken for perceptions."[8] Here, then, is one of the many paradoxes or contradictions to consider. Realism, in the general mimetic sense of "fidelity or truth to appearance" (which predates, by a long shot, the literary realism known as the "classic literary text") has been one of the most durable and pervasive modes of representation in Western art history. Like a garden weed, realism would seem to stubbornly resist elimination; perennially dispatched, it sprouts up ever stronger and more resilient, for, it must be said, even the newest technologies of image production are generally assimilated to realist codes, particularly if we loosely define them as systems of representation that efface their own material production, the signifier treated as identical to a (pre-existent) signified. This, above all, is what constitutes realist modes of representation as the bad object of ideology critique, whether that critique is informed by semiotics, post-Althusserian Marxism, or more recently, by feminist critiques of representation. Taking Roland Barthes as one exemplar of these critical positions, we might consider his notion of sign, drawn from the Saussurian insight that the sign, far from being natural, is always a historical and cultural convention. As Terry Eagleton glosses Barthes's argument, "the 'healthy sign,' for Barthes, is one which draws attention to its own arbitrariness – which does not try to palm itself off as 'natural' but which, in the very moment of conveying a meaning, commu-

nicates something of its own relative, artificial status as well."[9] Moreover, "the realist or representational sign...is for Barthes essentially unhealthy. It effaces its own status as sign, in order to foster the illusion that we are perceiving reality without its intervention."[10] In its elision of its own productivity, the reflective sign therefore promotes the illusion, characteristic of all realist styles, that the world effectively speaks itself. Here then is one of the arguments that privileges the work of the modernist avant-garde, and implicitly confers it with ethical superiority.

It is in the context of these critiques of realism that it is interesting to revisit Nochlin's work on realism. That *Realism* and her important two-part article "The Realist Criminal and the Abstract Law" are products of the early 1970s is, I think, significant.[11] At the time they were written, the authority of an anti-realist, high-modernist aesthetics was then perhaps at its height, notwithstanding the challenge of other kinds of art practices, first-wave feminist art among them. A sympathetic account of realism must thus be seen as some kind of challenge to reigning artistic orthodoxies. But we should consider too that these texts on realism were incubated, as it were, in the wake of 1968, and one of the briefs for realism (or for a certain practice of realism that underpins Nochlin's work on the subject) is however nuanced, politically inflected. While in no way subscribing to a vulgar reflection theory, and very different in its terms from a Lukácsian position, and with full acknowledgement of the ambivalence and contradiction that attends realist art, again and again Nochlin signals the progressive possibilities that realism opened up: "The social engagement of Realism did not necessarily involve any overt statement of social aims or any outright protest against intolerable political conditions. But the mere intention 'to translate the appearances, the customs' of the time implied a significant involvement in the contemporary social situation and might thus constitute a threat to existing values and power structures as menacing as throwing a bomb."[12] And with respect to aesthetic politics, Nochlin was concerned to affirm the value, as such, of the attempt to figure that other elusive and complex entity – experience: "Even if we beg the question by saying that a style – any style – is by definition no more than a series of conventions, we must still admit that the realists made a very stringent effort to fight clear of existing ones and to battle their way through to new, less shopworn and more radically empirical formulations of experience."[13] And here we might retrospectively note that the attempt to figure "experience" was likewise one of the imperatives of first-wave feminist art, and whether it is now judged successful or not in aesthetic terms, feminists understood that the absence of women's experience from representation – its invisibility – was part of a larger political problematic. This notion that the rendering visible

of those absent from the stage of history–what could be called the accession to representation–is itself a progressive development is what links the project of Erich Auerbach – specifically his luminous *Mimesis* – to Nochlin's *Realism*, and he is indeed cited in her text.[14]

But it is perhaps in the two parts of "The Realist Criminal and the Abstract Law" that certain of the stakes in a defense of artistic realism are made most evident.

The epigraph, for example, is from André Breton: "What is really important is that the criminal is at the very heart of the law. It's obvious: the law could not exist without the criminal."[15] Such a formulation suggests that the self-purification of modernist art, and the expulsive manner in which this putative purification was described by Clement Greenberg, is structurally dependent on its impure other.

Which in turn suggests that Plato's distrust of mimesis, or, for that matter, Barthes's dislike of realist representation, defends against something in excess of illusionism or bourgeois ideology.[16] Be that as it may, Nochlin states flatly that "for modernism, we may take it that abstraction is the law and that realism is the criminal."[17] Of what does this criminality consist? In this respect, she is able to summon up centuries of anti-realist commentary identifying realism with the low, the ugly, the vulgar, the vernacular; realism's penchant for privileging the specific over the universal; the promiscuity of realism's purchase. Here is Borenius, for example, on a Rembrandt nude: "Flabby breasts, ill shaped hands, nay the traces of the lacings / of the corsets on the stomach, of the garters on the legs, / must be visible, if nature was to get her due."[18] Or Clive Bell's "detail is the heart of realism, and the fatty degeneration of art."[19] The association of realism with the grotesque body is, of course, hardly incidental, and as we have learned from Naomi Schor, the idealist denigration of the individual detail has particular implications for feminism.[20] Nochlin, however, makes a somewhat different argument and one that has consistently informed her notion of the worth of realism: "The dominant imagistic structure of realism is metonymy–association of elements through contiguity – as opposed to the domination of metaphor in symbolist or romantic works. Whereas the non-realist may work through distillation and exclusion, the realist mode implies enrichment and inclusion. Realism has always been criticized by its adversaries for its lack of selectivity, its inability to distill from the random plenitude of experience the generalized harmony of plastic relations as though this were a flawed law rather than *the whole point of realist strategy*. The 'irrelevant' distractions characteristic of realist styles are not naïve mistakes in judgement but are at the heart of metonymic imagery, the guarantors of realist veracity. Irrelevance is indeed a prime feature of the

intractable thereness of things as they are and as we experience them. In realist works details often function synecdochically, substituting the part for the whole, not because they have any 'meaningful' relation to the whole – on the contrary – but merely because they are part of it in the realm of things as they are."[21]

The detail, of course, was precisely the point of departure in Barthes's influential essay "The Reality Effect."[22] The "irrelevant" barometer sitting atop the piano in Mme Aubain's parlor was for Barthes the very marker of a "new verisimilitude, which is precisely realism": "The pure and simple 'representation' of the 'real', the naked relation of 'what is' (or has been) thus appears as a resistance to meaning; this resistance confirms the great mythic opposition of the true-to-life (the lifelike) and the intelligible."[23] Barthes, however, can hardly be described as a simple foe of realism, especially in its great nineteenth-century literary incarnations; one does not, after all, produce a book like *S/Z* without a profound love of the text. That said, Barthes was in the same period celebrating the work of Brecht and Eisenstein, and indeed, it was in the late sixties and early seventies that left intellectuals on both sides of the Atlantic returned, as it were, to Brecht and to Brechtian realism.[24] The year of Nochlin's *Realism*, is as well the year of Colin MacCabe's important essays on realism, and while these are in fact structuralist critiques, they nonetheless involve the attempt to theorize a progressive and even a revolutionary cinematic practice that salvages certain elements of realism.[25] All of which is to say that Nochlin's brief for realism is part of a political environment in which the very urgency of the problem of realism was underwritten by political possibilities that seem, a quarter century later, increasingly foreclosed. Nevertheless, not the least important aspect of the questions Nochlin's realism texts pose is, like Madame Realism's frequent recourse to rhetorical questions, their trouble-making impulse: "To ask why realist art continues to be considered inferior to nonrealist art is really to raise questions of a far more general nature. Is the universal more valuable than the particular? Is the permanent better than the transient? Is the generalized superior to the detailed? Or, more recently: Why is the flat better than the three dimensional? Why is truth to the nature of the material more important than truth to nature or to experience? Why are the demands of the medium more pressing than the demands of visual accuracy? Why is purity better than impurity?"[26]

While certain of these questions are specific to painting, others are far more resonant. Certainly, feminists have good reason to question the terms that elevate the universal over the particular, and the pure over the impure. That said, there is one further issue to consider in relation to realism and that is the issue of pleasure, doubtless the most decisive factor in realism's

longevity. Pleasure, it must be said, has always been a problem in critical theory, nowhere more so than in relation to art where pleasure (other than that obtained by connoisseurs and intellectuals in relation to elite culture) is taken to be on the side of mass culture, kitsch, illustration, Norman Rockwell, Andrew Wyeth, and so on down the slippery slope leading to *Dynasty*. Clearly too, there is a general pleasure produced by illusionism itself, the zero degree, we might say, of realist practice. It was this pleasure that Plato's own contemporaries experienced, for what is Pliny's story of Zeuxis if not about the pleasure of the *trompe l'oeil* – a cheap pleasure in art perhaps, but a pleasure nonetheless. That our own antirealist orthodoxies contribute to our pleasures taken in Picasso's Cubist collage in no way detracts from the pleasures we may take in the *trompe l'oeil* virtuosities of Van der Spelt or Boilly or Peto. On the other hand, perhaps the desire to yield, or the desire to resist the blandishments of the realist seduction are a function of, or perhaps ought to be predicated on, the nature of what exactly is on offer? I conclude, therefore, where I began, with the other Madame Realism, as she wanders through Renoir exhibition: "She looked again at the masklike faces of children, the hidden faces of men dancing with women whose faces and bodies were on display. If masks, what were they hiding? she asked herself, moving closer to the painting as if that would reveal something. Instead she saw brushstrokes."[27] It may well be that Madame Realism's frustrated encounter with Renoir enacts the central paradox of realism itself in the age of conventionalism: possessed we remain with the desire to see and thus the desire to know, while being at the same time cognizant of all the conditions that veil vision and knowledge both.

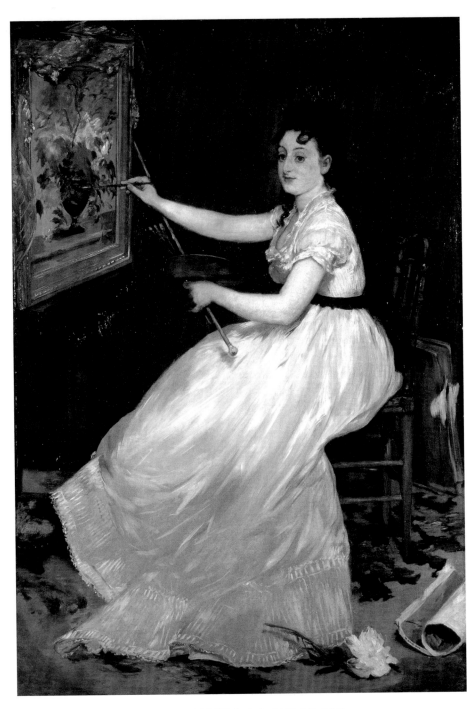

29 EDOUARD MANET, Portrait of Mlle E.G., 1870

Tamar Garb

Manet's *Portrait of Mlle E.G.*, recognized by many critics as a painting of the artist Eva Gonzalès when it was exhibited at the Salon of 1870, was regarded, from the start, as an awkward picture (29). Greeted by many of its viewers with outraged laughter or open derision, it became a focal point for the crowds of bemused or scandalized spectators who thronged to the Palais de l'Industrie.[1] Congregating in front of what was, for most, a bizarre and illegible picture, audiences could unite in their contempt for the audacious Manet and take pride in the fact that they, at least, had not been duped by yet another of his outlandish Salon submissions.[2]

As a nineteenth-century portrait of a young *bourgeoise*, the *Portrait of Mlle E.G.* needed to convey the specificity of the model while affirming her as the representative of a social type: young, refined and feminine. Maintaining a fine balance between the particularity of the individual and the shared characteristics of the group, the sitter had to appear both unique and generic. Pure resemblance was not enough. That, it was believed, was the remit of photography.[3] Painted portraiture needed to animate the figure and situate it appropriately so that setting, costume, demeanor and bearing revealed both the identity of the person portrayed and the milieu from which he or she hailed.

It was the balance between the generic and the particular, the faithful rendition and the respectful regard which the successful portraitist needed to achieve. Above all, in portraits of women, probity of vision needed to be tempered by propriety and discretion. The feeling was that Manet had not quite managed this. His sitter seemed more particular than typical, indeed over-individualized. Her strong features, striking dark hair, large round eyes and smiling self-absorption, all exceeded the composure required of impassive feminine respectability. One critic even accused Manet of giving his model "the physiognomy of a plaster doll with stupefied eyes and a nose like a parrot's beak."[4] The consensus was that Manet had succeeded in making a caricature of his model, betraying her trust and exposing her to ridicule.[5]

It was the irregularity of Eva Gonzalès's features, their marked singularity, that fascinated Manet. In an etching of her head, also produced in 1870, Manet seems to have exaggerated the features and asserted the bold

30 EDOUARD MANET, Profile of Eva
Gonzalès, turned to the right, 1870

shape created by the facial contours (30). In this more intimate medium
Manet heightened the specificity of the profile, the sharp linearity of the
etched line revealing the large hooked nose and characteristic high brow,
both of which become softened in the three-quarter view adopted in the
painted portrait. But Manet had not sufficiently adjusted his sitter's features
to society's expectations. Gonzalès's countenance still seemed highly indi-
vidualized, even ugly, to many of its first viewers.[6] Not only had Manet
called attention to his model's particularity but he had done so in a tech-
nique which seemed brutal and destructive. With his customary "crudity of
tones,"[7] "heavy-handed brushwork,"[8] and apparent lack of technical skill,[9]
he had made of a pretty woman "an abominable and flat caricature in oil,"[10]
giving her a "chalky physiognomy" and a "dazed and fixed expression" like
a "waxen doll propped on a living body."[11] It was difficult, therefore, for
critics to separate Manet's alleged attack on traditional French painting
methods and notions of Beauty from the assault on respectable femininity
which the picture represented. How could a painter famed for the creation
of "ugliness" be trusted to celebrate female "beauty?"[12] To Albert Wolff,
Manet had transformed a pretty woman into a "monster of a human crea-
ture," "an abominable caricature." His rendering of her amounted to an
insult.[13] To A. de Pontmartin, all of Manet's figures shown at the Salon of
1870, were nothing more than caricatures, idiotic and lifeless.[14] People were
no more important than the furniture and carpets that surrounded them.
Figures were subjected to the same broad touches and strokes that described

the interiors in which they were placed. For some this amounted to an assault on the body itself and an attack on the humanity of those represented. One critic wondered at the courage of the young woman who could smile in the midst of such filth.[15] A number were amazed at the "bravery" shown by the hapless creature whom Manet had so defiled.[16]

A number of critical accounts of the picture dwelt, in 1870, on the debasing of female beauty which Manet's technique habitually produced. Shadows became transformed, discursively, into dirt or dubious smudges which sullied the sitter at the same time as they testified to the alleged incompetence of the painter whose technique was described as nothing short of "savage." To one scathing commentator, Manet painted "like a Hottentot," an unschooled native with no understanding of tradition or technique.[17] Many commented that Gonzalès's face and body were too "flat," her skin tones too unmodulated, her physiognomy waxen and lifeless. There was little sympathy for the way in which Gonzalès's dark locks fell over her brow and bodice, creating vivid dark patches against her fair skin. Shadows at the nape of the neck and top of the arm looked foul and muddy, like excessive and inappropriate areas of body hair, insufficiently tamed and contained by the laws of decorum and respectability. Dark smudges appeared to mark the skin's surface, spoiling, streaking and obscuring those areas where hair meets skin, fabric meets flesh and light meets shadow. To be rehabilitated, wrote one critic of Manet's figures exhibited that year, the sitters would need to have their faces and hands scrubbed, their attire degreased and their dresses scrubbed.[18]

The description of Eva Gonzalès's costume as "dirty" is one that recurs. The white, muslin dress with its deep shadows and grey and blue tonalities seemed coarse and revealing to the painting's first viewers. The choice of costume had not been arbitrary. In a letter confirming the commission of the painting with Gonzalès's mother, Manet arranged to have the dress collected and brought to his home, where the painting was to be executed.[19] It was important to Manet, therefore, to pose the model in the formal, flowing white gown, broken only by the severe contrast of the black sash tied sumptuously behind her poised torso. But such a costume, with its exposure of naked flesh and bare chest, its peeping toe and flowing tresses is hardly appropriate day wear, let alone the characteristic attire of an oil painter, herself a much acclaimed exhibitor at the Salon of 1870. Indeed, anxieties over the dirtiness of Gonzalès's dress may also have been derived from a fear that she might soil herself in the process of painting. The incongruity of costume and pose seem to articulate the awkwardness of the sitter's double identity as artist and debutante. The brushes and mahlstick in her left hand come dangerously close to the white fabric of her frock and the

mahlstick itself casts one of the notorious "dirty" shadows onto the gown. Transparent at shoulders and chest, the dress's decolletage and skimpy sleeves display Gonzalès's full breasts, her plump neck and scandalously naked arms – arms which provoked a number of negative comments from outraged critics.

The dark tonalities which Manet deployed in describing shadows and recesses together with the jet black hair and shadowy eyes of his sitter did not only suggest uncleanliness (reminiscent of the notorious *Olympia*) but also evoked a sultry sensuality associated with southern peoples and "foreigners." The Salon of 1870 abounded with images of "gitanes," "juives" and other Orientalist confections which displayed the stock characteristics of sallow skin, abundant and flowing dark hair, exposed flesh and voluptuous figure.[20] But what was acceptable in the arena of fiction or fantasy, was not appropriate in the domain of domestic portraiture. Gonzalès's name and dark looks evoked Manet's genre paintings with Spanish performers from the early 1860s. But such public performativity was not the remit of bourgeois femininity. Far from being a marginal, anonymous performer on stage, street or in the bullring, Gonzalès inhabits a specific social space, a contemporary Parisian interior, in which she takes up the curious double position of both working artist and mysterious model.

Most awkward in this context are Gonzalès's naked, apparently boneless, arms. Plump and provocative, they seem scandalously exposed as they perform their task in front of the easel. For working arms they are curiously limp and disarmingly bare. The grip on the brush in the right hand seems tentative and uncertain and the palette in the left precariously balanced. It was on Gonzalès's "impossible"[21] arms that a number of critics fixated: too short for some,[22] too long or badly drawn for others,[23] comical or even grotesque for many,[24] this was the body part which was most frequently isolated in the criticism. The arms seemed ludicrous, laughable. These are not a respectable woman's arms; those should have been demurely covered. Nor are they the arms of the *bourgeoise* who busies herself at her handiwork, or those of a fashionable woman on her afternoon rounds where gloves would certainly have been worn. Only at the opera or a ball, or in the privacy of her boudoir, would a respectable woman's naked arms have been revealed. Situated as they are in what is patently an artist's studio, they suggest both inappropriate nakedness and the sexualization of an identifiable contemporary woman.

The eroticization of the female arm within an urban interior had specific connotations in the spring of 1870. In the months leading up to the Salon, Parisian newspapers were full of images of women exposing their naked arms to professional men. April 1870 saw a mass campaign for vac-

31 "La vaccinomanie," Journal amusant, 2 April 1870

cination against smallpox in Paris and satirists had a field day inventing caricatures of semi-clad young women baring their limbs to lascivious doctors armed with phallic syringes.[25] Dressed in frilly chemises, women swooned and fawned in the presence of the medical experts who seemed to take more than a scientific interest in the bodies offered up to them. Young and old, men and women were urged to be revaccinated by the authorities in February and March 1870 as fears arose that previous inoculations may have worn off and would not defend the population against a new epidemic of the defacing disease.[26] The humor in the situation was milked from all angles and the verb "vacciner" quickly acquired sexual connotations: "Let me go, you're beginning to vaccinate me too strongly," a reluctant woman cries

LE MOIS COMIQUE, PAR CHAM

EXPOSITION DE 1870
Les démangeaisons occasionnées par le vaccin faisant grimacer tous les portraits de cette année.

— Ton vaccin a-t-il pris ?
— Hélas! on m'a vacciné avec le vaccin d'un voleur! il ne fait que ça! prendre !

Embarras du vaccinateur mandé par la Vénus de Milo qui craint pour sa beauté.

32 CHAM, "Le mois comique," Le monde illustré, 1870

to her over-zealous male companion in one caricature whilst a listless lass is told to go and "be vaccinated" to alleviate her boredom in another (31).

The juxtaposition of bare female arms and elderly male experts suggested an inevitable sexual frisson. Some satirists made much of the piercing action of the needle and the penetration of the lady's flesh which it entailed. By pricking the flesh doctors transgressed the boundary between the seductive surface of femininity and its hidden interior. They entered the bodies of women and left their mark. It was this scar, this blemish that threatened to sully the perfection of the skin at the same time as leaving a trace of the transgression which was its cause. Fear of the needle was offset by the horror of defacement caused by the disease. The arm became highly invested with a rhetoric of idealism – its perfection needed to be protected against the defacing treatments demanded by science. Ironically, protection against a disease which was profoundly disfiguring was achieved through a violation of the body's boundaries, a puncturing that could be seen as both phallic and invasive.

The discourse on the female arm and its violation was present in discussions of both art and politics in 1870. Caricaturists drew parallels between the plebiscite on Napoleonic reforms of May 1870 and the effectivity of inoculation, wondering if the reforms, like the vaccine, would take.[27] Cham wondered how the most perfect of women, the Venus de Milo, was to overcome the absence of arms for her own protection (32). He also satirized the physiognomies of the female portrait subjects of 1870 by showing a model, arms bared, scratching herself vulgarly and grimacing from the effects of vaccination. On another occasion he drew a long-haired model in evening dress with grotesquely inflated, scarred arms and lamented the fact

that all the women in the portraits of that year appeared to have been vaccinated (33).

The exposure of a woman's arm in the presence of an older man was, therefore, overtly sexualized in contemporary discourse. The concept of an unblemished arm, a perfect limb, was much commented on and the anxiety over the maintenance of flawless extremities was exploited by satirists and caricaturists alike. It was quite in keeping with the mood of the moment that critics should notice Eva Gonzalès's naked arms, therefore, and that some should comment upon the "comical fashion" in which Manet had determined their contour.[28] Bumpy and uneven in outline, the one arm bonelessly outstretched, the other awkwardly poised, the lack of idealization in the picturing of the upper limbs could stand for the violation of femininity as a whole, its distortion by the techniques and technologies of modernity.

But it was not only Gonzales's *arms* that seemed inappropriately exposed in the portrait. All extremities were under scrutiny at this point, and, as a number of caricatures demonstrated, some cautious women pre-

33 CHAM, "Exposition 1870," Le Charivari, 10 April 1870

EXPOSITION 1870.
Les portraits de cette année se ressentent de la vaccine.

ferred to proffer their calves for inoculation rather than their arms (34). The appearance of Gonzalès's foot, poised on a footstool as if belonging to some latter-day Mme de Pompadour, and peeping coquettishly out from beneath the flowing gown, was incongruous in a painting of an artist at work. Reminiscent, like the arms, of the "boudoir" rather than the "atelier," this provocative detail contributed to the sexualization of the model's body while rendering her location at the easel awkward. Her position is insecure, her balance precarious, her role unconvincing. Even the placement of easel and chair seemed odd and uncomfortable. Arranged, according to one critic, as if chair and easel danced a saraband together, the perspective of the room appears awkward.[29] Turned away from her canvas and presenting a three-quarter view to the spectator, Gonzalès looks as if she would be more appropriately posed at a dressing table, applying her makeup, than in front of an easel. Indeed, for all the surrounding studio paraphernalia, it was not this painting that was to persuade critics of the professional ambitions of the young artist depicted. For that they looked to her own submissions to the Salon of 1870.

For Eva Gonzalès, listed in the Salon catalogue as a pupil of the fashionable Charles Chaplin rather than the contentious Manet, made her own artistic debut at the Salon of 1870.[30] Represented by two works, the maximum allowed to any one artist in that year, her exhibits received extensive coverage in the press.[31] A number of critics even offered her qualified praise while passing over Manet entirely.[32] Others only referred to Manet as an aside after discussing Gonzalès's two figure paintings in detail. Very often she was applauded at his expense. The naturalist critic Jules-Antoine Castagnary, for example, heaped praise on Gonzalès's *Young Soldier* (1870, Musée Gaston Rapin, Villeneuve-sur-Lot), describing the face as "strong and well modelled," the pose and expression as absolutely appropriate. Excusing certain weaknesses in the construction of the figure, Castagnary stressed that, in his view, Gonzalès had, for the most part, left Manet's faults to himself. Even Manet's "originality," which explained his "oddness" to his defenders Thédore Duret and Philippe Burty in 1870, could not excuse him for Castagnary.[33] Chance alone had brought Manet to mind, but his two submissions to the Salon were not themselves worthy of discussion.[34] For Olivier Pichat, writing in *Le Gaulois*, Gonzalès's *Young Soldier* displayed a "mastery that was truly masculine."[35] A number of critics praised her for avoiding the usual pitfalls of the woman artist. For Tony Révillon, who devoted a whole article on the front page of *La petite press* to the *Young Soldier*, Gonzalès's triumph was that she painted without the sentimentality common among women artists.[36] But, what critics could not understand was how an artist who had the strength to resist Manet's influ-

Quatrième année. — N° 14

PRIX DU NUMÉRO POUR PARIS ET LES DÉPARTEMENTS
25 centimes

Samedi 2 Avril 1870

PARIS-COMIQUE

DIRECTEUR
CARLO GRIPP

JOURNAL ILLUSTRÉ

ADMINISTRATION
6, Cité Trévise.

ABONNEMENTS: Paris, Six mois, 6 fr. Un an, 10 fr. Départements, Six mois, 7 fr. Un an, 12 fr. Les abonnements partent des 1er et 15 de chaque mois.

LA VACCINATION — PAR CARLO GRIPP

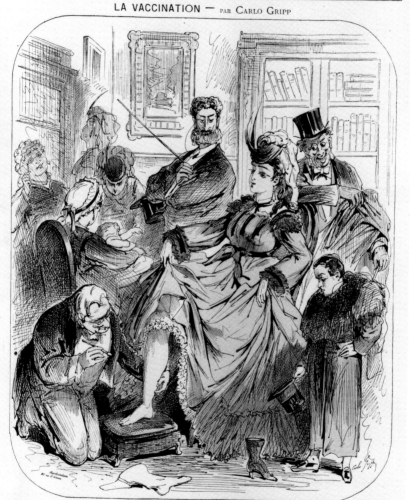

— Ah, docteur, que j'ai bien fait de ne pas me laisser vacciner au bras !.. ça marque... Et puis, c'est mon mari qui trouve que j'ai la jambe belle.
— Il ne la connaissait donc pas ?
— Lui !!! jamais de la vie !

34 Paris-Comique, 2 April 1870

ence in her own work, could subject herself to his control in the fabrication of her image. Gonzalès's success as an artist made her willingness to be depicted in the manner of the portrait unintelligible. One critic mockingly claimed that even someone about to be delivered for execution did not possess more courage than "the young person who had allowed M. Manet to represent her full length in a filthy dress."[37] Or in the words of Olivier Pichat: "what plunges me into a stupefaction which is impossible to describe is that Mlle Eva Gonzalès could have decided to pose for the portrait that Monsieur Manet wanted to make of her." Why, he continued, did she not, having been so charitable in allowing herself to be abused by him, condescend to give the master a few elementary art lessons herself?[38] Gonzalès's success gave hostile critics the opportunity to pour scorn over Manet's competence as teacher and mentor, a role in which Fantin-Latour's *Studio in the Batignolles* (1870, Musée d'Orsay, Paris), exhibited at the same Salon, enshrined him. Indeed Manet's own *Music Lesson* (1870, Museum of Fine Arts, Boston) prompted one caricaturist to think about potential drawing lessons for the artist himself.[39]

Manet's representation of Gonzalès exposed a woman artist to public scrutiny in a way that was regarded as highly invasive. Contemporary discourses on the woman artist stressed the discretion and privacy of this occupation, favoring women's engagement with painting over music or dance because of the protection that it afforded its practitioners. Secluded in the studio, the woman artist could be productive and serious whilst concealing her person from public display.[40] Where music was saturated with servitude and moral danger, and politics or public life involved unwomanly assertiveness, painting allowed women to retain their dignity and independence, affording them hours of recreation, silence and solitude. Emancipation via the palette, paintbrush, or mahlstick, wrote one reviewer of the 1870 Salon, was preferable to the pretensions of amazons or free thinkers and was generally to be encouraged.[41]

To paint a woman artist at work, therefore, was to risk exposing her to inappropriate public scrutiny. To accentuate a lady's individuality and exploit her specificity was to lift the veil of respectability with which her public persona should customarily be cloaked. To depict such a figure with naked, outstretched arms, and ungloved hands holding her tool in mid-dab, was to make a spectacle of her labor and to draw attention to her body in a prurient and impolite way.[42] So much was clear to Manet's critics in the spring of 1870.

What was not articulated by contemporary observers were the many compositional devices that made *The Portrait of Mlle E.G.* much more powerfully an image through which Manet projected his own authorship, than

one in which his sitter's professional identity could be recognised.[43] Gonzalès's person is situated in Manet's space, both literally and figuratively. Her body, saturated with the signs of femininity, is literally framed by Manet's insignia. This is even true of the painting, propped on the easel, at which she so tentatively dabs. A floral still life, this picture bears no resemblance to any work that Gonzalès had executed up to this date.[44] Indeed, Gonzalès was herself primarily interested in figures at this time, as her Salon submissions testified.[45] But it was as a flower painter, a traditionally female occupation, that Manet chose to represent her and he selected (what appears to be) one of his own paintings in order to set up the scene. One critic baldly stated that Gonzalès was shown "in the process of making a little Manet," implying that she was posed in front of one of the master's works, or that she was reproducing one, or creating one to his specifications.[46] Either way, it was Manet's imprint which was stamped onto the elaborately framed picture propped on the easel. As far as we know, Gonzalès had taken no interest in flower painting up to this point, while the painting does resemble a number of floral still lifes produced by Manet in the 1860s[47] (35). Paradoxically therefore, a man's picture provides an endorsement of a woman artist's femininity. Simultaneously, a woman artist's touch poised on the surface of her teacher's finished work, stands in for his masterful hand to which she is subject. The painted still life is, therefore, indexically linked to both artists on display, that is, to the depicted artist whose brush skates its surface, and to the depicting artist whose presence is felt both as the author of the picture within the picture and as its transcriber in the mise en scène into which it is now subsumed.

But the vase of flowers is also metaphorically linked to the woman on display, and here the analogy with Manet breaks down. For where the flowers could conceivably stand as a surrogate for Gonzalès herself, they could not possibly do so for Manet. The flowers provide a conventionally feminine sign. Depicted, framed and potentially veiled by the curious blue gauze that hovers on the guilded border, they provide a fitting reflection for the female protagonist in front of whom they are placed. A painting woman evoked a painted woman in nineteenth-century France, makeup being more appropriately woman's medium than oil paint. For many nineteenth-century commentators a woman's proper place was in front of the dressing table rather than the easel, and the surface at which she was accustomed to staring was the mirror rather than a canvas representing objects other than herself. Manet's still life, therefore, serves as a double for Gonzalès's person, while conceding no authority to her touch.

Manet's presence is further emphasized both iconically and indexically in the portrait. The fallen peony which lies on the carpet in the right-hand

corner casts a shadow over Gonzalès's dress marking her with a presence which is at once explicable and odd. Discarded or cut from the floral arrangement which we imagine but cannot see, it also signifies Manet's hand. Peonies were Manet's favored flower in the 1860s and Chinese peonies were cultivated in the garden of the Manet family home at Gennevilliers. Manet produced several paintings of this flower in the mid-1860s and included secateurs and cut blooms in a number of them.[48] Wittily and self-referentially therefore, Manet cites his own painterly production and allows one of his favourite blooms, cut at the stem, to stray into the portrait he makes of his talented pupil. The peony functions as a signature for Manet, simultaneously paying homage to Gonzalès's femininity, while denying her any autonomy or agency within the mise in scène. Once again it is through a flower, a conventional sign of femininity, that Manet casts his presence over the woman artist, subsuming her subjectivity into his own authoritative presence.

Nowhere is such an inscription of authority more evident than in the painted scroll that Manet included in the bottom right-hand corner of the portrait. This is clearly not Gonzalès's property. Here, on the border of an almost invisible painting, rolled up and discarded on the studio floor, Manet chose to sign his own name together with the date when the portrait was exhibited. The signature doubles up as an assertion of ownership over the property found in the studio and of the Salon submission itself. Wittily, Manet establishes himself as the only artist on display here, his own physical absence compensated for by his signatory presence announced by the strategic placing of the Proper Name, the sign of identification and ownership, the mark of the originator of the image.[49] Tantalizingly, we cannot be sure what is depicted on this signed scrap of canvas, but from the curving, scratchy line that peeps out at the corner, we might assume that it too depicts a peony and could represent the fallen flower by its side. That much is speculation, but such an interpretation would not be out of keeping with the complex duplications and layerings of the picture itself. Fallen from the vase (or the propped painting), the peony leaves its mark on Gonzalès only to be reincorporated as securely belonging to Manet in the only bit of the picture which actually bears his name.

Coming full circle around the figure, from the easel on the left to the leaning portfolio on the right, we see a figure fully framed by the authority and presence of her mentor. Whether this studio prop – the portfolio – positioned behind her chair, belongs to Gonzalès herself and signifies her itinerant presence in the studio or whether it is Manet's own, a safe place in which to stack fragments like the discarded scroll that lies on the floor, it is sealed with Manet's characteristic touch, a brilliant and effusive group of yellow brushmarks which boldly and assertively link this shadowy brown

35 EDOUARD MANET, Peonies in a Vase, 1864

shape to the painted scroll, the discarded flower and the gleaming gold frame which surrounds the still life. Closing the circle, this extravagant profusion of strokes is yet another signatory gesture which, while framing the image of the woman artist at work, asserts the authority of the real artist, Manet, that is represented here.

Where, we might ask, is Gonzalès's subjectivity in all this? How is her identification with her mentor reconciled with her own ambitions, desires and fantasies? That is the subject of another essay, and involves a careful tracking of Gonzalès's own work in the years after 1870 but, as a tantalizing coda to this piece, it is interesting to note that Gonzalès began herself to produce flower paintings soon after Manet had completed his portrait and, not surprisingly, it was peonies that she painted.

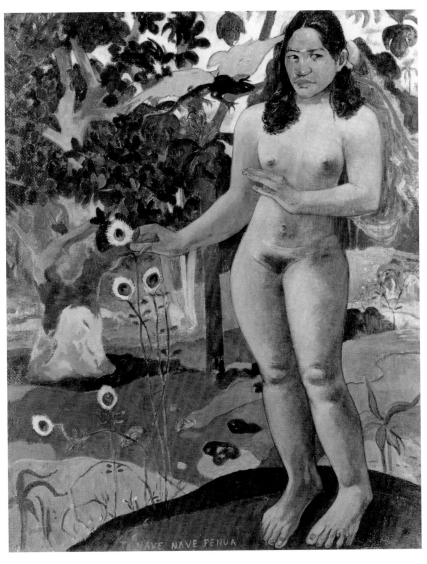

36 PAUL GAUGUIN, Te nave nave fenua (Land of Sensual Pleasures), 1892

Identity and Non-Identity in Gauguin's
Te nave nave fenua

Stephen Eisenman

1. Introduction

Te nave nave fenua (*Land of Sensual Pleasures*) of 1892 is among Paul
Gauguin's most audacious works from his first Tahitian period (36). The
nudity of the female figure is unusually frank, and the landscape especially
vivid, prompting expressions of alarm from the painting's first critics,
including August Strindberg. "I saw [in the painting] verdant trees that no
botanist would recognize," he wrote to the artist in 1895, "animals that
Cuvier never imagined and men that you alone have been able to beget....
And in your paradise there dwells an Eve who is not my ideal – for I myself
have an ideal or two of woman."[1] What most struck the playwright about
Gauguin's painting (and what caused him to refuse the artist's invitation to
write a catalogue essay) was its non-idealization of woman and nature.
Strindberg's litany of negations – "no botanist," "never imagined," "you alone"
and "not my ideal" – amounts to an implicit recognition of Gauguin's con-
structive principle of "non-identity." *Te nave nave fenua*, I shall argue, exem-
plifies not the "sheer-knitted-together-strength" in Edward Said's words, of
the discourse of Orientalism, but the fracture, artifice and irony of an art
that, as Nochlin writes, "denied the picturesque by rejecting...the signifiers
of Western rationalism, progress and objectivity *in toto*."[2] Gauguin's picture
represents not simply the romantic alienation or non-identity of the male
artist but the non-identity of his female, colonial subject.

2. A Brief History of Non-Identity

Non-identity is the philosophical and sociological concept – present in
Hegel and Feuerbach but critically elaborated in Karl Marx's *Economic and
Philosophical Manuscripts of 1844* – according to which subjects and
objects, subjects and themselves, and humans and nature are alienated or
estranged. This disaggregation of the subject, according to Marx, occurs
historically in circumstances of private property, separation of labor, com-
petition, capital accumulation and monopoly. Non-identity is alienation

(*Entäusserung*) at the level of consciousness, estrangement (*Entfremdung*) at the level of being. Marx writes: "This relation is the relation of the worker to his own activity as an alien activity not belonging to him; it is activity as suffering, strength as weakness, begetting as emasculating the worker's *own* physical and mental energy, his personal life, for what is life other than activity – as an activity which is turned against him, and neither depends on nor belongs to him. Here we have self-estrangement, as we had previously the estrangement of the thing."[3]

The Hungarian Georg Lukács elaborated insights from the early Marx in an essay called "Reification and the Consciousness of the Proletariat" from 1921. In this work, also deeply influenced by Max Weber and Georg Simmel, and pivotal for the subsequent development of critical thought, Lukács focused upon the subjective nature of alienation and the potential for transcendence by the working class. "With the modern, 'psychological' analysis of the work process (in Taylorism)," he writes, "this rational mechanization extends right into the worker's 'soul': even his psychological attributes are separated from his total personality and placed in opposition to it so as to facilitate their integration into specialized rational systems and their reduction to statistically viable concepts."[4] Thus for Lukács, modern identity – bourgeois and proletarian alike – is actually non-identity; it is a kind of fractured being that lies beyond the integrative reach of either consciousness or representation. For the bourgeois class, non-identity is complete; because of its causal and contingent relationship to commodity production, it has neither the interest nor the opportunity to understand its position within the total system, and thus to regain even a semblance of subjectivity. For the proletarian class however, non-identity is contingent: because of their position within the production process, workers have the opportunity to understand whereby their own labor power becomes the instrument for the capitalist acquisition and accumulation of value. The revolutionary proletariat may therefore come to apprehend the nature of reification itself, and in so doing regain identity. (Precisely what that subjectivity would consist of is uncertain, but it would presumably encompass the sensual and intellectual plenitude Marx recounted in the 1844 *Manuscripts* beneath the rubric "species being.") In the hands of revolutionary artists and intellectuals, this restored identity, or "consciousness of the proletariat" would be the basis for a new, realist art of exceptional, ideological clarity.

Lukács's proposition however, concerning the worth and even necessity of constructing a new realist art based on the unclouded consciousness of revolutionary subjects – even in advance of the revolution – has not carried the day. For Marxists and non-Marxists alike, the artistic limits imposed by the ineluctable fact of non-identity have continued to prevail.

Like Lukács, Bertolt Brecht embraced popularity and realism in art and literature, but he constructed a theatrical practice based upon the opposite: non-identity. "*Verfremdungseffekt*" ("estrangement-effect," or "defamiliarization-effect") is the name he gives to a number of dramatic devices – including the quotation of lines, the reading aloud of stage directions, and the intrusion of intertitles, songs and burlesque into dramatic situations – which undermines empathy and identification. Brecht, in short, uses theatrical *Verfremdung* as a weapon with which to heighten his audience's historical and critical awareness of social and economic *Entfremdung*. In this way, non-identity may be understood as both form and meaning in Brecht.

For Jacques Lacan, non-identity, or estrangement is constitutive of the ego at the very moment of its organization. The fixity of the child's image in the mirror stands as a silent and permanent rebuke to a self that is emotionally turbulent and physically unstable. The mirror stage thus inaugurates "the armor of an alienating identity, which will mark with its rigid structure the subject's entire mental development."[5] Non-identity will thus mark the self at every stage of life, and its impasses are existential. Only the intersubjectivity arising from speech permits provisional linkages of subject and object. Yet even here non-identity prevails: for Lacan as for Lévi-Strauss "behind all meaning there is a non-meaning."[6]

Lacan's particular "logics of disintegration," to cite Peter Dews phrase, has provided considerable impetus for the construction of post-modern theories of non-identity. Yet in recent years, a curious paradox has arisen. Even as theories of non-identity have reached a nihilistic apogee, they have been used to buttress claims of racial, ethnic, sexual and other subcultural identity. Put another way, the speaking self has been understood to be by nature fractured, homeless and alienated, while the silenced Other – for whom theorists purport to speak – has been seen as whole and rooted, and endowed with both agency and authority. The dialectical relationship between the two attitudes lies in the following: the loss of faith in so-called master narratives – the concept is Lyotard's – has left intact only "a multiplicity of apparatuses that transform units of energy into one another."[7] These latter "units" however – of libidinous energy and local knowledge – have become sacrosanct. They are in fact only master narratives themselves, albeit in more circumscribed domains. Granting full agency to modern colonial subjects must therefore mean recognizing that they too occupy fractured and alienated selves and societies. Precisely such a fractured, contemporary identity is represented, I believe, in Gauguin's *Te nave nave fenua*. The protagonist is masculine and feminine, alienated and estranged; she performs multiple roles, none of them with conviction; she is at once biblical temptress, traditional Maohi, and modern, laboring subject.

3. An Edenic Eve

Gauguin's painting depicts a naked Tahitian woman (generally identified as the artist's lover Teha'amana) assuming the posture of a figure from the facade of the great Buddhist temple of Borobadur in Indonesia. Gauguin owned a photograph of the relief and frequently quoted from it, first in *Exotic Eve*, a little painting made in Paris in 1890 (Private Collection, Paris), later in *Ia orana Maria* (*Hail Mary*) from 1891-2 (Metropolitan Museum of Art, New York), and near the end of his life in his grand and idealizing *Rupe rupe* (*Gathering Fruit*, 1899, Hermitage Museum, Leningrad). *Te nave nave fenua* is not large – thirty-five inches high, it can be described as exactly half life-size – but the figure is monumental; the top of her head is abridged by the frame and her toes caress the painting's lower margin. She is wide as well as high, and Gauguin clearly intends us to compare her *tronc* (the French word for "trunk" has the same dual meaning as in English) with that of the massive *hotu* tree at left. Her arms may similarly be compared to the two largest tree limbs, with each pair seeming frozen in a Tahitian dance position. Hovering above Taha'amana's right shoulder is a lizard with red bird wings, black body and a long tail. Human and reptile have perhaps just concluded an intimate colloquy, and expectancy seems to hover in the air. The foliage surrounding the principles is luxuriant and animate; plant tendrils in the left foreground beckon the viewer to enter the tropical glade, and flat planes of yellow-green, lavender and ocher bring background and foreground into close proximity.

The picture represents Eve in the Garden of Eden; that is to say, the episode in Genesis 3: 5-7 in which a serpent contradicts God in telling Eve that she will not die from the fruit of a particular tree found in the middle of the garden, but on the contrary, that "your eyes will be opened, and you will be like God, knowing good and evil." Eve thereupon ignores God's prohibition, plucks the fruit, eats it, and gives some of it to Adam. "Then the eyes of both were open," the narrative continues, "and they knew that they were naked; and they sewed fig leaves together and made themselves aprons." Gauguin has been faithful to the text, after his fashion. The fruit of the Tree of Knowledge is replaced by a flower (let us call it, as one critic did in 1894, a "flower of evil"), and the serpent is rendered as a reptile, perhaps because there are no snakes native to Tahiti, or equally plausibly, because Gauguin wished to reference Rembrandt's etching of *Adam and Eve* (1638, B.28, I). The latter work similarly represents the serpent as a reptile, a rare substitution itself likely inspired by Dürer's monstrous creature in the engraving – which Rembrandt owned – of *The Harrowing of Hell* (a.k.a. *Christ in Limbo*, 1512, B.16)[8].

Gauguin however, makes some telling adjustments to his art-historical and biblical source material; these serve to undermine Eve's feminine identity. Gauguin's nude is in fact a composite of Rembrandt's Adam and Eve. Like the Dutch master's Eve, she is hirsute and unadorned with loincloth; like his Adam, she enacts a complex drama with her hands, reaching out with one to grasp the forbidden fruit/flower and fending off temptation with the other. Those hands reveal that Eve is not the venal and ignorant instrument of Adam's tragic fault, but that she is herself a strong, if conflicted subject. This interpretation is strengthened by a sentence Gauguin inscribed – in creole – on the upper margin of a drawing with the same subject and similar composition made two years later in Paris: "Pas écouter li / li menteur" – "Don't listen to him / him liar," or else "I won't listen to him / him liar." (In standard French, the lines would be: "Ne l'écouté pas / c'est un menteur," or "Ne l'écoutez pas / il est menteur.") The sentence is completely extra-biblical, and likely derives from a line in the widely known and often performed *Mystère d'Adam*, a Christmas play from the late twelfth century that the artist may have seen performed in Pont-Aven. In the play, the stolid Adam admonishes his handsome farmwife not to listen to the serpent's temptations: "Ne creire jà le traitor! Il est traitre, bien le sai" (Don't you listen to him, he is a liar! I know all about him").[9] Adam, of course, is absent from Gauguin's drawing and painting; Eve must play both roles.

Eve's hermaphroditism – her strange marriage of male agency and female vulnerability – extends still further. She is shown completely naked, with her legs slightly parted and her pubic hair in full view. The complex interplay of tree limbs and human arms suggests an erotic coupling – the uterine-shaped tree notch has been, or soon will be penetrated by an extended limb or *membre*. Eve and the winged reptile growing from her shoulder conduct a flirtation, and the latter has a particularly long tail, the Tahitian name for which – *aero* – also means penis.

Not only the oppositions of male and female, but also those of mortal sin and pleasure are collapsed in Gauguin's picture. Eve is shown to have suffered no punishment and experienced no shame from having tasted the forbidden fruit. "She is Eve after the Fall," Gauguin wrote, "still able to go about unclothed without being immodest, still with as much animal beauty as on the first day."[10] The inscription on Gauguin's later drawing of the same subject – "Pas écouter li / li menteur" – may then also be Gauguin's own advice to Eve, and his rebuke of God. But Gauguin has not only sought to recombine woman with man, and mankind with God; he has also done something like the reverse, exposed monstrousness in beauty, and animality in the human.

4. The Tahitian Woman of Today

Although Gauguin's 1894 exhibition at Durand-Ruel attracted considerable press attention, only two critics spoke at any length about *Te nave nave fenua*. One recognized it as representing Eve in the Garden of Eden. The other tried to place it in a tradition of exoticist painting. "Why has the artist so far forgotten himself," wrote Thiébault-Sisson with evident perplexity, "as to see in the Tahitian woman of today, as in the Tahitian woman of old, only a female quadrumane."[11] Teha'amana's large hands and feet – the left foot has seven toes – prompted the critic to compare her to a "quadrumane," that is, a simian with feet adapted for use as hands. She has been judged atavistic, recalling Degas's notorious *Little Dancer of Fourteen Years* (Mellon Collection, Upperville, Virginia) of 1881. Much admired by Gauguin, the sculpture was described by one critic as "a monkey, an Aztec, [and] a puny specimen," and by another as "a young monster…[who belongs] in a museum of zoology, anthropology or physiology."[12]

In celebrating the animal in Teha'amana, Gauguin was at the same time, however, making an argument for recognition of her full, human subjectivity. Gauguin later wrote: "The feet of a quadrumane! So be it. Like Eve, the body is still an animal thing. But the head has progressed with evolution, the thinking has acquired subtlety, love has imprinted an ironic smile on the lips, and naïvely she searches for the 'why' of times past and present." Gauguin's dialectic – the instinctual and the cerebral – anticipates that of the Surrealist Georges Bataille. In the latter's essay entitled "The Big Toe," first published in *Documents* 6 (November 1929), he writes:

> The big toe is the most *human part of the human* body in the sense that no other element of the body is as differentiated from the corresponding element of the anthropoid ape (chimpanzee, gorilla, orangutan, or gibbon). This is due to the fact that the ape is tree dwelling, whereas man moves on the earth without clinging to branches, having himself become a tree, in other words, raising himself straight in the air like a tree, and all the more beautiful for the correctness of his erection. In addition, the function of the human foot consists in giving a firm foundation to the erection of which man is so proud (the big toe, ceasing to grasp branches, is applied to the ground on the same plane as the other toes).[13]

Yet even as the big toe provides "a firm foundation" it is also an unholy anchor, weighing humans down to earth, tying them to mud and ordure (what Bataille called "heterogenous matter"), and preventing their ascent to

37 PAUL GAUGUIN, Aita tamari vahine Judith te parari
(The Child–Woman Judith Is Not Yet Breached, also known as Annah the Javanese), 1893

heaven. Thus we rage at our feet, deform them, disfigure them, hide them, reveal them, laugh at them and desire them fetishistically all at once. "The play of fantasies and fears," Bataille writes, "of human necessities and aberrations, is in fact such that fingers have come to signify useful action and firm character, the toes stupor and base idiocy."[14] The foot for Bataille, as for Gauguin, was a revolutionary symbol precisely because it represented base materialism, emancipation from the tyranny of the superego, the ideal and the world of sublimation. For both men, fetishism was a weapon in the struggle against idealism, alienation, or non-identity.

Gauguin emphasizes bare feet in many works from Brittany and Tahiti, including *Vision After the Sermon* (1889, National Gallery of Scotland, Edinburgh), *Children Wrestling* (1888, Josefowitz Collection), *Aita tamari vahine Judith te parari* (*The Child-Woman Judith Is Not Yet Breached*, also known as *Annah the Javanese*, 37),*Vairaoumati tei oa* (*Her Name Is Vairaoumati*, 1892, Pushkin Museum, Moscow) and of course, *Te nave nave fenua*. (It also appears that Gauguin had a foot fetish, at least according to

his Vietnamese friend Nguyen van Cam, who described the artist's great erotic attraction to a homely Marquesan woman with a club foot.[15]) And in further anticipation of Bataille's dialectics, Gauguin pairs attention to feet with attention to hands, those bourgeois symbols of "useful action and firm character," those rational instruments of non-identity.

Less than a year after painting *Te nave nave fenua*, Gauguin revisited some of its themes, but this time through the medium of woodblock printing. Created in the winter of 1893-94, in the course of the artist's nearly two-year-long hiatus in France, the woodcut called *Nave nave fenua* in many ways reprises his painting of approximately the same title, though a number of differences may be observed (38). Most significant for our purposes is Gauguin's excision of his model's extra toes, and his new attention to her fingers. The figure in the woodcut *Nave nave fenua* holds a small forked branch in her right hand as she grasps the blossom of a spindly plant with her left. Here, she is neither performing a dance nor gesticulating to the evil lizard; she is instead engaged in agricultural work.

The work she is doing is sometimes called "marrying the vanilla." Vanilla vines – from which come vanilla beans and vanilla extract – were planted in great quantities in Tahiti in the nineteenth century and became one of the chief bases for the French plantation system. The plant is hermaphroditic, with the stamen and pistol separated by a small membrane, preventing self-pollination. In the South American tropics, where vanilla is native, it is pollinated by one particular species of hummingbird, flitting from plant to plant while it laps nectar; in the Pacific however, this bird is absent, and it requires artificial insemination.[16] Tahitian plantation managers therefore hired young Tahitian men and women to hand-fertilize each plant by means of a small forked stick which could effectively carry the pollen from plant stamen to plant pistil. The work is painstaking, repetitive and poorly paid. The woman in *Nave nave fenua* is holding such a forked stick and engaged in this very labor. (The identification of her activity was first made by a travel writer in the 1930s, but has been overlooked in the art historical literature.[17]) Modernity – in the form of alienated hand labor – thus intrudes upon the Tahitian idyll. Neither exotic Eve nor timeless primitive, the figure in the woodcut is a modern colonial subject in a French plantation. Her identity, like that of white men and artists in the tropics and the metropolis is fractured, her "activity," to recall Marx, "for what is life other than activity…is turned against [her] and neither depends on nor belongs to [her]."

In Gauguin's painting no less than his print, non-identity is averred. The artist's undermining of the primary sense of the Genesis narrative, inversion of sexual convention, celebration of the bestial at the expense of

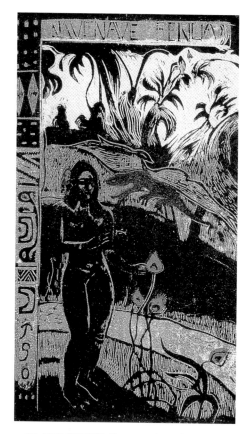

38 PAUL GAUGUIN, Nave nave fenua (Land of Sensual Pleasures), 1893-94

39 PAUL GAUGUIN, Aha oe feii? (What! Are You Jealous?), 1892

the human, and overall ironic stance places the work in a modern tradition
that includes painters such as Degas and writers like Bataille. But Gauguin's
painting also anticipates some strategies found in Brecht. Like the latter,
Gauguin had a preference for "third-person acting," that is, for having his
protagonists play parts or speak lines – consider *Aha oe feii? (What! Are
You Jealous?* 39) – as if they were placed in italics, or squeezed between
quotation marks. The many self-quotations and intertexts in *Te nave nave
fenua* – *Exotic Eve, Ia orana Maria*, the relief at Borubadur, the *Mystère
d'Adam*, Rembrandt, Dürer and Degas – constitute a *Verfremdungseffekt*
that served to repel many French critics and spectators, while at the same
time attracting a small core of insurgent allies. Yet in so representing colo-
nial identity as a form of modern non-identity, Gauguin – also like Brecht –

did not entirely foreclose a historical conquest of alienation. The animality of his Eve, polydactyl like a quadrumane, is the sign of her primitive identity. And primitivism is an artistic rhetoric – I have tried elsewhere to suggest – that has radical utopian, as well as affirmative implications.[18] In Gauguin's painting finally, an identity between body and nature, and between hand and labor may be glimpsed. Eve and the vanilla vine she reaches for are hermaphrodites, sexual beings who are complete unto themselves. They are emblems of a prelapsarian, and a post-colonial world – remote from our own – in which *Entäusserung*, non-identity, is finally overcome.

5. Postscript: Art and Labor

This last characterization of Gauguin's painting, as containing intimations of both integral freedom and alienation, is likely to recall the early writings of Georg Lukács – cited at the beginning of this paper – as well as work by the whole generation of social theorists who preceded him, including Tonnies, Weber and Simmel. These scholars all drew upon a distinction, found in Hegel, between "concrete totality" and the "abstract," that is, between a fulfilling, rich, communal life in harmony with nature, and an alienating, impoverished, isolated life in conflict with nature.[19] The contrasting terms popularized by Tonnies in 1888 were *Gemeinschaft* (the organic community) and *Gesellschaft* (the rationalistic society). Like Hegel's distinctions, these too are more metaphysical than sociological, more ideal than material; it was Marx after all, who insisted that Hegel be stood on his feet, and that the theory of Being be given a materialist basis by means of an interpolation of the concepts of wage, labor and capital. In 1907, Georg Lukács wrote a little essay simply titled "Gauguin" and it appears at first glance to be similarly metaphysical.[20] In his very first paragraph, he lays out a typical series of contrasts: between "the modern artist" and "Life," between "individual" and "symbol," and between "a harmonious solution" and a "tragic situation." This Hegelianism is not surprising given the early date of Lukács's essay; though the Hungarian writer was familiar with Marx from his school days, he did not make a thorough study of *Capital* until 1908, and his great and influential study *History and Class Consciousness*, cited earlier, did not appear until 1921. Nevertheless, I would claim that the Gauguin essay marks a significant movement from metaphysics to materialism in Lukács, or from aesthetic individualism to communalism, and that *Te nave nave fenua* in particular functioned as a catalyst. (Here Gauguin supplied the theory, Lukács the practice.)

Lukács's essay drew upon a number of sources, in addition to Hegel. The most immediate of these was Julius Meier-Graefe's *Entwicklungsgeschichte der Modernen Kunst*, published in 1904.[21] Both Lukács and Meier-Graefe's texts engage the Hegelian distinction, already noted, between "Life" and the "tragic situation." The history of modern art, according to this formula, is the history of the successive estrangement of art from the community, religious worship and even from life itself. Just as modern workers were freed from guild restrictions, so modern art was freed from bondage to religion and the royal courts. But the emancipation of art came with a high price. "Art was to be free" Meier-Graefe writes, "– but free from what? The innovators forgot that freedom implies isolation. In her impulsive vehemence, art cast away the elements that made her indispensable to man. The vaster the wide ocean of unbounded aims before her, the more distant was the terra firma which had been her home. She lost her native land." Meier-Graefe continues: "Art today exists only for the few, and these are far from being the most admirable or beneficent of mankind; they seem, indeed, to show all the characteristics of the degenerate. Loftiness of character, or of intelligence, are not essential to the comprehension of art." [22]

Lukács absorbed Meier-Graefe's cultural pessimism (and rejection of aestheticism), and much of this attitude remained with him throughout his life; indeed his later critiques of expressionism would be tainted (perhaps fatally) by degeneration theory. But Lukács resists Meier-Graefe in one crucial respect. He claims that in modern Tahiti, Gauguin discovered the very concrete "terra firma" that Meier-Graefe thought was forever lost to art. And for Lukács the key to that discovery was human labor. In Tahiti, art was understood to be a form of useful labor, and craft labor a form of art. Lukács writes: "The South Seas, thoroughly affirmed the humanity of Gauguin. He had found his place in society, no longer an exotic, luxury item in the hands of amateur collectors, nor a restless anarchist who threatened public safety. A savage (*vedember*) pointed out to him – for the first time in his life – that he could produce what no one else could, that he was a useful human being. Gauguin felt he was useful, they loved him and he was happy." Here Lukács has paraphrased an important passage in Gauguin's diary-novel *Noa Noa* in which the artist describes his friendship with a young native man who frequently came to his house, watched him work. Gauguin wrote:

One day, I put my tools and a piece of wood in his hands; I wanted him to try to carve. Nonplused, he looked at me at first in silence, and then returned the wood and tools to me, saying with complete simplicity

and sincerity that I was not like the others [other whites, that is], that I could do things which other men were incapable of doing, and that I was *useful to others*. I indeed believe Totefu is the first human being in the world who used such words to me. It was the language of a savage or a child, for one must be either one of these – must one not – to imagine that an artist might be *a useful human being*."[23]

Whereas Gauguin had once sought harmony solely "in the realm of art," according to Lukács, now he found it in life. Tahiti was not a dream world where Hegel's "concrete totality" was metaphysically summoned forth, but an actual place in time in which labor and life were integrated. "He became attentive to old legends," Lukács writes of Gauguin, "drawn to the primitive symbols of the natives who believed in them, and to the life of the Tahitians. He did not recoil," Lukács continues, "– as many other painters did – from nude figures in order to achieve a symbolic effect. In one of his letters to Strindberg, Gauguin wrote: 'The Eve I painted (she alone) can, logically, go naked before our eyes.' She is not simply a representation of a naked model."[24]

For Lukács finally, the tragedy of Gauguin is not that he failed to achieve his goal, but rather that in reaching it, he indicated to the rest of us that the solution to our tragic situation may be found only at great cost; it lies in a material transformation of European civilization, not in aestheticism or obeisance to metaphysical systems. "Every artist searches for his own Tahiti," Lukács concludes, "and, other than Gauguin, none have found it, nor are they likely to find it, unless things change so radically that anyone can anywhere conjure up his imaginary Tahiti.... Perfect decorative frescoes as Gauguin's paintings are, there is no architecture that could accommodate his art."

Lukács clearly paints far too rosy a picture of Tahiti, and so does Gauguin. The French plantation system had greatly disrupted the subsistence patterns and communalism of previous decades. Moreover, ancient Tahitian society – fatally undermined just a few decades after the Cook voyages – was highly stratified; its strict division of labor and complex system of taboo and tribute make it an unlikely model for a modern, communal utopia. But Gauguin and Lukács each understood, crucially, how to view the similarities and differences between Tahitians and Europeans – through the sharply focused lens of material life and labor. They did not fully reckon with the complexity of the pre-colonial past, or the colonial present of Tahiti, but they recognized that identity and non-identity – in Tahiti and Europe alike – are material effects of history, effects that artists and critics overlook only at the cost of a debilitating subjectivism.

Carol Ockman

"Who do you think you are, Sarah Bernhardt?" Although scarcely as common in this country as they were forty years ago, phrases like these are still routinely uttered by exasperated caretakers whenever a child, and especially a girl child, is being overly dramatic. How do we understand an icon's ability to socialize children fully seventy-five years after her death?

Linda Nochlin's *Women, Art and Power*, and specifically its title essay, is the starting point for this examination of Bernhardt's staying power as an icon. The essay, based on reflections from 1969 to 1987, pinpoints the real imbalance of power between men and women as it is codified in representation. Taken together with the terms "women" and "art," power, she observes, is most notable for its absence. In a wide-ranging analysis of works from David's *Oath of the Horatii* to Emily Mary Osborne's *Nameless and Friendless*, Nochlin shows how images consistently reproduce assumptions "about men's power over, superiority to, difference from, and necessary control over women." Two of Nochlin's assertions – that "the discourse of power and the code of ladylike behavior can maintain only an unstable relationship" and that woman's independent life outside the home is all too often linked to sexual availability – are especially pertinent to a consideration of nineteenth-century female icons whose visibility in the public realm inevitably compromised notions of respectability.[1]

Without minimizing the difficulties of representing women in positions of power, I want to suggest that theater, one of the few professions open to women, and to all social classes, afforded real possibilities for women's independence and social mobility in the nineteenth century. Sarah Bernhardt, *grande tragédienne*, international star, theater owner and impresario, and model for health and beauty aids, exemplifies the possibilities acting could provide in an age of nascent mass culture. Her embrace of new technologies (photography, posters, phonography) and new forms of popular entertainment (boulevard theater, vaudeville, film) enabled her to reach an ever wider audience as her career unfolded. Not only did she maintain a herculean performing schedule in places as far flung as Waco, Texas and Saint Petersburg, she recorded herself for posterity on film and disc, whose importance for the twentieth century could only have been imagined when she visited Thomas Edison in Menlo Park in 1880 or first graced the silver screen in 1900.[2]

Key to any understanding of Bernhardt and the powerful legacy she has left us is the reproductive function of mass culture itself. The term reproductive is meant to resonate in a variety of ways, from theater's mimetic function to the new technologies of mass production, to the possibilities of embodiment offered by an icon, what Wayne Koestenbaum describes as "your teacher in the art of training your "I" to feel like an "I."[3] Central to all these definitions is the role that the image plays in our ability to recognize an icon. Bernhardt enjoyed an active performing career from the early 1860s to a few days before her death in 1923 as well as a vast afterlife in theater, opera, film, musical comedy, stand-up, and drag performance. Replicated both live on the stage and through mass-produced imagery, her power, like that of any icon, depends on her continuing presence in the visual realm.

Bernhardt made her reputation in the classical theater, training at the Paris Conservatoire and eventually achieving renown as a tragedienne at the Comédie-Française. After being named to the prestigious position of *sociétaire*, Bernhardt broke her contract with the Comédie, first to go on tour with her own company in England and America and then to perform in boulevard theaters upon her return to France. Bernhardt exhibited all the signs of the popular entertainer by the mid-1880s: the display of feminine sexuality, economic and social independence, and the slippage between femininity and masculinity (40). Unlike her contemporaries Loïe Fuller or Yvette Guilbert, for example, Bernhardt used mass culture to bring high art to a popular audience. The arc of her career resembles nothing so much as a slow boomerang, moving from the margins to the center and then out again to the margins at accelerated speed. Her surprising decision to star in cinema when it ranked at the bottom of the heap of popular entertainments vastly increased her visual thrall, as did her stints in vaudeville, at the ages of sixty-seven and seventy-three. How long Bernhardt successfully managed to repeat herself is a matter of opinion. The fact that she managed to keep herself visible is not. Taken together with her long-lived standing as a great French tragedienne and a staggering array of social liabilities, Bernhardt's continuing presence helped to legitimize new forms of popular entertainment as well as the representation of marginal identities.

By definition nineteenth-century actresses lived and worked beyond the boundaries of propriety, whatever their background. Bernhardt's origins and subsequent behavior epitomized negative stereotypes of the figure of the actress in the French nineteenth-century imagination. The daughter and niece of Jewish courtesans and mother of an illegitimate son, she was infamous for her own sexual promiscuity. The stigma attached to women acting, and especially to those whose social origins and behavior confirmed

40 Sarah Bernhardt as Cleopatra, ca.1890

it in any way, may have titillated middle- to upper-class audiences, but it also made certain kinds of recognition virtually impossible. When Sarah Bernhardt was awarded the Légion d'honneur in 1914, at the age of seventy, it was the first awarded to an actress. Bernhardt had previously turned down the honor, offered to her once as theater director and again as professor at the Conservatoire. Likened to de Lesseps on the occasion in which the honor was finally bestowed, Bernhardt's cultural patriotism was evoked in the same breath as the building of the Suez Canal but the belated acknowledgement of her achievements *as an actress* cannot be overlooked.[4] Often reproducing the dichotomies between proper and improper women, the roles actresses played generally reinforced their position as social outcasts. Paradoxically, Bernhardt's performance of immodest heroines, whose final

41 FÉLIX NADAR, Sarah Bernhardt, ca.1864

death rattle served to confirm moral prescriptions of feminine behavior, in no way chastened her behavior off stage. If none of her heroines ended well, Bernhardt herself defied the scripts. In tracing an abbreviated visual lexicon of Bernhardt's career, my aim is to show how she turned her own violation of normative models to her advantage.

Félix Nadar's photographs of circa 1864, taken when Bernhardt was about twenty, are the mythic distillation of her early star quality (41). The artful cascades of drapery convey the dignity and sensuality admired by critics, who felt she transfigured the qualities of the classical tragedienne through her unprecedented emphasis on femininity.[5] And yet Bernhardt had no reputation as an actress when she sat for Nadar. Her debut at the Comédie-Française in 1862 was apparently unremarkable; she did not make a real name for herself until the late 1860s at the Odéon. Our appreciation of Nadar's achievement is in no small part enhanced by our knowledge of who Bernhardt becomes and by our expectation that the best female icon is a young female icon (if not a young, dead female icon, as we will see later). The youthful promise in this group of photographs depends equally, however, on the sitter's presumed sexual availability, inherent in the common conflation of actress, model, and prostitute at the time.

Bernhardt came to be known for romantic interpretations of the classical roles of Racine, notably Phèdre and the romantic repertory of the classical theater, ranging from Victor Hugo to Alexandre Dumas fils. During the years leading up to and including her departure from the Comédie, Bernhardt

became increasingly canny about her presentation of self. She compounded the assault on prescribed femininity by taking up sculpting and painting, and by designing a satin pants suit executed by couturier Frederick Worth for work in the studio. In 1876 she won an honorable mention for *Après la tempête* at the same Salon in which Georges Clairin and Louise Abbéma exhibited portraits of her (42). Clairin's portrait gives form to the central visual tropes of Bernhardt's career: the unfashionably thin body with its serpentine pose, the radical chic of her corsetless gowns, inspired by lingerie, which contributed to the success of *Camille* several years later, the passionate love for wild animals, boas, and furs, identified with the aberrant sexuality attributed to actresses and prostitutes. At the same time, this identification signaled her commitment to the bohemian and aesthetic milieux she shared with Nadar and other artists who recorded her image (43), including that literal Bohemian, Alphonse Mucha, the Art Nouveau poster artist and designer *extraordinaire* transposed from lower Slovenia to Paris.

42 GEORGES CLAIRIN, Sarah Bernhardt, 1876

43 ALPHONSE MUCHA, La dame aux camélias, 1896

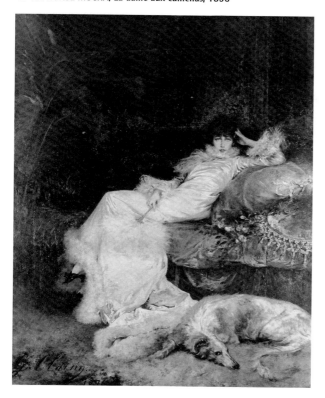

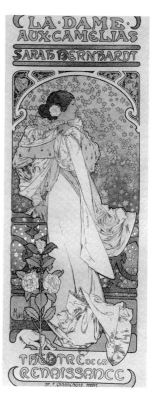

From the early 1870s Bernhardt's womanliness was contrasted to the *terribilità* of her precursor Rachel (1821-1858), who is often credited with reviving tragedy in France. The distinction crystallized over time. In 1879 during Bernhardt's highly acclaimed tour in London, one English critic characterized her as "by far the most feminine Phèdre" he had ever seen. As Adrienne Lecouvreur, he continued, Bernhardt employed every facet of her talent in order to accentuate her femininity: "...the wooing music of her sweet and silvery voice, the winning winding caresses of her lithe arms and slender figure, all the vocabulary of a loving woman's self-surrendering *abandon* in look, voice, and action."[6]

Beginning in the early 1880s, in collaboration with the playwright Victorien Sardou, Bernhardt introduced a series of melodramas, including *Théodora, Tosca, Cléopatra*, and *La sorcière* (see 40). These texts were constructed to put Bernhardt in situations that maximized her femininity. When she realized that this sensuous style constituted her uniqueness, Bernhardt, successful actress and entrepreneur that she was, simply turned up the juice. Writing at the time Bernhardt first presented Sardou's *Théodora* and *Cléopatra* to US audiences, a reporter for the *New York Times* observed that "good folk regarded her art as something forbidden, an alien evil. Young people did not tell their parents when they went to see her as Cleopatra....That scene in which the Serpent of Old Nile drew her coils round the throne of Marc Anthony, circling ever nearer with the venom of her wiles, was a revelation of things scarcely to be whispered...."[7]

The photograph of Bernhardt in her coffin of about 1880, formerly attributed to Melandri but now given to an anonymous artist, most resonantly captures her new freedom from a conventionally feminine script (44). Bernhardt must have had an uncanny relationship to death. Her very living depended on it. Her talent for dying was so marked that by the early 1880s a final agony was practically mandatory. For sixty years, she died nightly, and sometimes twice a day, as different heroines, and an occasional hero. In the photograph she staged death much as she did in the theaters. If we are to believe her memoirs, at home it was much the same. After a fire devastated her earlier residence, she describes her new apartment thus: "In front of the window was my coffin, in which I installed myself to learn my roles. When my sister came to live with me, I found it natural to sleep in this little bed of white satin that would be my last resting place."[8] People who knew her frequently mention that she always traveled with her art collection, including Clairin's 8" x 6" oil portrait of her, and her coffin. Small wonder that one of the most enduring myths about Bernhardt is that she slept in a coffin.

The photograph simultaneously conjures up the performance of death and her real death. As the popularity of images like John Everett Millais's

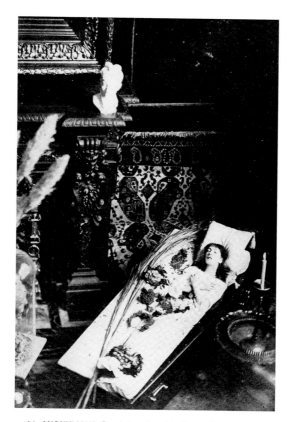

44 ANONYMOUS, Sarah Bernhardt in her coffin, ca. 1880

Ophelia (1850-51, Tate Gallery, London) suggests, death as the ideal state of submissive womanhood was such a staple of a masculine imagination during this period that many could barely look at a sleeping woman without seeing her as virtuously dead. By enacting death for consumption, Bernhardt gave voice again and again to cultural tropes about the achievement of transcendent spiritual value through female sacrifice.[9] The photograph short-circuits those associations: Bernhardt, of course, is not dead. She is a beautiful, still youthful woman feigning death. To heighten the parody, Bernhardt includes the bust she made of painter Louise Abbéma, like Bernhardt an artist struggling against prescriptive assumptions about women. Their friendship, which lasted until the actress's death, was the subject of gossip in those years.[10] The fact that the best known image to address the artist's eventual demise was fabricated and marketed by Bern-

hardt before she had even reached the midpoint of her life (she was about thirty-five) does more than proclaim her savvy self-promotional skills. The photograph also suggests that she herself fell victim to the cult of invalidism and early death that marked the ideal of bourgeois womanhood in the nineteenth century. She had cared for her younger sister and watched her die at the age of eighteen. Repeated references in Bernhardt's memoirs to her own suffering from what appeared to be tuberculosis and neurasthenia foretell a similar fate. The actress's new freedom from the Comédie-Française in the wake of her resignation in 1880, and the immediate success of her company abroad, had the effect of releasing her from societal expectations that she would die young.

Within months of her departure from the Comédie, Bernhardt embarked on her first tour of America, a seven-month journey during which she gave 156 performances in 50 cities. In what she clearly intended as the first volume of her memoirs, published in 1907, she concludes with a description of her triumphant return to France in the wake of her "great voyage." The last page of the 440-page tome ends on an elated, death-defying note: "I conclude the first volume of my souvenirs here, for this is really the first halting-place of my life, the real starting-point of my physical and moral being." After acknowledging the importance of her American sojourn in shaping her thought, she concludes:

> My life, which I thought at first was to be so short, seemed now likely to be very, very long, and that gave me a great mischievous delight when I thought of the infernal displeasure of my enemies. I resolved to live. I resolved to be the great artiste that I longed to be. And from the time of this return I gave myself entirely up to my life.[11]

Hindsight, more than prescience, shapes this particular farewell speech, in as much as Bernhardt was already sixty-three when the memoirs were published. Still, she could not have known that she would go on dying for another sixteen years.

If I am inclined to give some credence to Bernhardt's dramatic textual finale, it is because of timing. It was only after her triumph abroad that she took to the boulevard, adding melodramas, each with a death scene, written expressly for her by Sardou or another playwright, to her classical and romantic repertory. At the same time, she assumed control of the Théâtre de l'Ambigu, then became a partner in the Porte Saint Martin, went on to buy the Théâtre de la Renaissance and finally the Théâtre des Nations, which she renamed the Théâtre Sarah Bernhardt, now the Théâtre de la Ville. Her successful American tour and the greater ease of travelling by railroad and

steam engine enabled an international career of unprecedented proportions. And once she opened her arms to boulevard theater, she opened them to the newest manifestations of popular entertainment. In 1908 she first starred in cinematic treatments of her theater productions, including *La dame aux camélias*, in 1910 in British music-hall in *L'aiglon*, in 1912 in American vaudeville, with a series of one-acts from her plays.

Bernhardt's vast afterlife owes much to her ability to embody the classical theater for a popular audience. That ability is suggestive in terms of popular entertainment's capacity to accommodate elements marginalized by dominant discourses and in terms of the growing power popular entertainment wields. Like mass culture itself, Bernhardt depended upon an economy of repetition and reproduction, which was only enhanced by her longevity (she died at the age of seventy-nine). As one of her US reviewers put it: "Year after year Victorien Sardou turned out a new vehicle for her talent, as they turn out motor-cars, all on the same main lines, but each year's 'model' a slight mechanical improvement on the last."[12]

Far more important than what technology made possible is Bernhardt's *desire* for reproduction. She used photographs for publicity on a scale never seen before. From 1895 to 1900 Mucha was under contract to make the color lithographs advertising her performances in the poster format which stood at the intersection of bohemia and the entertainment business. For its detractors, the poster was a form of prostitution, accosting passersby in the street, garish, shameless, and complicit in what Maurice Talmeyr in 1896 described as the "total abolition of maidenly modesty," plaguing contemporary society. In the eyes of many, Bernhardt was an exalted *cherette*, at once prostitute and threatening figure of upward mobility. The poster's insistent display of the female body as advertising paralleled Bernhardt's bohemian strategies for flaunting the unconventionality she cultivated (45). Whether it was to promote her own productions or the sale of face powder, she instrumentally used the identification of woman as mass culture.[13]

Nor did Bernhardt limit herself strictly to the reproduction of her image. During her first farewell tour to America in 1880 (speaking of reproduction, I might add that there were nine farewell tours in America in all), she made a detour to Menlo Park, New Jersey to visit Thomas Alva Edison. Eventually she had her voice recorded. Bernhardt's decision to star in films was completely consistent with this desire to disseminate her image as broadly as possible.

Bernhardt's indomitable replication of self, together with her eminently imitable theatricality ensured, if not immortality, an impressively long run of life after death. Given the popularity of Ibsen in the early twentieth century, Bernhardt was often perceived as old fashioned by the time she did

film and vaudeville. Her importance has further been obscured by the tendency to compartmentalize her status as a classical actress. It is precisely the combination of histrionic style, outmodedness and insistent repetition, however, that made her such a wonderful comic foil and camp figure, and continues to do so.

Bernhardt had a profound effect on representations of female ethnicity and sexuality in popular theater and film from Fanny Brice to Sandra Bernhard, from Mae West to Madonna. When, in 1917, the great comic Fanny Brice sang a number called "I'm Bad," poking fun at then fashionable vamp Theda Bara, she was also taking a shot at Bernhardt (see 40). Both starred as Cleopatra in that year, Bara in film, Bernhardt in vaudeville. Similarly, when Bobby Vernon, one of the original keystone cops, spoofs Bara, he probably is also spoofing Bernhardt. When we add Bernhardt's emphasis on a sexual attractiveness that goes against the grain of one's sex to the gestural and emotive extravagance of her performances, it is hardly surprising that she was an enormously popular figure for impersonators. [14] Beginning in the 1880s and 1890s, some of the most distinguished names in popular entertainment impersonated Bernhardt (46). Francis Leon, who performed with Haverley's minstrels in the US, had so many imitators himself, he copyrighted his stage name as "The Only Leon." British born Marie Lloyd whom T.S. Eliot dubbed "the greatest music-hall artist of her time," impersonated Bernhardt in the role of the Indian princess Izeïl. In 1973 Charles Ludlam, one of the most distinguished recent Bernhardt impersonators, debuted in the title role of *Camille* in the Ridiculous Theater Company's production in New York.

Bernhardt herself skyrocketed to fame in 1868 at the Odéon where she played the role of a Florentine troubadour in François Coppée's *Le passant*. That she had a certain ironic relationship to her own transvestism is suggested by an undated photograph in which both Bernhardt and her friend Robert de Montesquieu are costumed off set as Zanetto. With headlines like "Bernhardt Soon To Turn Man," the press lampooned Bernhardt's penchant for breeches' roles late in her career, which is likely only to have increased her own delight in exceeding conventions.[15] She debuted as Hamlet in Paris in 1899 at the age of fifty-five and as the Duke of Reichstadt, the youthful heir to Napoleon, in Rostand's *L'aiglon* the following year (47). There is no doubt that Bernhardt's roles encouraged the performance of androgyny among a variety of players, both privately and publicly.[16] Although vaudeville declined in the 1920s, impersonation lived on in the legitimate theater and in Hollywood film. Eva Le Galliene revived *L'aiglon* on Broadway and Judy Garland briefly impersonates Bernhardt as the little eaglet in *Babes in Broadway* of 1941. If Bernhardt's classical status helped legitimized

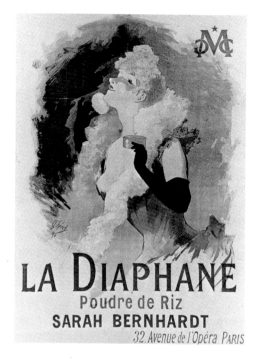

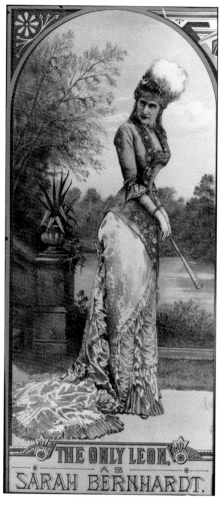

45 JULES CHÉRET, La Diaphane, 1890

46 Francis Leon as Sarah Bernhardt

androgyny and cross-dressing in more mainstream entertainment, affording performers such as Le Galliene and Garland a model that was not ludicrous, it also helped validate vaudeville and film. Bernhardt's example seems to have given a boost to immigrants intent on assimilation like Irish-born Francis Glasser – the only Leon (46) – or Theodosia Goodman, aka Theda Bara. Bernhardt's high-art status, particularly pronounced in the US because she was French, enables other performers to move from the margins to the center.

In 1997 Deborah Kass painted a multiple portrait of Linda Nochlin entitled *Orange Disaster (Linda Nochlin).* The portrait is part of "The Warhol

Project" the artist kicked off with the *Jewish Jackie* series (1995), depicting Barbra Streisand either singly or repeatedly in profile. By purposely choosing sitters who point to the absences in Warhol's roster of icons, Kass expands the canon in ways that Nochlin has taught us more powerfully than anyone of her generation. Kass's Warholian homages to figures, ranging from Streisand to Gertrude Stein to Robert Rosenblum to her own grandmother, put the artist and her heroes in the public realm that Warhol acknowledged and inhabited. Among the works in "The Warhol Project," *Orange Disaster (Linda Nochlin)* is unique in its reliance on an extant Warhol painting that is not portraiture, namely *Orange Car Crash* of 1963 in the Wallraf-Richartz Collection in Cologne. The huge format, about 3 x 3.8 m, approximates the dimensions of the Warhol prototype as does the color pairing. Rare in Warhol's work, the screamingly dissonant orange and fuchsia suit the sitter in Kass's view. The artist has used more paradigmatic color pairings, such as turquoise and black, for subsequent smaller versions of *Orange Disaster*, but anyone who knows Nochlin would have to second Kass's original choice. The power of the image is only enhanced by the substitution of fourteen car wrecks for ten double portraits. Comparing an eminent art historian, even one as refreshingly philistine as Linda Nochlin, to serial car wrecks, seems humorous, almost glib, at first, but it, too, is deadly serious.

In a way Kass does for Nochlin what Bernhardt did for herself in staging the anonymous coffin photo. While both images couple the sitter with death, each denies literal death in favor of a metaphorical invocation that functions rather to signal a new kind of life. By envisioning herself as dead, Bernhardt parodies respectable bourgeois ideals equating womanhood with invalidism, all the while paying paradoxical homage to the fact that dying nightly on stage enables her to live, in both the sense of making a living and of living in the public imagination. By replacing car wrecks with multiple portraits of Nochlin, Kass's *Orange Disaster* depicts a seemingly benign Nochlin who nevertheless functions as a kind of orange terror. Much like the image of Bernhardt in her coffin, *Orange Disaster (Linda Nochlin)* turns death into a sustained, if radical assertion of life. These images and the women they represent give the lie to assumptions "about men's power over, superiority to, difference from, and necessary control over women."[17] All rewrite a conventional script in ways that serve as models for those who have been made to feel powerless. And they do so in the public realm where women's independence has long been equated with, indeed reduced to, sexual availability.

When asked about the source for Nochlin's portrait, Kass responded: "[Linda Nochlin] dropped the bomb. She changed everything that came

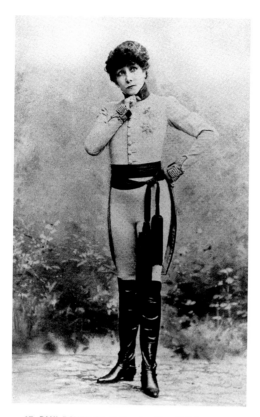

47 PAUL BOYER, Sarah Bernhardt as L'aiglon, 1900

before and everything that came after. She made people ask the right questions. She changed the discourse. She was our liberation."[18] That was certainly my experience when I took Linda Nochlin's third course on "Women and Art" in the summer of 1971 at Stanford and read "Why Have There Been No Great Women Artists?" six months after it was originally published. I remember where I was in physical space when it crossed my mind for the very first time, in the way that life-changing experiences often do, that I might actually become a college professor. As she has for countless others, Linda Nochlin has been my teacher in the art of training my "I" to feel like an "I." Much as Bernhardt did, Nochlin "…changed the discourse," opening a profession and its practice to those who might not have imagined themselves as participants. Icons and power, margins and center, are inconceivable without her.

48 ROGER DE LA FRESNAYE, The Conquest of the Air, 1913

A simple story: two young men are seated at a table, out of doors, in conversation. They are visually linked to nearby and distant landscape elements (including the pitched roofs of a village) by Cubist means; elements of Cézanne-derived "passage" open up parts of the figures to their surroundings and the rhyming of geometric volumes and planes, including several shadowed areas, locks the protagonists into a mosaic of ochers, burnt siennas, greens and grays. This triangular mass of warm-hued figures-and-ground anchors the image to the lower left corner of the picture. It also serves as a counterweight to the cool blues and the whites of the painting's aerated background. There we find, from the lower right, a sailboat gliding by on a river or lake, an enormous French flag, *le drapeau tricolore*, waving in the breeze in front of a cluster of nearly spherical clouds, and, at the upper left, a tiny, ocher-colored hot-air balloon. [1]

The Heroism of Understatement: the Ideological
Machinery of La Fresnaye's Conquest of the Air

Kenneth E. Silver

It was in Paris in the mid-1970s that Linda Nochlin and I met at the apartment of a mutual friend. While it is true that, unlike Roger de la Fresnaye's
1913 La conquête de l'air (The Conquest of the Air, 48), *there were neither sailboats nor hot-air balloons in the vicinity, nor a tricolore in sight, it was nonetheless under the sign of a shared francophilia that, as we talked long into the night, our friendship began. Our dialogue flourished in Poughkeepsie, where I joined Linda in the art department at Vassar; and, for many years now, we have had the good fortune to continue our friendship, and to continue talking, in New York. As it is with the best friendships, I have a sense with Linda of always being in* medias res, *in the midst of a master dialogue - an ur conversation, a primal schmooze - to which we always return. Accordingly, in the paper that follows, I would like to continue our dialogue by elaborating upon Linda's comments on Picasso's use of the tricolore motif, and extending it to a discussion of La Fresnaye's painting.*

By way of preface, I should say that it was unquestionably Linda Nochlin's example - her combining of art history and feminism, the mixture of which she helped invent - which has allowed me in a few instances to combine my art-historical training with my other training, the hard-knocks school-of-life curriculum, to enunciate male homosexuality as a key element in some important twentieth-century works. Indeed, I wish I could say that I have an illuminating "queer" reading to offer of La Fresnaye's Salon-sized oil painting, which belongs to the Museum of Modern Art, or that the The Conquest of the Air is somehow informed by La Fresnaye's relationship to Jean-Louis Gampert, his "significant other." Gampert was a decorative artist who designed the wallpaper and drapes for the Maison Cubiste in 1912, whose brilliantly colored coussins *had been favorably reviewed the previous year by none other than leading Parisian critic Louis Vauxcelles: "Pure indigos, intense oranges glow on the fabrics and the astonishingly successful pillows - a spiritually rejuvenated Louis-Philippe - by Gampert."[2] Alas, cushions, upholstery fabric, and homosexuality will get us, as far as I can tell, nowhere in particular with* The Conquest of the Air, *although a consideration of another kind of male bonding - the fraternal one - will be relevant to my reading of the picture.*

In as much as the French flag, the *tricolore*, is the most obvious parergal element of La Fresnaye's painting, the "Tricolorism" section of Linda Nochlin's "Picasso's Color: Schemes and Gambits" – which appeared in *Art in America* in December 1980 – is a useful starting point for my comments (as well as being one of my favorite passages in the Nochlin oeuvre). She is discussing Picasso's pastel *Dancing Couple* (Musée Picasso, Paris), of 1921-22:

> On first glance, it is hard to fathom what Picasso is getting at with this melancholy, lumpish pair. The general configuration seems to owe as much to the *image d'Epinal* or the popular poster as to the sophisticated monumentality of Picasso's current Neo-Classical style. The theme itself, and the composition, seemed to hark back to Courbet's so-called *Lovers in the Country*, recently redubbed *La valse*, and of course to works by Renoir featuring dancing couples – *Bal à Bougival*, for example.
>
> But on second glance, the patriotic motif asserts itself: the man wears bright blue; his head is haloed with a chalky powder-blue. He clasps his partner around the waist, protecting her dress with his crumpled handkerchief, as a proper young man would at a *bal*. She wears a white dress, reminiscent of classical drapery in its simplicity and fluted pleats. On her head is a wonderful, squashy, acid-red orange hat – a contemporary Phrygian bonnet. She turns her classical profile to the left. Presto! It is La République herself, Marianne, La France – with a profile strangely reminiscent of Picasso's – embraced by a solemn representative of *le peuple*. Whether or not it was Delacroix's Liberty that Picasso had in mind, or one of the innumerable variants on the popular allegorical figure of French nationhood, there is no doubt about the specifically French implications of his tricolor color scheme here." [3]

Nochlin did not simply grab her "nationalistic" reading from thin air, like some agile rabbit out of a "squashy" hat, but in full knowledge of the kinds of patriotic, tricolore images that Picasso had produced during the Great War, and of his more ironic, playful, Cubist ones of the prewar years. In these works, the tricolore appears by way of an abstracted fragment of the cover of a Michelin company brochure, "Notre avenir est dans l'air" (Our Future Is in the Air), a compilation of quotes from army officers advocating the development of aviation for French national defense. The tricolor, in this context, Nochlin wrote, functioned "as the signifier of French identity and modern progress," as well as noting that the brochure also signified in Picasso's works a more particular future in play, for both Cubism and modern art in general. We know that Picasso familiarly referred to Georges Braque as "Wilbur," [4] a reference to the American Wright Brothers, inventors

of the first heavier than air, navigable flying machine, and that it was in France, international center of aviation, that Wilbur Wright demonstrated the first airplane in 1908-9. She concludes: "...Picasso's inclusion of the blue-white-and-red propaganda leaflet cover may have had not merely the general implication of France as the country of progress, but the more specific one of France as the country of his and Braque's aviation-like daring in art." [5]

The joking references to the Wright Brothers and to pioneering aviation were but two elements of a larger project for Picasso and Braque: the "depersonalization" of the act of painting, manifest in the rapprochement of their difficult, hermetic, grisaille-toned Cubist canvases of circa 1910-11.[6] Daniel-Henry Kahnweiler claimed that Picasso and Braque's suppression of signatures on many of these works was "a deliberate gesture towards impersonal authorhsip";[7] Françoise Gilot recalled Picasso saying: "People didn't understand very well at the time why very often we didn't sign our canvases. Most of those that are signed we signed years later. It was because we felt the temptation, the hope, of an anonymous art, not in its expression but in its point of departure. We were trying to set up a new order and it had to express itself through different individuals. Nobody needed to know that it was so-and-so who had done this or that paint- ing.... As soon as we saw that the collective adventure was a lost cause, each one of us had to find an individual adventure."[8] Braque, likewise, looked back upon the decision to refrain from signing their paintings, at least for a brief period, as an effort in the direction of impersonal author- ship: "Picasso and I were engaged in what we felt was a search for the anonymous personality. We were prepared to efface our personalities in order to find originality."[9]

Picasso and Braque's search for an "anonymous" art – for a new order of vision that would transcend the personal, for a collective "originality" that was utopian in a specifically modern way – was more deeply allied to the signifying power of the Wright Brothers experimental flights in France than affectionate nicknames and textual, punning references might lead us to believe. Because, despite the continued allure that a lone, innovating genius might exert – whether a Bell, or an Edison, or a Marconi – by the turn of the century there was, in place, a highly visible, alternate model of technologi- cal innovation, a hyper-trophied one, a "doubled paradigm" of originality: the partnership. This could take the form of the husband-and-wife team, the most illustrious of which was, of course, the Curies, Marie and Pierre, who discovered Radium in 1897, and for which they were awarded the Nobel Prize in 1903. More often, though, and with a consistency that seems to defy the law of averages, it took the form of *brother*-inventors, as for

L'AVIATION PAR L'IMAGE

UN VOL DE WILBUR WRIGHT A PAU *Offert par les* Produits Nyrdahl

Wilbur et Orville Wright sont nés à Dayton, aux États-Unis, le premier, le 16 avril 1867, le second, le 16 août 1871. D'abord simples constructeurs de cycles, ils s'orientent en 1900 vers l'aviation. Après avoir multiplié jusqu'en 1902 les expériences de vol plané, ils fixent un moteur sur leur appareil, et réussissent, le 17 décembre 1903, un vol de 260 mètres, le premier qui ait été exécuté depuis celui d'Ader. Puis ils se perfectionnèrent jusqu'à voler 38 minutes en 1905.

En 1908, Wilbur Wright vient en France pour y accomplir les expériences exigées par le syndicat Weiller, pour l'achat de son appareil, au prix de 500.000 fr. Il y exécute ses vols fameux qui portèrent le record du monde, le 31 décembre 1908, à 121 km. 700, parcourus en 2 h. 23 s.

Ce record ne devait être battu que huit mois après, le 7 août 1909, par l'aviateur Sommer.

49 Postcard, L'aviation par l'image: Un vol de Wilbur Wright à Pau

50 Postcard, Biplan des frères Albert et Emile Bonnet-Labranche

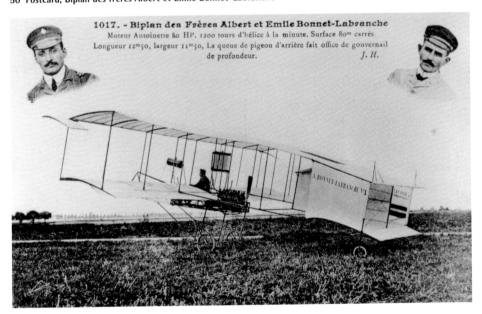

1017. - Biplan des Frères Albert et Emile Bonnet-Labranche
Moteur Antoinette 80 HP. 1200 tours d'hélice à la minute. Surface 80ᵐ carrés
Longueur 12ᵐ50, largeur 11ᵐ50, La queue de pigeon d'arrière fait office de gouvernail
de profondeur. *J. H.*

51 Postcard, Les frères Voisin

example the *frères* Lumière, inventors of the motion picture camera. Along-side the American Wright Brothers, were their French coevals, the pioneering brother-aviators, the Voisin Brothers, as well as the equally renowned Bonnet-Labranche brother-aviators (49–51). Even when there is no familial relationship, the history of aviation in France was repeatedly pictured as one of partnership, as for instance that of aviators Latham and Levavasseur, or of Moissant and his mechanic. Either by accident, or by way of some curious "copy-cat" phenomenon that has managed to escape the analytical gaze of cultural historians, technological avant-gardism by the turn of the century had taken an exponential leap beyond the individual. The amplitude of modernity, it seemed, required something bigger than the isolated talent – at the very least, something *twice* as big.[10]

In this context, we might say not only that Picasso and Braque's search for a transcendent, supra-personal aesthetic was culturally over-determined, but that so is the motif of the two "conversationalists" in the lower left foreground of La Fresnaye's *The Conquest of the Air* – following the lead of the picture's title, we assume, as most commentators have, that they are discussing aviation. In fact, based on four studies by La Fresnaye which survive, it is clear that the artist only gradually worked his way towards his aviation theme and its concomitant pairing of the protagonists. Although we can only make an approximate guess at their order, these comprise one oil

sketch and one pen-and-ink drawing of three protagonists, unaccompanied by balloon, sailboat, or tricolore; a gouache with three men, a balloon, a tricolore, and no sailboat; and another oil study, closest of the three to the final painting, with the talking pair, two sailboats, the tricolore, and no balloon. Somewhere in the working process, a single sailboat replaced the two, the balloon was definitively put in place, and the picture acquired its title. [11]

About the painting's title: the phrase "La conquête de l'air" was boilerplate for a work about aviation. Whether rendered in English or French, by the early years of the twentieth century "The Conquest of the Air" was probably the single most invoked catch-phrase for books, articles, or images about modern flight. Any library shelf in New York or Paris devoted to aviation will have numerous works with the same title. La Fresnaye knew that his title, whatever else it might imply, would refer to aeronautics. Yet, unlike Picasso, whose use of a popular phrase in the context of a fragment of visual ephemera allowed him to play perceptual and linguistic games with popular culture, La Fresnaye's pairing of picture and title are normative, if slightly elusive. The painting's lack, apart from its title, of a real-world referent to contemporary aviation – either the kind of metonymic sign provided by Picasso's Michelin Company brochure, or the image of an airplane of any kind – is the first indication that there is a curious disjunction at work. Guillaume Apollinaire, who rightly thought that *Conquest of the Air* was La Fresnaye's masterpiece, noted in his review of the 1913 Salon d'Automne that M. Bérard, Undersecretary of State for the Fine Arts, during his tour of the show stopped at length in front of the picture and "asked for explanations."[12] Was Bérard wondering why a painting titled *Conquête de l'air*, which ostentatiously waved the tricolore at the spectator, was so obviously devoid of pictorial evidence of France's very real, recent achievements in aviation? The next year, for instance, at the Salon des Indépendants, Bérard could have seen Robert Delaunay's Orphist *Homage to Blériot* (1914, Musée du Grenoble), with careful rendering, in the upper right, of the biplane in which Louis Blériot, on 25 July 1909, became the first man to fly across the English Channel.[13] In fact, newspaper photos of Blériot almost always included the tricolore, provided as a prop by a clever journalist from *Le matin* as soon as the Frenchman landed near Dover Castle on his epoch-making flight.[14]

This propagandistic linking of French patriotism and aviation is in no way surprising; technology and nationhood have been inextricably bound together throughout the modern period, as evidenced by, among other things, the role which they have played in tandem at various World Fairs for the last century and a half. More specifically, as Robert Wohl has so amply demonstrated, France identified herself and was identified by the

rest of the world as the "winged nation" par excellence: aside from her celebrated aviators like Blériot, and the Voisins, and the Bonnet-Labranches, France "organized the first successful aviation competition, staged the first exhibition of aircraft, opened the first flight training schools, and led the world before 1914 in the manufacture of airplanes."[15] One Russian poet-aviator referred to Paris in the early years of the century as "the capital of Europe, the capital of art, the capital of aviation."[16] This is why it was in France that the Wright Brothers first demonstrated their biplane for the world – only in France, in art as in aviation, could one legitimize one's claims of invention.

But none of this easy association of nation and airplane technology for La Fresnaye: a title that points us to aviation, a flag that further specifies his subject as *French* aviation, a pair of men (topos for aviation), but no *avion*. One will look in vain for a satisfactory explanation of this apparent contradiction in the art-historical literature; although it is among the most widely reproduced French pictures of the early twentieth century, *The Conquest of the Air* has received little extended commentary, undoubtedly because of its anomalous nature. The most plausible and by no means entirely misguided reading of the painting was first proposed by Alfred Barr in 1954 – who acquired it for the Museum of Modern Art – and it remains the only satisfying explanation of the picture's apparent discrepancies. Barr writes: "In 1908 at Le Mans, where La Fresnaye was born, Wilbur Wright made his famous record-breaking flight. But in his masterpiece, *The Conquest of the Air*, La Fresnaye does not insist upon technological triumphs – though the abstract parallels in the right foreground possibly refer to a biplane. Instead the air is gently conquered by a sailboat, the French tricolor, and in the distant empyrean, a balloon. Perhaps the chief conquest takes place in the minds of the men at the table who, with Cubist indifference to gravity, float high above the roofs of the village."[17] One variation or another of this reading of the picture as a refined, visual disquisition on the notion of "conquering air" – by sailboat, balloon, tricolore, and in the minds of the cerebral twosome – has been offered ever since.

Yet Barr's discomfort with his own reading, his awareness at any rate of its insufficiency, is apparent at the outset. For after setting the stage for his highly intelligent *explication du tableau* with a mention of the Wright Brothers, followed by the phrase, "La Fresnaye does not insist upon technological triumphs…" he turns right around and wonders if there might not be, after all, an airplane hiding in the abstract configuration at the lower right. (He is obviously clutching at straws; it looks more like a parapet.) As convincing as is the rest of his reading, Barr cannot quite shake off the feeling that something is missing.

And he had good reason for being less than completely comfortable with his elegant rationale. For one thing, there was the striking fact, which Barr probably knew, that La Fresnaye's brother, with whom he was quite close, was director of one of France's foremost aircraft companies, Nieuport, with its factory in the Parisian suburb of Meulan. This has led some commentators to see portraits of the artist and his brother – highly abstract ones, presumably – in the painting's seated discussants. Furthermore, regardless of his brother, we know that La Fresnaye himself did not disdain modern technology, especially not technology which bespoke French prowess. Just the year before he made *Conquest of the Air*, he had painted *Artillery*, now in the collection of the Metropolitan Museum of Art. There we find, in the midst of a French regimental *défilé*, the unfurled tricolore functioning as a backdrop to the prominent display of a passing French gun. As my former student, B.J. Van Damme, demonstrated in an unpublished paper, this is not any piece of artillery, but a specific technological achievement of which the French military were justly proud, the 75 millimeter cannon, called familiarly in French the "soixante-quinze" and in English the "French 75." This was a gun imitated by armies the world over, notable for its innovative hydro-pneumatic recoil system located below the gun barrel. In La Fresnaye's painting, the "soixante-quinze" is precisely delineated, its distinguishing feature pushed to the foreground: these are the double cylindrical shapes projected from the square gun shield, the longer being the gun barrel and the shorter the recoil gear.[18]

A brother in the aircraft business and a powerful interest in French military technology – no wonder Barr couldn't keep himself from hoping that an airplane might be lurking somewhere in *Conquest of the Air*. What happened to technology in a picture that, one would think, demanded it? At least part of the answer may have already occurred to an attentive reader: the problem of the American achievement, the Wright Brothers' controlled flight of a heavier than air machine. Indeed, the Wright Brothers' flights at Kitty Hawk, the first, lasting only 59 seconds in December 1903, covering the distance of only two football fields, and the second, in September 1905, which lasted forty minutes and covered a distance of twenty-four miles, were met with disbelief and even denial in the French aeronautical establishment and the French press. The widely read weekly, *L'illustration*, published a picture of the Wrights' plane at Kitty Hawk and commented, "its appearance is quite dubious and one finds in it every element of a 'fabrication,' not especially well done moreover."[19] Of course, after their successful demonstrations in France in 1908, the Wrights' accomplishment could no longer be denied. As aviator Louis Delagrange said at Le Mans: "Nous sommes battus!" (We are beaten!).[20]

But to be beaten on the flying fields of France by an American machine is not necessarily to be beaten in the discursive field of myth, which includes both the writing of history and the painting of Salon machines. For this other Franco-American contest – this battle of ideas and images as opposed to facts – La Fresnaye had something else he could draw on, something more than the glaring technological absence at the heart of his picture: a *presence* that could wrest French aeronautical victory from the jaws of transatlantic defeat. And that is the little ocher-colored balloon that floats in his painting's upper left above the too-perfect, fairy-tale clouds. Because it was first at Annonay, near Lyon, and then at Versailles, in 1783, that the Montgolfier Brothers, Joseph and Etienne – whose family firm, to this day, manufactures fine artists' drawing paper – launched the first hot-air balloon (a hot-air balloon in France is still called a *montgolfière*). Following in short order in 1783, France saw one conquest of the air after another: the team of Jacques Charles and the Robert Brothers next sent up the first hydrogen balloon from the Champ de Mars and, a few months later, Pilâtre de Rosier became the first man to ascend in a balloon (it was in a Rosier balloon that Bertrand Piccard and Brian Jones made history's first non-stop balloon flight around the world in March 1999). By way of the seemingly insignificant, primitive flying machine, La Fresnaye's picture argues that we have been insisting on the wrong technological triumph, that the "conquest of the air" was first, and therefore will remain, a French one. [21]

From 1783 to 1903, up until Kitty Hawk, the origin of aeronautics was indisputably French, and origins, *The Conquest of the Air* insinuates, cannot be altered. This is why, for instance, La Fresnaye sets his picture out of doors. It is not just that he wants to show us the *montgolfière* and the tricolore, thereby insisting that heavier than air, navigable flight is the also-ran-to balloon technology; it is also because the "natural course" of history and even "nature" itself – in the double sense of the *doux pays de France* and the French temperament – will always prevail. This is why commentator Charles Fontaine, writing in *Le matin* the year after the Wright Brothers' demonstrations in France, could still say, "Vive la France!… It was necessary and natural…that the invention of aviation should take place on French soil, for it's a soil that brings happiness to the human spirit."[22] Nor is it by chance that one could find, at the very center of the great Aviation show held at the Grand Palais in 1909, just behind Blériot's actual airplane, a reproduction of the Montgolfier Brothers' balloon (52). The French had no intention of letting go of their claim to priority in the air's conquest, at least not without a fight. Indeed, "not without a fight" is too strong a term here – Roger de La Fresnaye's painting makes a point of appearing *not* as a counter-argument, but as a self-evident proclamation of French precedent.

52 The Bleriot monoplane enthroned on the stand of honor in the Grand Palais, Paris, October 1909

It was meant to pull the rug out from under the triumphant, self-promoting American brothers in an expressly understated way. Apollinaire seems to have sensed the picture's strategy of understatement, if not its precise significance, when, reviewing the 1913 Salon d'Automne for *Les soirées de Paris*, he wrote: "Among the very few interesting works in this Salon, one of the most outstanding is Roger de la Fresnaye's *Conquest of the Air*.... In this unpretentious, clear picture, I note an effort that is surely heroic these days – an effort not to be astonishing."[23]

For his 1913 Salon entry, then, La Fresnaye has created a hybrid: one part classicizing Claudean landscape with figures, one part cubistic, neo-Cézanne cardplayers *en plein-air*. In a kind of Bergsonian transparency that unites past and present with intimations of future glory, he fashioned a perfect ideological construction, an image of French origins that naturalizes technology as it erases the Americans. Under the sign of the tricolore, *The Conquest of the Air* takes a contested history – and even a crushing defeat for national identity – and remakes it as a myth for modern France.

Chapter Ten

Carol Duncan

My subject concerns an unusual American museum – it is, among other things, an art museum – created in Newark, New Jersey, in 1909 by John Cotton Dana (1856-1929). As I hope to show, although Dana was at odds with much of the museum world of his time, the museum he shaped was very much a product of the Progressive era.

Dana came to New Jersey in 1902 not as a museum man – as yet, Newark had no museum – but to head the city's public library, which had just moved into a handsome new building. In his mid-forties, he was already nationally known as an outspoken and progressive librarian. Indeed, Dana was one of the first to call for the transformation of the old-fashioned library, conceived as a carefully guarded collection of high literature, into an efficiently managed center of information, accessible to, and responsive to the interests of, its community.[1] He brought to Newark a developed Progressive outlook and a set of decidedly "advanced" interests in things such as the Arts and Crafts Movement, Japanese prints, and modern architecture. Very soon the Newark Free Library was collecting photographs, prints and other visual materials and, beginning around 1903, mounting art exhibitions in its unused upper floors. In 1909, this museological activity was institutionalized with the establishment of the Newark Museum Association. Dana would head both the new museum and the library until his death twenty years later. The museum would remain inside the library until 1926, when it finally moved into its own building three blocks away.

There was nothing very unusual about an American city establishing a library and museum and erecting impressive new buildings for them at this time. Since the 1870s, the American business elite had regarded libraries, museums and concert halls as necessary ornaments for any city that wanted to be taken seriously as a prosperous, civilized, and politically stable community. Art museums not only conferred upon their benefactors social distinction, they also effectively announced to national and international business communities the presence of a city on the rise.[2]

Newark could certainly claim such a status. Situated across the Hudson River from New York, the city had been an important center of industry since the Civil War. Now, at the beginning of the twentieth century, it was

well on its way to becoming one of the nation's major industrial giants. But, as with so many other industrial cities, Newark's urban sprawl was famously ugly, dirty, and disorganized. The population of its overflowing slums was continually augmented by streams of immigrant labor recruited from all corners of Europe by the city's businesses. By 1913, two thirds of Newark were foreign born – mostly Italian, Jewish, German, Irish, Greek, and Slavic. Indeed, in Newark as elsewhere in America, the presence of so many immigrants from southern and eastern Europe had much to do with the urgency with which art museums and other cultural institutions were established. "Old-stock," Anglo-Saxon Americans, fearful of being culturally and politically swamped, erected art museums in part to separate themselves from the newcomers, but also with the vague hope that such institutions could unite the disparate class and ethnic elements of their cities into one community with a single (i.e., northern European) culture. Such initiatives, along with the contradictory motives that drove them, should be understood as part of a broader political effort to rationalize and reform politics both nationally and locally, modernize and improve urban environments, and institute a more elevated civic culture. So in Newark, a reform-minded and ambitious business class worked to turn the city into an efficiently managed municipality, with all the amenities that, in their view, distinguished a great city. Or, to put it more plainly, they were bent on wresting control of the city's government away from machine bosses and establishing prestigious cultural institutions with which they could identify themselves.[3]

By the time Dana came to Newark in 1902, American cities were in the midst of the first great age of art-museum building. Within the next few years, almost every major city would build an impressive-looking municipal museum. Invariably, the new buildings recalled one or another moment of the classical past – a Greek temple, a Roman bath, or a Renaissance palace. Largely empty to begin with, they were quickly filled by status-seeking millionaire businessmen, who, eager to associate their names with such prestigious institutions, gathered art treasures by the boat-load during shopping expeditions in Europe. Municipal museums in Boston, New York, Chicago, Cleveland and many other cities were thus supplied with paintings attributed to old masters, rare tapestries, antique furniture, china, glass, stucco ceilings, gilded woodwork, marble fireplaces and numerous other old and valuable *objets*.

At first, important donors were allotted separate galleries in which their collections could be displayed intact and separate from those of other donors. Gradually, however, museum men realized (learning from European models like the Louvre and London's National Gallery) that an aggregate of many separate collections did not add up to a serious museological whole.

In a truly authoritative museum, the parts formed a unified art-historical program, enabling visitors to follow step by step the "progress" of the major European schools. A tour of a quality museum was thus a ritual in which the visitor could subjectively reexperience through art the civilized achievements of the human spirit. Art objects from Renaissance Italy and Classical antiquity were especially valued as embodiments of the summit moments of past civilizations.

By the turn of the century, more relativist notions of history were helping to broaden the art-historical canon. But while museums opened to a greater range of art, Renaissance and Classical art kept their privileged status for decades to come. In any case, art museums showed little besides western European art and its Near Eastern antecedents. The very category of art was defined mainly in terms of European representational styles. Museums did accept a few courtly styles from Asia and the Far East, but consistent with the racist and Eurocentric thinking of the day, objects made by non-European peoples were generally excluded from museum displays. Classified as "artifacts," they were relegated to ethnographic or anthropological museums. And just as art collections were programmed to track the evolution and progress of civilizations, anthropological and natural history collections were arranged to support theories of social, cultural, or biological evolution. The entire art/artifact dichotomy was premised on the assumption that non-European races were still mired in the realm of necessity and thus could produce only objects of practical or instrumental value – canoes, spears, or fetishes – things which might be scientifically interesting but which could never please aesthetically, enlighten philosophically, or attest to mankind's quest for spiritual freedom and self-knowledge. As post-colonial critics have long pointed out, such ideas rationalized the devastating effects of imperialist greed on the "undeveloped" world, representing the real relations of colonialism as a triumph of civilization.[4]

Newark's new museum set out to be as different as possible from the standard American museum of the early twentieth century. Calling it "a museum of service," Dana conceived it as a Progressive alternative, a prototype museum for modern cities everywhere. The Newark Museum was to be an experiment that asked the question, What kind of museum best serves the needs of an industrial city? – rather than the question usually asked by other cities, What is the best way to acquire an art museum like New York's or Boston's, or better yet, Paris's or London's? Dana took great delight in spelling out the difference between his museum goals and these others. Throughout his career, in books, pamphlets, articles and interviews, he expounded what was wrong with the conventional museum and what his Newark Museum was doing instead. In vivid, plain-spoken and sometimes

biting prose, he never tired of lampooning the pretentiousness, solemnity, and snobbery of the orthodox museum model. And while he was at it, beginning around 1912, he began campaigning for a new, purpose-built museum building, separate from the Library, that would allow him to realize more fully his ideas.

Dana grounded his critique of museums in ideas common to many Progressivist theorists of his time. His earlier writings are especially flavored by the ideas of Thorsten Veblen, whose widely read book, *The Theory of the Leisure Class* (1899), Dana found "delightful." In it, Veblen portrayed the super-rich as the shallowest and most socially primitive part of society, exactly the opposite of its own cherished self-image as the most cultivated and civilized. With straight-faced irony, Veblen detailed the upper class's insatiable appetites for luxuries, arguing that its expensive pursuits, over-cultivated manners, stupendous art collections and immense houses were but different ways of conspicuously consuming and wasting wealth. The value of such ostentatious waste, he argued, resides largely in its capacity to signify class – to distinguish its users from their social inferiors – those on whose productive creativity and labor the idle rich parasitically live. For Veblen, "taste," "a Sense of the beautiful," does not exist independently of the economics of social use: if we find costlier things more beautiful than cheap ones, it is not necessarily because we put more monetary value on the beautiful but because the concepts of beauty that thrive in our culture tend to validate as beautiful that which is more expensive.[5]

Dana's own pronouncements about conventional American art museums are often blatantly Veblenesque. In a pamphlet entitled *The Gloom of the Museum*, he wrote: "The rich and ruling class must always keep itself distinct from the lower classes in its pleasures and pastimes.[6]

Dana also mounted visible demonstrations of Veblen's theory of the beautiful in his museum. In 1928, he displayed a selection of well-designed, mass-produced objects costing no more than 10¢ or 25¢ under a sign that

53 Newark Museum, Inexpensive Objects Exhibition, 1928

54 Newark Museum, Inexpensive Objects Exhibition, 1928

proclaimed: "Beauty has no relation to price, rarity or age" (53 and 54). Thus, Veblen helped Dana to a broad, Bourdieu-like theoretical perspective complete with ideas about the social meaning of aesthetic values.

Like many of his contemporaries, both pro- and anti-capitalist, Dana believed that a new social order was in the making. Veblen himself predicted that the workings of modern business and the imperatives of large-scale production would lead to the collapse of the present leisure class and the rise of a new, more rational and efficient era of mass-produced plenty – to be managed by an elite of highly trained technocrats.[7] Dana, too, was confident that the future would be made by and belong to business. As he wrote: "Business runs the world...[which] gets civilized just as fast as men learn to run things on plain business principles. A public institution does its best work when it is useful to men of business."[8]

Dana conceived his museum as an educational instrument designed to help bring about and serve the coming industrial order. The museum prototype he was developing was to be a socially active, transformative institution. To accomplish its task, it must differ in every respect from the conventional model – from the kinds of objects it displayed, to the kind of looking and learning it would stimulate, to the kind of people and community it would

help build and serve. In his writings, Dana contrasted this bright and optimistic museum vision to the "gloom" of the old museum, which he portrayed as a graveyard of leisure-class fashion and wasted wealth.

The future for which he argued would not put art museums in remote parks. It would build no "temples to dead gods…or copies of palaces of an extinct nobility.…" The new museum would not be a ceremonial space removed from everyday life: it would have no top-lighting or Great Halls.[9] Dana was especially opposed to a new current of museum culture that began to gain ascendancy around the time he arrived on the scene. Rooted in the Aesthetic Movement, this current valued aesthetic pleasure as the supreme end of art. Its best known and probably most extreme advocate was Benjamin Ives Gilman of the Boston Museum of Fine Arts. Gilman argued that works of art attain their deepest meaning only when they are removed from their original context and put in art museums, where all but their aesthetic meaning falls away. By contemplating them as pure *objets d'art*, viewers achieve what Gilman described as a state of secular grace.[10] In Dana's view, the solemn museum ritual that Gilman advocated, and that he instituted in Boston's Museum of Fine Arts, was itself a form of conspicuous and wasteful consumption – of architecture, time and training. His museum would not be "one more of those useless, wearisome, dead-alive Gazing Collections."[11] It would not be filled with costly and ancient oil paintings, objects that, according to Dana, attracted "undue reverence" and "extreme veneration."[12] Nor would its collections be shaped by the enthusiasms of "the memorial-seeking rich."[13]

In many ways, Dana's ideal museum was an American Progressivist reworking and machine-age updating of London's Victoria and Albert Museum. Educated opinion, including many advocates of the Arts and Crafts Movement, firmly believed that displays of textiles, ceramics, ironwork, and other decorative arts could improve the skills, taste, and even the morality of the working classes, and generally enhance modern life.[14] However, as Dana knew, the objects that public art museums acquired and exhibited as decorative arts were usually the kinds of things collected by American millionaires in search of aristocratic identities – clocks, silver, china and the like made for European nobility. As he put it, "The kinds of objects, ancient, costly and imported, that the rich feel they must buy to give themselves a desired distinction, are inevitably the kinds that they, as patrons and directors of museums, cause those museums to acquire."[15]

In Dana's museum, decorative arts meant useful things produced in the modern world with modern technology, things that were affordable to working people. Yet, his gibes about "gazing museums" and oil paintings did not totally exclude the kind of art objects that defined museums else-

where. Although Dana had little interest in oil paintings, he understood that "a city as big and rich and as increasingly conscious of itself as [Newark]" ought to have some first rate treasures, if only to keep up competitively with other cities out to make an impression.[16] But Dana also insisted that museums best serve their communities not when they buy the wares of "archaeologists, excavators and importers" but when they collect and exhibit works of art made by living men and women residing in their own communities.[17] Indeed, the Newark Museum was years ahead of other public collections in its purchases of American art, including works by progressive and modernist artists such as John Sloan and Max Weber.

Besides collecting and displaying objects, Dana's model museum was also to be an active educational institution. "It is easy for a museum to get objects," he wrote, "it is hard for a museum to get brains." A brainy museum touches, instructs, and entertains common people, makes life "more interesting, joyful and wholesome,"[18] is alive with learning children and adults, and abounds with information, handbooks and leaflets. It exhibits things people use, things they can afford, things made in their own city. "A great city department store of the first class is perhaps more like a good museum of art than are any of the museums we have yet established," he wrote. They are easy to get to, open to all for long hours, have interesting displays and show things in storage on request; they have good lighting, good rest rooms and advertise effectively.[19] A good museum should do as much and more. It should give lessons in local flora and fauna, local history and geography. It should serve the "mixed population" [read: immigrant populations] of a big industrial city in a modestly decorated, practical building that people can easily reach.

The Newark Museum practiced much of what Dana preached. It exhibited fine arts, industrial arts and decorative arts, both machine- and handmade. In 1912, it became the first American museum to show the products of the Deutsche Werkbund (55). Dana regarded these products as brilliant realizations of the marriage of art and industry, a theme that occupied him increasingly through the years. The exhibition's many objects, displayed in simple vitrines designed by Dana himself, were carefully installed and isolated with an eye for their aesthetic values. The museum also featured New Jersey industries, as in a 1926 exhibition about leather products and processing, one of Newark's most important industries. On another occasion, Dana filled the museum's exhibition rooms with bathtubs, sinks, toilets, and urinals, products of another New Jersey industry. Interviewed about it for a newspaper, Dana declared the American bathtub an object of beauty. "It suggests the possibility of art in America far surpassing any art which the world has ever known. Machine art. Collective art."[20] But again, the

55 Newark Museum, Exhibition of Modern German Applied Arts, 1912

museum did not neglect "art." On the contrary, the range of art it recognized was remarkably broad. Besides original work by living American artists, it showed plaster casts of Greek sculpture, copies of European old masters, an outstanding collection of Tibetan bronzes, and an important collection of Japanese prints.

Thus, in Dana's museum, museological boundaries that prevailed elsewhere were consistently ignored. Art, science and industry met and merged. The idea of the museum as a collection of rare treasures and a dispenser of fixed truths was replaced by the more library-like concept of the museum as a center of information, a reservoir of the ever-developing and changing data characteristic of the modern world.[21] To Dana, copies and reproductions of art could be more useful than originals because they could be loaned out. Accordingly, among the many innovations he instituted into the Newark Museum was a loan department. Especially geared to the needs of school teachers, it lent originals as well as copies. Dana also established a system of branch museums, which he introduced into the library branches he had previously created. And he advocated putting art in the windows of empty stores in poor neighborhoods, in schools, and in factories.[22] Both the library and the museum had children's departments, another Dana invention.

Especially in contrast to the elitism and pretentiousness of conventional art museums, the Newark Museum was strikingly populist and experimental. Indeed, some of Dana's ideas – collapsing distinctions between art and artifact, putting art in neighborhood storefronts, and introducing what today are called interactive displays – are still considered "experimental." His museum, moreover, was unusually successful in attracting a large and diverse audience, including significant numbers of immigrants, who were often drawn to the museum by exhibitions of arts and crafts from their homelands. No other American art museum (if I can call Newark that) I have studied went to greater lengths to bring in immigrant people and make them feel that they belonged there. No doubt, much of the Museum's early success in this regard was due to the location of the museum inside the library: immigrants were almost always more at ease in libraries than art museums. Even so, Dana made extra efforts to reach out to immigrants, publishing library notices in Polish, Yiddish, and other languages (56), opening a branch of the museum and library in the middle of the most heavily populated immigrant neighborhood, and keeping it open into the night every day of the year.

One must wonder why Newark's business elites, unlike their counterparts in so many other American cities, did not insist on a conventional art museum. What made Newark's upper crust different from Brooklyn's, Cincinnati's, Cleveland's, and those of other cities, some smaller than Newark? I do not have an easy answer for this. The sheer force of Dana's personality, his energy, confidence and conviction, surely must have counted for a lot. And then, the very rich families that lived off Newark's industries most likely

56 Newark Public Library Notice, 1918

NEWARK FREE PUBLIC LIBRARY
North end of Washington Park
Broad and Bridge Sts.
open, 9-9.30 daily; Sundays 2-9

Here are books in English, German, French, Italian, Yiddish, Russian, Polish, Arabic, Lithuanian, Ruthenian, Hungarian, which anyone can borrow. 1,200,000 borrowed last year.
This was the first fine public building which Newark people built for themselves. Its interior stairways and pillars are of marble from Italy and America. In it are pictures, statues, bronzes and other objects of art which will remind you of your homes in other lands. Pictures may be borrowed here like books. 103,000 were borrowed in 1917.
Come and see. Take our card and become a member of your Library. Ask for what you want.
The Free Public Library of Newark, NJ
1918

had access to the prestige of high-art rituals elsewhere, in their private collections or in donor relationships to more conventional – and prestigious – museums in nearby cities. But in an important way, the city's elites were willing to adopt the Progressivist cultural program Dana offered. There were, to be sure, some among the ruling elite who would have preferred a more conventional art museum: for a time, Dana had to battle a group of such men on the Board of the Museum. But firmly backed by the city's powerful mayor, he eventually vanquished them.[23]

Historians often emphasize the contradictory nature of Progressive era thinkers and reformers, their ability to look realistically at the forces shaping the modern world even as they clung to an old-fashioned faith in the determining power of individual morality. Dana was just such a mix of modern insight and nineteenth-century conviction. He initiated many of what became standard practices in modern libraries and museums; compared to the established institutional practices of his day, he looks radically democratic. But he was hardly radical in the political sense. His museum was predicated on a vision of the future that would be built and run by a managerial class of pragmatic technocrats. He seems to have greeted this emerging industrial order with no critical caution on behalf of workers. On the contrary he urges a future in which workers will achieve a good life as consumers of useful, well-designed commodities produced by rationally planned, technologically smart work processes. His museum was not to be a site of critical reflection about the future and the quality of political life it offered but rather an instrument to educate the work force that would best serve the needs of the emergent industrial order. In Dana's museum, aesthetics substituted for politics. Put another way, if Dana's museum would educate its visitors to be citizens of a future democracy, then it would also redefine and limit the rights and freedoms of "democracy" to mean the freedom of consumer choice.

In any case, like many thinkers of the time, Dana saw nothing good in workers' struggles against corporate power, since, as he saw it, modern industry, by naturally seeking greater productivity and profit through increased efficiency and mechanization, was actively improving the conditions of existence for workers and managers alike. There was no need for workers to struggle against the ruling industrial powers, since their needs coincided with industry's demand for efficiency and productivity. In the utopian community implicit in his museum goals, men and women would live happily, productively and harmoniously, but always within the limits and needs of the industrial order that circumscribed their lives. As he sub-titled one of his books, the museum model he advocated was "the kind of museum it will profit a city to maintain."[24]

Color War: Picasso's Matisse Period

Rosalind Krauss

The extremely hygienic effect of Yve-Alain Bois's 1999 exhibition, "A Gentle Rivalry: Matisse and Picasso," is that at last it pierced the claustrophobic spaces that have been so tirelessly constructed to house each of these modern masters, breaking them open to let in the air of other concerns beyond the matter of individual greatness and its reflection in the immediate entourage of the one or the other. With Picasso, particularly, this is not only welcome but important. For the perspective of slavish admiration that has focused itself on him, rapidly intensifying as it has in the postwar period to project him as an infallible aesthetic Midas with only the need of the changing *dramatis personae* of his own household to fire his endlessly fecund artistic imagination, has greatly distorted the historical record. The sober reminder that Bois provides, as he records the vituperative assessment of Picasso's massive 1932 retrospective, shows us the degree to which the early thirties found Picasso on shaky ground. Accused of having no painterly gifts and of having deserted his genius, he is consistently denied an artistic future, as one critic after another consigns Picasso's contribution to the past. "His current downfall is one of the most troubling problems of our time," is one assessment; while another states: "If we did not know that he was at the origin of some modern forms of art, we would not believe in him any more."[1]

Indeed, there are two compendia to which one can turn to form a picture of Picasso's situation at this time. One of these is the *Cahiers d'art*, from its inception in 1926 to, say, 1931 or the beginning of 1932; the other is the distressingly thin volume of Zervos's catalogue of Picasso's work, the seventh, which spans this same period. These six years of the *Cahiers* are fervently modernist in the field of architecture, with large spreads devoted to Le Corbusier, Mies, Gropius, and the design of industrial buildings. They are also on the watch for emerging talent among painters and sculptors, with lavish articles on such figures as Brancusi or Arp. Within this *esprit nouveau* context, Fernand Léger's career is repeatedly tracked, each move in its development documented as a logical prolongation of Cubism. And as the progenitor of Cubism and collage, Picasso is also fulsomely represented. It is only as the treatment of his contemporary production unfolds that Picasso begins to appear as retrograde and outmoded. His Neo-Classicism

57 PABLO PICASSO, La crucifixion, 1927

fits in all too nicely with coverage of late Renoir or Corot; his violent heads of Olga from the mid-1920s look exceedingly flat and powerless in the *Cahiers*' black and white reproductions; only his *Metamorphoses*, presented as a sculptural project, have a feeling of freshness in this context. Most troubling of all, however, is the evidence, published in the opening number of 1927 in an essay on Picasso's recent drawings, that the master has been looking at someone else, to wit a very young newcomer named Joan Miró[2] (57). With their graphic language possessing the linear fluidity phasing off into the kind of formlessness found in a work like *The Policeman* (58), Picasso's drawing shows his crucified Christ flanked by Miró-like characters straight out of the *Lady Strolling on the Rambla of Barcelona* (1925, Museum of Art, New Orleans) or the *Portrait of Mme B.* (1924, Private Collection).

The fascination Miró exerted on Picasso had first begun to surface in the 1926 *Dressmaker's Studio* (Musée nationale d'art moderne, Centre Pompidou,

58 JOAN MIRÓ, The Policeman, 1925

Paris) where the surprising all-over skein that forms the rhythmic armature of this still more or less Cubist work betrays the impact of Miró's paintings and drawings from 1924 such as *The Family* (1924, Museum of Modern Art, New York) or *Harlequin's Carnival* (Albright-Knox Gallery, Buffalo), which was shown at the Gallery Pierre in 1925, the same gallery that a few months thereafter housed the one Surrealist group exhibition Picasso consented to join and in which his own work hung next to that of the younger man. It is, however, in the anatomical drawing of the very large *Painter and Model* (59), done slightly later in 1926, that what seems to be at work to displace the Cubist lexicon itself is Miró's specific vocabulary of the body as a collection of part objects – with enormous feet or tiny pinheads, as in *Sourire de ma blonde* (1924, Private Collection) or *Hand Catching a Bird* (1926, Private Collection) or *The Statue* (60), these parts connected to one another only through what reads as the graphic sign for surges of desire, as

59 PABLO PICASSO, Painter and Model, 1926

in *The Kiss* (1924, Collection José Mugrabi) or *Le corps de ma brune...* (1925, Private Collection).

This effect within Picasso's art continues into the late 1920s in both the specific anatomical shapes and the weightless quality of the line that forms them, giving an underwater character to the works, as though we were seeing polypoid sea-creatures suspended in an aqueous milieu, a quality typical of Miró throughout the late 1920s, such as the *Dutch Interiors* and particularly insistent in his drawings of 1930. In some of the drawings Picasso makes preparatory to his 1930 *Crucifixion* (Musée Picasso, Paris), one feels the presence of Miró's collages from Montroig in 1929, or of drawings like *The Lovers* (1930, The Morton G. Neumann Family Collection) or other anatomical fantasies.

If this evidence takes on any weight, however, it is because of its context. The extraordinary slightness of Picasso's output in these years, as well as his wild gyrations between various styles, as he continues to take up and

60 JOAN MIRÓ, The Statue, 1925

drop in turn Neo-Classicism, late Cubism, and what I am here calling his Miró-ism, all this attests to a kind of rudderlessness that the onset of his affair with Marie-Thérèse Walter in 1927 did nothing whatever to redirect. André Breton's assessment of the situation, which he summarized in the *Artistic Genesis and Perspective of Surrealism* as "the influence of Miró on Picasso," have been wounding to Picasso's own self-esteem.[3] For it is one thing to make a set of Olympian witticisms by evoking the styles and manners of great, dead masters such as Ingres or Poussin or Corot; it is quite another to be caught out in an imitation of the younger proponent of a style more advanced than one's own.

In the early thirties, however, there was a new consolidation of Picasso's effort around a pneumatic vocabulary, expressed in both painting and sculpture, which has come to be known as the Marie-Thérèse style and which represents an upsurge of sensuous opulence and erotic directness that leaves behind the violence of feeling of the preceding years. It is Yve-Alain

Bois's recoding of this material under the name Matisse that both forms the point of departure for his own demonstration and forces one to see the extent to which Picasso is speaking through Matisse's vocabulary in these works, whether they are the somnolent odalisques ceding to the embrace of their ornamental surroundings or the classico-phallic sculptures recasting the idea of the head as a migration of body parts (61 and 62). In either instance Matisse is there at the level of formal language and of feeling tone: his Jeanette V of 1913 (Private Collection) or his *Tiaré* of 1930 (Private Collection) providing both the example for the massing apparent in the various heads and busts of Marie-Thérèse and the peculiar vacancy of their affect; his odalisques from 1926-27, creating the peculiar combination of fleshy lassitude and decorative hysteria that now envelops Picasso's mistress.

The explanatory model Bois offers for Picasso's assimilation of his own work to Matisse's is that at the end of the 1920s – with Surrealism no longer compelling him and the avant-garde appearing to him to have run its course in the self-evacuation that he believed abstraction to be – the aesthetic isolation in which he now found himself led to an identification with Matisse.[4] As the other great painter committed to the Western tradition of figurative art, Matisse thus became the necessary partner for Picasso, the true gauge against which he could measure his own efforts to reactivate the past.

But from what I have said about the presence of Miró inside Picasso's work, a continuing goad that can be felt for example in the onset of collages using trash and sand at the very moment in 1930 when Miró is also working with sandpaper and detritus, then the idea of a loss of interest in Surrealism seems to me to be not so obvious. Furthermore, if we agree that, while Picasso felt comfortable quoting from the great dead he was not at ease in an imitation of a younger contemporary, then his move towards Matisse becomes all the more perplexing. Since if we read it, as I do, as a direct case of pastiche, then we have to ask certain questions about the image of voluntarism projected by Bois's model of move and counter-move between the two artists.

This is because my own assessment of Picasso's pastiche, which began in the late teens, is that it is a very troubling phenomenon indeed. The available historical explanations for it are either internal or external. Picasso is seen either as taking his own collage principle of incorporating foreign material and now applying it to the contents of the Louvre, so that a variety of classical styles enter the frame of his work like so many swatches of wallpaper or calling cards; or Picasso is understood as succumbing to the clamor of the world around him, whether that be the politics of nationalism or the tastes of a fashionable upper class.

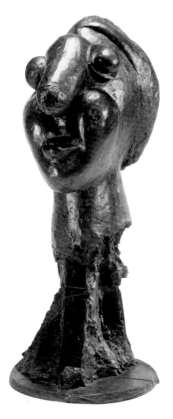

61 PABLO PICASSO, The Mirror, 1932

62 PABLO PICASSO, Head of a Woman, 1931

Neither of these two possibilities captures the tragedy of pastiche, however, since neither of them measures it against the extraordinary promise of what came before. If for the first, it is the natural outcome of Cubism, then Cubism's own rigor has been woefully misunderstood. And if for the second, it is indeed a betrayal of Cubism but forced on its inventor by a concatenation of external circumstances, then the strength that must have been necessary for Cubism's invention disappears from view behind a picture of strange but unexplained indetermination and dependency.

It was in response to what seemed to me this explanatory vacuum that I developed my own model for understanding Picasso's embrace of pastiche in, roughly, 1917, a grip that grew ever more tenacious far into the 1920s.[5] If I review this argument here it is in order to bring the turn of events in the early thirties more clearly into focus. Based on the psychoanalytic concept

of reaction-formation, I analyzed Picasso's Neo-Classicism as a form of defense against an event that must be understood as internal to himself, namely the very project implicit within Cubism. By 1915 it had become obvious that Cubism itself had spawned two forms of art, abstraction on the one hand and the readymade on the other, both of which however were anathema to Picasso. These two are generally seen as divergent possibilities. But if we understand the readymade as an embrace of various means of mechanizing and deskilling the practice of art – means that include photography – then the readymade and abstraction can in fact be seen to join hands at the level of a serious relation to the forms of industrial production, namely automation and serialization.

The defense Picasso mounted against this threat has to be understood in relation to the fact that – as the logical extension of Cubism itself – what was being warded off was something coming from within. It is this that not only fuels the energy of this reaction but articulates its structure as the inverse of what it is defending against. For just as in the classic cases of reaction-formation, where obsessional cleanliness or avarice are defenses against the pleasure-in-dirt of an early anal-sadistic stage, the conversion of an impulse into its opposite seems to control Picasso's own form of stylistic transformation as he takes up pastiche. Thus it is the sublimatory drive, the need to ward off the low by assuming the high, while all the time – like the masturbator who takes refuge in a compulsive hand-washing that furtively repeats the forbidden gestures – preserving the low within the high, it is this that produces the unconscious logic of Picasso's choice.

Nowhere is this more obvious than in the two qualities with which Picasso imbues his Neo-Classical portraits: namely, automation and serialization. In the very way repetition grips the string of Ingresque images that Picasso turns out between 1915 and 1923, the serialization of the pose manifests the sitter as a kind of readymade persona, a quality underscored by the automated character of Picasso's relation to drawing in these works. For Picasso's line, undoubtedly modelling itself on the already industrialized engravings of eighteenth-century designers like Flaxman, assumes the kind of woodenly invariant and uninflected contour that makes it seem like tracing, an alienated relation to the model that results in just the kind of anatomical simplifications and "misunderstandings" that abound in these portraits. Further, automated and deskilled, the traced line forms a pair with industrial drawing's own mechanization of the contour and its production of a kind of graphic affectlessness.

Thus from these portraits, to the pastiches of Corot or Renoir, to the suites of dancers or bathers, the automation of Picasso's line gathers into his supposed "classicism" the very qualities against which that classicism

63 PABLO PICASSO, The Blue Acrobat, 1929

was intended as both an alternative and a defense. Whether it is the serial-
ized runs of Neo-Plasticist experiments combined with abstraction's use of
the compass and the straightedge; or whether it is the bow to mechanical
drawing in the graphic representations of the readymade, the automation
celebrated by the progeny of Cubism is unconsciously repeated by its reluc-
tant parent. Indeed, as these two presumed opposites meet in a classicism
grown as hard as steel and as mechanical as a mass-produced object, the
"neo-classical" encounters its own parody in both the mechanomorphs of
Picabia and the abstract lozenges of Mondrian, where it sees itself reflected
in their cool rigor, their symmetry, and their aloofness.

The structure of Picasso's pastiche is, then, sublimatory and defensive.
It is both a disavowal of the low towards which his own drives have taken
him and the embrace of a presumably elevated form which is nothing but
that same "low" in disguise. If we turn now to the chronologically first sign
that Picasso had exchanged his pastiche of Neo-Classicism for a pastiche of
Matisse – namely the series of acrobats and swimmers from the winter
of 1929-30 (63), with their flattened silhouettes reaching centrifugally
towards all four edges of the picture, the continuity of their contour and the

64 JOAN MIRÓ, Flame in Space and Nude Woman, 1932

binarism of the color scheme into which they are locked, all echoing the expansiveness particular to Matisse's greatest works, such as his 1910 *Dance* (Museum of Modern Art, New York) – our vision needs to be bifocal. For this floating, dilating reach of flattened figures through a surge of monochromatic space also characterizes the great Miró's of the mid and late 1920s, works such as *The Lasso* (1927, Fogg Art Museum, Cambridge, MA) or *Un oiseau poursuit une abeille et la baise* (1927, Private Collection), which have, however, a far greater abandon and erotic charge than comparable Matisse's.

This is the moment, I would say, when Matisse emerges as a defense against Miró, a high, ornamentalized, and inoculated version of the power and urgency of Miró's vision. Nowhere is the meaning of this exchange more evident than in the comparison to be made between Picasso's Matis-

sean sleepers of 1932 and Miró's bathers and recumbent women from the same year (64). The fixation on the sexual, the enclosure of the erotic subject firmly within her own boundaries even as those boundaries become tumescent and swell towards the picture's frame, all this is consistent from one set to the next; but in the Miró's this assumes a violence and erotic urgency that has been transformed in the Picasso's into the languid self-absorption of the Matissean odalisque (see 61).

The only place where violence steals back into the heart of these works is in the lashing arbitrariness of their color, a use of chroma which – with its strident "day-glo" intensities and its cellular, cloisonnist structure – has, as Bois rightly insists, nothing to do with Matisse[6] (65). And Picasso was, in fact, very proud of this chromatic arbitrariness, as he made clear to Tériade, who interviewed him just before his big 1932 retrospective in which his full

65 PABLO PICASSO, Repose, 1932

range of ornamentalized, somnolent nudes in this bloated, curvilinear, odalisque style, were to appear. "How often," Picasso begins to Tériade, "have I found that, wanting to use a blue, I didn't have it. So I used a red instead of a blue. Vanity of things of the mind."[7]

Responding to this remark, Yve-Alain Bois comments: "This statement could not be more contrary to Matisse's concept of color, where each color plane plays a definite role in the overall 'harmony' of the picture. Once the intensification of hues is seen only as a way to emphasize the arbitrariness of color, Matisse's unsurpassable gift as a colorist becomes irrelevant."[8] But behind this clear rejection of a Matissean harmonic – the idea that a color chord and a pictorial idea are so wedded that nothing about them, neither their actual hues nor the extent of the surfaces over which they expand, could be altered –behind this, there is the sound of yet another rejection in Picasso's dismissive "vanité des choses de l'esprit." For although Matisse's color, in its lack of arbitrariness, its sense of being compelled by the image itself, establishes itself as highly "motivated" in the structural-linguistic sense of this word, such color can hardly be called a "thing of the mind." It projects a color atmosphere, a color feeling, but not an intellectualized relation to chroma.

The idea, however, of producing an extreme justification of color, such that – like Matisse's – it could never be read as arbitrary, but – unlike Matisse's – it would be generated by means of the most rational possible method, is a function of an altogether separate current in the art of the late twenties and early thirties. For it was abstract art, most notably in its Neo-Plasticist form, that treated color as both limited to, and entailed by, its reduction to the primary hues of the painter's system, the pictorial absolutes of red, yellow, and blue. This objectification of color can be said to be the further step that abstraction takes generally in the 1920s, where the mechanization of contour in, say, Mondrian's pictures of the late teens, is now matched by a kind of automation of the palette. Indeed, the primary colors functioned as a badge of mechanization itself, with various celebrations of the industrial process – from the International Style in architecture to the robotic conception of the human figure in Léger's art – translating this rationalization of design into red, yellow, and blue.

It is interesting to experience the hostility directed at this phenomenon from members of Picasso's own aesthetic circle. In the wake of the big "Cercle et Carré" exhibition in 1930 in Paris, in which Mondrian showed two Neo-Plastic pictures, Zervos and *Cahiers d'art* ran an editorial attacking abstraction, which they accused of having leached all emotion out of art to replace it with the emptiness of mechanically drawn geometric planes and what they called a "purely ornamental" distribution of primary colors. Out of

politeness the editors of the *Cahiers* invited Mondrian to reply to this, which he did with extraordinary dignity and succinctness on the same page as their statement.[9] By the next issue of the magazine Léger had also leapt to the defense, to be joined by Willi Baumeister in the following number, and Kandinsky in the one thereafter. Léger was particularly incensed by the accusation of ornamentalism, replying that Neo-Plasticism's localization and reduction of color had resulted in paintings that were able now to deal in "unimpeachable plastic fact."[10]

In these years there were, then, two color systems to which Picasso's arbitrariness was a clear refusal. Since both were modernist, neither turned to the colors of nature for the source of their "motivation" or cause; both motivated or justified their color reflexively, with reference to what was internal to the pictorial field itself. For Matisse this meant the harmonic of a given canvas; for de Stijl and many of the "Cercle et Carré" artists it meant the color system out of which painting was built and of the material and objective nature to which these elements would uniquely refer.

Now, not only was Picasso allergic to the red, yellow, and blue he saw all around him, a reaction that could only be an extension of all his original hostility to abstraction, but this parade of self-justification would likely have irritated him as well. For deep within his own development of the very Cubism from which abstraction had sprung, there had been an extremely important analysis of color in order to gain access precisely to its arbitrariness, not in just the aspect of wilfulness that one sees in the work of 1931-32, but in the semiological sense of the term. The very arbitrariness that Picasso had wrung from the shards of cut paper in his invention of collage, so that it would become clear that each material element, or signifier, could be seen to open onto not just more than one visual interpretation, or signified, but often onto interpretations that were directly opposed to one another – the same shape now signifying the foot of a glass, now its liquid contents or perhaps its hollow interior, now its figure, now its background – this arbitrariness had worked to establish a wholly new pictorial language, in which the sign – unmotivated and arbitrary – was in continual circulation.[11] And it was an arbitrariness that Picasso obviously wanted to extend to the element of color, so that color would not be a direct, phenomenological experience, but a mediated one, made manifestly semiological in the terms structural linguistics had set up for the activity of the sign: relative, oppositive, and negative.

Picasso's brief experiments with Ripolin enamel, brought on most probably through the impact of Futurism in early 1912, had been a first exploration of a kind of coloristic arbitrariness, namely the arbitrariness of either symbolic color, as in national flags, or commercial color, as in com-

modity packaging. The cityscape Picasso made in Sorgues that summer, *Landscape with Posters* (National Museum of Art, Osaka), was as far as he went in this direction, probably because no matter how distant from nature a commercial color might be, and thus how mimetically "arbitrary," nonetheless within the pictorial field it wears its own aesthetic justification on its sleeve in terms of the immediacy and directness of its visual appeal. The fuchsia of the Léon hats billboard, for example, may have no referent in nature but, as it beams its way directly from canvas to retina, its impact has all the immediacy of a field of poppies; and it thus remains a case of direct, visual stimulation. As with Kahnweiler's observation that color resisted incorporation into the Cubist language during the movement's analytic phase, color's unimpeachable directness made it incompatible with Picasso's operations during the opening two years of collage.

The theory I have advanced elsewhere is that Picasso broke through to a semiological control of color in early 1914 when he came into possession of some mauve wallpaper, stippled in purple and white, in a hallucinatingly parodic imitation of the Neo-Impressionist, divisionist stroke.[12] If divisionism had broken color into dots of pure chroma so that hues would mix not on the artist's palette but in the viewer's eye, this was in an effort to produce the most direct and unmediated experience of color, color in a complicated balance of complementaries as the intense precipitate of light itself. But now, by exciting a reading of Seurat's system while at no time unleashing the actual coloristic activity of that system, the stippled wallpaper presented itself as the answer to the problem of how to mediate color, how to signify it without displaying it, how to turn it into a code, how to produce it as a sign. Nine more collages were made with the mauve wallpaper and by the time Picasso had arrived in Avignon that summer, he had gained full control of this pointillist language.

In marking his first really achieved, though short-lived phase as a colorist, paintings from Avignon such as *Green Still Life* (1914, Museum of Modern Art, New York) or *Portrait of a Young Girl* (1914, Centre Pompidou, Paris) have often been read as evidence of the sudden influence of Matisse. This is to ignore the logic internal to these works in which the display of extreme arbitrariness, as color is consistently denatured away from the play of complementaries and the division of light, bends it to the purposes of the sign. For the first time, Picasso is performing as someone whose language could be color for the very reason that he had succeeded in turning color into language.

Picasso's Neo-Classicism had brought this to an end; and indeed one of the reflexes of his relationship to this stylistic vocabulary was the series of pictorial jokes he made about its distance from color, about its relation to

chroma being nothing but the fill-in or overlay of an armature of drawing in black and white.[13] This makes the upsurge of color at the outset of the thirties all the more significant as the mark of a new departure within his work.

Many scholars, among them Rosenblum, Daix, and FitzGerald, have spoken of the outbreak of color in these works and the way its "decorative sumptuousness suggests a rivalry with Matisse."[14] For Bois, however, it is precisely Picasso's use of color that functions as a resistance to Matisse, operating from within other forms of assumption of the older man's style, as a resistance that Bois calls – using one of Harold Bloom's revisionary ratios – Picasso's "daemonization" of Matisse's color.[15] Accordingly Bois has stressed, and I am following him here, the arbitrariness of Picasso's chromatic language in these works.

But this brings us face to face with what I have been avoiding throughout this discussion, namely the determination on the part of many historians to naturalize and thus to motivate Picasso's choices throughout most of his career, and specifically in the case at hand to see them as the expression peculiar to the actual forms and even the colors of his model for these works: Marie-Thérèse Walter. Rosenblum, quoting Picasso's poetry of 1935, uses its description of Marie-Thérèse's "cheveux blonds," and "bras couleur lilas,"[16] to take Linda Nochlin's seminal discussion of Picasso's symbolic use of color and push it one step closer to nature. For the implication is that Picasso's application of the complementaries yellow and violet to Marie-Thérèse's body moves his work towards the empirical truth of the referent, like Monet and Renoir who shocked their nineteenth-century public so by revealing that the color of flesh in shadow is lavender.

The real power and originality of Nochlin's extraordinary article "Picasso's Color: Schemes and Gambits," however, was its insistence on this color's removal from nature and its condition as mediated.[17] Her opening example, a still life from 1927 – in which she shows Picasso setting Gauguin off against Cézanne by juxtaposing a Tahitian triad of red-orange, yellow-green, and blue-violet, against the earth-sun-and-shadows of Aix-en-Provence – sets up this model of color as indirect, because coded through the idioms specific to other artists. And even as she identifies the yellow and violet complementaries as a consistent symbolic trope for Picasso's rendering of Marie-Thérèse in the dreaming and sleeping works of the early thirties, Nochlin continues to organize these as part of a language that opposes the hot sensuality of Gauguin's tropics to the cool remoteness of Cézanne's Mont Sainte-Victoire, often speaking that language, as before, in one and the same picture.

As brilliant as this reading is, and as much as its intentions can be seen to go in the other direction, its effect has been to "re-motivate" Picasso's

color, first, by setting up a chromatic symbol specific to Marie-Thérèse and, second, by implying – in the same way that Neo-Plasticism would for the primaries, red, yellow, blue – that the complementary opposition of yellow and violet touches base in the nature of art itself, motivated by the color wheel and by the prismatic truths of light. We are thereby distracted from the fact that Marie-Thérèse had to share violet and yellow with both Olga and Dora Maar and that anything like a consistent color harmonic is swamped time and again by a wild chromatic hysteria and "abrasiveness," to use Yve-Alain Bois's word.

Indeed, in stressing its reckless intensity and its deskilled use of thick black line to weld together this chromatic excess, Bois sees Picasso's color-handling in these pictures as having reached down into the medium of posters and of advertising, thereby turning away from the cadences of the Matissean interior to speak the slang of the street.[18] And if this is the case, might not this arbitrariness of the commodity language be the bridge connecting the two phases of Picasso's production as a "colorist"? And might his reactivation of the color mauve not be – within the complex tug of war of reaction-formation – a reversion to the moment of his own mastery in the matter of color, his own displacement of it into the field of the sign? In the arbitrariness that belongs to the semiological, lavender would stand here for Seurat every bit as much as for Marie-Thérèse.

Kouroi and Communists:
A Memoir of the Spanish Civil War

Eunice Lipton

Those who know Linda Nochlin have their formative memories of her. The earliest ones – those first sitings – then later, the more complicated, more durable meetings. For me, two experiences coalesce. Both have to do with words and politics. As a young teacher in the mid-1960s, I used her Realism and Impressionism Sources and Documents books.[1] Their accessibility and pungency amazed me as well as their mingling of erudition with expressive language. But most of all there was her unmistakable courage. Here is the first paragraph of *Realism and Tradition in Art*:

> "The tradition of all the dead generations weighs like a nightmare on the brain of the living." With these words, written in 1852, Karl Marx characterized the problem faced by innovators in all realms of thought and action in the middle of the nineteenth century. In art, as in politics, pitched battles were waged between the proselytizers for the new and the upholders of established values, between those who sought to create with contemporary sensibility a new imagery appropriate to the modern age and those who clung desperately to the desiccated attitudes and outworn vocabulary of the past.[2]

Karl Marx? And Art History? By the time I had read this I had already spent three years in the marble-halled, chandelier-hung, tapestry-draped Institute of Fine Arts (NYU). There was nothing vaguely like this kind of writing there.

In the same book, Nochlin writes this about Courbet: "It is precisely due to the advantages bestowed upon [him] by his popular origins, the advantages of spontaneity and intuitive, rather than intellectual, apprehension, that he is the great artist that he is."[3] His personal life mattered? How his parents spoke to him, what it smelled like in their kitchen, what books they read or didn't read?

The second telling experience was reading Nochlin's dissertation on Courbet as I prepared for orals. The intensity spilling across the academic language was astonishing. My god, she loved him. His politics, no doubt, but also his good looks and bravura, a reminder of someone perhaps. She describes the artist as "arrogant and conceited," his letters "full of boastful

remarks, and his reports of his successes, both personal and professional, are always rhapsodic." Far from being critical, this behavior seems to amuse Nochlin.

But analysis of contemporary politics in Courbet's work was Nochlin's conscious strategy. On page two she states: "It is the contention of this thesis that the 1848 Revolution and the climate of ideas associated with it played a crucial role in determining the development and character of this style."[4] Politics *effected* style! Perhaps I must remind readers here that in the 1960s, when this dissertation was written, "style" was an entity unto itself, shaped by nothing but the artist's temperament and the style of past art.

One of Nochlin's most stunning and convincing assertions was her reading of the *Burial at Ornans.* "The richness of the pictorial details," she writes, "tends to give an almost equal emphasis to all areas of the canvas, a pictorial 'democracy.'" In the next paragraph she refers to this strategy as Courbet's "compositional *égalitarianisme.*" And so the radical Revolution of 1848 finds its glory in his work.

Whether Nochlin writes about the effect of Courbet's class on his work or the absence of nudes by women artists, or the Orientalism in the work of J.-L. Gérôme, I do believe it was the leftist convictions of her Brooklyn Jewish family that fueled her. In particular their responses in the 1930s, that desperate decade that ended with Hitler's murders, a decade whose one inspiring moment was the fight against Franco in the Spanish Civil War. I think that Linda's attraction to realism, her bond to the nineteenth century is in part a result of her family's commitment to international politics, to the plight of real people suffering real ills in the coal fields of America but also on the hills and mountains of Spain. Linda's family were liberals, mine were Communists, but Spain is a passion we share.

Marxism as a critical tool demands attention to material reality as well as an analysis of the interaction among different spheres of experience. Nochlin was never really a Marxist. Theory per se has always put her off. Or rather she is not someone who marches to one drummer. In fact, she doesn't march at all. Exclusivity and adherence is not her way. To the contrary, she is contrary. Nonetheless, her attention to realism(s) in art and the physical as well as social properties of art proclaims her philosophical roots in Marxism. If she doesn't exactly ask with Raymond Williams, What does art *do*, rather than What art *is*,[5] she has always been committed to an idea of art history that is dynamic, where men and women behave and produce in societies that make specific demands on them. Artists and works of art are not fixed, glamorous shrines. Courbet's roots grow in a popular and not a bourgeois world, gender defines lives of women artists and men, being Jewish effects the look of art, the behavior of artists.

Politics, however, played a strange trick on me. Perhaps on Linda too. The real world was finally a bit too much, and I developed the strange habit of turning life into art. Upstate New York landscapes brought early Monet to mind. A handsome man's body made me think of plump late-classical *kouroi*. Nature – life – put me off. Until about ten years ago, when I found that those very *kouroi* as well as a painting by Gustave Caillebotte did the reverse.

But Linda's work set the bait. If as an American Jew I had fled the after-shocks of World War II, and as the child of Communists I shuddered and withdrew in the face of McCarthyism and the murder of the Rosenbergs and plunged headlong into Art, then her Courbet thesis seemed to say, Try to put the two together. It was the first glimmer.

Then in 1971 came her "Why Have There Been No Great Women Artists?" and so many of us climbed up on those ramparts and with eyes wide in disbelief surveyed the absence of women and went to work on our many, merry, projects of reseeing and rethinking.

My father's youngest brother went to Spain in May of 1938. He was among 45,000 men and women, from 52 countries, who traveled there between 1936 and 1938. Twenty-eight hundred came from the US, from every state in the union except Delaware and Wyoming. They were workers, intellectuals, clerks, artists, lawyers, doctors, nurses, sailors, longshoremen. Some were educated, most hadn't finished high school. They were the first fully integrated battalion in American history. More than a third were Jews. They became known as the Abraham Lincoln Brigade. A third of them died there fighting fascism three years before the US entered the war against Germany.

Why the naked bodies of sculpted young Greek men bring my uncle to mind is hard to say (66). The old habit perhaps of looking at something beautiful and strange, wandering safely lost for a precious moment, abandoning necessity for pleasure, but also examining unknown wounds under cover of illusion. I look at these figures in profile and from the back, their hairless, graceful chests like gently curving violins, their buttocks round like apples. They are young, sturdy men who look away, unthreatening men, and self-contained. If the Women's Movement and writing such as Linda's "Why Have There Been No Great Women Artists?" brought women to consciousness of our presence and absence in history and in our daily lives, it also brought us to consider men anew, the slide between male and female, the muddling of identities. You could care about a sweet young man. Why, you could even be one.

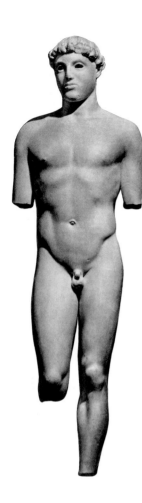

66 Statue of a Youth (The Kritios Boy), 480–470 BCE

67 GUSTAVE CAILLEBOTTE, Man at His Bath, 1884

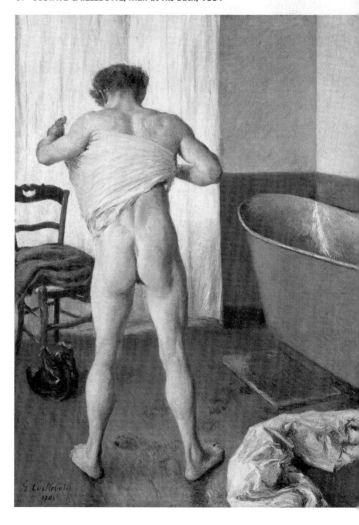

68 First Platoon, 3rd Company, Abraham Lincoln Battalion, Sierra Pandos, August 1938

Gustave Caillebotte's naked man (67) stands with his back to the viewer, his loins ruddy from the heat of his bath, his fluffy auburn hair damp and shimmering. He is muscular, perhaps a swimmer or a rower. You can't tell from looking at him whether his body is the epicenter of his being, or if he is just enjoying a daily pleasure. And so it is when I think of my uncle's body. How can I know how he lived in it? And why he went to Spain.

I found photos of him when I was a child. They were hidden in the attic of my grandparents' rooming house in the Catskills.

"Look at that big picture," my six-year-old brother David nudged me (68): a group of men in berets and soldiers' hats sitting and lying under a tree on a warm summer's day.

"That's Dave," he said pointing to our father's brother on the right side of the picture, with his particular blond hair and no hat, a sprig of flowers tucked behind his ear.

Our cousin Jerry picked out a couple of very small photos (69). In two, Dave wears a dark-colored boatneck sweater over a work shirt opened at the neck on top of which is a rough wool coat. Young man as revolutionary, perhaps.

"Look at these with another guy," says Jerry. "They're like Siamese twins."

"Now he's a soldier too," five-year-old Debby screeches, grabbing another photo (70) and pointing to the man on the left, "You see his hat?" Yes, a soldier, but ghostly, threadbare, a skinny, nervous man whose clothes hang indifferently upon him, just pockets, buttons and sleeves.

"Why?" is the everlasting question. Why did he go? Why did any of them go? It's what everyone asks the vets and they always say, "To fight fascism. That's why we went, that's why we all went." But it's not a sufficient answer. Yes, Dave was a member of the Young Communist League (YCL). He worked for unionization and tenants' rights. He went to endless meetings, distributed the *Daily Worker*, studied. But he was also a dutiful son. He wrote his parents from Spain: "I am sitting on a mountain among vineyards and olive trees covered with the blood of Spain. I am looking at the sunset and I weep, and weep and weep. I am crying with hot tears that are pouring out of my eyes and I don't want to stop.... Because I think of you my dear parents. The thought of the pain and anguish I cause you and the thought that you think of me while you are reading this letter. I cry because I could not kiss you before I left because I could not tell you where I was going and not explain why."

What moves a person from contemplation to action? From the newspaper articles and radio reports, to the first telephone calls, the passport office, the illegal sojourn. In the late 1930s every American passport was stamped, "Not Valid for Travel in Spain."

None of his friends could explain it. They couldn't even tell me what he looked like coming into a room or how he spoke, his voice or his diction, or even his opinions. It was an aura that came to them, a gentleness and goodness that they recalled. He seemed the least likely to leave. One leader of the YCL described Dave as "gentle and sweet, an innocent. His humanity always came out, you felt it all the time. Anyone who knew him, loved him. He was our angel, our sweet loving David." Some one else said, "Dave had a spiritual quality to him, almost magical, a kind of wonderful innocence. But he wasn't adventurous, he was contemplative. He even evoked in you a feeling of, 'What can we do for you? Come on Dave, what can we do for you?'"

When I reach Dave's friend Evelyn Schein for the first time and tell her I'm doing research on Dave, she gasps, "Dave's been on my mind all these years. I can't believe you've found me.... I never knew a man like him, so

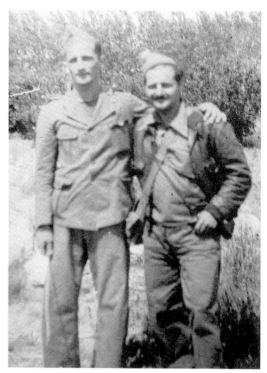

69 Photographs of Dave Lipton alone and with a friend, 1938

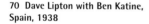

70 Dave Lipton with Ben Katine, Spain, 1938

soft and kind and good. I'd be early for a class and hiding behind a book," she continues, "and Dave would come over and talk to me. It meant a lot. And it wasn't easy in those situations. The men were always vying for the limelight. But not him. He wasn't a flashy, talky, leaderly type. He was dependable, constant. He never raised his voice. He listened."

I ask if she was sexually drawn to him. No, she says, it was never like that. I wonder why, but don't inquire. I think about the playful photographs with the other man.

"Why Have There Been No Great Women Artists?" Linda asked. I wonder, Why don't we heroize gentle men? Why do the writhing figures in Hell seem alive and not the angels? Is there no frisson for the boys who watch and wait, who act in their own good time, who listen?

Why did my uncle go? I can't stop asking. No one I know has gone to Bosnia or Rwanda or Kosovo.

Alvah Bessie, a vet of the Brigade and a writer who later became one of the Hollywood Ten and was blacklisted, answered the question this way: "Men went to Spain for various reasons, but behind almost every man I met there was a common restlessness, a loneliness. In action these men would

fight like devils, with the desperation of an ironbound conscience; in private conversation there was something else again. I knew, about myself, that the historical event of Spain had coincided with a long-felt compulsion to complete the destruction of the training I had received all through my youth.... It was necessary for me...to work...in a large body of men; to submerge myself in that mass, seeking neither distinction nor preferment...the opposite of a long middle-class training."[6]

The poet Edwin Rolfe, also a vet, has this response: "Just what it was that sent each single one of these Americans across the Atlantic to fight for the independence of Spain will never be completely known. The bridge between the impulse and the act is a highly personal process.... There is a no-man's land between conviction and action into which the great majority of humankind never venture."[7] Never venture.

Everyone in my family has an answer to, Why? Dave's oldest brother Phil says, "He had nothing to do in the United States. He had no profession, no goals. He couldn't turn to his parents. And our other brother was only interested in women, sex and cards. I lost my grip on him." My father says, "Dave was involved politically a hundred percent. I can't even visualize this guy *looking* for a job, he was so involved politically. Look, he had his mind made up. He felt he had to go. It was commitment. That's why he went." My mother's explanation about her brother-in-law's departure was that his mother was overbearing. "Dave had to get away," she tells me. When my brother looks back on his uncle's act, he's angry. "Why the Cause," he asks, "and not the family? To give your life for a great cause, or for humanity, is easy. But to support your family, to support one person that you love throughout his life, that's what's tough. He betrayed his family. He didn't get a job, and he ran away."

I see this man, my uncle, on the day of his departure on the deck of the SS Manhattan, 18 May 1938. He searches the pier for someone he knows. His teeth hurt. He grips the railing, his heart beat shoving his chest up and down. He strains to hold in his tears. He reminds himself that he has to go, that it's the only honorable thing to do. He has no job, Spain is being destroyed, his best friend Larry is leaving the city.

The tug begins to pull the ship out and anxiety overwhelms him. He fights the urge to jump and go home. He turns and scans the deck searching for the twelve other volunteers he knows are on board, but whom he's not supposed to contact. Seven are returning volunteers. That's what committed people do, Dave thinks to himself, what it means to them, the Spanish Republic, democracy, fighting fascism.

Across the sea with new comrades and a blue sky, plenty of time to think, too much time. Push it away. Don't worry. Concentrate on where

you're going and why. Traveling down to Paris, then further down to the southwest of France and across the Pyrénées. No one speaks. You pull along, one behind the other, knowing you are heading exactly where you mean to be.

Alvah Bessie wrote: "You felt: many of these men will never see their friends or families again; they don't know what they're getting into; their idealism has blinded them to the reality of what they will have to face. And you knew immediately that you were wrong; that they were so far from being blind that it might be said of them that they were among the first soldiers in the history of the world who really knew what they were about.... Their very presence on the French frontier was a [pledge] of their understanding and their clarity; no one had made them come...."[8]

My uncle stumbles, and suddenly he's worrying about his mother. He's hungry, a gnawing feeling in his stomach, a touch of nausea. Why is he thinking of her? She would know he was hungry. He misses her. He looks up from the stony mountain path, stunned by the majesty of the night sky and all the men pushing together across to Spain. Yes, this is what he wants to be doing. And when finally he is there—across the border—he weeps and laughs with the others. They hug each other. For a moment they rest. It is early June 1938.

In 1988 Linda published "Courbet's Real Allegory: Rereading *The Painter's Studio*." She peruses the literature on the painting and finds that everything appears to be known about it, "The search for meaning is apparently exhausted," she says, "there is nothing left to discover." This, of course, irks her as she finds herself "shut out of the house of meaning." Studying the painting she notices that she is drawn time and again to the impoverished Irish woman suckling her baby left of center. She begins to pay attention to her attachment to this figure and in a burst of uncanny brilliance she decides to read the painting *as a woman* across the body of the beggar woman. Nochlin tosses her red head, girds her own aging body, and though speaking in requisite critical cadences, she roars out her ownership of her life-long experience and strides across the discourse of that painting like Liberty on the Barricades. She writes:

> For me, reading as a woman...the Irish beggar woman constitutes not
> just a dark note of negativity within the bright Utopian promise of the
> allegory of the *Painter's Studio*...but, rather, a negation of the entire
> promise.... Figuring all that is unassimilable and inexplicable—female,
> poor, mother, passive, unproductive but reproductive—she denies and

negates all the male-dominated productive energy of the central portion, and thus functions as the interrupter and overturner of the whole sententious message of progress, peace, and reconciliation....[9]

This performance makes me wonder what writing as a Jew would be like.

What made my uncle leave? All the little things and the final straw? Could it have been Hitler? Was he afraid as a Jew? Was he afraid for his parents? Was the Nazi annexation of Austria in March of 1938 the decisive event for him? Hyman Katz writes his mother from Spain on 25 November 1937, "Together with their agent, Franco, [Mussolini and Hitler] are trying to set up the same anti-progressive, anti-Semitic regime in Spain, as they have in Italy and Germany...can I sit by and wait until the beasts get to my very door?"[10] Wilfred Mendelson writes to his parents on 22 June 1938, "One word to Sam on the Jewish question. The real international language here is Yiddish. Jews from Germany, France, England, Poland, Czech, Hungary, Rumania, all the front ranks of their respective movements have come to battle the common enemy of the workers, and of the Jews...."[11]

Did my uncle care about being Jewish? He was a Communist for whom such distinctions were discouraged. Still, his native tongue was Yiddish. It's the language he spoke with his parents, the language he wrote to them in. He followed the European news in the Yiddish *Freiheit*, as well as the *Daily Worker*. Was this blond Benjamin of his family going to war to protect his parents?

I ask Dave's friend Bill Wheeler, whom he met on the boat going to Spain, "Did it matter to you that Dave was Jewish? Did you think about it?" "No," he said, "we didn't think about such things." Then five minutes later he said, "To tell you the truth, I think I went to Spain because of my Jewish friends, because of what Hitler was doing to them, and then his going and helping Franco."

Bill was the Captain of Dave's Company. I met him through an inquiring letter I'd sent to a number of vets of the Brigade. I'd included a photo of Dave with his comrades under the tree in Spain. Bill wrote this to me:

I do remember your uncle...and now thanks to you, he has a name that time and a flagging memory have erased. Dave's death more than any of the too many others I have witnessed has haunted me to this day.... We were at rest the evening before the crossing [of the Ebro]. He handed me a letter written in Yiddish asking me to mail it to his brother...if anything should happen to him. I remember telling him 'You will make it O.K. Just remember to keep your head and fanny down.' The next day he asked for the letter back and tore it to bits. It

was shortly after this that I was checking our position at the front and Dave walked over towards me asking [me something]. Just as I yelled to him to get down, he was struck by a sniper's bullet [and sank] slowly to the ground in front of me.

Dave knew he was going to die the instant he opened his mouth to speak to Bill and watched something flickering on the horizon when he should have been looking at Bill. Something pulled him away, some longing to be somewhere else. What horrors he had already seen. His comrades, handsome in their stolen moments, smoking a cigarette, gazing at the cloudless sky, sometimes looking directly at him, their thick hair and smooth skin, the wild pulse of warfare followed swiftly by the sullen emptiness of waiting. Then those same heads torn to gory shreds, blood and tissue, nothing where their eyes and soul had been.

The International Brigades leave Spain at the end of October 1938, a defeated army. On the morning of 29 October, Spaniards fill the streets to say goodbye. Dolores Ibarruri, a Communist leader known as La Pasionaria, addresses the crowds:

> They gave up everything, their loves, their countries, home and fortune; fathers, mothers, wives, brothers, sisters and children, and they came and told us: "We are here. Your cause, Spain's cause is ours...." You can go proudly.... You are history. You are legend.... We shall not forget you, and when the olive tree of peace puts forth its leaves again, entwined with the laurels of the Spanish Republic's victory— come back!... Come back to us.... [T]he whole Spanish people...will cry out with all their hearts: Long live the heroes of the International Brigades!...[12]

In October 1996, the surviving Brigadistas traveled to Spain and were made honorary citizens. Celebrations and banquets took place all over the country. Cities poured out to greet them. The sound of clapping hands filled the air like so many castanets, and everywhere the Brigadistas went a corridor opened up for them, and tears flowed down the cheeks of young and old as hands reached tenderly towards these ancient warriors. Gracias, they called out to them. Gracias.

So, a memory of Spain for Linda, a tiny piece of the rich mosaic that has been and continues to be her life.

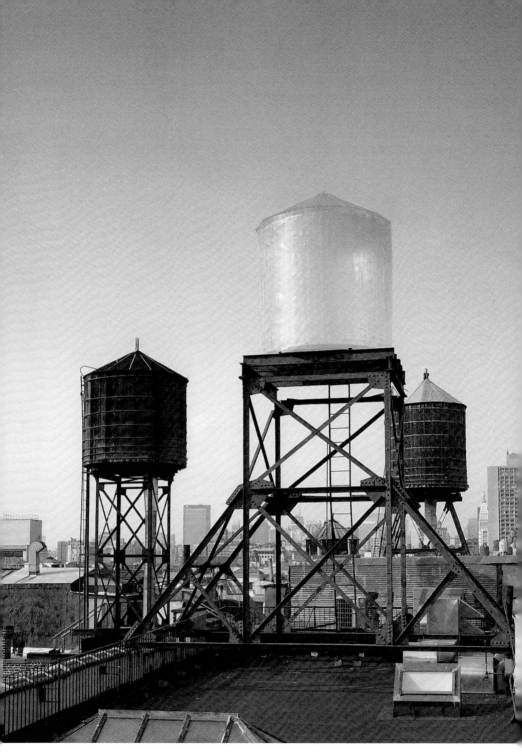

71 RACHEL WHITEREAD, Water Tower, June 1998–June 1999

The scene is set. A clear water tower, its walls gone, sits blankly against a white sky. Words from the diary of a German artist are heard. His name is Gerhard Richter. Like the water tower, he addresses the city of New York.

> The more the city fascinates me, the more I suppress the overwhelming rage and hostility that I feel towards this city, in all its magnificence, modernity, beauty, and above all its incomparable, unmatchable vitality, which are denied to me, and which I can only admire, full of envy and raging, impotent, hateful jealousy (as a Cologne, Düsseldorf, Dresden man); this city of the elect and the privileged, of wielders of power and decision-makers, which implacably raises up and destroys, producing superstars and derelicts; which is so merciless and at the same time so beautiful, charming, dreamlike, romantic, paradisal. The city that exerts such a deadly fascination; the city that has killed many others besides Palermo. This city, this monster, with its tall, old buildings that seem so familiar and cosy and convey such a sense of security. I envy the New Yorkers, and I think with discontent of Germany, the stifling fug of its society, its affluent philistinism, its all-smothering, oppressive ugliness. I shall rebook tomorrow and fly home early.[1]

In the distance a plane in retreat.

Manhattan has many skylines, all of them deadly and fascinating, a gray sea of waves. Big cities often drown their young as well as their artists, their own as well as their outsiders, but New York's version of this treachery usually strikes after a dream dissolved in gold. The dream contains recurring episodes, applause, excitement, the rush of windfalls, profits. The mythical skyline arches over it all and has succeeded in becoming the dream's physical equivalent, which is why New York has dominated the idea of the city in the twentieth century and been the measuring stick for all the others. Nowhere else has an urban sea seemed to reach from the depths of hope to air.

At the edge of the scene any number of words could be heard. Like Richter's they are isolated lines, spoken from the past, offstage. Ten years before Richter, Josef Beuys had made an entrance, all wrapped in felt, in

New York to live with a coyote in an art gallery, proclaiming that he liked America and that America liked him. America is not usually measured in coyotes. Nor is New York, where locals have been more inclined to calculate in terms of rats. A few years after Beuys, the Dutch architect Rem Koolhaas would come and count the rabbits, their population by then pretty much erased in the evolutionary step toward what he was calling the modern city's Culture of Congestion.[2] He himself would neither romance the city nor leave it abruptly; he just called himself Manhattan's ghost writer, a young architect sketching a collective delirium terminating on a grid. Only later would he acknowledge the strength of the tide. "This architecture," he said, for he now wrote more summarily, "relates to the forces of the Grosztad like a surfer to the waves."[3] Foreigners have often seen New York's surfaces better. They have the advantage of seeing them fresh.

Recently the Public Art Fund gave Rachel Whiteread, who is English, the opportunity to make the clear tower. She made it cloud but kept it light. She wanted to find a form that would take one away from the city crowd and produce a brief difference, an interruption, "a peaceful moment" she kept saying, that would draw no particular attention to itself.[4] She told those who kept asking that she wanted "to make something not there."[5] She stayed away from both the crests and the streets. Her tower redraws the line between the city and the sky from a point not even ten stories up. It is as if the entire skyline has been lowered, as if something had pulled on the fable's hem, something going under the urban surface here. But Whiteread knew her tower would be subjected not only to the implosion of the Grosztad but to light. "On a cloudy, gray day," she explained, "it might just completely disappear. And on a really bright blue-sky day, it will ignite."[6] She would retreat from the skyline to return to it.

Right away Rachel Whiteread saw that she would retreat and return through the figure of a water tower and that she would be casting an existing wooden one of the nineteenth-century type into clear resin. For those familiar with her work, this seemed perfectly logical. Rachel Whiteread is known for her casts. The casting she favors is descended from the ancient craft process of retreat and return in which a mold is made of an object, the mold is removed and then separately refilled with another material. Molds were made to be broken at the end of the process; typically the finished product emerged made of something else. Through the ancient process, objects found their negatives and then through a transformation lost themselves and them; one surface detached from another only to be itself subjected to a new surface's detachment from it. Objects kept coming, then their solid shadows, from which emerged new objects. Objects were not exactly returning, it would be better to say they were recurring. The tower would be no exception.

The tower would be cast and brought back in resin, lighter, a clear ghost of itself, looking like nothing, looking like solid water. It would seem intangible and weigh $4^{1}/_{2}$ tons. Close up its surface still shows the imprint of the original wood wall but from a distance it looks as though any trace of the wall has vanished entirely, leaving only the contents to stand there, rather improbably, straight. But in fact only the inside of the tower has been cast, which means that the clear tower is actually no tower at all, only an unbroken mold which has pulled an inside, a void, solidly out. It sits on its dunnage as a vision and a riddle, a surface. That's all. No other tower will ever be cast from it. Water must tower. A negative must be read positive. Whiteread made all this read for the city.

The surfaces of her earlier work had been fairly clearly pulled from the surface of death. As if to explain, she would tell her first interviewers about having had an odd job cleaning up in Highgate Cemetery; she might go on to tell of a TV documentary showing the metal coffins at Spitalfields being relieved of a sludge.[7] Her early cast of a Victorian room would bear the title *Ghost*; her early cast of the space under a bed would be called *Shallow Breath*. She would speak at some length of the importance for her of J. G. Ballard's novel *Crash*: "It was the exploration of the sexual nature of our relationship with machines that interested me... The main character is obsessed with the eroticism of mutilation and wounds inflicted by car accidents. Seeing the imprint of the dashboard on someone's face. It's a bizarre kind of casting; the imprint where the animate and the inanimate meet." And then she would continue, "although I don't think my work is necessarily about death. It has to do with the way our culture treats death; other cultures celebrate it and we try to brush it under the carpet."[8]

She herself brushed death somewhere else in order to meet it and cast it. The precise location and composition of death remained mysterious. Somehow she got it outside. She showed her results, rough plaster surfaces bearing the touch of former surfaces, sometimes lower class Victorian walls, sometimes plain ordinary things. She was making casts from a variety of different materials, using a range of colors and textures that as much as suggested human body fluids and postures, clitoral folds and nipples, and she would say so. She still was casting used things, household objects and the furniture of rest, bathtubs and mattresses and chairs. She would prospect for these objects in roadside rubbish and flea markets, not minding that the old things heaved the touch and smell of humanity at her as she took them away. She fully accepted the possibility that she might find their piss on her face.[9] But ultimately hers would be a dry theater of casts without characters and she herself would offer fewer and fewer words to their viewers. Things alone would enact the shift of a life out of time, out of body, the shift to

another color and dust. In their recurrence they appeared to contain the force of a fate. But they never would speak, not even in oracles, not even through questions.

One wishes for words though, or at least better vantage. For one must go higher than skyscrapers to speak of this kind of encounter, outside, with death and even then simple overviews are impossible. Nietzsche gave his over-man, Zarathustra, the power to see these things. But what could Zarathustra say after the sight? Zarathustra began by speaking to the sun and then descending, in Nietzsche's words, going under. He would pull his own abyss out into light. But Zarathustra himself would fall and nearly die from the nausea brought on by this unthinkable inversion of consciousness. "To every soul there belongs another world," he said afterward to his animals; "for every soul every other soul is an afterworld. Precisely between what is most similar, illusion lies most beautifully; for the smallest cleft is the hardest to bridge." And the animals would reply at length, formulating this recurrence for him as the existence of being in every Now, and the sphere There rolling around every Here.[10] They begin to describe something of the effect of Whiteread's procedure, her molds' small clefts and their sensation of some latent There. Her traffic with the after-life is not modern.

In ancient Egypt the exchange with death was understood to take many lifetimes; mummification built man a stage known only to the tomb. In ancient Greece, it was understood that this kind of knowledge, if brought to light, could weaken and defeat a city. Remember the wooden horse. But this is the late twentieth century. Wooden horses no longer hold armies and Zarathustra's animals have scattered. Ours is a time of little explanation. The city of London can be surprised from the East by a sculpture. This occurred in 1993 when Whiteread took a Victorian terrace house in east London, in Bow, that had already been slated for demolition and, as a commission for Artangel, cast its interior into a concrete block.[11]

Her *House*, as it was called, stood on a green, alone, oddly solid. Its surfaces had once contained the air of an actual home but the air, warm or damp, and the talk inside was all gone now, sucked out before it could be fanned into the echo and scuttle around it. *House* took the Here and There paradox to an architectural scale. Whiteread would speak of having wanted to mummify its space.[12] This time around, everything she said in public was being quoted extensively. She found herself being turned into a suspicious person. Suddenly everywhere there were many people beside her and they were speaking at once.

House attracted the attention of the city in a way that few works of art in our time have managed. Torrents of admiration and abuse of all kinds were unleashed. Some took the form of words scrawled on the house itself:

"HOMES FOR ALL BLACK + WHITE." "WOT FOR"; "WHY NOT?" Some became pictures. A happy face turned up; so did a skull and cross-bones. Sidney Gale, the former owner, complained loudly, not realizing how his small attempts at politeness would be made to sound in the press. What did he think when his words became broadsides for attribution, announcing "they've taken the wee-wee out of me?"[13]

The critic for *The Independent* praised *House* as extraordinary.[14] The local councillor, Eric Flounders, called it an "excrescence." Flounders received much press coverage for his repeated attacks on *House.* At one point he wondered why someone, for he addressed a particular interlocutor, "from the leafy elegance of South Edwardes Square, where a lump of concrete of this type would never be tolerated, feels able to inflict this monstrosity on a local community which has clearly said it does not want it. Public sculpture," he continued, clearly warming to the larger issues raised by his subject, "is answerable to those whose environment it inhabits, and on that basis *House* has no place in Bow. Nor, for that matter, do the disruptive crowds who come to see it. The argument that it 'makes people talk' is equally absurd. A ten-foot pink plastic penis in the middle of South Edwardes Square would make people talk, but I doubt if you'd favour it."[15] But there were those in Bow who called it lovely, like the bus driver who lived across the street.[16] The British tabloid press kept is own sarcastic, running score. What was it about *House* that made people scramble for alternatives like this? *House* itself simply stood there implacably against the charge, faced with a city, an unwanted chorus, wild words, and a circus. The conditions of theater do not quite suffice to describe all the play in this situation. The scene in London had unravelled. Congealed air met the wind.

House was demolished in early 1994, as planned, after being shown for three months. Its demolition finally cleared the block to which it had once belonged and let it become a fully green space, the kind of new urban condition advocated by the councillor. But if this can be considered a war, *House* was Whiteread's victory. For it she won Britain's Turner prize. Meanwhile she had started a fellowship year in Berlin, had already participated in "Documenta 9" and was now using not only London, as she liked to say, for a sketchbook but also Germany.[17] Her work moved easily through the corridors of the international art market. In 1994 the Public Art Fund in New York commissioned *Water Tower.* Not long after that Whiteread would win the competition for a Holocaust monument in Vienna and in 1997 she would be chosen to represent Great Britain at the Venice Biennale. She had begun working more consistently with and on a large, often architectural scale. And her work had come to pull its insides out into outsides farther and farther from home and the grave. It could now expect to face an ever-

widening scene, a spreading outside, a locale looking more like a world. Was it only an art world? Can such an outside even be considered a city?

What is a city? By now the answer to this question is not obvious even to professionals. The very icon of metropolis, New York, is fluctuating unnaturally. And the dream of gold? New Yorkers always knew they lived in a city constantly being re-articulated, especially if one looked close, but these days the pace of change, much remarked, is fast. The city is being penetrated by massive new influxes of foreigners, who bring to town not only fresh sources of labor but also fresh capital for investment and development. The immigration rate is now as high as that at the beginning of this century. Immigrants comprise more than a third of New York's 7.5 million inhabitants.[18] Currently the city's immigrant population is counted at 2.7 million (or 36% of the city), with 60% of its population either themselves immigrants or children of immigrants. Most are black, Latino, and Asian.[19] They speak many languages. They bring economic links with them that cross urban and national borders. For this flow of labor and capital is fueling the late twentieth-century's transnational economy. A new dynamic of retreat and return, dream and danger, hope and air, is resetting the city's image and redrawing the city's limits. The conditions of theater do not describe this situation either.

Above planes arrive. The new immigrants, whatever their social class, move differently than their forerunners did. They usually keep real contact with their homeland, telephoning it often and flying home periodically. It is not unusual for immigrant communities to operate their own native-language radio and TV channels and to broadcast the day's regular programming from home. The Koreans in Queens, the Russians in Brighton Beach, the Dominicans in Washington Heights, the west Africans in the Bronx, for example, have new ways to grasp the simultaneous presence of There and Here and Now. They have lives of global scope. Their paths can subsume the same cities that once consumed souls. The skyline is being crossed daily. Above planes depart.

These conditions do not appear as random or loose generalities. Typically people express them differently. For half a century, the New York community from the Mexican village of Chinantla has made an annual pilgrimage back. Leticia Lopez goes on break from college with everyone else to admire the sky, "nice and blue," and the quiet: "People [there]," she says, "don't go through the same crazy routine: wake up, go to school, go to work, go home, eat dinner, go to sleep. Down here life has time to breathe."[20] Liliana Maldonado, a computer student, makes a similar trip every summer to her parents' hometown in Ecuador. "What it feels like to me," she says, "is a relief."[21] But these are pauses in a rhythm that returns them to New

York. Fernando Mateo, a successful businessman known nationally for his campaign to trade toys for guns, a child of Dominicans and a man who, like many new immigrants, holds onto dual citizenship, expresses his and their situation very simply: "I believe people like us have the best of two worlds. We have two countries, two homes. It doesn't make any sense for us to be either this or that. We're both. It's not a conflict. It's just a human fact."[22] It's just the route they take with their families through life to death. In 1996 more than half the Dominicans and Mexicans, a third of the Ecuadorians, a fifth of the Jamaicans, and 16% of the Greeks who died in New York City were sent home to be buried.[23] They will not have been immune from New York's treachery; the living know they could well find themselves in the position of Amadou Diallo, a Guinean street vendor who had already divided his childhood between Liberia, Thailand, and Singapore while his parents set up their business in gemstones. As a teenager he too would spend summers in his parents' village of Hollande Bouru. And then he would come to New York and die young when forty-one shots were fired at him by police as he stood unarmed in his doorway.[24]

When Rachel Whiteread looked for a peaceful moment in this New York City newly awash in new people, did she know that it was now regularly being found in Africa, in Mexico, in Ecuador? And that such a peace was not taken as a vacation? She gave peace an urban shape in her inverted tower of water. Was it rural? She had once described a rare country moment, "when there are no birds singing and there's no wind, you just get this silence that is absolutely concrete, it completely smothers you."[25] It gives the country an urban condition. But New York is not itself capable of this kind of silence. Moreover New York no longer seems solid.

The new immigrants have been joined by an equally dramatic increase in new tourists, many of whom are American citizens. It is said that last year some 33 million tourists came to New York, of which only a fifth were foreign.[26] But New York's expanding tourist industry is geared toward the foreigners, for they have been shown to be the economic force, spending some $1.3 billion last year just on shopping whereas all the American tourists put together doled out not even half that.[27] Compared to the super-profits of the city's financial and real estate markets, this seems relatively small potatoes in comparison, but the combination of all these different capital expenditures has led to a much higher level of sales pitch and prosperity on the city's streets, one aimed at everybody. The streets of Manhattan teem with the activity of mixed economy, increased services, hype. There is more neon, larger signage, a faster flicker and a growing electronic shine. This is a city proposing a glowing transnational scale for the measurement of life. It is no longer defined by monuments or waves.

Infatuated with both Wall Street and Times Square, it has yet to find a single image. It may not have an image.

Against this scene, which is shuffling people and light and is at heart sceneless, Rachel Whiteread wanted her *Water Tower* to sit, not there. She had hoped to find a site for the tower in an anonymous neighborhood. The best site to emerge was ironically in Soho, the old seventies art neighborhood in lower Manhattan that had become synonymous with the eighties art boom and is now being further revised into a zone of luxurious residence and retail. Soho too has its share of large signage. The rents for its retail spaces have increased by half during last year alone. Another magnetic combination, an aesthetic patina, a haven for new tourists.[28] On the day of the *Water Tower's* installation Rachel Whiteread joined them. Standing on the street, she remarked to no one in particular, "I had nothing to do with it. I'm just a tourist."[29] Is this a fact?

What is an artist? Neither tourist nor traveler exactly, Whiteread works in New York temporarily, a foreign artist making foreign art, in this case a tower organized by the American-based and privately operated Public Art Fund and sponsored by Beck's, the German beer. One would not want to call her an immigrant. Artists usually are not. Immigrant remains a word laden with inferior, unprofessional class connotations, despite all the late twentieth-century evidence to the contrary, despite the mutation of the term immigrant into a word of increasing ambiguity. Let us say to begin with that Rachel Whiteread's sphere of operation and the scope of her work make it necessary to call her a global artist, a global artist being nothing less than a form of new immigrant, a person perpetually half-assimilated and airborne, a living soul always there and not there. Her *Water Tower* takes on many of the qualities of the immigrant as it rises above the domain of all the people, all the characters. It rises above the skyline to be seen above it against the sky. However it looks more like the city. It will be a sceneless structure. In that way it speaks not only for the new urban fabric but also to the new condition of the global work of art.

The imploding spine of the art genealogies cannot very well explain or support the *Water Tower*, no more than a borrowed scenario will. So much has had to go under to get to this point. The individual work of art has had to step beyond itself and aspire to the size and capitalization of architecture in order to register its individuality and find notice internationally, even if it does not want to abandon its former activity entirely and become architecture outright. It is frequently said that this greater size and cost make it more difficult for collectors and even museums to hold the large work of art. But equally there are blessings. For a large work of art like the *Water Tower* is in effect asking to be held only by the world. There it can enter the

expanding scene of global lives; perhaps there it will find and touch them. Perhaps in its inversion of urban conditions solids will exist as mobile voids. Neither self-contained nor a self-figure the *Water Tower* retreats and recurs; it can be there and not there; it can renew ancient casting techniques; it turns on an antiquated form. It can show the present and the past something of their place. It can trade in paradox. It seems to hold paradox. Therefore it cannot simply be a tower. Let it also be a well.

As Zarathustra traveled further along his path, he made a practice of speaking in aphorisms that tested perception, for he disdained the practice of knowledge as nut-cracking.[30] He tried instead to show what another way of thinking might entail. "Ice cold," he declared, "are the inmost wells of the spirit: refreshing for hot hands and men of action." His disciples listened. He continued, "You stand there honorable and still and with straight backs, you famous wise men: no strong wind and will drives you. Have you never seen a sail go over the sea, rounded and taut and trembling with the violence of the wind? Like the sail, trembling with the violence of the spirit, my wisdom goes over the sea – my wild wisdom."[31] Ultimately he would prefer to use song to express this path of his thought, though his songs have no score and sound like puzzles. Even in the late twentieth-century city, there is no singing them again. Zarathustra too can only speak now from some indeterminate point offstage. If night has come and all fountains speak more loudly, how now is Zarathustra's soul too like a fountain?

Can a tower too be water? Can water be sky? No city on earth, no life on earth, has the scale of the sky. Whiteread has given her tower an unusual ability to contact it, as if through light alone the tower could come to detach and attach to its height. The tower lets the light of the sky fall through it like fire; at night it hides. In its clarity it accepts the sky's every mood, every color, every darkness, every dawn. And yet the tower cannot transcend itself and become death or sky, it must keep the form of a tower, of its nothing, of its water. Some call it a ghost. Sometimes it plays like a child as a cloud. Yet through it, an idea of another life is being washed upward; an idea is being defined by the elements. We have come very high. Clouds are notoriously silent. Normally water falls.

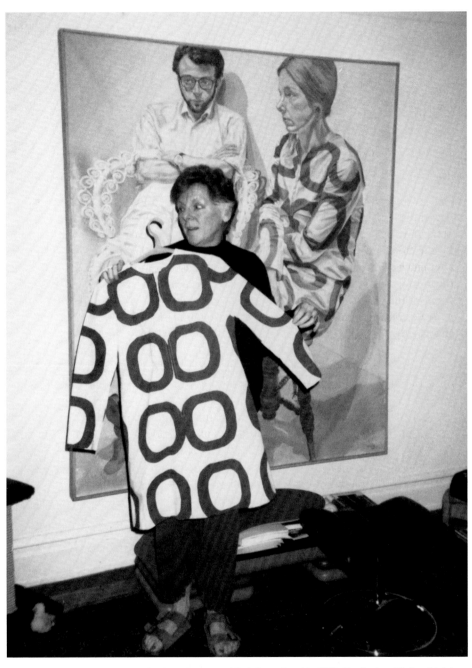

72 Linda Nochlin posing with the dress she wore while being painted by Philip Pearlstein, with Pearlstein's Portrait of Linda Nochlin and Dick Pommer visible behind her, New York, ca.1990

Nothing, I think, is more interesting, more poignant and more difficult to seize, than the intersection of self and history.

Linda Nochlin, 1994

New York City, January 1974

In her hotel room at the College Art Association, Nochlin and I are meeting for the first time. She interviews me for a position at Vassar College, but after much deliberation I decide to teach at the University of California, San Diego. I always wonder, however, what it would have been like to teach with Nochlin.

How would my own intersection between self and history have been changed by daily conversations with her?

Bay Area, California, February 1997

Nochlin is lecturing at Mills College, Oakland, where I teach, and – amidst a series of excursions (a particularly vivid memory is of Nochlin boldly singing Spanish Civil War songs for half an hour while I drive cautiously along twisting mountainous roads) and conversations about feminist art history, friendship, old age, community, traveling and multiple homes – she tells me she is planning to write an autobiography, *A Walk in the Park*, which will begin in the Brooklyn parks of her childhood.

I often ask myself over the next couple of years, how will Nochlin write about her work and life from the vantage point of her later sixties? How will she now remember her childhood?

New York City, April 1999

In the elegant, chandelier-lit lecture room of New York University's Institute of Fine Arts, which is hosting "Self and History: A Symposium in Honor of Linda Nochlin," I start my fragmented, performance-like presentation, "Self/History Intersections from A to Z," with a slide inscribed with questions addressed both to Nochlin and the audience. They read:

"The self?

History?

The intersection of self and history?

Intersections?

Interventions?

Inventions?

Inscriptions?"

My presentation is deeply colored by the experience of the current war in Kosovo, and by an intense exchange in London during March of 1999 with Rose Hacker, my adopted mother, and Alice Sommer, a friend. Both these Jewish women are in their nineties: Rose spent some of the war living with my mother and myself outside London, and Alice, a Czech Jew, kept herself and her son alive in the Theresianstadt camp for two years by playing the piano to camp visitors. As we went back and forth painfully between memories of World War II and the current situation in Yugoslavia, I felt the poignant intersection between self and history deeply present in our conversation.

In the NYU symposium I announce that I intend to return shortly to New York to visit with Nochlin, and that "among the conversations I would like to have with her – if she is willing – is how does being Jewish affect her sense of self and history. Another question I want to pose is how does she see her age affecting this intersection. We will be, you must remember, two women in our later sixties talking to one another."

New York City, May 1999

Eleanor Roosevelt and Glenn Gould represent the two qualities I hold highest, social justice and beauty.

Linda Nochlin, 1998

In Nochlin's West End Avenue seventh-floor comfortable, slightly old-fashioned apartment, we begin a series of taped conversations, often based on Nochlin's responses to images – which I have selected from her huge collection of photographs – that I place on the dining room table in front of her.

[Photos 73 and 74] We pore over a small album of informal snapshots, which record the summer of 1941 that the ten-year-old Linda Weinberg spends alone with her mother in La Jolla, California. In one a smiling child crouches in the waves, and in another, a smiling woman sits upright on a grass lawn near the sea.

73 Linda Weinberg, La Jolla, California, 1941

74 Elka Weinberg, La Jolla, California, 1941

[Photo 75] Nochlin, a seventeen-year old, wide-eyed young woman, who is part of the first American youth-hostel group, visiting London after the war in 1948.

[Photo 76] Nochlin, an elegantly dressed young instructor, and the recent author of "Why Have There Been No Great Women Artists?" standing in 1972 in the grounds of Vassar College, Poughkeepsie.

[Photo 77] Nochlin, hat pulled down rakishly to one side of her head, hand on hip and a palm tree behind her, posing in a bathing costume in Miami, Florida in 1965.

[Photo 78] Nochlin, madonna-like, holding her young daughter, Daisy, in 1969. In this year, she later writes, "Three major events occurred in my life: I had a baby, I became a feminist, and I organized the first class in 'Women and Art' at Vassar College." [1]

[Photo 79] Nochlin, standing together with Ann Sutherland Harris and Pierre Rosenberg, at the opening of "Women Artists, 1550-1950" in Los Angeles, a 1976 landmark event in feminist art history.

75 Linda Weinberg, age 17, and friend, London, 1948

76 Linda Nochlin, Vassar College, Poughkeepsie, 1972

77 Linda Nochlin, Miami, Florida, 1965

78 Linda Nochlin with daughter, Daisy, 1969

79 Anne Sutherland Harris, Linda Nochlin, and Pierre Rosenberg at the opening of the exhibition "Women Artists 1550-1950," Los Angeles County Museum of Art, 1976

80 Linda Nochlin and friends at an abortion-rights rally in Washington, DC, in 1995. Top row, left to right: Rosalyn Deutsch, Abigail Solomon-Godeau, Liza Solomon; bottom row: Diane Neumaier and Linda Nochlin

81 Linda Nochlin and Ewa Lajer-Burcharth, Moulin-de-Torçay, France, 1993

[Photo 80] Nochlin, an activist, participating with other feminists in an abortion-rights rally in Washington DC in the early 1990s.

There are also abundant images recording festive and poetic gatherings with friends, for example:

[Photo 81] Nochlin and Ewa Lajer-Burcharth lolling in two lacy, elaborate hammocks in a wooded area in Moulin-de-Torçay, France, in 1993, and

[Photo 82] Molly Nesbit and Tamar Garb laughing, as they attend a dinner party at Nochlin's New York apartment in around 1993.

There are also photographs of Nochlin alone.

[Photo 83] In Hawaii in 1998, Nochlin, dressed dramatically in black, and surrounded by the stony gray landscape of Volcano National Park, looking out confidently through dark sunglasses.

[Photo 72] In New York around 1990, Nochlin glancing sideways, holds up the blue and white dress which she wore in Philip Pearlstein's 1968 double portrait of herself and Dick Pommer, her second husband. Behind her on the wall of her apartment is the painting itself.

During our three days together in Nochlin's Manhattan apartment, we explore, analyze and speculate about the varied spaces and times of her life

82 Molly Nesbit and Tamar Garb at a dinner party at Linda Nochlin's apartment, ca.1993

83 Linda Nochlin, Volcano National Park, Hawaii, 1998

and writings, looking through published and unpublished texts, notebooks, and diaries – hour after hour, from morning until evening. Sometimes we eat, either in her apartment or a nearby restaurant; occasionally, exhausted, we sit in silence, but for the most part we continue to talk.

Out of this intense exchange, I have culled (extensively rearranging and editing) some of Nochlin's memories and thoughts about four topics: childhood, writing, the relationship of self and history, and "defining moments" and friendships in her life.

Part 1. Of Childhood

LN: "I realized I was brought up with idealism, care and attention and with excellence and beauty, and so I was startled to find out later that the rest of the world wasn't like that. It was not a childhood that prepared you for life's hard knocks, and I realize that a lot of my weaknesses come out of that experience."

MR: "And also your strengths?"

LN: "Yes, both."

Jules and Elka Weinberg, Nochlin's parents, were married in 1930, and Linda Weinberg is born on 30 January 1931, their only child. The family lives in Brooklyn, New York.

She attends the Brooklyn Ethical Cultural School, a highly progressive school (the song for Nochlin's graduating class in 1943 was "Hail the Hero-Workers") where creativity is stressed. "We were loved and cherished by the most extraordinary teachers, whom I actually kept up with in later life." The students read poetry, and write plays; boys and girls are treated equally; and Nochlin, a precocious child, flourishes in this environment. She loves art, and paints all the time. She also writes: in 1940-1941 she produces a little handwritten book, in which she announces, "I may not be very well informed upon the subject of modern art but from what I have seen of it, I still don't know why they call it art."

Nochlin regales me with stories about her grandparents and her parents, and about great-uncle Abraham, a wealthy dapper gynecologist, who meets and marries Happy Fanny Fields, a glamorous star of the British Vaudeville stage.

[Photo 84] "We have quite an assortment of pictures and postcards of her, mainly in her Dutch Girl costume, but here is one of Fanny as Gretchen in *Aladdin*."

We browse around in piles of loose photographs, some dated and some not, and through many photo albums, old and new. We search through the 1938-1939 volume of *Who's Who in American Jewry* to find biographical entries on her two grandfathers, Jacob Heller and Harry Weinberg.

[Photo 85] "This studio portrait is from 1880, and was taken in Vineland, New Jersey which is where the Greenspuns, my great-grandparents on my father's side, settled. It was a kind of utopian colony, founded by the Baron de Hirsch, to help Jews establish themselves in this country by learning to farm."

"For me, they're like historical characters. My grandmother Weinberg (née Minnie Greenspun) – she is the baby in this photograph – is the only one I really knew, although maybe I did meet my great-grandmother. My grandmother grew up in Vineland, attending a one-room schoolhouse there. I adored her, and got my red hair from her and my great-aunts."

"She was a most remarkable woman, a country woman and very independent. One of the first, if not the first, women to have a driver's license in New York State at a time when you had to know how to change tires, and fix the motor. She was not a bookish person, but she loved to read as well

84 Happy Fanny Fields,
ca.1910

85 Greenspun family,
Vineland, New Jersey, 1880

86 Linda Weinberg playing
nurse to her grandfather,
Jacob Heller

as do things like fishing and gardening; she also loved doing things with me. For example, she would make a large cake and I'd make a little one. She spoiled me terribly, but then, so did the rest of my family."

[Photo 86] As a child Nochlin remembers dressing up as a "nurse" to minister to her obstetrician maternal grandfather, Jacob Heller, who had been born in Minsk, Russia, and had come to the US in 1892.

"I loved this grandfather, and I was very close to him. He was the one who introduced me to books and took me to Coney Island to ride on the merry-go-round. Grandpa Heller was certainly deeply interested in Jewish theater, poetry and culture, but he was even more interested in vanguard culture generally. He was a very early member of the Theater Guild. He read a great deal of English literature, and he made me read all the Russian classics when I was very young – I remember reading *Dead Souls* when I was only eleven. I also remember my grandmother reading Dostoevsky's short stories aloud to us after supper. But my grandfather also had an attachment

to odd, now almost forgotten writers like Lord Dunsany and Lermontov, so I read them, too."

"The whole family on both sides was Left. My other grandfather, who owned a newspaper business, was Harry Weinberg. He was also born in Russia, and was a friend and supporter of Henry Wallace when he ran on the third-party ticket. My Uncle Bob was, I'm sure, a CP member; he left the country at the time of the McCarthy investigations."

MR: "What did it mean to be Jewish when you were born in the early thirties?"

LN: "We lived in Brooklyn, and basically we didn't know anybody who wasn't Jewish except for maids who were either Polish, Irish or black. Incidentally we were totally secular; I never went inside a synagogue until a cousin had a bar mitzvah at thirteen. When I went to Vassar, it was a definite culture shock."

"Of course, you can imagine what it was like when the war burst upon us. In Brooklyn, everyone still had relatives in Austria, Poland and Russia, and every single one of them disappeared except for the very few who could be gotten out. I know my grandfather Weinberg stood guarantor for a whole group of relatives whom he brought over at that time, and still other cousins escaped to Uruguay and some, I think, went to Canada. My Weinberg grandpa's uncle (or was he a great-uncle?) had been the chief Rabbi of Vienna and that whole family, my grandfather told us, had been made into soap."

[Photo 87] "Here I am, at age ten, with my parents in Arizona in 1941. They were so good looking, so glamorous, at a time when most Jewish parents seemed lumpy – but mine definitely weren't! They were wonderful dancers. They danced together, and they fought together, and eventually – much later when I was twenty-nine – they divorced."

"As a young man, my father had worked in my grandfather's news delivery business, but got bad arthritis when he was in his early thirties, so we came out to Arizona for a year to see if this milder weather would help him. In Tucson he rode horses, and he had beautiful boots and hats. He drank, flew planes, hunted and fished."

[Jules Weinberg died age 78, 10 November 1986, in Lake Placid, NY.]

"My father was a rebel, and kind of wild. I'm sure I got a lot of my temperament from him: outgoing, wanting to be impressive (he liked to impress people with his talents), and a bit competitive."

[Photo 88] "My mother was so elegant, and also extremely smart. She loved literature and she read James Joyce's *Portrait of the Artist* out loud to me when I was eight. Sometimes she'd play the piano and I'd play the recorder,

87 Jules, Linda, and Elka Weinberg, Arizona, 1941

88 Elka Weinberg, date unknown

or we would play a duet. She had studied dance and we would dance together. She was very keen on taking me to the ballet, something I still love, and took me to see every good play on Broadway when I was older."

"She was, however, much less confident than I am in the world. She never had a real job and was a true amateur, in the best sense. She didn't want me to marry and get pregnant because, unlike most mothers, she thought I should just be brilliant and creative – that was her vision of me."

[Elka Heller (she took back her maiden name when she divorced) died age 85, 15 January 1994, in New York City.]

MR: "What did you learn from your mother?"

LN: "My deep feeling for the arts and literature and music and the belief that they are the most important things in the world. Culture was just an automatic part of our life. It had nothing to do with upward mobility or social striving. It was just what she loved, what I loved and what we did together."

MR: "And that shaped your own vision?"

LN: "Yes. It may seem strange, because I am a deeply political person, but I am an aesthete on some level, too, and art is the most important thing in the world for me."

Part 2. Of Writing

LN: "I want to write differently."
MR: "How?"
LN: "More freely."

89 Linda Nochlin, "Plaint in the Museum," 1944

PLAINT IN THE MUSEUM

"We are the ghosts of the past,
The dead reincarnate.
We are the snuff-boxes, the fans, the lace shawls, the mummy-cases,
Costumes once the height of fashion.
We are the jewel-hilted daggers,
The yellow-leafed hour-books.
We are the objects of pride
And of passion.
We saw despair
And young love exulting.
We have seen the doom of empires,
The crumbling of dynasties.
Now, neatly assorted and expertly catalogued,
We pass living death
Inside glass cases."

"We have come here
To beg and beseech you
Not to forget us,
Not to pass by us,
Not to jeer and not to yawn
As the tired-eyed lecturer
Drawls out his sermon."

"I am a China Sheperdess.
From a strategic point
On the marble-topped bookcase
I watched Du Barry
Shaping the course of men's lives
With her penpoint.
Fat and vulgar was Du Barry
With fishwives' hands
Which all the perfumed ointments of France
Could not alter.
But oh, she was shrewd,
A true daughter of the people."

"I am an onyx jar that held
The eye-black of a princess.
A daughter of the Pharaoh was she,
A slim and sloe-eyed
Flower of the desert.
Poor lotus-skinned little princess,
She died of strong poison
Administered by an Assyrian slave-girl,
And was laid to rest
In a deep-vaulted pyramid
At the side of her ancestors."

Increasingly as we talk during our three days together in Nochlin's home, I see her as driven by a lifelong commitment to writing. Certainly she is a writer who writes on art history, but first and foremost primarily a writer. I recall Nochlin's 1994 description of herself: "I started my academic career as a philosopher, my non-academic one as a painter and poet."[2]

[Photo 89] On 16 November 1944, Linda Weinberg composes a poem, "Plaint in the Museum" from the viewpoint of objects in the museum: "We are the ghosts of the past / The dead reincarnate / We are the snuff-boxes, the fans, the lace shawls, the mummy-cases…" The young poet ends by warning her readers that they, too, will be enshrined in museums, they too will be

"And hear me, oh children of today!
In the days before I was Number 671B,
(Circa 1200),
I was a cherrywood cradle.
Many a little charge was rocked
And sung to sleep
On my broad bosom.

'Hush my baby,
Cease thy cry,
God is watching from the sky.
If thou sleepst until the day,
The Lord will wash thy tears away.'"

"If after this
You still do not believe
That our possessors too
Once laughed and sang,
Choked and stuttered,
Cursed and fumed,
Bit their nails and sucked their thumbs,
Were greedy and generous,
Gentle and fierce,
Then we have one more word
To say to you.
Know this, all you gay young scoffers,
You yawning, shuffling scornful moppets,
That in one short minute of eternity
Your compacts and cigarette-cases,
Your bracelets and silk stockings,
Razors and can-openers,
Will be here with us,
Passing living death
Inside glass cases.

And you, - you will be mouldering skeletons
Sleeping eternal sleep in your graves,
While the men of another era
Yawn and shuffle
Through the damp, musty halls of the museum."

Linda Weinberg
November 16, 1944

gazed upon by a future generation: "Your compacts and cigarette-cases / Your bracelets and silk stockings / Razors and can-openers / Will be here with us…"

After reading this poem out loud to me, Nochlin comments: "Museums have been a most important part of my experience since I was very young – I used to go to the Brooklyn Museum all the time when I was a child – and also you can see that, even at thirteen, I had the notion of history as something personal. Yes, there's history out there, but we are also going to be history, too, and we're going to be treated like history."

90 Linda Nochlin, "At Merton College, Oxford," 1950

THE HONEKKER SONG 553

After a while, Lou heard the plain chant again. "Yah-yah. She doesn't know the Honekker song."

But this time Margaret answered. Her voice had a keyed-up braveness.

"I do, too," she said. "I know the Honekker song as well as you."

What now? her mother wondered. Didn't the child know that in this situation "Good King Wenceslaus" would be worse than useless?

But Margaret sang out a song the others knew, too, especially Rebekah, whose par-ents spoke French at home. But they were silent, perhaps with surprise.

"*Au clair de la lune*," Margaret sang, "*mon ami Pierrot.*"

As the silence lasted, her voice grew stronger. "*Prêtes-moi ta plume,*" she sang, "*pour écrire un mot.*"

The next evening, when the Ryders were decorating their tree, Margaret, in a flowered flannel nightgown, hung golden cones and silver bells on the lower branches. She went on singing the Honekker song. "*Au clair de la lune, mon ami Pierrot.*"

AT MERTON COLLEGE, OXFORD

LINDA WEINBERG

By Merton's darkening walls I sat,
Brushed by the fall of summer's rain,
Feeling the eternal Jew,
Homunculus, starting in my veins.

Now in the garden of the mind
Blooms the dark vintage of my race;
No memory binds me to its vine,
Yet shattering Time unlocks the gate.

By Toledo's walls I wept,
(Drinking my tea and milk the while),
Under the flame-pierced sky of Spain
Bound to the burning stake, I smiled.

No cymbals clash, no sparrow falls,
I sip, I talk, I choose a cake;
Where is the writing on the wall?
When shall the stone of silence break?

Through Vilna's icy lanes I fled,
Safe in the dark shroud of dismay;

But the bright star shining on my head
No summer's rain shall wash away.

On Erudition's arm I walk
Past the stern guardian of the Right,
Blazing with borrowed wit, I talk
Of Plato, Augustine and Christ.

With lowered eyes, I phrase the Greek,
Sharpen the point in flawless French;
What dark-voweled language did I speak
Rocking with wisdom on my bench?

Once in a city's arms I dreamed,
But Oxford's towers have pierced my sleep;
A midnight voyage on the sea—
Now by Babylon's waters I weep.

Destruction's sheltering touch at last
In passive union binds all men;
Still the deceptive tongue of brass;
Jerusalem shall not rise again.

LINDA WEINBERG is a senior at Vassar College, where she is editor-in-chief of the *Vassar Review*. She has contributed to various school publications but this is the first poem she has published professionally. She visited the British Isles in the summer of 1948 and spent three days at Oxford.

On the postcard:

Dear Mom, Wed night

Am in Montpellier seeing
marvellous Courbet collection here
Curator very helpful – I have evi-
dently made an important discovery
about one of the paintings. I am
going to see some of his private
collection tomorrow night.
Jessie and mother N. had a
wonderful time in Mallorca, both
came back considerably fatter.
They are now home in Paris during
my absence. Olga and I decided
to put off car trip 'til better
weather, since roads bad – I
took train here. I love this city.
It's a University town, full of young
people, very picturesque. Had
wonderful lunch and fell into pro-
found stupor after it. And so to
bed in order to be fresh for
more museum tomorrow.

love, Linda

768. COURBET - La Rencontre ou, Bonjour, Mon-
sieur Courbet.
Encounter or Bonjour, M. Courbet.
Musée de Montpellier.

RÉPUBLIQUE FRANÇAISE POSTES 0.65
DINAN VALLÉE DE LA RANCE

Mrs. Elka Heller
201 Eastern
Parkway
Brooklyn, N.Y.
U.S.A

Par Avion

91 Linda Nochlin, postcard to Elka Weinberg, February 1963

[Photo 90] We read further poems by her, including "At Merton College, Oxford," published in 1950 in *Commentary*, but written when she was in her sophomore year at Vassar, majoring in philosophy. In it, Nochlin appears: "By Merton's darkened walls I sat…. Feeling the eternal Jew…. By Toledo's walls I wept…. Through Vilna's ice lanes I fled…. Now by Babylon's waters I weep."

LN: "Here in this poem I'm going through history as a Jew."

MR: "And years later, in 1967, as an art historian, you find the Wandering Jew, in a popular print, as the source for Courbet's painting and publish 'Gustave Courbet's *Meeting*: A Portrait of the Artist as a Wandering Jew' in the *Art Bulletin*."

[Photo 91] In Nochlin's archives we unearth a postcard from February 1963 of Courbet's *Meeting*, which she has sent to her mother. On it, Nochlin writes: "Am in Montpellier seeing marvelous Courbet collection here. Curator very helpful – I have evidently made an important discovery about one of the paintings."

LN: "And then I go on to write about Degas and the Dreyfus Affair in 1987 ('A Portrait of the Artist as an Anti-Semite')…"

[Photo 92]

MR: "…and you co-edit *The Jew in the Text* with Tamar Garb in 1995, and in your introduction you reflect, 'Why do they hate us so much?'….'Sometimes reading these texts and myriad others, detailing the dark face of anti-Semitic representations, I have actually felt compelled to run to the mirror.'"

Nochlin reads compulsively in college – as she continues to do so until the present day. "I wanted to be an English major. That seemed perfectly natural, but I had such a terrible English freshman-year teacher that I decided I wouldn't take English, but, of course, I would write and read anyway. So I majored in philosophy and minored in Greek and art history. I read enormously: all the great Russians, and Thomas Mann, Katherine Mansfield, Virginia Woolf, and Katherine Anne Porter."

MR: "Poetry?"

LN: "T.S. Eliot, obviously, and William Blake and John Donne. I went on to get my master's in English literature with Marjorie Hope Nicholson at Columbia University, and wrote on Richard Crashaw. I loved the metaphysical poets, and always have, all through my life. And a little later, I was reading William Carlos Williams and Hart Crane."

MR: "French writers?"

LN: "Gide was a major figure for me. Especially when I wrote my own novel, Gide was absolutely primary. Proust, of course, and Flaubert. And the poets, Baudelaire above all, but Laforgue and Nérval too."

MR: "Your own novel?"

LN: "I wrote almost a thousand pages of it while I was in Paris in 1958, but I've never done anything with it. It's called 'Art and Life.' Do you want me to show it to you?"

Buried in a box at the back of one of Nochlin's cupboards, we find an amazing stack of ten notebooks which contain the handwritten novel – together with a manuscript for "The Age of Salzberger," a novella based on an encounter as a graduate student with Professor Walter Friedländer at NYU Institute of Fine Arts. We root around further, and discover a 1958-1959 Paris diary, which has interesting parallels to the diary format of the unfinished novel. Pivotal in the development of the narrative of "Art and Life" is the heroine's visit to Grünewald's Issenheim Altar in Colmar; a few years later Nochlin edits excerpts from this section of the manuscript to publish separately as her first book, *Mathis at Colmar: A Visual Confrontation* (New York: Red Dust, 1963).

[As part of his presentation at the New York University symposium, Robert Rosenblum, once Nochlin's fellow graduate, and now a colleague and friend, reads a passage from *Mathis at Colmar* in which Nochlin con-

92 Cover of LINDA NOCHLIN and TAMAR GARB, eds.,
The Jew in the Text, 1995

templates Christ's feet. "They have lost their function as weight-bearing members, entities of flesh and bone that could walk, wear shoes, hold up a body...now, they are twisted roots of suffering, stringy, pulpy and tobacco-colored like the old useless roots that appear above the ground, patient with toadstools, all sinews and puffs." For many of us listening, including myself, this was our first introduction to that startlingly vivid early writing.]

MR: "When you left the novel unfinished, did you feel that you'd made a choice of becoming an art historian, or did you figure out you would be an unusual art historian for whom writing would remain central?"

LN: "Well, I don't think I was ever that conscious, although clearly I was torn in Paris at that time. Let's face it, I did both there. I knew I wanted to be an art historian, but I wanted to write novels too. I just wanted to write. It didn't matter, in a way, what I wrote but, as a scholar, I had to write differently because you have to be very self-critical to do art history, whereas you have to let go of all that to do the other stuff."

Nochlin returns to the States and finishes her dissertation on "The Development and Nature of Realism in the Work of Gustave Courbet." She is now a single mother (her first husband, Philip Nochlin, had died in 1960), teaching at Vassar. In the summer of 1962, she focuses intensely on her Ph.D. text. "I sat down, sent my daughter Jessica away to stay with friends, got up at six o'clock every morning, reviewed my notes, and went to the library. I typed every single day on the electric typewriter my father was good enough to give me, typing fourteen hours a day. I finished the whole manuscript in six weeks, and gave it to my advisor, Robert Goldwater, who said, 'Put in a paragraph about color, and it's finished.' But I still was working on my dissertation the next year in Paris, finally handing it when I returned to the States."

MR: "Why Courbet?"

LN: "I didn't love him more than other artists – indeed, I would say Manet is really more my boy—but I was very interested in how art and politics got together, and what could be better than Courbet as far as that was concerned?"

MR: "And now? You once said finding feminism in 1969 was like St Paul's dramatic conversion to Christianity on the way to Damascus. How have you and Courbet been getting along since that time of sudden illumination?"

LN: "Well, of course, I began to read Courbet differently, which is not to say that I always look at paintings as a woman. I'm a lot of other things besides a woman. I have a lot of other identities, as do we all."

[Photo 93] "When I wrote that big two-part article for the *Courbet Revisited* exhibition catalogue in 1988, I really felt the need to re-read Courbet through the eyes of feminism, as opposed simply to finding some feminist truth in Courbet's consciousness. I worked on the essay for a long time while I had a Guggenheim Fellowship and was at the Institute for Advanced Studies at Princeton."

MR: "In your coda to 'Courbet's Real Allegory: Rereading *The Painter's Studio*,' you observe first from the wings of a theater, so to speak, assuming the normal voice and position of the art historian – 'a sort of neutro – or neutered-masculine one.' After this, you decide to place yourself central stage. You explain to your readers that now 'I take over Courbet's role as 'creator' and assume my femininity (as he has his masculinity) in the construction of a discourse of gender from the raw material offered by the visual artifact.'"

93 Cover of LINDA NOCHLIN and SARAH FAUNCE,
Courbet Reconsidered (The Brooklyn Museum of Art, 1988)

[Photo 94] "And then you carry out that brilliant strange reading – in which you situate yourself, too – about the Irish beggar woman whom, you argue, interrupts 'the flow of the intentional meaning' of Courbet's painting. You write: 'For me, reading as a woman, but nevertheless reading from a certain position of knowledge and hence privilege, in the United States in the twentieth century, the Irish beggar woman constitutes not just a dark note of negativity within the bright Utopian promise of the allegory of *The Painter's Studio* as a whole, but rather, a negation of the entire promise.... In short to me, reading as a woman, the Irish beggar woman sticks out like a sore thumb.'"

I have always found this essay to be one of the most writerly of your art-history texts. Do you?"

LN: "Yes, it is the one where I felt the freest to indulge in a variety of positions, to be writerly in the Barthian sense."

"I wanted to enter into this picture. I wanted to criticize it. I wanted to be a part of it in some interesting way. I like Jane Gallop's remark that 'one can effectively undo authority only from a position of authority in a way that exposes the illusions of that position without renouncing it.'"

94 GUSTAVE COURBET, The Painter's Studio:
A Real Allegory Summing Up Seven Years of My Artistic Life, detail, 1854–55

MR: "We seem to have returned full circle in this conversation about writing, which began with 'Plaint in the Museum,' in which you, as a thirteen-year old, give voice to the China Shepherdess in the museum. And here you are, many years later, at it again!– now speaking up for Courbet's Irish woman."

LN: "Well, you know, I do like to make objects talk!"

MR: "Any last thoughts about writing?"

LN: "I would say that writing utterly depends on reading. It doesn't depend on experience, although experience can set it off. But that's like the idea that you are expressing *yourself* in art, but what you are really doing in art is expressing *art*, although your self may put it together."

"To be able to write without having read? I don't believe it for a moment. I think some of the problems which people have with writing now is that they don't read enough. I have lived much more in books than in life – whatever that may mean. I feel most fully myself when I am listening to music, writing, reading, walking, looking at paintings. That's when I'm me."

Nochlin tells me she has written very little poetry since the early 1970s, but that she intends to read poetry this summer in Italy, in preparation for perhaps returning to writing poems.

MR: "Why think of writing poetry again now?"

LN: "Well, because at certain points I've had a split career, for example in Paris when I wrote that novel and did art history, so why can't I now write art history and do poetry? Poetry is certainly the easiest 'other' to do – just think of William Carlos Williams who was a physician, and Wallace Stevens, the insurance agent."

[Later in the summer of 1999, Nochlin e-mails me from Bellagio a poem she has written, "Ashes in the Closet":

In my front closet
Are three large boxes
Made of cedar, lined with lead.
They are for the dead.
They take up too much room;
They displace the coats and boots.
They are in paper bags;
They are my roots.

These cedar boxes hold
My husband, my mother, my aunt.
You can't get much closer than that
To your past or your kin, all three
In a single unsuitable space,
Coat closet as lieu de mémoire
A less-than-sacred armoire:
They sustain me.

But sometimes as time goes by
I waver, I wonder why
I don't scatter them over the sea. That was
My original plan.
But somehow I never can
Contemplate life without them,
Solidly based,
The boots displaced
In my front closet,
Watching over me
Keeping me less than free
Eternally.

The work of mourning's a bore
But my boxes are something more
Because they sit right on the floor
Keeping the dead alive
Keeping the past in the present
Keeping the ashes concrete.
(I can smell them at night in my sleep.)
I curse when I search for a boot
And bump into their adamant weight
I rejoice when I think, Here they are!
They never can leave me again
They will always bring back the same pain,
They never will leave me again.

[Bellagio, 6/4/99]

Part 3. Of Self and History

[Photo 95] We begin our discussion about the relationship of the self to history with Nochlin's poem published in 1973, "Matisse Swan Self," that she wrote as a response to a photograph she had seen of Matisse sketching a swan. "It struck me when I saw that photograph that it was taken in 1931, the year of my birth. There is nothing that connects Matisse and me except history. Biography is history, and I think, despite all the current rejection of biography in certain aspects of modern theory – and I understand perfectly why – it is important to see the sense in which biography always engages with history; they are inseparable."

Nochlin then recites the beginning of her poem:

"The year that I was born Matisse
Natty in a grey fedora hat,
Goateed, sat
In a boat sketching a swan in the Bois de Boulogne."

And then turns to a later passage:

"Only coincidence connects my birth, the indifferent swan,
Matisse's hand moving across the paper,
That and the hopeless urge to bind
The too contingent self to history
By anchoring at visible islands."

MATISSE SWAN SELF

The year that I was born Matisse
Natty in a grey fedora hat,
Goateed, sat
In a boat sketching a swan in the Bois de Boulogne.

(The swan glides to the right, pays no attention;
Matisse, all attention, gazes down
At the unseen image on his lap).

One can trace the progress of this work
From diffidence to imperial certitude:
A final thrust of neck so forceful in its sweep,
A flap of wing so focused one might say
Nothing swan escapes it.

Only coincidence connects my birth, the indifferent swan,
Matisse's hand moving across the paper,
That and the hopeless urge to bind
The too contingent self to history
By anchoring at visible islands.

Yet the elegant floating,
The neck so neatly and naturally
Curved back upon itself,
The fanned wings momentarily uplifted
Poised not so much for flight as ritual gesture,
The brilliance of the light—

All the possibilities are there:
Mystery of swans
of lakes
of lines
of purity, of choosing.

Linda Nochlin

6

95 LINDA NOCHLIN, "Matisse's Swan Self," 1973

MR: "I am struck by your phrase, 'the too contingent self with history,' and that elsewhere you have stated that 'nothing, I think, is more interesting, more poignant and more difficult to seize, than the intersection of self and history.'"

"What is a self?"

LN: "An individual in all its aspects, a life, a place from which one looks out at the world and experiences it with some feeling, some responses. It's a vantage point."

MR: "And history?"

LN: "History is the big stuff, but also the little stuff. It is everything that happens to everyone else! It's what's written about, what's theorized about. There are various ways of recording history, but it is always the passage of time thought over, made meaningful in some way through a methodology."

MR: "And the relationship of all this to growing older?"

Nochlin responds by talking about her reactions to two works by Van Gogh (*Portrait of Père Tanguy*) and Cézanne (*Portrait of a Peasant*); in both of which there is an older figure represented. "A lot of my descriptions here have to do with how age as well as sex is implicated. And in a chapter I haven't yet written but want to write for my Bathers book about perspective and the sea, I have a certain sequence about my grandfather swimming out to sea. It's about the anxiety of perspective, and how perspective, in a way, is invented to shore up our anxiety about death and disappearance. So here we are again with the self and history - my grandfather swimming at Neponsit and Renaissance perspective! Of all art historians, only Panofsky writes his own old age into his work, in a marvelous text about Titian's old-age style. Oddly enough I am not at all worried about making my mark on history, at least not consciously. But I do have some concern about looking back – for example, on the immense amount of stuff we have just unearthed together in the last couple of days – and thinking how much of every life, of every historical circumstance, is left by the wayside."

"These days I sometimes have a terrible writer's block, and yet here is a huge body of my writing, unpublished, unknown, even untyped, from my past. One feels in a way that one doesn't want to die without some of this, at least, coming to the surface."

"I feel more and more the enormous contrast between young people for whom the year 1968 is history, and people like us for whom 1968 was experience; we were in it! Or I think of how history runs back through our families: how my mother remembered the end of World War I, and my grandfather remembered coming to the United States, remembered what it was like to be on that boat. How my grandmother remembered being one of the first women to learn to drive a car.... It is terrible to feel that you are apart from history, that history is something cold and objective that only happens to important people, and only happens way back in the past. That history is dead."

"The moving thing is when history proves itself not to be dead, when it clearly intersects with your own life and, even more poignantly, when you can have some effect on the shaping of that history, however minor."

MR: "When I gave my presentation this spring at the New York University symposium, I wove in references to a series of image-word prints that I love – Young Soon Min's 'Defining Moments.'"

"What do you see as some of your most defining moments?"

LN: "I've mentioned some of them in the last few days. Being in La Jolla with my mother after a year in Arizona. Being at Merton College in Oxford and realizing that not everyone was like me – that there were people who had totally other lives and totally other environments. My defining moments have usually been elsewhere. One of the reasons that I wrote and wrote, and kept a diary when I went to France for the first time in 1958 was that I was in a totally other culture, despite having read so much French literature, and French history."

MR: "Is there anything between 1958-1959 and the late 1960s that constitutes a defining moment for you?"

LN: "I don't know. Painful moments, joyful moments, yes, but perhaps not defining."

MR: "And your encounter with feminism in 1969? You have described that year and the years that followed as being the time when the nature of your intersection with history changed dramatically."

"You write in 'Part Two: Starting from Scratch,' of your essay 'Memoirs of an Ad Hoc Art Historian': 'It was no mere passive conjunctions of events that united me to the history of that year and those that followed, but rather an active engagement and participation, a sense that I, along with many other politicized, and yes, liberated, women, was actually intervening in the historical process and changing history itself: the history of art, of culture, of institutions and of consciousness. And this knowledge even today, more than twenty-five years later, gives us an ongoing sense of achievement and purpose like no other.'"[3]

LN: "Yes, that was certainly a defining moment."

MR: "And after that?"

LN: "When I realized I was getting old. I think that was a defining moment, but more gradual—slowly realizing that I wasn't young any more, that I wasn't even middle aged!"

MR: "And do you have the equivalent to Yong Soon Min's final image in her series, the mythical mountain that unites North and South Korea? Do you have a utopian mountain…a utopian valley…a utopian space?"

LN: "No, but I like where I live! My utopian space is the Upper West Side of Manhattan, although I'm not an insane NY patriot, but I do feel most at home here. Paris next."

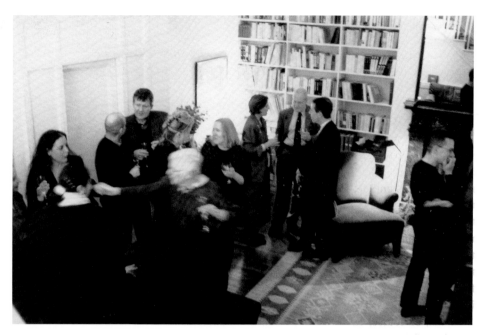

96 Celebration dinner at the apartment of Richard Sennett and Saskia Sassen,
"Self and History: A Symposium in Honor of Linda Nochlin," 16 April 1999

"I've lived in this apartment for about 21 years..."

MR: "...and have a kitchen, two bedrooms, a living room and dining
room, books, paintings, cats, photographs..."

LN: "...and lots of CDs and records because music is my utopia, music
and dance. I go to about three concerts a week of music or dance – at least
three. Not theater so much as I like things that are more abstract."

MR: "I have always seen friendship as integral to your life."

LN: "Yes, friends are central to my life because they aren't obligatory.
The obligation comes in the course of the relationship itself, but it is not
part of some social contract, so to speak – although of course my relation-
ships with my parents, my husbands and children have been pretty intense,
and wonderful. But it is through friendship really that so many of my ideas
have been clarified. I really do believe that art history, or any intellectual
discipline, is a cooperative and collaborative one."

[Photo 96]

MR: "That was one of the most touching aspects of the symposium at
NYU this April – that not only were you surrounded by colleagues but that
so many of your colleagues were dear friends of yours."

Afterword

Linda Nochlin

What strikes me most about the essays in *Self and History* is the range of vision they represent. Each text is unique in its approach, in its subject matter, indeed, its very conception of the art-historical project itself. Thus, the material in this anthology is not only of extraordinary quality, but constitutes an expression, in each case, of the self in question. My friends – for this is what they are – do not comprise a particular school of thought with readymade answers to readymade questions, but are free-wheeling, free-thinking agents of the work of art history. If there is anything that unites these voices, it is perhaps their rejection of the status quo rather than conformity to it. They all have their own paths to follow: each essay materializes a trace of the self upon the boundless shores of history.

I am, of course, emotionally as well as intellectually attached to the occasion of these essays. They were presented at a symposium at my place of work (and my graduate school), the Institute of Fine Arts, New York University. They commemorated my forthcoming seventieth birthday, but also an entire of life in art history, beginning where I ultimately ended – at the Institute. It was, therefore, entirely appropriate that the first address (now essay) should have been presented by Robert Rosenblum who was my near contemporary at the Institute and who, like me, now teaches there. Bob (whom I always think of as Bobby) literally enacted that "intersection of self and history" which I have talked about by inserting me back into my historical context with memories of our non-conformist youth. The intellectual biography he presented so movingly was also a waltz down memory lane for me. With his unerring scholarly precision, he managed to unearth early works by Linda Nochlin, including an essay on Grünewald and a piece on Pre-Raphaelitism that I had almost forgotten, or certainly marginalized, myself. His talk was not only a scrupulous piece of scholarship, but also an example of Bobby's typical generosity of spirit that brought tears to my eyes.

Ewa Lajer-Burcharth, now a professor at Harvard University, was my student at the CUNY Graduate Center, outstanding among a stellar group. We have gone on to become close friends. Combining issues of sexuality and gender theory with archival research and a close reading of visual texts, she sheds new light on an offbeat but oddly paradigmatic architect of the eighteenth century.

John Goodman, like Ewa a "dixhuitiemist," also chose sexuality as the text for his paper. Like Ewa, he is a close reader and sharp and original thinker. Diderot has been his subject of investigation more than once, and each time he offers up fresh interpretations of critical themes. John, I might add, is not only an expert in art and literary matters, but in musical ones as well: we have shared many concerts and operas together, and I have profited from his experience in areas which are unfamiliar to me, especially opera.

Tamar Garb, most appropriately given our many years of feminist engagement, has offered a brilliant new reading of Manet's portrait of Eva Gonzalès, contextualizing the work within contemporary notions of femininity, of medical practice, and of portraiture itself, and shedding new light on the master-pupil relationship which existed between male teacher and female student. Whenever I go to England I stay with Tamar and her wonderful family (including her two cats) in her house, which is conveniently – given my penchant for walks in the park – close to Finsbury Park.

Robert Simon's paper brings back memories of happy days in Paris. I would never have written the piece on Géricault (presented first as a talk at the Louvre symposium on the artist, published in *October* and then in *Representing Women*) without his inspiration. We spent many evenings together in cafés, talking about life and art, or going to old movies together. Apropos of "The Axe of the Medusa," I remember seeing *The Bad Lieutenant* and *The Duelist* with Robert at one of the little rerun houses near the Pantheon and relishing the violence of the one and the references to Napoleonic painting in the other.

Abigail, like Ewa, was my student at the CUNY Graduate Center, but in both cases, I claim no responsibility for the brilliance and originality of their production. It was never a question of teaching, only encouraging. Abigail's rereading of "Realism" is typical of her unerring textual analysis, her winkling out of complexity and contradiction from apparently unified texts, her ability to provide new overtones of meaning in what, for me, is already history. We have so many memories, good and bad, in common that I wouldn't know where to begin. We also share a love of ballet (Ballanchine) and a love of music (seventeenth and eighteenth century especially), good food, good wine, good friends, Paris. Equally important, we have marched together – most recently to defend abortion rights in Washington. We share a political commitment as well as an aesthetic one.

I first heard Stephen Eisenman when he was still a graduate student, giving an extraordinarily original lecture on Redon. I said to myself, "this is someone to watch," and I didn't have to wait long: his piece on "The Intransigent Artist, or How the Impressionists Got Their Name" was a highlight of the 1986 catalogue of *The New Painting* exhibition. He later partic-

ipated with an equally original talk (later an article) in a session I chaired on "The Political Unconscious in the Nineteenth Century" at CAA. Not the least of our connections is a wonderful and contentious trip we took through Brittany in the company of Steve's wife, the anthropologist Mary Weissmantel, and Abigail Solomon-Godeau. We could agree on nothing concerning Gauguin, but found unity in our interest in menhirs and other relics of pre-historic Brittany, interpreted for us by Mary.

Carol Ockman, who has already significantly interpreted Ingres from a feminist perspective, moves off into what one might think of as cultural studies or visual representation in her piece on Sarah Bernhardt, subject of a forthcoming book about the fin-de-siècle diva. Carol and I are old friends, united by a Paris connection as well as by many years of feminist thought and practice.

Rosalind Krauss is without a doubt one of the foremost scholars and theoreticians of twentieth-century art of our time. Indeed, no serious discussion of the subject is possible without her textual or actual presence. Together, despite – or maybe because of – the differences in our viewpoints, we worked to make the Graduate Center at the City University of New York the wonderful place that it was. Her impact on my work, both in the form of criticism and in stimulating self-criticism, is inestimable. Rosalind is one of the best editor-friends a girl could have. What is even more remarkable, she is also expert advisor in the realm of clothing, makeup and décor. She is truly a Renaissance woman – post-modern, of course.

Ken Silver is another Paris connection. That is where we met and drank wine and got high and talked all night about everything under the sun: art, ideas, life, people, love, food, friendship. We have remained friends ever since. Ken's work has been inspirational, ranging from his now classic *Esprit de Corps* to his sensational show on Soutine, to his pioneering article on the construction of gay identity in vanguard production ("Modes of Disclosure" in the *Hand-Painted Pop* exhibition catalogue). His friendship has been a support through thick and thin.

Carol Duncan has always been, and continues to be, a maverick. As her alter ego, Cheryl Bernstein, she has called into question many of the sacred assumptions of modernism. From her work on the museum to her specific critique of MoMA's "red-hot mamas," her work acts as a constant gadfly presence in the discourse of the modern. And she has not only a tough and brilliant mind, and the kindest of hearts, but also an inimitable sense of humor.

Like Rosenblum's and Roth's essays, Eunice Lipton's piece deals with biography – and autobiography – as it intersects with history. Eunice and I go back a long way; she has described our meeting, at Hunter College,

in her remarkable demi-art-historical text, *Alias Olympia*, in which she forged a new method of integrating the personal with the art historical, objective research with subjectivity. Now she has moved further afield, into an area that for me as for her, marks the earliest memories of childhood: the Spanish Civil War. No one could be more engaged, and self-consciously engaged with the intersection of self and history, than Eunice.

Moira Roth is an experienced practitioner in the field of biography, and artist of the interview, who has produced volumes on Duchamp, Performance Art, and Rachel Rosenberg, among others. Moira perhaps took the "Self/History" theme suggested by the Festschrift title most literally. Yet nothing Moira does is ever literal: it is always fact interwoven with speculation, feeling and intelligence. One feels one's quotidian life and work somehow transformed into a project at once more provocative and more lyrical by Moira's magic wand. California has often been the site of our meetings: San Francisco, Berkeley, outdoors in Marin County with its redwoods and lighthouse, and, most recently, the pier at Santa Monica. She is now encouraging me to write a memoir of my own, and I shall probably do so under her insistent tutelage – eventually.

Finally, there is Molly Nesbit, who was my student at Vassar in the good old days and is now one of the most interesting and original writers (and, with her interest in film, producers) of the visual working today. Her piece – or rather, her take – on Rachel Whiteread's *Water Tower* in Soho was cast in the mode of visual poetics; it moved in time and space. As a scholar of photography (Atget, specifically), of Duchamp, of art education in France early in the century, Molly is a stalwart comber of the archive. As a thinker – a muser – she is self-propelled, freewheeling, unique.

Finally, I should like to say a few words about those who made both the symposium and the present volume possible. Thank you, my dear old friend Phyllis Lambert, who first opened my eyes to the splendors of the contemporary avant-garde with a symposium on the subject which she co-organized when I was a freshman at Vassar in 1947-48. She has continued to supply all of us with intellectual and material support ever since. Phyllis, with her customary generosity, helped make the symposium the gala occasion it was. Many thanks as well to Jim McCredie, head of the Institute of Fine Arts, who has provided generous support for this, as for all my projects undertaken here. Jim is always present at these occasions: they wouldn't be festive without his encouraging presence. Many words of thanks to my friend and fellow teacher at the IFA, Richard Sennett. A few words wouldn't be sufficient to suggest all the memories we share in common, but in many

ways he was one of the inspirations for this occasion and the volume that resulted, and of course provided the venue, and the culinary skills, for the magnificent dinner party which was an integral part of the occasion of the symposium. Leonard Barkin, one of our leading scholars of the Renaissance, a more recent but decidedly bosom buddy, also contributed his famous knowledge of food and wine to the occasion.

Many thanks, too, to my longtime editor and supporter, Nikos Stangos, my dear good friend at Thames and Hudson.

Last, but far from least, I want to give my heartfelt thanks to my former graduate student, now a full-fledged Ph.D. herself, Aruna D'Souza, who, with an able committee of students, undertook the daunting task of getting it all together: organizing the talks, the transportation, editing the manuscripts, pushing on the contributors – a full time job accomplished with grace and efficiency in a graduate student's "spare time." That the event was such a perfect one, and that the subsequent publication saw the light of day, is all due to Aruna's perseverance. And thanks, too, to Tom McDonough for his bibliography of my works, no small achievement given the length of my publishing life and the obscurity of some of the publishing venues. Finally, thanks to the missing presences who are nevertheless always present on such occasions: my late husband, Richard Pommer, and my mother, Elka Heller. Each in his or her own way made me who I was and who I continue to be: they live on as part of my, and many other people's, essential being.

It is hard to make sense of one's life and life work as they draw to a close. So much seems random, haphazard, chancy, propelled by external forces rather than inner conviction. But looking over these essays I see, projected onto the collective efforts of my friends and colleagues, at any rate, a shape, a purpose, and a direction. In the very diversity of the subjects and methods, in the uniqueness of each individual creator's position, I see an overarching purpose, a quest. May I be naïve enough, at this late date, to call it a quest for the truth? It is, of course, the quest that is the important part, and that more than anything else seems to me to define what this volume is about.

Notes and Sources

Introduction

1. Linda Nochlin, "Memoirs of an Ad Hoc Art Historian," in *Representing Women* (London and New York: Thames & Hudson, Interplay series, 1999), p. 10.
2. See, for example, Griselda Pollock, "Feminist Interventions in the Histories of Art: An Introduction," in Vision and Difference: Femininity, Feminism and the Histories of Art (London: Routledge, 1988), pp.1-17.
3. Nochlin, "Memoirs of an Ad Hoc Art Historian," op. cit., p.10.
4. John Clarke, cited in Dick Hebdige, *Subculture: The Meaning of Style* (Routledge: London and New York, 1979), p. 104.
5. Ibid, p. 16.
6. Nochlin has described the usefulness of paradoxicality in her work as such: "The establishment of a seeming contradiction between works or situations... is one of my preferred strategies in constructing an argument or deconstructing an art-historical 'given.'" Nochlin, "Memoirs of an Ad Hoc Art Historian," op. cit., p. 14.
7. Linda Nochlin, *The Body in Pieces: The Fragment as a Metaphor of Modernity*, The 26th Walter Neurath Memorial Lecture (London: Thames & Hudson, 1994); Linda Nochlin, "Manet's *Masked Ball at the Opera*," in *The Politics of Vision: Essays in Nineteenth-Century Art and Society* (New York: Harper and Row, 1989); Linda Nochlin, "A House Is Not a Home: Degas and the Subversion of the Family," in *Representing Women*, op. cit.
8. Roman Jakobson, "Two Aspects of Language and Two Types of Aphasic Disturbance," in *Language in Literature*, ed. Krystyna Pomorska and Stephen Rudy (Cambridge, Mass., and London: The Belknap Press of Harvard University Press, 1987), p.111.
9. Linda Nochlin, *Realism* (Harmondsworth, England: Penguin Books, coll. Style and Civilization, 1971).
10. Linda Nochlin, "The Realist Criminal and the Abstract Law," *Art in America* vol.61, no.5 (September-October 1973): 54-61 and vol.61, no.6 (November-December 1973): 96-103.
11. This dilemma is articulated most clearly in her essay in Sarah Faunce and Linda Nochlin, eds., *Courbet Reconsidered*, exhibition catalogue (New York : The Brooklyn Museum of Art, 1988).
12. Linda Nochlin, "Degas and the Dreyfus Affair: A Portrait of the Artist as an Anti-Semite," *The Politics of Vision*, op. cit., p.162.
13. Ibid., p.163.
14. Linda Nochlin, "Géricault, or the Absence of Women," in *Representing Women*, op. cit., p.79.

15. Here, one might contrast Michael Fried's interpretation of Courbet's *Grain Sifters*, articulated in his essay "Courbet's Femininity" which appeared in the catalogue for *Courbet Reconsidered*, op. cit., with Nochlin's, presented in an essay on "The Image of the Working Woman" in *Representing Women*, op. cit. For Fried, Courbet's depiction of a powerful female protagonist in this painting was the sign that the artist was projecting himself into her figure, and the author claims that this identification between Courbet and his depicted female figures was common, as well as being the sign of a "feminine," if not feminist, impulse in his art. Nochlin, by contrast, sees that the relatively powerful and positive depiction of woman in this painting was the by-product of Courbet's manipulation of other representation codes: Courbet, by showing the changing nature of agricultural technology in the wake of the 1848 revolution, was necessarily, though not intentionally, intervening in the representation of the female peasant.

Chapter Two

This text is dedicated to Linda, the most irreverent and inspiring teacher cherished in particular for her key insights regarding the visual representation of sexuality and sexual difference. From her illuminating study on "Eroticism and Female Imagery in Nineteenth-Century Art," published in Woman as Sex Object, *which she co-edited with Thomas Hess, to the essays most recently anthologized in her* Representing Women, *Linda's thinking on the relation between self and sex has offered an unconventional maternal architecture of intellectual provocation in which I came to feel at home.*

1. Thomas Laqueur, *Making Sex. Body and Gender From the Greeks to Freud* (Cambridge, Mass.: Harvard University Press, 1990), p. 149.
2. Ibid., pp. 181-192. The "discovery" of the anatomical difference may have not occurred as trenchantly as Laqueur has suggested - others have argued that the recognition of the anatomical difference was far less absolute at the outset of the modern period than Laqueur would have us believe - but the fact that the contours of a new, anatomically-based and distinctly modern understanding of sexual difference and sexuality began to appear precisely in the eighteenth century cannot be denied. For a critique of Laqueur's position see the review of his book by Richard Nye and Katherine Park, "Destiny is Anatomy," *The New Republic*, 18 February 1991, pp. 53-7. For the

historical instability of the anatomically-based notion of sexual difference, see Estelle Cohen, "The Body as a Historical Category: Science and Imagination, 1660-1760," in Mary G. Winkler & Letha B. Cole, eds., *The Good Body. Ascetism in Contemporary Culture* (New Haven and London: Yale University Press, 1994), pp. 67-90.

3. The "Boudoir" entry in the *Dictionnaire de Trévoux* (Paris, 1762).

4. Annik Pardailhé-Galabrun, *The Birth of Intimacy: Privacy and Domestic Life in Early Modern Paris*, trans. Jocelyn Phelps (Philadelphia: Philadelphia University Press, 1991), p. 64. See also Michel Delon, "L'invention du boudoir," in Roger Durand, ed., *C'est la faute à Voltaire. C'est la faute à Rousseau. Receuil anniversaire pour Jean-Daniel Candaux*, (Geneva: Librairie Droz, 1997), pp. 71-77.

5. Nicolas Le Camus de Mezières, *The Genius of Architecture; or, The Analogy of That Art with Our Sensations*, trans. David Britt (Santa Monica: The Getty Center for the History of Art and the Humanities, 1992), pp. 115, 117.

6. Ibid., p. 116.

7. For biographical information and the basic outline of Lequeu's career, see Philippe Duboy, *Lequeu. An Architectural Enigma* (Cambridge, Mass.: MIT Press, 1987).

8. Lequeu's drawing corpus remains at the Cabinet des estampes, Bibliothèque nationale, Paris. Part of it has been reproduced in Duboy, ibid., together with an inventory of the whole oeuvre (useful though it contains errors).

9. Kaufmann "discovered" Lequeu in the 1930s and included him among the three Revolutionary architects in his influential book published first in Vienna, in 1933, and then, in an English translation as "Three Revolutionary Architects: Boullée, Ledoux and Lequeu," in *Transactions of the American Philosophical Society* (Philadelphia), n.s., XLII (October 1952). He also published a biographical article on Lequeu in *Art Bulletin* XXXI (June 1949): 130-135. Though Kaufmann saw Lequeu's "weird [architectural] fantasies" as belonging with the architect's era, essentially, Lequeu was important for him as a "forerunner of significant trends in the twentieth century." ("Three Revolutionary Architects," p. 558).

10. Jacques Guillerme, "Lequeu et l'invention du mauvais goût," *Gazette des beaux-arts* LXVI (September 1965): 153-166. See also Jean-Jacques Marty-l'Herme, "Les cas de Jean-Jacques Lequeu," *Macula*, no. 5/6, pp. 138-149.

11. Anthony Vidler, "Asylums of Libertinage. De Sade, Fourier, Lequeu," *The Writings of the Walls. Architectural Theory in the Late Enlightenment* (Princeton, NJ: Princeton Architectural Press, 1987), pp. 103-124; and Duboy, *Lequeu*, op. cit.

12. Duboy's theory is based on the discrepancies in call numbers and other oddities in Lequeu's donation to the Bibliothèque nationale that he discovered and that suggest, in his view, that someone must have tampered with the corpus of these visual documents. Playing a cultural-historical detective, Duboy established a track of reference based on comparative analysis, visual and

conceptual, and leading directly to Marcel Duchamp. See Duboy, *Lequeu*, op. cit., esp. pp. 77-104 and 352.

13. The term symptom recurs throughout Freud's work in reference to different kinds of psychoneurotic effects produced by a psychical process of working out, and especially in relation to a form that a repressed memory takes in order to be admitted to consciousness. See J. Laplanche and J.-B. Pontalis, *The Language of Psychoanalysis*, trans. Donald Nicholson-Smith (New York: W.W. Norton, 1973), pp. 76 and 446. For an extensive meditation on the symptom as a cultural formation, see Marjorie Garber, *Symptoms of Culture* (New York: Routlege, 1998).

14. See Vidler, "Asylums of Libertinage," op. cit.

15. Such "interiorized" views, as Robin Evans has noted, could be found already in the seventeenth century, in the illustrations of town squares with the perimeter elevations of buildings folded out, but what was new about the eighteenth-century drawings was that they fleshed out single rooms as interiors not just squares or gardens. Hence, from mid-eighteenth century on, interiors began to be described in a far more detailed and spatially convincing fashion. See Evans, "The Developed Surface. An Enquiry into the Brief Life of an Eighteenth-Century Drawing Technique" (1989), *Translations from Drawing to Buildings and Other Essays* (Cambridge, Mass.: MIT Press, 1997), pp. 200-203.

16. This publication was one of the symptoms of a broader process of transformation of graphic representation in the wake of ongoing revolutionary recasting of the professions of architects and engineers, a process in which Lequeu actively sought to inscribe himself. There are similarities between his project and that of his contemporary, Monge, who taught a course in descriptive geometry at the École polytechnique in 1794, where Lequeu was employed as draughtsman between 1793 and 1801. On the relation between Lequeu's project and Monge's descriptive geometry, see Duboy, *Lequeu*, op. cit., p. 15.

17. Cited in Duboy, ibid., p. 45.

18. Linda Nochlin, entry on the *Origin of the World* in Sarah Faunce and Linda Nochlin, eds., *Courbet Reconsidered*, exhibition catalogue (New York: The Brooklyn Museum of Art, 1988), p. 176.

19. See Jacques Lacan, "Seminar XI," in *The Seminars of Jacques Lacan*, ed. Jacques-Alain Miller, *Book VII. The Ethics of Psychoanalysis 1959-1960*, trans. Dennis Porter (New York: W.W. Norton, 1992), pp. 139-164; and Sigmund Freud, "The Uncanny" (1919), in *The Standard Edition of Complete Psychological Works*, ed. James Strachey, vol. 17 (London: Hogarth Press, 1953-73): 217-56.

20. Helpful for my discussion of the Lacanian uncanny here were essays by Mladen Dolar, "'I Shall Be with You on Your Wedding-Night': Lacan and the Uncanny," and by Joan Copjec, "Vampires, Breast-Feeding, and Anxiety," both published in the special issue of *October* 58 (fall 1991): 5-23 and 24-43, respectively.

21. This was suggested by Mladen Dolar, and differently by Joan Copjec: see Dolar, ibid., esp. pp. 16-21; and Copjec, ibid., esp. pp. 40-43.

22. That is, by the Declaration of Rights of Man, more

generally, by the discourse of liberty, and by the universal (male) suffrage and, with it, the notion of *homo suffragans* introduced in France in the course of the Revolution. For the effects of these developments on the post-Revolutionary concepts of subjectivity, see Elisabeth G. Ledziewski, *Révolutions du sujet* (Paris: Méridiens Klincksieck, 1989).

23. Laqueur, *Making Sex*, op. cit., esp. chap. 5.

24. For the 1804 Civil Code, see Francis Ronsin, *Le contrat sentimental. Débats sur le mariage, l'amour, le divorce, de l'Ancien Régime à la Restauration* (Alençon: Aubier, 1990), chap. 7. For a useful brief overview of its effects on the condition of women, see Madelyn Gutwirth, *The Twilight of the Goddesses. Women and Representation in the French Revolutionary Era* (New Brunswick, NJ: Rutgers University Press, 1992), pp. 371-4.

25. In the folder at the Bibliothèque nationale, this *Self-Portrait* appears as a frontispiece to Lequeu's *Architecture civile*. Here is how the author described it: "Jean Jacques Lequeu faisant réflexion, sa tête nue est appuyée sur sa main droite fermée et la guache sur quelques détails d'un nouveau plan de Paris et encore dessus, un appui évidé pour Bibliothèque, le tout dessiné par lui-même." Ms., Cabinet des estampes, Bibliothèque nationale, Paris.

26. In the *Figures lascives* folder at the Bibliothèque nationale, this drawing appears as first, though Duboy reproduces it in a different sequence (see Duboy, *Lequeu*, op. cit., p. 291). Lequeu's inscription under the image reads: "Agdestis or Agidistis, son of Jupiter, who was both man and woman." This figure is based loosely on the so-called *Hermaphrodite albani*, the Roman sculpture preserved in villa Albani in Rome. See Marie Delcourt, *Hermaphrodite. Mythes et rites de la bisexualité dans l'Antiquité classique* (Paris: Presses universitaires de France, 1992), pp. 94-95.

27. See Werner Szambien, "L'inventaire après décès de Jean-Jacques Lequeu," *Revue de l'art*, no. 90 (1990), pp. 104-107.

Chapter Three

1. On this painting, see *Watteau 1684-1721*, exhibition catalogue (Washington: The National Gallery of Art; Paris: Galeries nationales du Grand Palais; Berlin: Schloss Charlottenburg, 1984), pp. 333-36. Its date is uncertain; I use that favored by Pierre Rosenberg and Donald Posner. A print after the painting by Philip Mercier, probably engraved shortly after Watteau's death (c. 1722-23; excluded from the *Recueil Jullienne*), is "censored": the fabric of the woman's nightgown is made to cover her entire midriff as well as her upper thighs (reproduced in ibid., p. 334).

2. "The servant, who stares at the revealed sex of her mistress as though in a trance, proffers the sponge and water like an acolyte presenting the sacred objects of the Mass. This surely is meant as 'overtones of sacrilege,' 'a mock religious scene,' a travesty of Christian worship, intensifying the pleasure of the (male) viewer who was the intended recipient of the Revelation." Linda Nochlin, "Watteau: Some Questions of Interpretation," *Art in America* 73 (January 1985):

68-87. This quote pp. 82-83.

3. On these three paintings, see: Donald Posner, *Antoine Watteau* (Ithaca, NY: Cornell University Press, 1984), pp. 99-107. The Norton Simon picture is based on a drawing by Watteau of a reclining nude woman to whom a maid is about to administer a clyster (*The Remedy*, n.d., Private Collection, Paris; on this drawing, see *Watteau 1684-1721*, op. cit., pp. 164-65). The right portion of this composition, featuring the maid, has been excised from the painting, but the latter originated in a network of contemporary treatments of the suggestive clyster theme, which was very much of its time. See Donald Posner, "Watteau's *Reclining Nude* and the *Remedy* Theme," *The Art Bulletin* vol. LIV, no. 4 (December 1972): 383-89.

4. Caylus' life of Watteau, delivered as a lecture to the Académie de peinture et sculpture on 3 February 1748, is now most accessible in Pierre Rosenberg, ed., *Vies anciennes de Watteau* (Paris: Hermann, 1984), pp. 53-91; this anecdote on p. 85.

5. Jeanine Baticle, "Le chanoine Harenger, ami de Watteau," *Revue de l'art* 69 (1985): 55-68. For a judicious summary of current scholarship on the vexed question of Watteau's will, see pp. 71-72 of Colin Bailey, "'Toute seule elle peut remplir et satisfaire l'attention': The Early Appreciation and Marketing of Watteau's Drawings, with an Introduction to the Collecting of Early French Drawings During the Reign of Louis XV", *Watteau and His World: French Drawing from 1700 to 1750*, exhibition catalogue (Merrell Holberton, London and The American Federation of Arts, 1999), pp. 68-92.

6. Rosenberg, *Vies anciennes de Watteau*, op. cit., p. 85.

7. See Anne-Claude Philippe, comte de Caylus. *Oeuvres badines complettes du comte de Caylus*, 12 vols.(Amsterdam, 1787); Thomas Gaehtgens, "Archeology and Enlightenment: The comte de Caylus and French Neo-Classicism," in Colin Bailey, ed., *The First Painters of the King: French Royal Taste from Louis XIV to the Revolution* (New York: Stair Sainty Matthiesen, 1985), pp. 37-45.

8. Donald Posner, "Watteau mélancolique: la formation d'un mythe," *Bulletin de la Société de l'histoire de l'art française, année 1973*, 1974, pp. 345-61; Norman Bryson, *Word and Image: French Painting of the Ancien Régime* (Cambridge: Cambridge University Press, 1981), pp. 58-88.

9. Caylus in Rosenberg, *Vies anciennes de Watteau*, op. cit., pp. 66, 68, 72.

10. François Moreau, "Watteau libertin?," in François Moreau and Margaret Morgan Grasselli, eds., *Antoine Watteau 1684-1721: The Painter, His Age and His Legend* (Paris and Geneva: Champion-Slatkine, 1987), pp. 17-22.

11. Pierre Bayle, *Dictionnaire historique et critique*, 3rd ed., 4 vols. (M. Bohm: Rotterdam, 1720) 3: 3017-18. The relevant portions of the fourth clarification are readily accessible in translation: Pierre Bayle, *Historical and Critical Dictionary: Selections*, ed. and trans. Richard H. Popkin (Indianapolis and Cambridge: Hackett, 1991), pp. 438-39. I use a modified version of Popkin's translation.

12. For a recent study of Bayle's thought that complicates

the canonical understanding of him as a father of Enlightenment critique, see Thomas M. Lennon, *Reading Bayle* (Toronto, Buffalo, London: University of Toronto Press, 1999).

13. Immanuel Kant, "What is Enlightenment," in I. Kant, *Philosophical Writings*, ed. Ernst Behler (New York: Continuum, 1986), pp. 263-69.

14. Most recently in Robert Darnton, *The Forbidden Best-Sellers of Pre-Revolutionary France* (New York and London: W.W. Norton & Company, 1995), which contains a partial translation of *Thérèse Philosophe*.

15. Robert Darnton, "Sex for Thought," *New York Review of Books*, 22 December 1994, pp. 65-74.

16. Literature on eighteenth-century literary pornography has proliferated recently. For a judicious overview and bibliographical references, see Lynn Hunt, ed., *The Invention of Pornography: Obscenity and the Origins of Modernity, 1500-1800* (New York: Zone Books, 1993). See also two recent anthologies of French eighteenth-century libertine fiction, both with excellent introductions: Raymond Trousson, ed., *Romans libertins du XVIIIe siècle* (Paris: R. Laffont, c. 1993); Michel Feher, ed., *The Libertine Reader: Eroticism and Enlightenment in Eighteenth-Century France* (New York: Zone Books, 1997).

17. Donald Posner, "Boucher's Beauties," *The Loves of the Gods: Mythological Painting from Watteau to David*, exhibition catalogue (New York: Rizzoli and Fort Worth: Kimbell Art Museum, 1992), pp. 60-71. Artists who treated the Hercules and Omphale theme in this moment include François Lemoyne (1724, Musée du Louvre, Paris), Jacques Dumont le Romain, (1728, Musée des Beaux-Arts, Tours), Charles-Antoine Coypel (1731, Alte Pinakothek, Munich), and François Boucher (1731-34, Hermitage, St. Petersburg). For color reproductions and extended discussions of the Lemoyne, Coypel, and Boucher canvases (in the case of the Lemoyne, of a variant autograph version), see entries by Colin Bailey in *Loves of the Gods*, op. cit., pp. 244-49, 308-13, and 372-79.

18. Roger de Piles, *Cours de peinture par principes* (Paris: Éditions Gallimard, 1989). Quoted passages on pp. 12, 8-9.

19. On this question, see: Rémy Saisselin, *The Enlightenment against the Baroque: Economics and Aesthetics in The Eighteenth Century* (Berkeley: University of California Press, 1992); Ellen Ross, "Mandeville, Melon, and Voltaire: The Origins of the Luxury Economy in France," *Studies on Voltaire in the Eighteenth Century*, vol. 155 (1976): 1897-1912.

20. Joan B. Landes, *Women in the Public Sphere in the Age of the French Revolution* (Ithaca and London: Cornell University Press, 1988).

21. Marc-Antoine Laugier, *Essai sur l'architecture / Observations sur l'architecture* (Paris: Pierre Mardaga, 1979), esp. pp. 1-8.

22. On this painting, see Pierre Rosenberg, *Chardin 1699-1779*, exhibition catalogue (Cleveland Museum of Art, 1979), pp. 210-12.

23. *François Boucher, 1703-1770*, exhibition catalogue (New York: The Metropolitan Museum of Art, 1986), pp. 267-71.

24. Rosenberg, *Chardin 1699-1779*, op cit., pp. 279-81.

25. As noted by Martha Wolf, "An Early Painting by Greuze and its Literary Associations," *Burlington Magazine* 138 (September 1996): 580-85. With characteristic audacity and self-consciousness, the Chicago Greuze also evokes a painting of the *Repentant Magdalene* by Charles Lebrun (c. 1656-57, Musée du Louvre, Paris) that was much admired in the eighteenth century.

26. A 1777 print after Greuze, perhaps a reproduction of a now-lost painting by him dating from circa 1765, shows a richly dressed woman asleep in a chair, having dropped off while reading the book open on the table beside her (engraved by Jean-Michel Moreau le jeune and retouched by Jacques Aliamet; reproduction and discussion in Wolf, "An Early Painting by Greuze", op. cit., p. 583). Dedicated to Madame Greuze, whom it presumably depicts, it is a bourgeois variation on the Boucher portrait of Madame de Pompadour in Munich mentioned above (Salon of 1757); its title, *La Philosophie endormie*, makes clear its imbrication in the network of imagery under discussion.

27. This print is from a times-of-day cycle, but the other three images are not as provocative. See Bibliothèque nationale, Cabinet des estampes. *Inventaire du fonds français. Graveurs du XVIIIe siècle*, vol. 10 (Paris: Bibliothèque nationale, 1968): 122-24. These prints were published independently, but for an essential study of the erotics of contemporary book illustration that casts interesting light on them, see Philip Stewart, *Engraven Desire: Eros, Image, and Text in the French Eighteenth Century* (Durham and London: Duke University Press, 1992).

28. Schall is little-studied; on this painting, see Richard Rand et al., *Intimate Encounters: Love and Domesticity in Eighteenth-Century France* (Princeton: Princeton University Press, 1997), pp. 180-82.

29. Note, however, that women figure prominently in eighteenth-century Parisian police records pertaining to the distribution of salacious "philosophical" literature. See Margaret Jacobs, "The Materialist World of Pornography," in Hunt, *The Invention of Pornography*, op. cit., pp. 157-202 and 366-73; this observation on p. 183.

30. See Virginia E. Swain, "Hidden from View: French Women Authors and the Language of Rights, 1727-1792," in Rand, *Intimate Encounters*, op. cit., pp. 21-38.

31. For a compelling and well-documented feminist study of the sexual politics of discourse, social practice, and prejudice in Enlightenment Paris, see Dena Goodman, *The Republic of Letters: A Cultural History of The French Enlightenment* (Ithaca and London: Cornell University Press, 1994).

Chapter Four

1. Charles Clément, *Géricault, étude biographique et critique*, 3rd ed. (Paris, 1879), p. 232.

2. Richard Wrigley, *The Origins of French Art Criticism: from the Ancien Régime to the Restoration* (Oxford: Oxford University Press, 1993), p. 299. Basic primary and secondary sources in French on the hierarchy of genres and on classical art theory are too numerous to mention, though it is well worth noting at least Annie

Becq, *La genèse de l'esthétique française moderne. De la raison classique à l'imagination créatrice 1680-1814*, 2 vols. (Pisa: Pacini, 1984). In English, discussions include Rensselear W. Lee, *Ut Pictura Poesis: The Humanistic Theory of Painting* (New York: Norton, 1967); Michael Fried, *Absorption and Theatricality: Painting and Beholder in the Age of Diderot* (Chicago: University of Chicago Press, 1980); Thomas Puttfarken, *Roger de Piles' Theory of Art* (New Haven and London: Yale University Press, 1985); as well as Wrigley's book.

3. G. E. Lessing, *Laocoon, or, On the Limits of Painting and Poetry* (1766), trans. W.A. Steel, in H.B. Nisbet, ed., *German Aesthetic and Literary Criticism*, (Cambridge: Cambridge University Press, 1985), p. 99. This discussion here and throughout is greatly indebted to Henri Zerner, "La problématique de la narration chez Géricault", in *Géricault* (Paris: Editions Carré, 1997), pp. 47-64. This essay first appeared in the *Proceedings of the XXVIII International Congress of History of Art*, 15-20 July 1992 (Berlin, Akademie Verlag, n.d., 1993?), pp. 569-78.

4. Alexandre Corréard and Henri Savigny, *Naufrage de la frégate la Méduse faisant partie de l'expédition du Sénégal en 1816* (Paris: Corréard, 1817). Summaries, with reference to Géricault, are given in Lorenz Eitner, *Géricault's Raft of the Medusa* (London: Phaidon, 1972), and Eitner, *Géricault: His Life and Work* (London: Phaidon, 1983). Detailed accounts may be found in Georges Bordonove, *Le naufrage de la Méduse* (Paris: Éditions Robert Laffont, 1973), and Phillipe Masson, *L' affaire de la Méduse - le naufrage et le procès* (Paris: Tallandier, 1989). The best comprehensive works on Géricault to date are Régis Michel et al, eds., *Géricault*, exhibition catalogue (Paris: Louvre, 1991); and Régis Michel, ed., *Géricault*, actes du colloque "Géricault", Paris-Rouen, 1991, 2 vols., (Paris: La documentation française, 1996).

5. Illustrations of the project may be found in Germain Bazin, *Théodore Géricault. Étude critique, documents, et catalogue raisonné*, tome vi:Génie et folie (Paris: Wildenstein Institute, 1994) and Eitner, *Géricault's Raft*, op. cit., and Eitner, *Géricault: His Life*, op. cit.

6. From Alexandre Corréard and Henri Savigny, *Narrative of a Voyage to Senegal* (London, 1818), re-edition (Marlboro, Vermont: The Marlboro Press, 1986), p. 68, a contemporary translation of the Corréard-Savigny book.

7. Ibid.

8. Anonyme [Fabien Pillet], "Musée Royal. Exposition des tableaux (premier article)", *Journal de Paris, politique, commercial et littéraire*, 28 August 1819, p. 3.

9. Cited in Puttfarken, *Roger de Piles'*, op. cit., p. 8.

10. Cited in Fried, *Absorption and Theatricality*, op. cit., note 89, pp. 214-215.

11. Corréard and Savigny, *Narrative of a Voyage to Senegal*, op. cit., p. 40. The episodes were depicted in a number of contemporary prints: see, for instance, Eitner, *Géricault's Raft*, op. cit., fig. L.

12. Corréard and Savigny, *Narrative of a Voyage to Senegal*, op. cit., p. 41

13. Ibid.

14. Ibid., p. 42.

15. Ibid., p. 47.

16. See illustrations in Eitner, *Géricault's Raft*, op. cit., plates 5-8; Eitner, *Géricault: His Life*, op. cit., pp.166-68; and Michel, *Géricault*, exhibition catalogue, op. cit., pp.144-45, 147. See as well, Bazin, *Théodore Géricault*, op. cit.

17. See illustrations in Phillipe Grunchec, *Master Drawings by Géricault*, exhibition catalogue (Washington, DC: International Exhibitions Foundation, 1985), p.137, fig.70d; Eitner, *Géricault's Raft*, op. cit., pl.6; Eitner, *Géricault: His Life*, op. cit., p.166; and Michel, *Géricault*, exhibition catalogue., op. cit., p.145.

18. On politics and *The Raft*, see *Géricault*, actes du colloque, op. cit., vols. 1 and 2, passim; and Maureen Ryan, "Liberal Ironies, Colonial Narratives and the Rhetoric of Art: Reconsidering Géricault's *Radeau de la Méduse* and the *Traite des nègres*," in S. Guilbaut, M. Ryan, S. Watson, eds., *Théodore Géricault. The Alien Body: Tradition in Chaos*, exhibition catalogue (Vancouver: University of British Columbia, Morris and Helen Belkin Art Gallery, 1997), pp.18-51. See as well, in the same volume, Bruno Chenique, "On the Far Left of Géricault," pp.52-93.

19. Corréard and Savigny, *Narrative of a Voyage to Senegal*, op. cit., passim.

20. Ibid., pp.59-60.

21. Ibid., pp.60-1.

22. Ibid., p.66.

23. Ibid., pp.67.

24. The story of the cut towline appears in the earliest published account of the shipwreck, based on writings by Savigny, which formed the basis of the Corréard-Savigny book: "Naufrage de la Méduse," *Journal des débats*, 13 September 1816, p.2. This story is dropped from the 1817 and 1818 editions of the book, but is picked up in a review of *The Raft* at the 1819 Salon: [A.H.] K[ératry], "Troisième lettre d'un vieil ami des arts à son ami," *Le courrier*, 30 August 1819, p.3.

25. These and other related questions are addressed in Henri Zerner, "Le portrait plus ou moins", *Géricault* (Paris: Éditions Carre, coll. Arts & esthétique, ed. Gilles A. Tiberghien and Olivia Barbet-Massin, 1997), pp. 65-87. The essay was originally published in Michel, *Géricault*, actes du colloque, op. cit., t.1, pp.323-336.

26. Cited and discussed in Jean-Claude Lebensztejn, "Une source oubliée de Morley", in Michel, *Géricault*, actes du colloque, op. cit., t.2, p. 893.

27. See the discussion by Régis Michel in Michel, *Géricault*, exhibition catalogue, op. cit., p.30; and Régis Michel, "Le nom de Géricault, ou l'art n'a pas de sexe mais ne parle que de ça," in Michel, *Géricault*, actes du colloque, op. cit., pp.1-37, passim.

28. Géricault and the fragment are discussed in, among others, Régis Michel, "Le nom de Géricault," op. cit., passim; Charles Rosen and Henri Zerner, *Romanticism and Realism: The Mythology of Nineteenth-Century Art* (New York: Viking, 1984). Discussions of the Romantic fragment may be found in Rosen/Zerner; Phillipe Lacoue-Labarthe and Jean-Luc Nancy, *The Literary Absolute: The Theory of Literature in German Romanticism*, trans. P. Barnard and C. Lester

(New York: The State University of New York Press, 1988); and Rodolphe Gasché, "Forward: Ideality in Fragmentation," in Friedrich Schlegel, *Philosophical Fragments*, trans. P. Firchow (Minneapolis: University of Minnesota Press, 1991), pp.vii-xxxii.

29. Jules Michelet, *Journal*, tome 1 (1828-1848), ed. Paul Viallaneix (Paris: Gallimard, 1959), p. 332.

30. See illustrations in Michel, *Géricault*, exhibition catalogue, op. cit., pp.32-33.

31. Lebensztejn, "Une source oubliée de Morley," op. cit., p.893.

32. The project is discussed and illustrated in Wheelock Whitney, *Géricault in Italy* (New Haven and London: Yale University Press, 1997), pp. 89-155.

33. On the Fualdès project, see Robert Simon, "Géricault and *l'affaire Fualdès*," in Michel, *Géricault*, actes du colloque, op. cit., t.1, pp.161-78.

34. On the question of popular imagery, see Robert Simon, "Géricault and the *fait divers*", in Michel, *Géricault*, actes du colloque, op. cit., t. 1, 1996, pp. 255-72.

35. Clément, *Géricault*, op. cit., p.304.

36. Zerner, "La problématique de la narration chez Géricault," in Zerner, *Géricault*, op. cit., p.59.

37. Cited in Bruno Chénique, "Géricault: Une Vie," in Michel, *Géricault*, exhibition catalogue, op. cit., p.305.

38. C.P. Landon, *Salon de 1819* (Paris, 1819), p.66. And see the discussion in Robert Simon, "Shipwreck of the *Méduse*," in *Géricault. Dessins et estampes des collections de l'École des Beaux-Arts*, exhibition catalogue (Paris: École nationale supérieure des beaux-arts, 1997), p.233.

39. Linda Nochlin, "Géricault, or the Absence of Women," *October* 68 (spring 1994): 45-59. The essay was originally published in Michel, *Géricault*, actes du colloque, op. cit., t.1, pp.323-336.

40. Nochlin, ibid., p. 47.

41. Ibid., p. 50.

42. Ibid., p. 51.

43. Ibid., p. 59.

Chapter Five

1. Lynne Tillman, "*Dynasty* Reruns: 'Treasure Houses of Great Britain,'" *Art in America* vol. 74, no. 6 (June 1986): 35.

2. Ibid.

3. Tillman, "Madame Realism Asks: What's Natural About Painting?", *Art in America* vol. 74, no. 3 (March 1986): 123.

4. Christopher Norris, *New Idols of the Cave: On the Limits of Anti-Realism* (Manchester and New York: Manchester University Press, 1997), p. 6.

5. One of the standard conventionalist arguments relevant to the visual arts is E. H. Gombrich, *Art and Illusion: A Study in the Psychology of Visual Perception* (Princeton: Princeton University Press, 1960). Gombrich's brand of conventionalism, however, receives a stern rebuke in Norman Bryson's own conventionalist account *Vision and Painting: The Logic of the Gaze* (Cambridge: Cambridge University Press, 1983) on the grounds of its alleged neglect of the ideological, the historical, and the contextual determinations that make any cultural product appear "realistic."

6. Linda Nochlin, *Realism* (Harmondsworth, England: Penguin Books, 1971).

7. Terry Lovell, *Pictures of Reality* (London: British Film Institute, 1980), p. 6.

8. Nelson Goodman, *Languages of Art: An Approach to a Theory of Symbols* (Indianapolis and Cambridge: Hackett Publishing Company Inc., 1976); Jean-Louis Baudry, "The Apparatus: Metapsychological Approaches to the Impression of Reality in the Cinema," in Gerald Mast, Marshall Cohen, Leo Braudy, *Film Theory and Criticism: Introductory Readings* (New York and Oxford: Oxford University Press, 1992), pp. 690-707. The complete quotation from Baudry is as follows: "The cinematographic apparatus is unique in that *it offers the subject perceptions 'of a reality' whose status seems similar to that of representations experienced as perception*" (his italics), p. 704.

9. Terry Eagleton, *Literary Theory: An Introduction* (London: Blackwell, 1986), p. 117.

10. Ibid., p. 118.

11. "The Realist Criminal and the Abstract Law," part I, *Art in America*, v. 61, no. 5 (September 1973): 54-61; "The Realist Criminal and the Abstract Law," part II, *Art in America* v.61, no. 6 (November-December 1973): 96-103.

12. Nochlin, *Realism*, op. cit., p. 50.

13. Ibid., p. 51.

14. Erich Auerbach, *Mimesis: The Representation of Reality in Western Literature*, trans. Willard Trask (Princeton: Princeton University Press, 1974).

15. Nochlin, "The Realist Criminal," part I, op. cit., p. 54.

16. Certainly one of the pollutants that high modernist aesthetics defends against is that of mass culture, consistently associated with femininity and feminine consumption. The gendered aspects of modernist self-purification are discussed by Andreas Huyssen, in "Mass Culture as Woman: Modernism's Other," in Tania Modleski, ed., *Studies in Entertainment: Critical Approaches to Mass Culture* (Bloomington and Indianapolis: Indiana University Press,1986).

17. Nochlin, "The Realist Criminal," part I, op. cit., p. 56.

18. Ibid., p. 60.

19. Nochlin, "The Realist Criminal," part II, op. cit., p. 97.

20. Naomi Schor, *Reading in Detail: Aesthetics and the Feminine* (New York and London: Methuen, 1987).

21. Nochlin, "The Realist Criminal," part I, op. cit., p. 54.

22. Roland Barthes, "The Reality Effect" in Barthes, *The Rustle of Language*, trans. Richard Howard, (Berkeley and Los Angeles: University of California Press, 1989), pp. 141-148.

23. Ibid., p. 146.

24. See, for example, the special issue of *Screen* vol. 15, no. 2 (summer 1974).

25. In this respect, see Colin McCabe, "Theory and Film: Principles of Realism and Pleasure," in *Screen* vol. 17, no. 3 (autumn 1976).

26. Nochlin, "The Realist Criminal," part I, op. cit., p. 55.

27. Tillman, "Madame Realism Asks," op. cit., p.124.

Chapter Six

It was not difficult for me to decide on a suitable tribute

to Linda Nochlin. *Linda has boldly asserted that the 1860s were 'the best decade ever' so I knew I had to choose a painting produced in this period. She has always said that Manet is the only artist about whom she cannot be objective and of course, there had to be a woman artist in the picture.* Manet's Portrait of Mlle. E.G. *presented itself to me as an obvious choice for my paper and I offer it to her now with immense gratitude and affection.*

1. For representative accounts of the laughter which greeted this painting when it was first exhibited, see A. de Pontmartin, "Le Salon de 1870," *L'univers illustré*, 7 May 1870, p.298; Olivier Merson, "Salon de 1870," *Le monde illustré*, 21 May 1870, p. 331. One critic, in a poem addressed to Manet expressed his own admiration for the picture despite the fact that "ce portrait, rendez-vous des rires et du blame." See Anon., "Salon de 1870 – Croquis Rimés," *Paris-Caprice*, 21 May 1870, p. 747. Théodore Duret saw Manet's originality as the cause of his incomprehensibility and praised him for the very quality that made him the object of widespread derision: "Nous nous arrêtons en conséquence devant les toiles de Manet, mais nous ne sommes pas seuls a stationner devant elles. Au contraire, il y a foule autour de nous, et de suite nous nous apercevons que le bon public, qui tout a l'heure s'extasiait devant n'importe quel pastiche, se gaudit maintenant de notre artiste original, précisément a cause de l'originalité et de l' invention qui nous attirent et nous séduisent." T. Duret, "Le Salon," *L' électeur libre*, 9 June 1870, p. 92. For many commentators, the painting prompted only silence. A number of important Salon reviewers ignored it even in specialized articles on portraits at the Salon. See, for example, A. de Lostalot, "Salon de 1870," *L' illustration*, 18 June 1870, pp. 438-9; C. Clement, "Exposition de 1870," *Journal des débats*, 14 May 1870; Louis Enault, "Salon de 1870," *Le constitutionnel*, 17 June 1870.

2. This, at any rate, was the view of the caricaturist for *L'illustration* who, in his satirical page on "Les dames du Salon," featured the stupefied spectators rather than the lady herself in his ironic homage to their refinement and taste. See *L' illustration*, 25 June 1870, p. 465. A number of critics accused Manet of sheer exhibitionism and attention seeking in his submissions of 1870. Denounced for despising hard work, many critics held that if he would only put in some effort, he would be able to produce work of quality. See, for example, A. Baignères, "L'exposition officielle de 1870," *Revue contemporaine* vol. LXXV (May-June 1870): 507; L. Debitte, "Le Salon de 1870," *Le Sicambre*, 29 May 1870, p.2; Bleu-de-Ciel, "Le Salon de 1870," *Le velocipède illustré*, 22 May 1870, p. 2.

3. For comments on the relationship between painted portraiture and photography see A. Baignères, "L'exposition officielle de 1870," op. cit., p. 507. The worst that a portrait could do was to convey "the vulgar appearance of a painted photograph." See H. Fouquier, "Salon de 1870," *Le Français*, 5 May 1870.

4. See V. Fournel, "Le Salon de 1870," *La gazette de France*, 8 June 1870.

5. "Quelles que soient les variations de l'art moderne, qu'il soit classique, académique, bourgeois, romantique, fantaisiste, amant de l'idéal ou courtisan de la réalité, *la Dame aux yeux ronds, la Femme aux double croches, l'Homme à la guitare*, n'en resteront pas moins au-dessous et au delà de la caricature. ... C'est la destitution définitive de l'expression et de l'âme: ce n'est plus matérialisme, c' est le crétinisme dans l'art. La peinture a déjà supprimé la nature divine; ne lui permettons pas d'anéantir la nature humaine." A. de Pontamartin, "Le Salon de 1870," op. cit., 7 May 1870, p.298. On the subject of Manet's portraits as caricatures see also L. Laurent-Pichat, "Salon de 1870," *Le réveil*, 13 May 1870, p. 3. On the trust required between portraitist and model, see C. Lemonnier, "Salon de Paris – 1870,"in *Les peintres de la vie* (Paris 1888), p.88.

6. Balance was everything, and the imperatives of accurate recording had to be adjusted to the demands of taste and sobriety. For a discussion of portraiture in these terms, see J. Grangedor, "Le Salon de 1868," *Gazette des beaux arts*, June 1868, p. 520.

7. G. Klein, "Salon de peinture 1870," *Le rideau*, 14 May 1870, p. 3. J.-A. Castagnary praises Gonzalès for avoiding Manet's fault of suppressing half tones in her own Salon submissions. See Castagnary, "Salon de 1870," *Le siècle*, 3 June 1870.

8. M. Chaumelin, "Salon de 1870," *La presse*, 21 May 1870.

9. O. Pichat, "Salon de 1870," *Le Gaulois*, 16 May 1870, p. 3.

10. A. Wolff, "Le Salon de 1870," *Le Figaro*, 13 May 1870, p. 2. The familiar accusation of flatness was made repeatedly of this painting. One critic even remembered to juxtapose this old chestnut with a cat, a sure signifier of the scandalous author of *Olympia*: "Le chat de Mlle Gonzalès, s'il peignait, rougirait devant sa maîtresse de produire une peinture aussi plate!!!" wrote one outraged critic. See Anon., "Revue des lettrès, arts et sciences," *L' arc-en-ciel*, no. 33 (June 1870), p. 274.

11. G. Klein, "Salon de peinture 1870," op. cit., p. 3.

12. For a discussion of Manet in these terms see O. Pichat, "Salon de 1870," 16 May 1870, op. cit., p. 3.

13. A. Wolff, "Le Salon de 1870," op. cit., p. 2.

14. See A. de Pontmartin, "Le Salon de 1870," op. cit., 7 May 1870, p.298.

15. L. Laurent-Pichat, "Salon de 1870," op. cit., 13 May 1870.

16. "J'admire comme un vrai phénomène le courage de Mlle E.G.... qui a osé affronter en face les redoutables pinceaux du jeune maître..." V. Fournel, "Le Salon de 1870," op. cit. Or, in the words of Laurent-Pichat, "Les saintes au désert ou livrées aux bourreaux ne sont pas plus courageuses que la jeune personne qui a permis à M. Manet de la représenter en pied avec une robe blanche aussi sale." "Salon de 1870," op. cit., 13 May 1870.

17. V. Fournel, "Le Salon de 1870," op. cit.

18. L. Laurent-Pichat, "Salon de 1870," 13 May 1870, op. cit., p.3.

19. The letter read: "If Mlle Gonzalès and you are still of the same mind, I would be very happy to start the portrait on Sunday at whatever time suits you - it seems more convenient to do it at home at 49 rue de St Pétersbourg, where there is a small room that I can use as a studio. If you agree, I shall send someone on Sunday morning to pick up Mademoiselle Gonzalès' dress." See letter from Manet to Mme Emmanuel Gonzalès, June-July? 1869, in J. Wilson-Bareau, ed., *Manet by Himself: Correspondence and Conversation, Paintings, Pastels, Prints and Drawings* (Boston: Little, Brown, 1991), p.52.

20. Regnault's *Salomé*, for example, enjoyed much acclaim, the figure's exotic allure, tousled tresses and lascivious cruelty being easily digestible. Critics agreed that this painting was the most widely discussed exhibit at the Salon. See Ch. Wallut, "Le Salon de 1870," *Musée des familles*, July 1870, p. 315. Wallut lists a number of works with Jewish themes at the Salon. Renoir's *Femme d' Alger* was also exhibited. See caricature by Cham, *Le Charivari*, 29 May 1870.

21. They were named as such in *Le Charivari*, 10 May 1870, p. 101.

22. See O. Pichat, "Salon de 1870," 21 May 1870, op. cit.

23. See the mock conversation staged by M. le Professeur Courbet and "Un manettiste" in *Le Charivari*, 10 May 1870, p. 101.

24. O. Pichat, "Salon de 1870," 21 May 1870, op. cit.

25. For a satirical account of people going to be vaccinated, see "Le comédie de vaccin," *Journal amusant*, 9 April 1870, p. 6. See also X. Aubryet, "La fête du Vaccin," *La vogue parisienne*, 25 February 1870, p. 1 for a description of the fashion for vaccination.

26. For a contemporary medical view on the necessity for vaccination see, Dr Danet, "Variole, Vaccination, Revaccination," *Journel officiel de l'Empire français*, 12 June 1870, pp. 637-638.

27. See the caricature published in *Le Charivari*, 15 April 1870, p. 91.

28. See note 41.

29. See O. Pichat, "Salon de 1870," 21 May 1870, op. cit.

30. As one critic put it: "...Mlle Eva Gonzalès est élève de M. Chaplin, qui n'est pas seulement le peintre des femmes, mais qui est aussi leur professeur: la plupart de nos jeunes exposantes sortent de son atelier." Louis Enault, "Salon de 1870," *Le constitutionnel*, 23 May 1870. In a mock plebiscite conducted by the *Journal amusant*, women voted overwhelmingly for Chaplin rather than Courbet as "des peintres des dames françaises." See the cover of the *Journal amusant*, 28 May 1870.

31. For the rules of submission to the Salon of 1870, see A. de Lostalot, "Salon de 1870, considérations générales," *L' illustration*, 11 June 1870, p. 423.

32. See, for example, Terigny, "Salon de 1870; Le Genre et le Portrait," *Revue internationale de l'art et de la curiosité*, 15 May 1870, pp.427-445. To add insult to injury, this critic discussed Fantin Latour's *L'atelier aux Batignolles*, exhibited in the same Salon, without apparently recognizing its central character.

33. Defence of Manet, where it existed in 1870, centered on his "originality." See Ph. Burty, "Le Salon," *Le rappel*, 11 May 1870. T. Duret, "Le Salon," op. cit., p.92.

34. Once again Manet had not lived up to his potential and had failed to produce paintings which had succeeded in picturing contemporary society. See J.-A. Castagnary, "Salon de 1870," op. cit.

35. He went on to say, "La tête très bien dessinée est d'un joli caractère, l'ensemble du tableau dénote le tempérament d'un véritable artiste." O. Pichat, "Salon de 1870," 21 May 1870, op. cit.

36. T. Révillon, "Salon de 1870, L'enfant de troupe," *La petite presse*, 18 June 1870.

37. L. Laurent-Pichat, "Salon de 1870," 13 May 1870, op. cit.

38. On the contrary, he discovers, it is Manet who teaches Gonzalès and he is all the more impressed by her ability to resist his dangerous personality. See O. Pichat, "Salon de 1870," 21 May 1870, op. cit.

39. See "Le Salon de 1870 par Cham," *Le Charivari*, 15 May 1870, p. 3.

40. For an extensive defense of women artists in these terms, see Léon Legrange, 'Du rang des femmes dans les arts', *Gazette des beaux arts* VIII (October-December 1860): 30-43.

41. See A. de Pontmartin, "Le Salon de 1870," *L'univers illustré*, 18 June 1870, p.394. The Salon of 1870 saw an unprecedented number of female exhibitors whose seriousness and virtue was widely recognized and affirmed.

42. Théodore Duret was one of the tiny minority of critics in 1870 who could not understand what the fuss was all about. He praised the color and tonal harmonies of the ensemble and concluded: "quant aux traits de visage, si on leur retrouve le type d'une saveur si particulière, qui est celui de M. Manet, ce type est au moins cette fois-ci plein de vie et ne manque point de élégance.' See T. Duret, "Le Salon," op. cit.

43. For a discussionof Manet's self-projection in his *Portrait of Emila Zola*, see T. Reff, "Manet's Portrait of Zola," *Burlington Magazine*, January 1975, pp.35-44.

44. See Marie-Caroline Sainsaulieu and Jacques de Mons, *Eva Gonzalès, 1849-1883. Étude critique et catalogue raisonné* (Paris: Bibliothèque des arts, 1990).

45. Manet himself painted her in a much smaller contemporary picture that was never exhibited in his life time, showing her from the back, standing at the easel and working on a figure painting.

46. One critic said of her that she was "en train de confectionner un petit Manet ... sur toile." See Un Frotteur, "Le Salon de 1870. Notes d'un frotteur," *Le courrier des deux mondes*, 8 May 1870, p. 6.

47. Gonzalès painted her first known flower painting late in 1871 and completed it in 1872. Although it is possible that Gonzalès experimented with flower painting while under Manet's tutelage, it is unlikely that she would have completed one to the extent shown here, or that it would have been elaborately framed. For a survey of Gonzalès's work at this time see Sainsaulieu et de Mons, *Eva Gonzalès*, op. cit., p.98. For a discussion of Manet's still lifes see James H. Rubin, *Manet's Silence and the Poetics of Bouquets* (Cambridge, Mass. and London: Harvard University Press, 1994) and Kathleen Adler, *Manet* (London:

Phaidon, 1986), pp. 184-194. Although the painting on the easel is not securely identifiable as a particular Manet it does display the generic characteristics of his floral still lifes of the period.

48. See Rubin, *Manet's Silence*, op. cit., pp. 175-186 and Adler, *Manet*, op. cit., pp. 188-189.

49. For a fascinating account of the meaning of the "signature" see Jacques Derrida, "Signature Event Context," in *Margins of Philosophy* (Chicago: University of Chicago Press, 1982), pp.307-330.

Chapter Seven

Many thanks to Mary Weismantel for her criticism of successive drafts, and to David Craven, for sending me, from the Georg Lukács Archives in Budapest, the short Gauguin essay in the original Hungarian.

1. Auguste Strindberg, "L'actualité: Le misogyne Streinberg [sic] contre Monet," *L'éclair*, 15 February 1895, p.1; in Richard Brettell et al., *The Art of Paul Gauguin*, (Washington: National Gallery of Art, in association with New York Graphic Society Books, 1988), p. 270.

2. Linda Nochlin, "The Imaginary Orient," in *The Politics of Vision: Essays on Nineteenth-Century Art and Society* (New York : Harper and Row, 1989), p. 39.

3. Carl Marx and Friedrich Engels, *The Marx-Engels Reader*, ed. Robert C. Tucker (New York and London: Norton, 1978), pp.74-5.

4. Georg Lukács, *History and Class Consciousness*, trans. Rodeny Livingstone (Cambridge, Mass.: The MIT Press, 1976), p. 88.

5. Jacques Lacan, *Écrits: A Selection* (New York: Norton, 1977), p.4; cited in Peter Dews, *Logics of Disintegration: Post-Structuralist Thought and the Claims of Critical Theory* (London and New York: Verso, 1987), p. 55.

6. Claude Lévi-Strauss, "A Confrontation," *New Left Review* 62 (July-August 1970): 64; in Peter Dews, *Logics*, op. cit., p.74.

7. J.-F. Lyotard, *Les transformateurs Duchamp* (Paris: Éditions Galilée, 1977), p. 23; cited in Perry Anderson, *The Origins of Postmodernity* (London and New York: Verso, 1998), p. 30.

8. See for example, the Gauguin's comments in Paul Gauguin, *Racontars de rapin* (Monaco: Sauret, 1993), pp. 32,37. The central figure in the *D' ou venons nous...* is derived from a drawing in the Louvre formerly attributed to Rembrandt.

9. Quoted in Erich Auerbach, *Mimesis: The Representation of Reality in Western Literature*, trans. Willard Trask (Princeton: Princeton University Press, 1974), p.147.

10. Paul Gauguin, *The Writings of a Savage*, ed. Daniel Guérin (New York: Viking Press, 1978), p. 137.

11. Francois Thiébault-Sisson, "Les petits salons," *Le temps*, 2 December 1893; in Marla Prather and Charles F. Stuckey, eds., *Gauguin. A Retrospective* (New York: Hugh Lauter Levin Associates, distributed by Macmillan Publishing, 1987) p. 218.

12. Cited in *The New Painting: Impressionism 1874-1886* (San Francisco: The Fine Arts Museum, 1986), pp. 340-342.

13. Georges Bataille, *Visions of Excess. Selected Writings, 1927-39*, ed. and intr. Allan Stoekl, translated by Allan Stoekl, with Carl R. Lovitt and Donald M. Leslie, Jr. (Minneapolis: Universtity of Minnesota Press, 1986), p.20.

14. Ibid., p. 22.

15. Ky-Dong (Nguyen van Cam), *Les amours d'un vieux peintre aux Îles Marquises*, ed. Jean-Charles Blanc (Paris: A tempera, 1989, p. 48; Also see Guillaume Le Bronnec, "La vie de Gauguin aux Îles Marquises," *Bulletin de la société des études océaniennes* vol. IX, no. 5 (March 1954): 203.

16. Camille Dreyfus and André Berthelot, (s.v. vanillier), *La grande encyclopédie* (Paris, 1786-1902).

17. Irene Green Dwen Andrews, *Latitude 18 South: A Sojourn in Tahiti* (Cedar Rapids: The Torch Press, 1940), p. 47.

18. "Triangulating Racism," *The Art Bulletin* vol. LXXVIII, n.4 (December 1996): 603-609.

19. See the discussion in Herbert Marcuse, *Hegel's Ontology and the Theory of Historicity*, trans. Seyla Benhabib (Cambridge and London: The MIT Press, 1987), passim.

20. Georg Lukács, "Paul Gauguin," in *The Lukács Reader*, ed. Arpad Kadarkay (Oxford and Cambridge: Blackwell, 1987), pp.160-165. The translation appears to be highly idiosyncratic. I made some changes in translation based upon my best efforts with the original: Gyorgy Lukács, "Gauguin," *Ifjukori muvek (1902-1918)* (Budapest: Magveto Kiado, 1977), pp. 111-115; 852. Originally published in *Muszadik Szazad*, no. 8 (June 1907), pp. 559-562.

21. Julius Meier-Graefe, *Entwicklungsgeschichte der modernen Kunst. Vergleichende Betrachtung der bildenden Künste, als Beitrag zu einer neuen Aesthetik*, 3 vols. (Stuttgart: Julius Hoffmann, 1904).

22. Julius Meier-Graefe, *Modern Art: Being a Contribution to a New System of Aesthetics*, trans. F. Simmonds and G. Chrystal (London and New York: W. Heinemann, G. P. Putman's Sons, 1908), reprinted in Charles Harrison and Paul Wood, eds., Art in Theory: 1900-1990 (Oxford and Cambridge: Blackwell, 1992), p.55.

23. Paul Gauguin, *Noa Noa: The Tahitian Journal*, trans. O.F. Theis (New York: Dover, 1985), p. 18.

24. Paul Gauguin, *Avant et après* (Taravao, Tahiti and Paris: Édition Avant et apres, 1989), p. 33.

Chapter Eight

1. Linda Nochlin, "Women, Art and Power" in *Women, Art and Power and Other Essays* (New York: Harper and Row, 1988), pp. 1-36. The citations are from pp. 1-2 and 8.

2. For her audiography and filmography, see Gerda Taranow, *Sarah Bernhardt: The Art Within the Legend* (Princeton, NJ: Princeton University Press,1972), p. 262ff.

3. Wayne Koestenbaum, *Jackie Under My Skin: Interpreting an Icon* (New York: Plume Books, 1996), p. 284.

4. For discussion of Henri Lavedan's likening of Bernhardt to de Lesseps, see Carol Ockman, "Dying Nightly: Sarah Bernhardt Plays the Orient,"

in Jill Beaulieu and Mary Roberts, eds., *Orientalism's Interlocutors: Rewriting the Colonial Encounter* (Chapel Hill: Duke University Press, 2000).

5. Jules Lemaître cited in Taranow, *Sarah Bernhardt*, op. cit., pp. 108-109.

6. Tom Taylor cited in Taranow, *Sarah Bernhardt*, op. cit., pp. 111, 113. Original italics.

7. Undated clipping from the *New York Times*, Box 2: Sarah Bernhardt star clippings, The Harvard Theater Collection.

8. Sarah Bernhardt, *Memories of My Life, Being My Personal, Professional, and Social Recollections as Woman and Artist* (New York: D. Appleton and Company, 1907).

9. Bram Dijkstra, *Idols of Perversity: Fantasies of Feminine Evil in Fin-de-Siècle Culture* (New York: Oxford University Press, 1986), p. 28 and chap. 2, passim.

10. The photograph is often reproduced cropped.

11. Bernhardt, *Memories of My Life*, op. cit., p. 456.

12. Unidentified clipping. Box 2: Sarah Bernhardt star clippings, Plays G-O, The Harvard Theater Collection.

13. My discussion of posters is indebted to Marcus Vernhagen, "The Poster in *Fin-de-Siècle* Paris: 'That Mobile and Degenerate Art'" in Leo Charney and Vanessa R. Schwartz, eds., *Cinema and the Invention of Modern Life* (Berkeley, CA: University of California Press, 1995), pp. 103-129. The citation is from page 115. On the identification of woman and mass culture, see Rachel Bowlby, *Just Looking: Consumer Culture in Dreiser, Gissing and Zola* (New York: Methuen, 1985), esp. chap. 2; Andreas Huyssen, *After the Great Divide: Modernism, Mass Culture, Postmodernism* (London: The Macmillan Press, 1988), chap. 3; and Mary Louise Roberts, "Review Essay: Gender, Consumption, and Commodity Culture" in *American Historical Review* 3 (June 1998): 817-844.

14. I draw here on note 9 of Susan Sontag's "Notes on 'Camp'" in *Against Interpretation* (New York: Doubleday, 1990): "...the most refined form of sexual attractiveness (as well as the most refined form of sexual pleasure) consists in going against the grain of one's sex. What is most beautiful in virile men is something feminine; what is most beautiful in feminine women is something masculine,"p. 279.

15. Unidentified clipping. Box 2: Sarah Bernhardt press clippings, The Harvard Theater Collection.

16. Natalie Barney and the Marquis of Angelsey are among those who impersonated Bernhardt's *Hamlet* and *L'aiglon* in private theatricals. See Martha Vicinus, "Turn-of-the-Century Male Impersonation: Rewriting the Romance Plot" in Andrew H. Miller and James Eli Adams, eds., *Sexualities in Victorian Britain* (Bloomington: Indiana University Press, 1996), esp. pp. 195-200.

17. Nochlin, *Women, Art and Power*, op. cit., pp. 1-2.

18. Deborah Kass, conversation with the author, 24 March 1999.

Chapter Nine

1. The picture's structure is reminiscent of Pieter Brueghel's *Landscape with Fall of Icarus* (Brussels,
Musée des Beaux-Arts), with its ledge-like left foreground acting as a foil to the landscape beyond (which in each case includes a prominent boat on the water). Perhaps there is an intentional if subtle reference here, on La Fresnaye's part, to that earlier picture of a mythic, failed attempt at the air's conquest, for which his own image would then be the corrective. I would like to take this opportunity to thank Niccolò Calararo of the Conservation Art Service of San Francisco for inviting me to examine *The Conquest of the Air* with him at the Museum of Modern Art in November, 1998, and to Michael Duffy, of the Museum's Conservation Department, as well as other staff members, for facilitating my examination and freely offering their expertise. I am also grateful to Fereshteh Daftari, Assistant Curator in the Museum's Department of Painting and Sculpture, for providing me access to the department's files on the painting.

2. Louis Vauxcelles, "'L'art décoratif' au Salon d'Automne," *Gil Blas*, 12 October 1911, p. 2; cited in Nancy J. Troy, *Modernism and the Decorative Arts in France: Art Nouveau to Le Corbusier* (New Haven and London: Yale University Press, 1991), p.78.

3. Linda Nochlin, "Picasso's Color: Schemes and Gambits," *Art in America* vol. 68, no. 10 (December 1980): 117.

4. William Rubin says, and gives much evidence for it, that Picasso's nickname for Braque, "Wilbourg," was in use by the spring of 1912. See Rubin, *Picasso and Braque: Pioneering Cubism*, exhibition catalogue (New York: The Museum of Modern Art, 1989), pp. 31-33.

5. Nochlin, "Picasso's Color," op. cit., p. 109.

6. See Rubin's discussion of "depersonalization" in Picasso and Braque's art in *Pioneering Cubism*, op. cit., p. 19.

7. Daniel-Henry Kahnweiler, *Juan Gris: His Life and Work*, trans. Douglas Cooper (New York: Abrams, 1969), p. 124, cited in ibid.

8. Françoise Gilot and Carleton Lake, *Life with Picasso* (New York: McGraw-Hill, 1964), p. 75.

9. Georges Braque, "Against Gertrude Stein," *Transition*, no. 23, suppl. (July 1935), pp. 13-14, in ibid., p. 19.

10. Even Robert Wohl, on whose excellent cultural history of early aviation, *A Passion for Wings: Aviation and the Western Imagination 1908-1918* (New Haven and London: Yale University Press, 1994) I have relied heavily, does not take note of the "fraternal" motif in aviation, apart from his superb discussion of the Wright Brothers. Nor, to my knowledge, have cultural historians broached the question of the significance of the many partnerships and collaborations in technical and scientific innovation at the turn of the century. On the other hand, art historians Whitney Chadwick and Isabelle de Courtivron have edited a book of case-studies of artist/partners: *Significant Others: Creativity and Intimate Partnership* (New York: Thames & Hudson, 1993).

11. The four studies are cat. nos. 133, 134, 135, and 136 in Germain Seligman, *Roger de la Fresnaye: With a Catalogue Raisonné* (Greenwich, Connecticut: New York Graphic Society, 1969).

12. "M. Bérard's longest stops were in front of Chéret's *Masquerades*, La Fresnaye's *Conquest of the Air*

(here the minister asked for explanations), and Gleizes's *The City and the Port...*," Guillaume Apollinaire, "The Opening," (orig. "L'intransigeant," 15 November 1913), in *Apollinaire on Art: Essays and Reviews 1902-1918,* ed. Leroy C. Breunig, trans. Susan Suleiman (New York: The Viking Press, 1972), p. 326.

13. See the excellent article by Pascal Rousseau, "La construction du simultané: Robert Delaunay et l'aéronautique," *Revue de l'art* 113 (1996): 19-31.

14. The journalist was Charles Fontaine, who included himself in the photograph with Blériot and the French flag. See Wohl, *Passion*, op. cit., pp. 60-1.

15. Ibid., p. 2.

16. Vasily Kamensky, *Put entusiasta* (The Path of the Enthusiast; orig. ed. 1931) (New York: Orpheus, 1986), p. 110, cited in Wohl, *Passion*, op. cit., p. 2.

17. Alfred H. Barr, *Masters of Modern Art* (New York: The Museum of Modern Art, 1954), p. 74.

18. B.J. Van Damme, "Moving Towards War: La Fresnaye and the French 75" (unpublished seminar paper for "Visual Arts and French Society," Institute of French Studies, New York University, spring 1994).

19. Quoted in Wohl, *Passion*, op. cit., p. 21.

20. Ibid., p. 33.

21. Although he does not offer an interpretation of *The Conquest of the Air*, nor does he discuss the presence (or lack) of an airplane in it, A. L. Chanin is the only commentator I am aware of who even mentions French ballooning in his discussion: "This painting reflects a time when France was a world leader in aeronautics. When La Fresnaye glorified French air pride, Germany boasted of Count Zeppelin's airships. But man's first ascent had taken place in Paris in 1783..." "The World of Art: Cubist de la Fresnaye, New Forms and the Soul of France," *The Compass* (New York), 22 July 1951 (newspaper clipping in La Fresnaye file, Department of Painting and Sculpture, The Museum of Modern Art).

22. Charles Fontaine, *Le matin*, 25 July 1909, cited in Wohl, *Passion*, op. cit., p. 33.

23. Guillaume Apollinaire, "The Salon d'Automne: La Fresnaye," (orig. in *Les soirées de Paris*, 15 November 1913), in *Apollinaire on Art*, op. cit., p. 333.

Chapter Ten

I first met Linda Nochlin in 1968, when she was a visiting professor at Columbia University and I was finishing my Ph.D. there. A few years later, after we had become friends, we discovered an even earlier connection. Each of us had had a grandmother who grew up in the same rural New Jersey community of Russian Jewish immigrants. Given its smallness, it seems safe to assume that they knew each other and, I like to think, played together as children.

The paper I am reading today and which I dedicate to Linda touches on immigrants in New Jersey and also on art museums, a topic about which Linda has also written.

1. For a good introduction to Dana, his writings and his importance as a library and museum man, see *Librarian at Large: Selected Writings of John Cotton Dana*, ed. and intr. Carl A. Hanson (Washington DC: Special Librarians Association, 1991); and Chalmers Hadley, *John Cotton Dana: A Sketch* (Chicago: American Library Association, 1943).

2. This and following paragraphs on American art museums draw from research published in my *Civilizing Rituals: Inside Public Art Museums* (London and New York: Routledge, 1995), chap. 3.

3. Herbert Gutman, *Work, Culture, and Society in Industrializing America* (New York: Alfred A. Knopf, 1976); Samuel P. Hays, "The Politics of Reform in Municipal Government in the Progressive Era," *Pacific Northwest Quarterly* 55 (October 1964): 157-69; Samuel H. Popper, "Newark, NJ, 1810-1916: Chapters in the Evolution of an American Metropolis" (Ph.D. thesis, New York University, 1952); and Paul A. Stellhorn, "Depression and Decline: Newark, NJ: 1929-1941" (Ph.D. thesis, Rutgers University, 1982).

4. See James Clifford, *The Predicament of Culture: Twentieth-Century Ethnography, Literature, and Art* (Cambridge, Mass. and London: Harvard University Press, 1988); Tim Barringer and Tom Flynn, eds., *Colonialism and the Object: Empire, Material Culture and the Museum* (London and New York: Routledge, 1998); Annie E. Coombes, *Reinventing Africa: Museums, Material Culture and Popular Imagination* (New Haven and London: Yale University Press, 1994); and Sally Price, *Primitive Art in Civilized Places* (Chicago and London: University of Chicago Press, 1989).

5. Thorsten Veblen, *The Theory of the Leisure Class* (1899), intr. C. Wright Mills (New York: Mentor Books, 1953). See especially pp. 60ff and 95ff.

6. John Cotton Dana, *The Gloom of the Museum* (Woodstock, Vt.: The Elm Tree Press, 1917), pp. 5-8. Much of this text was originally published in 1910.

7. Thorsten Veblen, *Veblen on Marx, Race, Science and Economics* (New York: Capricorn Books, 1969). Text originally published in 1919 as *The Place of Science in Modern Civilization and Other Essays*. See also David F. Noble, *America By Design: Science, Technology, and the Rise of Corporate Capitalism* (New York: Knopf, 1979); and David W. Noble, *The Paradox of Progressive Thought* (Minneapolis: University of Minnesota Press, 1958).

8. Hadley, *John Cotton Dana*, op. cit., p. 63.

9. John Cotton Dana, *The New Museum* (Woodstock Vt.: Elm Tree Press, 1917), pp. 12 and 17.

10. Benjamin Ives Gilman, *Museum Ideals of Purpose and Method* (Cambridge: The Boston Museum of Fine Arts, 1918), pp. 56 and 108.

11. John Cotton Dana, *The New Relations of Museums and Industries* (Newark: The Newark Museum Association, 1919), p. 13.

12. Dana, *Gloom*, op. cit., p. 20.

13. Dana, *The New Museum*, op. cit., p. 22.

14. For the goals of the Victoria and Albert Museum (originally called the South Kensington Museum) see E. P. Alexander, *Museum Masters: Their Museums and Their Influence* (Nashville, Tenn.: American Association for State and Local History, 1983), chap. 6.

15. Dana, *Gloom*, op. cit., pp. 5-8.

16. Dana, *The New Relations*, op. cit., p. 15.

17. John Cotton Dana, "The Value of the Study of Art in Our Institutions of Higher Education," *Art Bulletin* 1, no. 4 (1918) :69-83.

18. Dana, *Gloom*, op. cit., p. 20.

19. Dana, *Gloom*, op. cit., p. 23.

20. "The Connection Between Art and Bathtubs," interview of John Cotton Dana by Charles W. Wood, in the *World* (New York), editorial section, 28 May 1922.

21. There are marked parallels between the information explosion of Dana's day and that of our own. There can be no doubt that Dana would have been interested in the World Wide Web as a library tool to move knowledge around the globe. In 1929, just before he died, he called for the creation of a kind of pre-cyberspace search engine, a "centralized fact-finding and information service" which would disseminate by "mail, telegraph, wireless and special messengers" the names and addresses of public and private laboratories of research, government departments, and other sources of information about "the latest discovered facts in the fields of pure and applied science, technology, invention, geography and commerce." Such an organization would eliminate wasteful duplication of research and speed progress by saving countless hours of time. John Cotton Dana, in "Libraries as Business Research Centers," *Library Review* 2 (1929), reprinted in *Librarian at Large*, op. cit., pp. 68-70.

22. John Cotton Dana, *A Plan for a New Museum. The Kind of a Museum It Will Profit a City to Maintain* (Woodstock, Vt.: Elm Tree Press, 1920), pp. 16-20.

23. The story can be deduced from various letters and memos from Dana dating from 1914 and 1915, in the Dana papers in The Newark Public Library.

24. Dana, *A Plan for a New Museum*, op. cit.

Chapter Eleven

1. These come from Germain Bazin (in *L'amour de l'art*) and Claude Roger-Marx (in *L'indépendance roumaine*), respectively, as cited in Yve-Alain Bois, *Matisse and Picasso* (Paris: Flammarion, 1998), p. 74.

2. *Cahiers d'art* (1927), pp. 96-100.

3. André Breton, *Surrealism and Painting*, trans. Simon Watson Taylor (New York: Icon Editions, 1972), p. 70.

4. Bois, *Matisse and Picasso*, op. cit., pp. 15, 37.

5. See my *Picasso Papers* (New York: Farrar, Straus, and Giroux, 1998).

6. Bois, *Matisse and Picasso*, op. cit., p. 72.

7. His words were: "Combien de fois au moment de mettre du bleu j'ai constaté que j'en manqué. Alors j'ai pris du rouge et l'ai mis à la place du bleu. Vanité des choses de l'esprit." As cited in Bois, *Matisse and Picasso*, op. cit., p. 72.

8. Bois, *Matisse and Picasso*, op. cit., pp. 72-4.

9. *Cahiers d'art* (1931), p. 41.

10. *Cahiers d'art* (1931), p. 151.

11. This is developed in the chapter, "The Circulation of the Sign," in my *Picasso Papers*, op. cit.

12. In *The Picasso Papers* I argued that from internal evidence the stippled wallpaper must have fallen into Picasso's hands in February or March of 1914 and that the first collages employing it would have been made

at that time. In response to this, Mary Anne Caws generously sent me a possible source for this new run of wallpaper via a letter Duncan Grant sent to Clive Bell in February, 1914, after a visit to Gertrude Stein: "She took me to see Picasso which I very much enjoyed. I promised to take him a roll of old wallpapers which I have found in a cupboard in my hotel and which excited him very much as he makes use of them frequently and finds it very difficult to get. He sometimes tears such pieces off the wall. I think I shall find it difficult to know what to say if I go alone. One wants a Roger [Fry]'s tongue or a Gertrude's bust to fall back onto. I must say I was very much impressed by his new works." The Tate Museum Archives, London.

13. See for example, *Portrait of Jacinto Salvado as Harlequin* (1923, Zervos V, 17); and *Portrait of Olga* (1921, Musée Picasso, Paris).

14. Pierre Daix, *Picasso, Life and Art* (London: Thames & Hudson, 1987), p. 221; and Robert Rosenblum, "The Reign of Marie-Thérèse Walter," in *Picasso and Portraiture* (New York: The Museum of Modern Art, 1996), p. 344.

15. Bois, *Matisse and Picasso*, op. cit., p. 72.

16. Rosenblum, "The Reign of Marie-Thérèse Walter," op. cit., p. 345.

17. Linda Nochlin, "Picasso's Color: Schemes and Gambits," *Art in America* vol. 68, no. 10 (December 1980): 105-22, 177-83.

18. Bois, *Matisse and Picasso*, op. cit., p. 72.

Chapter Twelve

1. Linda Nochlin, ed., *Realism and Tradition in Art, 1848-1900*, and *Impressionism and Post-Impressionism, 1874-1904* (Englewood Cliffs, NJ: Prentice-Hall Inc., Sources and Documents in the History of Art series, ed. H. W. Janson, 1966).

2. Nochlin, *Realism and Tradition*, op. cit.

3. Nochlin, Realism *and Tradition*, op. cit., p. 45.

4 . Linda Nochlin, *Gustave Courbet: A Study of Style and Society* (New York: Garland Publishing Inc., 1976), p. 2; orig. "The Development and Nature of Realism in the Work of Gustave Courbet" (Ph.D. thesis, Institute of Fine Arts, New York University, 1963).

5. Or more precisely Raymond Williams wrote: "I think the true crisis in cultural theory, in our own time, is between this view of the work of art as object and the alternative view of art as a practice." In "Base and Superstructure in Marxist Cultural Theory," *New Left Review*, no. 82 (1973), p. 15.

6. Alvah Bessie, *Men in Battle* (orig. Scribners, 1939; San Francisco: Chandler & Sharp Publishers Inc., 1954), pp. 181-182.

7. Cited in Cary Nelson and Jefferson Hendricks, eds., *Madrid 1937: Letters of the Abraham Lincoln Brigade from the Spanish War* (New York: Routledge, 1996), p. 30.

8. Bessie, *Men in Battle*, op. cit., p. 13.

9. Linda Nochlin, "Courbet's Real Allegory: Rereading 'The Painter's Studio,' in Sarah Faunce and Linda Nochlin, eds., *Courbet Reconsidered* (New York: The Brooklyn Museum, 1988), pp. 21, 27.

10. Nelson and Hendricks, *Madrid 1937*, op. cit., p. 32.

11. Ibid., p. 40.
12. Cited in Peter Carroll, *The Odyssey of the Abraham Lincoln Brigade. Americans in the Spanish Civil War* (Stanford, California: Stanford University Press, 1994), pp. 205, 367.

Chapter Thirteen
This essay was commissioned by The Public Art Fund and published in their book, Looking Up: Rachel Whiteread's Water Tower, *ed. by Louise Neri (New York: The Public Art Fund, 1999), pp. 99-109.*

1. Gerhard Richter, *The Daily Practice of Painting: Writings and Interviews 1962-1993,* ed. Hans-Ulrich Obrist, trans. David Britt (Cambridge: MIT Press, 1995), diary entry dated 6 September 1984, pp. 108-109.
2. Rem Koolhaas, *Delirious New York: A Retroactive Manifesto for Manhattan,* 2nd ed. (New York: Monacelli, 1994), see especially the introduction. First edition 1978.
3. Rem Koolhaas, "Delirious New York Redux," *Zone,* nos. 1-2 (undated), p. 448.
4. See the interviews with Jonathan Jones, "East End or West Side. Home Is Where the Art Is," *Independent,* 11 February 1998; with Carol Kino, "Up on the Roof," *Time Out,* 4 June 1998, pp. 67-68; and with Carol Vogel, "SoHo Site Specific: On the Roof," *New York Times,* 11 June 1998, p. E4.
5. "Eyes on the Skies," *Artforum,* January 1998, p. 34.
6. Both statements are quoted by Darcy Cosper in "Rachel Whiteread's Water Tower: Casting New York," *Metropolis,* June 1998, p. 99.
7. See especially the Iwona Blazwick interview, done in Berlin in October 1992 and published in Rachel Whitread (Eindhoven: Stedelijk Van Abbe Museum, 1992-93), p. 11. See also the interview with Lynn Barber, "In a Private World of Interiors," *The Observer Review,* 1 September 1996, pp. 7-8; and the interview by Andrea Rose in the 1997 Venice Biennale catalogue, pp. 29-35.
8. Whiteread quoted by Doris Van Drathen in her article, "Rachel Whiteread: Found Form, Lost Object," *Parkett,* no. 38 (winter 1993), p. 31. See also the Blazwick interview, op. cit.
9. Blazwick, op. cit., p. 13
10. Friedrich Nietzsche, *Thus Spoke Zarathustra: A Book for All and None,* trans. Walter Kaufmann (New York: Modern Library, 1995), pp. 217-218. The book was published in stages in 1883, 1884, and 1892.
11. *House* has been given excellent critical assessment in James Lingwood, ed., *Rachel Whiteread House,* (London: Phaidon and Artangel, 1995).
12. In her interview with Francesco Bonami, "The Nothingness Supplied With Space," in *Art from the UK* (Munich: Sammlung Goetz, 1998), p. 158.
13. Lingwood, *Rachel Whiteread House,* op. cit., p. 133.
14 .Ibid., p. 134.
15. Councillor Flanders is quoted by Simon Watney in his essay "On *House,* Iconoclasm & Iconophobia," in Lingwood, *Rachel Whiteread House,* op. cit., pp. 105, 108.
16. Lingwood, *Rachel Whiteread House,* op. cit., p. 138.
17. Christoph Grunenberg, "Mute Tumults of Memory," essay in *Rachel Whiteread* (Basel: Kunsthalle Basel, 1994), op. cit., p. 20.
18. The number of immigrants coming to the United State in this decade is expected to reach 10 million, surpassing the record of 8.8 million from 1901 to 1910. These figures come from the Immigration and Naturalization Service, as quoted in "Record Immigrant Flow Fuels US Home Market," *New York Times,* 2 July 1998, p. F9.
19. Deborah Sontag and Celia W. Dugger, "The New Immigrant Tide: A Shuttle Between Worlds," *New York Times,* 19 July 1998, pp. 1, 28-30. For an extensive discussion of the phenomenon globally see Saskia Sassen, *Globalization and its Discontents* (New York: New Press, 1998).
20. Deborah Sontag, "A Mexican Town That Transcends All Borders," *New York Times,* 21 July 1998, p. B7.
21. Sontag and Dugger, "The New Immigrant Tide," op. cit., p. 30.
22. Ibid., p. 1.
23. Ibid., p. 28.
24. Amy Waldman, "Killing Heightens the Unease Felt by Africans in New York," *New York Times,* 14 February 1999, pp. 1, 39; Susan Sachs, "Top Officials in Guinea Meet Plane Carrying Peddler's Body," *New York Times,* 16 February 1999, pp. B1, B5; Susan Sachs, "Slain Man's Mother Is Center of Attention in Guinea," *New York Time,* 17 February 1999, pp. B1, B5; Susan Sachs, "Wanderings Over, A Son Is Laid to Rest," *New York Times,* 18 February 1999, p. B5.
25. Iwona Blazwick's interview in *Rachel Whiteread,* op. cit., p. 11.
26. "Giuliani Takes Credit for Growth in Tourism," *New York Times,* 25 August 1998.
27. Leslie Eaton, "Chic Has a New Address," *New York Times,* 27 November 1998, pp. B1-4.
28. See Roberta Smith, "The Ghosts of Soho," *New York Times,* 27 August 1998, pp. B1-2 and Terry Pristin, "In Soho, Consumerism Is an Art," *New York Times,* 26 September 1998, pp. B1-2.
29. C. Carr, "Going Up in Public," *Village Voice,* 23 June 1998.
30. Nietzsche, *Thus Spoke Zarathustra,* op. cit., p. 125.
31. Ibid., p. 105.

List of Illustrations

1893-94, woodcut printed in color with stencils, block 35.5 x 20 cm. Museum of Fine Arts, Boston.

39 Paul Gauguin, "Aha oe feii? (What! Are You Jealous?)," 1892, oil on canvas, 68 x 92 cm. Pushkin Museum, Moscow.

40 Sarah Bernhardt as Cleopatra, ca.1890, photograph.

41 Félix Nadar (Gaspard Félix Tournachon), Sarah Bernhardt, ca. 1864, photograph. Musée d'Orsay, Paris. Photo ©RMN, Paris.

42 Georges Clairin, *Sarah Bernhardt*, 1876, oil on canvas, 250 x 200 cm. Musée de la Ville de Paris, Musée du Petit-Palais, Paris. Photo: Lauros-Giraudon - Art Resource.

43 Alphonse Mucha, *La dame aux camélias*, 1896. ©ADAGP, Paris and DACS, London 2001.

44 Sarah Bernhardt in her coffin, anonymous photograph, ca.1880.

45 Jules Chéret, *La Diaphane* (Sarah Bernhardt advertising face powder), 1890. ©ADAGP, Paris and DACS, London 2001.

46 Francis Leon as Sarah Bernhardt. Photo courtesy of The Houghton Library, Harvard Theater Collection, Cambridge, Mass.

47 Paul Boyer, Sarah Bernhardt as L'aiglon, 1900.

48 Roger de la Fresnaye, *The Conquest of the Air*, 1913, oil on canvas, 235.9 x 195.6 cm. The Museum of Modern Art, New York. Mrs. Solomon Guggenheim Fund. Photo ©2000 The Museum of Modern Art, New York.

49 *L'aviation par l'image: Un vol de Wilbur Wright à Pau*, postcard. Collection of the Author.

50 *Biplan des frères Albert et Emile Bonnet-Labranche*, postcard. Collection of the Author.

51 *Les frères Voisin*, postcard. Collection of the Author.

52 The Bleriot Monoplane enthroned on the Stand of Honor in the Grand Palais, Paris, October 1909.

53 Newark Museum, Inexpensive Objects Exhibition, 1928. Photo: Newark Museum/Art Resources.

54 Newark Museum, Inexpensive Objects Exhibition, 1928. Photo: Newark Museum/Art Resources.

55 Newark Museum, Exhibition of Modern German Applied Arts, 1912. Photo: Newark Museum/Art Resources.

56 Newark Public Library Notice, 1918. From T*he Library*, The Newark Library, 1919.

57 Pablo Picasso, *La crucifixion*, in *Cahiers d'art*, no.1 (1927). Photo: Katherine Smith. ©Succession Picasso/DACS 2001.

58 Joan Miró, *The Policeman*, 1925, oil on canvas, 248 x 194.9 cm. The Art Institute of Chicago:, Gift of Claire Zeisler, 1991. Photo: ©2000, The Art Institute of Chicago. ©ADAGP, Paris and DACS, London 2001.

59 Pablo Picasso, *Painter and Model*, 1926, oil on canvas, 137.5 x 257 cm. Musée Picasso Paris. Photo ©RMN. ©Succession Picasso/DACS 2001.

60 Joan Miró, *The Statue*, 1925, oil on canvas, 80 x 65 cm. Private Collection. ©ADAGP, Paris and DACS, London 2001.

61 Pablo Picasso, *The Mirror*, 1932, oil on canvas, 13.7 x 97 cm. Private Collection. ©Succession Picasso/DACS 2001.

62 Pablo Picasso, *Head of a Woman*, 1931, cast 1973, bronze, 86.4 x 36.5 x 48.9 cm. The Patsy R. and Raymond D. Nasher Collection, Dallas. Photo: David Heald, courtesy of the Nasher Collection, The Solomon R. Guggenheim Museum. ©Succession Picasso/DACS 2001.

63 Pablo Picasso, *The Blue Acrobat*, 1929, graphite and oil on canvas, 162 x 130 cm. Musée nationale d'art moderne, Centre Georges Pompidou, Paris. Photo ©RMN – Gerard Blot. ©Succession Picasso/DACS 2001.

64 Joan Miró, *Flame in Space and Nude Woman*, 1932, oil on wood, 41 x 32 cm. Fundacion Joan Miró, Barcelona.

©ADAGP, Paris and DACS, London 2001.

65 Pablo Picasso, *Repose*, 1932, oil on canvas, 162 x 130 cm. Private Collection. ©Succession Picasso/DACS 2001.

66 *Statue of a Youth (The Kritios Boy)*, 480-470 BCE, marble, height 116.7 cm. The Acropolis Museum, Athens.

67 Gustave Caillebotte, *Mat at His Bath*, 1884, oil on canvas, 166 x 125 cm.: Josefowitz Collection, National Gallery, London.

68 First Platoon, 3rd Company, Abraham Lincoln Battalion, Sierra Pandos, August 1938. Photo: Eunice Lipton family.

69 Photographs of Dave Lipton alone and with a friend, 1938. Photo: Eunice Lipton family.

70 Dave Lipton with Ben Katine, Spain, 1938. Photo: Eunice Lipton family.

71 Rachel Whiteread, *Water Tower*, June 1998 – June 1999. Rooftop, West Broadway at Grand Street, New York City. Photo: Marian Harders. Courtesy of the Public Art Fund.

72 Linda Nochlin posing with the dress she wore while being painted by Philip Pearlstein, with Pearlstein's Portrait of Linda Nochlin and Dick Pommer visible behind her, New York, ca.1990.

73 Linda Weinberg, La Jolla, California, 1941.

74 Elka Weinberg, La Jolla, California, 1941.

75 Linda Weinberg, age 17, and friend, London, 1948.

76 Linda Nochlin, Vassar College, Poughkeepsie, 1972.

77 Linda Nochlin, Miami, Florida, 1965.

78 Linda Nochlin with daughter, Daisy, 1969.

79 Anne Sutherland Harris, Linda Nochlin, and Pierre Rosenberg at the opening of the exhibition "Women Artists 1550-1950," County Museum of Art, Los Angeles, 1976.

80 Linda Nochlin and friends at an abortion-rights rally in Washington, DC, in 1995. Top row, left to right: Rosalyn Deutsch, Abigail Solomon-Godeau, Liza Solomon; bottom row: Diane Neumaier and Linda Nochlin.

81 Linda Nochlin and Ewa Lajer-Burcharth, Moulin-de-Torçay, France, 1993.

82 Molly Nesbit and Tamar Garb at a dinner party at Linda Nochlin's apartment, ca.1993.

83 Linda Nochlin, Volcano National Park, Hawaii, 1998.

84 Happy Fanny Fields, carte-de-visite photograph ca.1910. Collection of Linda Nochlin.

85 Greenspun family, studio portrait, Vineland, New Jersey, 1880.

86 Linda Weinberg playing nurse to her grandfather, Jacob Heller.

87 Jules, Linda, and Elka Weinberg, Arizona, 1941.

88 Elka Weinberg, date unknown.

89 Linda Nochlin, "Plaint in the Museum," 1944.

90 Linda Nochlin, "At Merton College, Oxford," 1950.

91 Linda Nochlin, postcard to Elka Weinberg, February 1963.

92 Cover of Linda Nochlin and Tamar Garb, eds., T*he Jew in the Text* (London and New York: Thames & Hudson, 1995).

93 Cover of Linda Nochlin and Sarah Faunce, C*ourbet Revisited* (New York: The Brooklyn Museum of Art, 1988). Courtesy of The Brooklyn Museum of Art and the Toledo Museum of Art.

94 Gustave Courbet, *The Painter's Studio: A Real Allegory Summing Up Seven Years of My Artistic Life*, detail, 1854-55, oil on canvas, 360.7 x 599.4 cm. Musée d'Orsay, Paris. Photo: Ken Aptekar.

95 Linda Nochlin, "Matisse's Swan Self," 1973.

96 Celebration dinner at the apartment of Richard Sennett and Saskia Sassen, "Self and History: A Symposium in Honor of Linda Nochlin," 16 April 1999. Photo: Tom McDonough.

* Reprinted in *Women, Art, and Power*
† Reprinted in *The Politics of Vision*
†† Reprinted in *Representing Women*

"The Development and Nature of Realism in the Work of
Gustave Courbet: A study of the Style and Its Social and
Artistic Background." Ph.D. Thesis, Institute of Fine Arts,
New York University, 1963. Published as *Gustave Courbet:
A Study of Style and Society*. New York: Garland
Publishing, 1976. See also "Summaries of Dissertations,"
Marsyas 11 (1962-64): 79-80.
Mathis at Colmar: A Visual Confrontation. New York: Red
Dust Inc., 1963.
Review of Joseph C. Sloane, *Paul Marc Joseph Chenavard, The
Art Bulletin* XLVI (1964): 113-116.
"Innovation and Tradition in Courbet's *Burial at Ornans*,"
Marsyas suppl. II ("Essays in Honor of Walter Friedländer")
(1965), pp.119-26. Reprinted in Petra ten Doesschate Chu,
ed., *Courbet in Perspective*. Englewood Cliffs, NJ: Prentice-
Hall, coll. The Artists in Perspective, 1977, pp.77-87.
† "Camille Pissarro: The Unassuming Eye," *Art News* 64 (April
1965): 24-27, 59-62. Revised version was published in
Christopher Lloyd, ed., *Studies on Camille Pissarro*. London
and New York: Routledge & Kegan Paul, 1986, pp.1-14.
(This is the version reprinted in *The Politics of Vision*.)
editor, *Realism and Tradition in Art, 1848-1900: Sources and
Documents* and *Impressionism and Post-Impressionism,
1874-1904: Sources and Documents*. Englewood Cliffs,
NJ: Prentice-Hall, Sources and Documents in the History of
Art series, ed. H. W. Janson, 1966.
"Gustave Courbet's *Meeting*: A Portrait of the Artist as a
Wandering Jew," *The Art Bulletin* XLIX (September 1967):
209-22.
Introduction in *Realism Now*. Poughkeepsie, NY: Vassar
College Art Gallery, 1968. Reprinted in *Art News* (January
1971); and in G. Battcock, ed., *Super Realism: a Critical
Anthology*. New York: E.P. Dutton, 1975, pp.111-125.
"The Invention of the Avant-Garde: France, 1830-1880," *Art
News Annual* 34 ("The Avant-Garde") (1968). Reprinted as
Avant-Garde Art. New York: Collier and Art News, 1971.
"The Art of Philip Pearlstein," in *Philip Pearlstein*. Athens, Ga.:
Georgia Museum of Art, University of Georgia, 1970.
"Metropolitan Museum: The Inhabitable Museum," *Art News*
68 (January 1970): 36, 45, 58.
"Ugly American: The Work of Philip Pearlstein," *Art News* 69
(September 1970): 55-57, 65-70.
Realism. Harmondsworth, England: Penguin Books, coll. Style
and Civilization, 1971.
* "Why Have There Been No Great Women Artists?" in Vivian
Gornick and Barbara K. Moran, eds., *Woman in Sexist
Society*. New York and London: Basic Books, 1971, pp.344-

366. Reprinted in *Art News* 69, no.9 (January 1971): 22-
39, 67-71. Reply R.L. Leed, 69 (February 1971): 6; in
Thomas B. Hess and Elizabeth C. Baker, eds., *Art and
Sexual Politics*. New York: Newsweek Books, 1971, pp.1-
39; and in *Art News* 91 (November 1992): 114+. Abridged
version translated into Russian as "Pochemu ne byvaet
velkikh khudozhnitz?," *Heresies* 7, no.2 (1992): 38-42.
"Gustave Courbet's *Toilette de la mariée*," *Art Quarterly* 34,
no.1 (spring 1971): 30-54.
"Museums and Radicals: A History of Emergencies," *Art in
America* 59 (July-August 1971): 26-39. Reprinted in Brian
O'Doherty, ed., *Museums in Crisis*. New York: George
Braziller, 1972, pp.7-41.
* ---- and Thomas B. Hess, editors. *Art News Annual* 38
("Woman as Sex Object: Studies in Erotic Art, 1730-1970")
(1972). Reprinted as *Woman as Sex Object*. New York:
Newsweek Books, 1972. Includes "Eroticism and Female
Imagery in Nineteenth-Century Art," pp.8-15.
Review of Albert Boime, *The academy and French Art in the
Nineteenth Century*, *The Burlington Magazine* 114
(August 1972): 559-560.
"Matisse Swan Self" [poem], *Hudson River Anthology* 1
(winter 1973): 6.
"The Realist Criminal and the Abstract Law," *Art in America*
61, no.5 (September-October 1973): 54-61 and no.6
(November-December 1973): 96-103.
"Miriam Schapiro: Recent Work," *Arts Magazine* 48, no.2
(November 1973): 38-41.
"Oh, Say Can You See?" [Review: publications on American
art], *New York Times Review*, 2 December 1973, pp.4-5,
24, 30, 36, 40, 44, 48, 50.
"The 19th Century: French Nineteenth-Century Sculpture and
American Art," in Abram Lerner, ed., *The Hirshhorn
Museum & Sculpture Garden*. New York: Harry N. Abrams,
1974, pp.25-96.
* "Some Women Realists," *Arts Magazine* 48, no.5 (February
1974): 46-51 and 48, no.8 (May 1974): 29-33. Reprinted
in G. Battcock, ed., *Super Realism: a Critical Anthology*.
New York: E. P. Dutton, 1975, pp.64-78.
"How Feminism in the Arts Can Implement Cultural Change,"
Arts in Society 2, nos.1-2 (spring-summer 1974): 80-89.
"Paterson Strike Pageant of 1913," *Art in America* 62 (May-
June 1974): 64-68. Reprinted in B. A. McConachie and D.
Friedman, eds., *Theatre for Working-Class Audiences in
the United States, 1830-1980*. Westport, Conn. and
London: Greenwood Press, 1985, pp.87-96.
"By a Woman Painted: Eight Who Made Art in the 19th
Century," *Ms Magazine*, July 1974, pp.68-75, 103.
"Formalism and Anti-Formalism," *Quadrille* 9, no.1 (fall 1974):
35-42.
Review of T.J. Clark, *The Absolute Bourgeois: Artists and*

Politics in France, 1848-1851 and *Image of the People: Gustave Courbet and the Second French Republic, 1848-1851, Art in America* 62, no.5 (September-October 1974): 15.

Review of Herbert Read, *Education Through Art, New York Times Review,* 13 October 1974, section 7, p.36.

"Dorothea Tanning at CNAC," *Art in America* 62, no. 6 (November-December 1974): 128.

In *Miriam Schapiro: the Shrine, the Computer and the Doll House.* San Diego, Calif.: Art Gallery, University of California San Diego, 1975.

Statement in *Works on Paper: Women Artists.* New York: Women in the Arts Foundation and The Brooklyn Museum, 1975, p.5.

Grandes femmes petits formats at Iris Clert," *Art in America* 63, no.1 (January-February 1975): 90.

"Ellen Johnson of Oberlin: Mainstream in Middle America," *Art in America* 63, no.2 (March-April 1975): 27-29.

"Forum: What Is Female Imagery?," *Ms. Magazine,* May 1975, pp.62+.

――― and Ann Sutherland Harris. *Women Artists: 1550-1950.* Los Angeles: Los Angeles County Museum of Art and New York: Alfred A. Knopf, 1976. Translated into French as *Femmes peintres, 1550-1950,* trans. Claude Bourguignon, Pascaline Germain, Julie Pavesi, and Florence Verne. Paris: Des Femmes, 1981. Selections reprinted as "Women Artists in the 20th Century: Issues, Problems, Controversies," *Studio International* 193 (May-June 1977): 165-74; and "Excerpts from 'Women and the Decorative Arts'," *Heresies* 1, no.4 (winter 1978): 43.

"Rackstraw Downes," *Art in America* 64, no.1 (January-February 1976): 101-102.

"Leslie Torres: New Uses of History," *Art in America* 64, no.2 (March-April 1976): 74-76.

Review of Teddy Brunius, *Mutual Aid in the Arts from the Second Empire to Fin de Siècle, The Art Bulletin* LVIII (June 1976): 308-310.

――― and Henry A. Millon, editors. *Art and Architecture in the Service of Politics.* Cambridge, Mass. and London: MIT Press, 1978.

"The Changing Vision: Women Artists of the 19th and 20th Centuries," in Ann B. Steir, ed., *Women on Women.* Toronto: York University, 1978, pp.45-65.

"Courbet, die Commune und die Bildenden Künste," in Klaus Herding, ed., *Realismus als Widerspruch: die Wirklichkeit in Courbets Malerei.* Frankfurt: Suhrkamp Verlag, 1978, pp.248-261, 316-318.

Contribution to "Late Cézanne: A Symposium," *Art in America* 66 (March 1978): 90-91.

* "Lost and *Found*: Once More the Fallen Woman," *Art Bulletin* LX, no.1 (March 1978): 139-52. Reply with rejoinder, T.J. Edelstein, LXI (September 1979): 509-10.

"Débat sur l'exposition 'Courbet' au Grand Palais," *Histoire et critique des arts* (May 1978), pp.123-38.

"Meyer Schapiro's Modernism," *Art in America* 67 (March-April 1979): 29-33.

Review of Germaine Greer, *The Obstacle Race: The Fortunes of Women Painters and Their Work, New York Times,* 28 October 1979, section 7, p.3.

"The *Cribleueses de blé*: Courbet, Millet, Breton, Kollwitz and the Image of the Working Woman," in K. Gallwitz and K. Herding, eds., *Malerei und Theorie: das Courbet-Colloquium 1979.* Frankfurt, 1980, pp.49-73.

Introduction in Joyce Baronio, *Forty-Second Street Studio.* New York: Pyxidium Press, 1980.

In Thalia Gouma-Peterson, ed., *Miriam Schapiro: A Retrospective, 1953-1980.* Wooster, Oh.: College of Wooster, 1980.

In *New York Realists 1980.* Sparkill, NY: Thorpe Intermedia Gallery, 1980.

* "Florine Stettheimer: Rococo Subversive," *Art in America* 68, no.7 (September 1980):64-83. Reprinted in Elisabeth Sussman and Barbara J. Bloemink, *Florine Stettheimer: Manhattan Fantastica.* New York: Whitney Museum of American Art and Harry N. Abrams, 1995.

"In Detail: Courbet's *A Burial at Ornans,*" *Portfolio* 2, no.5 (November-December 1980): 32-37.

† "Léon Frédéric and *The Stages of a Worker's Life,*" *Arts Magazine* 55, no.4 (December 1980): 137-43.

"Picasso's Color: Schemes and Gambits," *Art in America* 68, no.10 (December 1980): 105-22, 177-83.

† "Van Gogh, Renouard, and the Weaver's Crisis in Lyons: the Status of a Social Issue in the Art of the Later Nineteenth Century," in Moshe Barasch and Lucy Freedman Sandler, eds., *Art the Ape of Nature: Studies in Honor of H. W. Janson.* New York: Harry N. Abrams, 1981, pp.669-688.

Introduction in *Real, Really Real, Super Real: Directions in Contemporary Realism.* San Antonio, Tex.: Witte Memorial Museum, 1981, pp.25-35.

Review of "Realist Tradition at The Brooklyn Museum"[traveling exhibit], *The Burlington Magazine* 123, no.937 (April 1981): 263-269.

Review of Maurice Agulhon, *Marianne au combat: l'imagerie et la symbolique republicaine de 1789 à 1880, Oxford Art Journal* 4 (July 1981): 62-64.

"Edward Hopper and the Imagery of Alienation," *Art Journal* 41, no.2 (summer 1981): 136-141.

"Return to Order," *Art in America* 69, no.7 (September 1981): 74-83, 209-211.

"The De-Politicization of Gustave Courbet: Transformation and Rehabilitation Under the Third Republic," *October* 22 (fall 1982): 64-78. Reprinted in Michael R. Orwicz, ed., *Art Criticism and Its Institutions in Nineteenth-Century France.* Manchester and New York: Manchester University Press, 1994.

"The Telling Detail: What It Reveals About Painting," *House and Garden* 155, no.1 (January 1983): 136-43.

"Visions of Languor: Paintings by John Singer Sargent and John Alexander," *House and Garden* 155, no.4 (April 1983): 124-129+.

† "The Imaginary Orient," *Art in America* 71, no.5 (May 1983): 118-31, 187-89, 191.

"Fantin-Latour: Beyond Fruit and Flowers," *House and Garden* 155, no.6 (June 1983): 130-37, 190-97.

"A Ceramic Sculptor's Art About Art: The Work of K. Sokolnikoff," *House and Garden* 155, no.7 (July 1983): 154+.

"Masterpieces in the Garden," *House and Garden* 155, no.9 (September 1983): 170-77, 181-82.

"The Stylish Art of Louise Dahl-Wolfe," *House and Garden* 155, no.9 (September 1983): 194.

† "A Thoroughly Modern Masked Ball," *Art in America* 71, no.10 (November 1983): 188-201.

"Revolution Out of Bounds," review of Ronald Paulson, *Representations of Revolution (1789-1820), Art in America* 71, no.11 (December 1983): 11-12.

Introduction in *American Women*. Evanston, Ill.: Terra Museum of American Art, 1984.

"Crystalline Fantasies," *House and Garden* 156, no.6 (June 1984): 38, 42, 48, 50.

"Malvina Hoffman: A Life in Sculpture," *Arts Magazine* 59, no.3 (November 1984): 106-10.

"Joan Mitchell: Art and Life at Vetheuil," *House and Garden* 156, no.11 (November 1984): 192-97, 226, 228, 232, 236, 238.

Introduction in *Catherine Murphy: New Paintings and Drawings 1980-1985*. New York: Xavier Fourcade Gallery, 1985.

Entries for works by Jack Beal, Henri Matisse, Pablo Picasso, and Joe Shannon, in Karl Kilinski II, *Classical Myth in Western Art: Ancient Through Modern*. Dallas, Tex.: Meadows Museum and Gallery, Southern Methodist University, 1985, pp.44-45, 64-67, 78-79.

"Paris Commune Photos at New York Gallery: An Interview with Linda Nochlin," *Radical History Review* 32 (1985): 59-74.

"Watteau: Some Questions of Interpretation," *Art in America* 73 (January 1985): 68-87.

"High Bohemia: G.V. Whitney's Long Island Studio," *House and Garden* 157 (September 1985): 180-189.

† "Courbet, Oller and a Sense of Place: The Regional, the Provincial and the Picturesque in Nineteenth-Century Art," *Horizontes* no.56, vol.28 (1985): 7-13.

Introduction in Debra Bricker Balken, ed., *Nancy Graves: Painting, Sculpture, Drawing, 1980-1985*. Poughkeepsie, NY: Vassar College Art Gallery, 1986.

"Painting's New Public" [review of Thomas E. Crow, *Painters and Public Life in Eighteenth-Century Paris*], *Art in America* 74, no.3 (March 1986): 9, 11, 13, 15.

"Renoir's Men: Constructing the Myth of the Natural" [contribution to "Renoir: A symposium"], *Art in America* 74, no.3 (March 1986): 103-07.

"Second Impressions" [review of The New Painting: Impressionism 1874-1886], *House and Garden* 158 (July 1986).

"Art: Portraits in Prints," *Architectural Digest* 43, no.8 (August 1986): 128-133.

"Courbet's *L'origine du monde*: The Origin Without an Original," *October* 37 (summer 1986): 76-86.

"Degas' *Young Spartans Exercising*" [letter], *The Art Bulletin* LVIII, no.3 (September 1986): 486-488.

"Courbet" [contribution to "What Would You Ask Michelangelo?"], *Art News* 85, no.9 (November 1986): 100.

† "Degas and the Dreyfus Affair: A Portrait of the Artist as an Anti-Semite," in Norman L. Kleeblatt, ed., *The Dreyfus Affair: Art, Truth, and Justice*. Berkeley, Calif.: University of California Press, 1987, pp.96-116. Reprinted in Maurice Berger, ed., *Modern Art and Society: An Anthology of Social and Multicultural Readings*. New York: Icon Editions, 1994.

guest editor, "The Political Unconscious in Nineteenth-Century Art," *Art Journal* 46, no.4 (winter 1987). Includes "Editor's Statement," pp.259-60.

"Art: A Sense of Fashion," *Architectural Digest* 44, no.2 (February 1987): 110-15+.

---- and Sarah Faunce. *Courbet Reconsidered*. New York: The Brooklyn Museum of Art, and New Haven, Conn.: Yale University Press, 1988.

†† Includes "Courbet's Real Allegory: Rereading *The Painter's Studio*," pp.17-42.

"Judy Pfaff, or The Persistence of Change," in *Judy Pfaff: 10,000 Things*. New York: Holly Solomon Gallery, 1988, pp.6-13.

Women, Art, and Power and Other Essays. New York: Harper & Row, 1988. Chinese translation, 1995. Title essay reprinted in N. Bryson, M.A. Holly, and K.P.F. Moxey, eds., *Visual Theory: Painting and Interpretation*. Cambridge: Polity in association with Blackwell, 1991, pp.13-46; title essay translated as "Les femmes, l'art et le pouvoir," *Cahiers du Musée national d'art moderne* no.24 (summer 1988), pp.44-61.

"La Révolution française de Zuka," in *Zuka: The French Revolution Through American Eyes*. Paris: Mona Bismarck Foundation, 1988, pp.3-7. Reprinted as "Zuka's French Revolution: A Woman's Place Is Public Space," *Feminist Studies* 15, no.3 (fall 1989): 549-562.

"Morisot's *Wet Nurse*: The Construction of Work and Leisure in Impressionist Painting," in C. Beutler, P.-K. Schuster and M. Warnke, eds., *Kunst um 1800 und die Folgen: Werner Hofmann zu Ehren*. Munich: Prestel Verlag, 1988. Reprinted in T.J. Edelstein, ed., *Perspectives on Morisot: Essays*. New York: Hudson Hills Press, 1990; and in Norma Broude and Mary D. Garrard, eds., *The Expanding Discourse: Feminism and Art History*. New York: Icon Editions, 1992.

"Success and Failure at the Orsay Museum, or What Ever Happened to the Social History of Art?" [contribution to "A Symposium: The Musée d'Orsay"], *Art in America* 76, no.1 (January 1988): 85-88.

"En plein air," *Interview* 18, no.4 (April 1988): 122.

The Politics of Vision: Essays on Nineteenth-Century Art and Society. New York: Harper & Row, 1989.

"*Le chêne de Flagey* de Courbet: un motif de paysage et sa signification," *Quarante-huit/Quatorze* no.1 (1989), pp.15-25.

† "Seurat's *Grande Jatte*: An Anti-Utopian Allegory," *Museum Studies* 14, no.2 (1989): 132-53.

"Fragments of a Revolution," *Art in America* 77, no.10 (October 1989): 156-167, 228-229.

Introduction in *Mujer en Mexico/Women in Mexico*. New York: National Academy of Design, 1990.

"Pornography as a Decorative Art: Joyce Kozloff's Patterns of Desire," in Joyce Kozloff, *Patterns of Desire*. New York: Hudson Hills Press, 1990, pp.9-13.

"Bathtime: Renoir, Cézanne, Daumier and the Practices of Bathing in Nineteenth-Century France." Groningen, The Netherlands: Gerson Lectures Foundation, 1991.

Foreword in Abigail Solomon-Godeau, *Photography at the Dock*. Minneapolis: University of Minnesota, 1991, pp.xiii-xvi.

†† "A House Is Not a Home: Degas and the Subversion of the Family," in Richard Kendall and Griselda Pollock, eds., *Dealing with Degas: Representations of Women and the Politics of Vision*. New York: Universe, 1991, pp.43-65.

"Delacroix's *Liberty*, Daumier's *Republic*: Gender Advertisements in Nineteenth-Century Political Allegory," in *XXVIIe congrès international d'histoire de l'art*. Strasbourg, 1992.

"Responses," *The Yale Journal of Criticism* 5, no.2 (spring 1992): 119.

"Mary Frank," in *Mary Frank: Messengers*. New York: Midtown Payson Galleries, 1993.

"'Matisse' and Its Other," *Art in America* 81, no.5 (May 1993): 88-97.

"State of the Art: Philip Pearlstein, *Portrait of Linda Nochlin and Richard Pommer*," *Artforum* 32, no.1 (September 1993): 142-43, 204.

The Body in Pieces: The Fragment as a Metaphor of Modernity. London: Thames & Hudson, 1994.

"Starting from Scratch," in Norma Broude and Mary D. Garrard, eds., *The Power of Feminist Art: The American Movement of the 1970s*. New York: Harry N. Abrams, 1994. Reprinted in *Women's Art Magazine* no.61 (November-December 1994), pp.6-11.

"Cora Cohen: Recent Paintings," in *Cora Cohen*. New York: Jason McCoy Gallery, 1994.

"Issues of Gender in Cassatt and Eakins," in Stephen F. Eisenman, ed., *Nineteenth Century Art: a Critical History*. London: Thames & Hudson, 1994, pp.255-273.

†† "Géricault, or the Absence of Women," *October* 68 (spring 1994): 45-59. Reprinted in R. Michel, ed., *Géricault*. Paris: La documentation française, 1996, pp.403-422.

Contribution to Paul Gardner, "Who Are the Most Underrated and Overrated Artists?" *Art News* 93, no.2 (February 1994): 113-114.

"Vassar, Art and Me: Memoirs of a Radical Art Historian," *Vassar Quarterly* 90, no.2 (spring 1994): 20-24.

†† "Body Politics: Seurat's *Poseuses*," *Art in America* 82, no.3 (March 1994): 70-77, 121, 123.

Conversation with Thierry Mugler, in Holly Brubach, "Whose Vision Is It, Anyway?," *New York Times*, 17 July 1994, section 6, p.46-49.

"Flesh for Phantasy: Lucian Freud – Frayed fraud," *Artforum* 32, no.7 (March 1994): 54-59. Reply and rejoinder, 33 no.3 (November 1994): 7-8.

Review of Jill Johnston, *Secret Lives in Art: Essays, Artforum* 33, no.3, suppl., (November 1994): 2, 6.

Contribution to "The Best and Worst of 1994," *Artforum* 33, no.4 (December 1994): 66.

---- and Tamar Garb, editors. *The Jew in the Text: Modernity and the Construction of Identity*. London: Thames & Hudson, 1995. Includes "Starting with the Self: Jewish Identity and Its Representation," pp.7-19.

"'Sex Is So Abstract': The Nudes of Andy Warhol," in *Andy Warhol Nudes*. Woodstock, New York: The Overlook Press, 1995.

"Learning from 'Black Male'," *Art in America* 83, no.3 (March 1995): 86-91.

"Forest Ranger" [review of Simon Schama, *Landscape and Memory*], *Artforum* 34, no.2 (October 1995): 15, 114.

"Cézanne's Portraits." Lincoln, Nebraska: College of Fine and Performing Arts, University of Nebraska, 1996.

In *Margaret Sargent: A Modern Temperament*. Wellesley, Mass.: Davis Museum and Cultural Center, Wellesley College, 1996.

"Cézanne: Studies in Contrast," *Art in America* 84, no.6 (June 1996): 56-67, 116.

"Art and the Conditions of Exile: Men/Women, Emigration/Expatriation," *Poetics Today* 17, no.3 (fall 1996): 317-337. Reprinted in Susan Rubin Suleiman, ed., *Exile and Creativity: Signposts, Travelers, Outsiders, Backward Glances*. Durham, NC: Duke University Press, 1998.

"Francis Bacon" [Centre Georges Pompidou, Paris; exhibition], *Artforum* 35, no.1 (October 1996): 109-10.

Contribution to "The best and Worst Exhibitions of 1996," *Artforum* 35, no.4 (December 1996): 87.

---- and Joelle Bolloch. *Women in the 19th Century: Categories and Contradictions*. New York: The New Press, 1997.

"Impressionist Portraits and the Construction of Modern Identity," in Colin B. Bailey, *Renoir's Portraits: Impressions of an Age*. New Haven, Conn. and London: Yale University Press, 1997, pp.53-75.

In *Rupert Garcia*. San Francisco: Rena Branston Gallery, 1997.

Foreword in Kathy O'Dell, ed., *Kate Millett, Sculptor: the First 38 Years*. Catonsville, Mary: Fine Arts Gallery, University of Maryland Baltimore County, 1997.

"The Vanishing Brothel" [review of John Richardson, *A Life of Picasso, vol.2: 1907-1917*; Norman Mailer, *Portrait of Picasso as a Young Man*; and *Picasso and the Spanish Tradition*], *London Review of Books* 19, no.5 (March 6, 1997): 3-5.

"Kelly: Making Abstraction Anew," *Art in America* 85, no.3 (March 1997): 68-79.

Review of Robert Hughes, *American Visions, London Review of Books* 19, no.21 (October 30, 1997): 10.

"Objects of Desire: The Modern Still Life" [Museum of Modern Art, New York], *Artforum* 36, no.2 (October 1997): 91-92.

Contribution to "Top Ten x 12," *Artforum* 36, no.4 (December 1997): 90-91.

"Mary Frank *Inscapes*," in *Mary Frank: Inscapes*. New York: DC Moore Gallery, 1998.

"Bonnard's Bathers," *Art in America* 86, no.7 (July 1998): 62-67, 105. Also published in *Tate* 14 (spring 1998): 22-30.

"Signage Infection" [review of Marjorie Garber, *Symptoms of Culture*], *Artforum* (fall 1998), p.4.

"Painted Women" [exhibit], *Art in America* 86, no.11 (November 1998): 106-111, 141.

In *Joy Episalla: Inside/Out*. New York: Debs & Co., 1999.

In Michael Plante, *Deborah Kass: the Warhol Project*. New Orleans: Newcomb Art Gallery, 1999.

In *Ellsworth Kelly: Drawings 1960-1962*. New York: Matthew Marks Gallery, 1999.

Foreword in Thalia Gouma-Peterson, *Miriam Schapiro: Shaping the Fragments of Art and Life*. New York: Harry N. Abrams, 1999.

Representing Women. London: Thames & Hudson, Interplay Series, 1999.

Review of Griselda Pollock, *Mary Cassatt: Painter of Modern Women* and Judith Barter, *Mary Cassatt: Modern Woman, London Review of Books* 21, no.8 (1999): 9.

"Matisse and Picasso: A Gentle Rivalry" [interview with exhibition curator Yve-Alain Bois], *Artforum* 37, no.6 (February 1999): 70-77, 114-115.

Contribution on Chuck Close, *Nancy* (1968), to "Four Close-ups (and One Nude)," *Art in America* 87, no.2 (February 1999): 66-69. Reply and rejoinder 87, no.4 (April 1999): 25.

"Irritating Women," *New York Times Magazine*, 16 May 1999.

"Mama Dada" [review of Naomi Sawelson-Gore, *Women in Dada: Essays on Sex, Gender, and Identity*], *Artforum* (summer 1999), p.4.

"Issues & Commentary: Saluting 'Sensation,'" *Art in America* 87, no.12 (December 1999): 37, 39.

Contribution to "Best of the '90s: Books," *Artforum* 38, no.4 (December 1999): 136.

1378